Louis Vuitton

Art, Fashion and Architecture

Louis Vuitton

Art, Fashion and Architecture

Contributions by Simon Castets, Jill Gasparina, Emmanuel Hermange, Taro Igarashi, Marie Le Fort, Ian Luna, Marie Maertens, Rebecca Mead, Cédric Morisset, Glenn O'Brien, Olivier Saillard, Valerie Steele & Philippe Trétiack.

RIZZOLI
NEW YORK

First published in the United States of America
by Rizzoli International Publications, Inc.
300 Park Avenue South, New York, NY 10010
www.rizzoliusa.com

Louis Vuitton: Art, Fashion and Architecture
Copyright Essays © 2009 Taro Igarashi, Jill Gasparina and
Olivier Saillard

Copyright Texts © 2009 Simon Castets, Emmanuel Hermange,
Marie Le Fort, Ian Luna, Marie Maertens, Rebecca Mead,
Cédric Morisset, Glenn O'Brien, Olivier Saillard, Valerie Steele
and Philippe Trétiack

For Rizzoli International Publications:
Editor: Ian Luna
Editorial Coordinator: Allison Power
Editorial Consultant: Lauren A. Gould
Editorial Assistant: Mandy DeLucia
Production: Maria Pia Gramaglia, Kaija Markoe and
Colin Hough Trapp
Translation Services: Art &Translation, Dominique Zargham, Marie
Iida and Douglas Danoff

Design: Li, Inc., New York

For Louis Vuitton:
Editorial Advisor: Hervé Mikaeloff
Head of Publications: Julien Guerrier
Editor: Valérie Viscardi
Head of Picture Library: Marie-Laure Fourt
Picture Research: Ségolène Dy Rosa with Anne-Céline Fuchs and
Anne-Claire Peroys
Head of Graphic Studio: Arancha Vega
Artistic direction: Ludovic Drouineaud

A Deluxe and limited edition of *Louis Vuitton : Art, Fashion and
Architecture* has been designed by Takashi Murakami exclusively
for Louis Vuitton and distributed in Louis Vuitton stores only.

Printed in China

2009 2010 2011 2012 2013 / 10 9 8 7 6 5 4 3 2 1
Library of Congress Control Number: 2009924298
ISBN: 978-0-8478-3338-2
Deluxe edition ISBN: 978-0-8478-3355-9

Thanks to the whole team at Louis Vuitton, and particularly to
Pietro Beccari, Nathalie Bouquet, Eléonore de Boysson, Elise
Bracq, Yves Carcelle, Loraine Deveaux, Isabelle Franchet, Jun
Fujiwara, Isabelle des Garets, Xavier Dixsaut, Nathalie Fremon,
Raphaël Gérard, Marc Jacobs, Antoine Jarrier, Florence
Lesché, David McNulty, Nathalie Moullé-Berteaux, Marie-Ange
Moulonguet, Nicolas Paschal, Christian Reyne, Mona Sharf,
Nathalie Tollu, Heather Vandenberghe, Valérie Vanhoutte, and
Marie Wurry.

Rizzoli International Publications would like to thank Charles
Miers, Ellen Nidy, Casey Kenyon, Masako Iida, Craig Barnes,
Patrick Li, Roxane Zargham, Seth Zucker, Emma Reeves,
Don Crawley, Nabil Elderkind, Molly Stevens, Ruben Toledo,
Patrick Demarchelier, Kathryne Hall, Bec Couche, Julia Triebes,
Sylvia Griño, Jill Konek, Betsy Biscone, Jessica Marquez,
Candice Marks, Paula Mazzotta, Jimmy Cohrssen, Jan Helleskov,
Corice Canton Arman, Chenelle Hall, Sylvie Huerre, Kathryne Hall,
Dawn Lucas, Norman Jean Roy, Razzia, Caroline Eggel,
Joakim Andreasson, Stephanie Smith, Joann Hong, Alexandra
Schillinger, Astrid Anrep, Anna Engberg-Pedersen, Catherine
Philbin, Brianne Sutton, Brian Anderson, Charles-Antoine Revol,
Lorenza Bravetta, Steven Pranica, Patrick Toolan, Lupe Ramos,
Joe Fountain, Gloria Ahn, Moraiah Luna, Anthony Petrillose,
Walter de la Vega and Claire Gierczak.

Table of Contents

Preface

A symbol of elegance and the French art de vivre, Louis Vuitton has cultivated a close relationship with the world of art since its founding in 1854. Inventing the art of travel, Louis Vuitton and his successors kept pace with a rapidly changing age, and worked with the most accomplished engineers, decorators, painters, photographers and designers of the day. This fascination with ever-new forms of expression grew through the subsequent decades and continues today under the guidance of its creative director, Marc Jacobs; shoes, watches, jewelry and prêt-a-porter collections have joined the malletier's distinctive bags and travel accessories

Louis Vuitton's interest in the arts grew sure strength in the 1980s when it began working with painters like César, Sol LeWitt and Olivier Debré. Demonstrating the influence of art on artisanship, these richly textured collaborations became a tradition and reached a new level when Marc Jacobs joined the company in 1997. Passionate about contemporary art, Jacobs invited some of the world's most renowned artists to join forces with Louis Vuitton, increasing the points of exchange between art and fashion to an unprecedented degree.

Among these renowned partnerships, the late Stephen Sprouse, Takashi Murakami and Richard Prince even intervened directly with the company's products, freely appropriating its forms and visual identity. Collaborations between Louis Vuitton and other artists have taken a variety of forms: shop window designs, site-specific art installations for stores, exhibitions at the Espace Louis Vuitton on the top floor of the Champs-Élysées flagship store, and the acquisitions of new works for the house's own collection.

In the same sprit, Louis Vuitton has called upon an international pantheon of architects to design its stores, including Jun Aoki, Kumiko Inui and Peter Marino. Advertising campaigns have also created opportunities to work with talented photographers as Jean Larivière, Annie Leibovitz, Inez Van Lamsweerde and Vinoodh Matadin.

Louis Vuitton: Art, Fashion and Architecture offers a critical selection—far from exhaustive—of the creative exchanges between Louis Vuitton and an ever-growing list of artists, architects, photographers and designers. A unique document of the relationships the world's leading luxury brand has forged with key figures involved in making of contemporary culture, this volume presents an original perspective on the increasingly symbiotic relationship between art and luxury.

Author Profiles

SIMON CASTETS

Simon Castets is a writer and critic based in New York. He curated the exhibit *Mellow Fever* for Galeries Lafayette's contemporary art space and has contributed to publications including *Frog, Uovo, Yishu, Flash Art and Art Asia Pacific*. He now conducts research for the Centre Georges Pompidou Foundation, is the Art Editor for *V* magazine and *V Man*, and is an editorial contributor to an upcoming issue of Visionaire, to be released in Fall 2009.

JILL GASPARINA

Jill Gasparina is a curator and independent art critic based in Paris. She is the author of *I Love Fashion: l'Art Contemporain et la Mode* (2007). She teaches at the École des Beaux-Arts in Bordeaux and at HEAD in Geneva. She contributes to different magazines and periodicals: *Art21, 02, Frog and Cahiers du MNAM*. She is currently preparing a thesis on massification phenomena in contemporary art. She is the artistic co-director of Salle de Bains, a contemporary art space in Lyon.

EMMANUEL HERMANGE

Emmanuel Hermange is a writer, art critic and educator. He was the assistant to the editor-in-chief of *La Recheche Photographique*, where he published his first essays in 1989. He regularly writes articles for scientific books and artist's monographs, as well as exhibition reviews and other texts for various magazines, including *Art Press, Pour Voir, L'Oeiol, Parachute, Critique d'Art, Études Photographiques, Romantisme and Universalia*. He teaches the history of the arts at the École Supérieure d'Art in Grenoble and works regularly at the École Nationale Supérieure de la Photographie in Arles. In 1998, he was awarded the Lavoisier fellowship by the French Ministry of Foreign Affairs.

TARO IGARASHI

Taro Igarashi is an architectural critic, curator and educator based in Tokyo. His work has appeared in numerous books, including *Superflat Architecture and Japanese Subculture* (2000), *Buddhism and Metabolism* (2005), *Latecomers Living on an Utterly Flat Battlefield* (2006), and the catalogue for the exhibition *The "Post-bubble" Era and Architecture* (2007). He has also written numerous books in Japanese, including *Gendai kenchiku ni kansuru 16 sho* (16 Chapters on Contemporary Architecture), *Utsukushii toshi, minikui toshi* (Beautiful City, Ugly City), and *Senso to kenchiku* (War and Architecture). He is associate professor of engineering in the graduate school of Tohoku University, in Sendai, Japan. He curated Japan's exhibit in the Lisbon Architecture Triennale in 2007.

MARIE LE FORT

Marie Le Fort is an international correspondent based Paris. She contributes to the magazines *Numéro, Wallpaper*, Soon* and *Air France Madame* where she writes regularly on the work of contemporary artists and the creative exchange between luxury and the world of art.

IAN LUNA

Ian Luna is based in New York and is the author or co-author of several books on architecture, design and fashion, including *A Bathing Ape* (2008) with Nigo; *Tokyolife: Art and Design* (2008), with Toshiko Mori; *On the Edge: Ten Architects from China* (2007) with Yung Ho Chang; *Retail: Architecture and Shopping* (2005); *Imagining Ground Zero: The Official and Unofficial Proposals for the World Trade Center Site* (2004), with Suzanne Stephens; and *New New York: Architecture of a City* (2003).

MARIE MAERTENS

Marie Maertens is a journalist and art critic. She writes on contemporary art and the art market, and is a regular contributor to the magazines *L'Oeil, Le Journal des Arts* and *Technikart*. She is the editor-in-chief of *Technikart*'s special edition on contemporary art, published in Fall 2008 and the author of *L'art du marché de l'art* (2008). She also writes for *L'Officiel, Arts Programme, Wad and Whitewall Magazine*. She teaches at Icart and is curating several exhibitions scheduled for 2010.

REBECCA MEAD

Rebecca Mead is a writer at the *New Yorker* magazine, where she has written profiles of Santiago Calatrava, Ronald Lauder, Nico Muhly, and Slavoj Zizek, among many others. She is the author of *One Perfect Day: The Selling of the American Wedding* (2007).

CÉDRIC MORISSET

Cédric Morisset began working as a curator when he was invited by the International Biennial of Design in Lisbon in 2003. He has since organized several exhibitions in France and abroad, including *French Reference* at the 1933 exhibition hall Shanghai, (2008), at Museum of Guangdong in Canton (2008), Märkisches Museum, in Berlin (2007) and *Icons of Design* Marq, Museum of Architecture, Buenos Aires (2008) and at Museu da Casa Brasileira, São Paulo (2009). Morisset is a regular design contributor to *A.D., Mixte* and to *Le Figaro*. He is currently preparing a book of interviews with the Brazilian designers Humberto & Fernando Campana.

GLENN O'BRIEN

Glenn O'Brien is a writer, editor and creative director. As Editorial Director of Brant Publications, he oversees *Interview, Art in America* and the magazine *Antiques*. He writes a monthly column for *GQ* and a weekly column for the Italian edition of *Vanity Fair*. His copywriting has been behind some of the most influential advertising of our time, and for years he was one of the most widely read writers about music. He remains one of the most influential writers on art in the world.

OLIVIER SAILLARD

Olivier Saillard is a fashion historian based in Paris and is head of programming at the Musée des Arts Décoratifs. Saillard contributes to the magazines *Elle, Crash* and *Jalouse*. He is the author of the book *Les Maillots de Bain* as well as *Christian Lacroix* (with Patrick Mauriès Christian Lacroix and Grégoire Alexandre). He is an expert in contemporary fashion and has curated numerous landmark exhibitions and designer retrospectives since 1995. He curated an exhibit on the complete work of Sonia Rykiel in 2009.

VALERIE STEELE

Valerie Steele is director and chief curator of The Museum at the Fashion Institute of Technology in New York, where she has organized more than twenty exhibitions in the past ten years, including *Gothic: Dark Glamour* (2008); *Love & War: The Weaponized Woman* (2006); and *London Fashion* (2002). She is author or co-author of more than a dozen books, including *Ralph Rucci* (2006); *The Corset: A Cultural History* (2001); *Paris Fashion* (1999); *Fifty Years of Fashion* (1997); *Fetish: Fashion, Sex and Power* (1996); *Women of Fashion: 20th-Century Designers* (1991); and *Fashion and Eroticism* (1985). She is also founding editor of the influential scholarly quarterly, *Fashion Theory: The Journal of Dress, Body & Culture*.

PHILIPPE TRÉTIACK

Philippe Trétiack is an architect, urban planner, journalist and writer. He is a correspondent for *Elle* and is a regular contributor to *Elle Décoration* and *Beaux-Arts*. He is the author of over twenty books and has written extensive essays on the Anti-mafia movement in Italy as well as analytical biographies on Andy Warhol, Raymond Lowy, Cartier and others. He wrote a controversial architectural pamphlet, "Faut-il pendre les architectes?" (2001) and was made a Chevalier of the Order of Arts and Letters. His study of Iranian clerics earned him the Prix Louis Hachette in 2007.

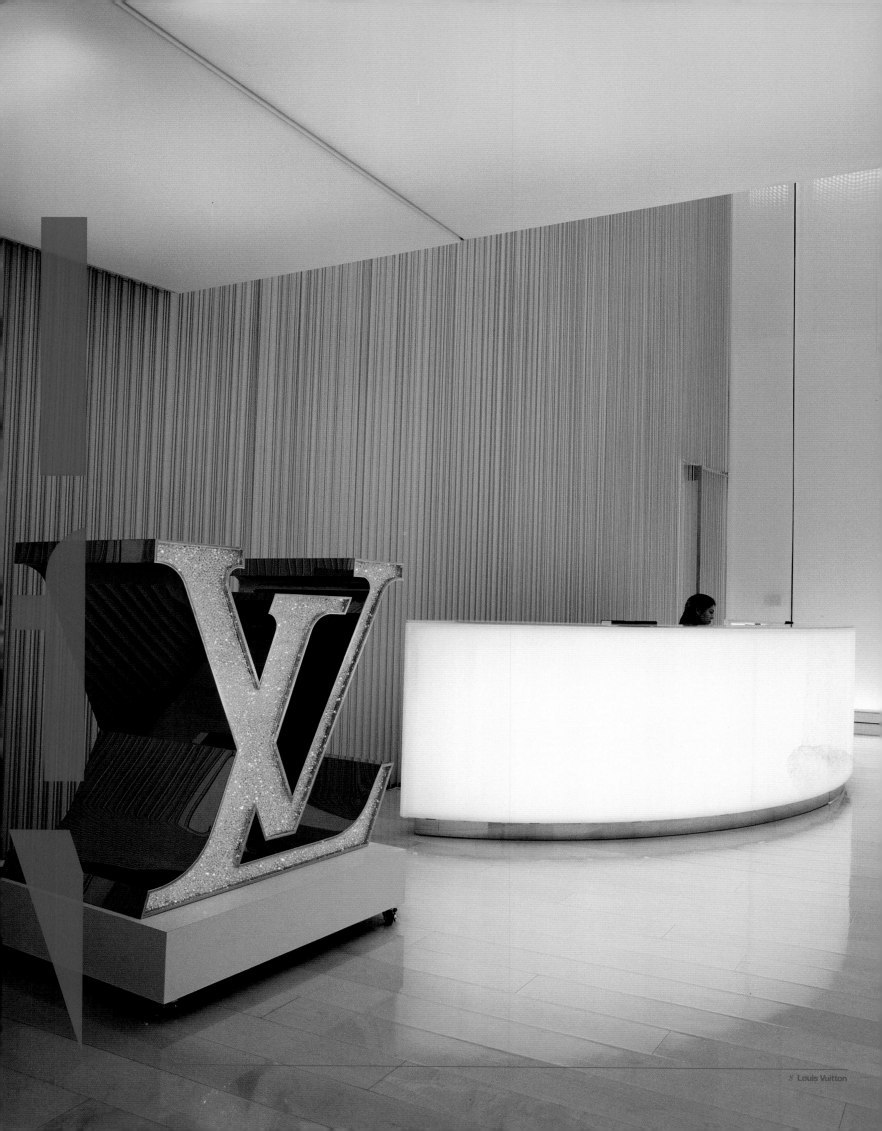

by Taro Igarashi

by Taro Igarashi

Learn from Vuitto

ning

ing

Louis

on

Learning from Louis Vuitton
by Taro Igarashi

THE SHOCK OF LOUIS VUITTON, NAGOYA
Everything began in Nagoya in 1999.

The Louis Vuitton store in Nagoya by the architect Jun Aoki stands as a rectangular solid in the corner of a shopping district. While its shape is simple, the building's shop windows are built from a double-pane wall of fritted glass that cause passersby to be momentarily transfixed. Louis Vuitton's trademark checkerboard or Damier pattern—known vernacularly as *ichimatsu*—is etched on both the outer and inner walls, and creates a beautiful moiré effect. The geometric patterns seem to flutter and undulate as one walks around the building, an experience that can never be approximated by a still photograph.

Aoki's conceit is most beautiful at night, when the boutique's interior light, diffused by the fritted glass, gradually illuminates the darkness. Evocative of an opulent jewelry box, the building's transparency achieves greater effect deeper into the evening, as it looms mysteriously over a nondescript streetscape. Restrictions were imposed on altering the interior plan of the shop, and the architect used this to his advantage, focusing instead on the facades by employing a technique, that while simple and delicate, renders striking visual effects largely through the manipulation of texture and light.

The geometric illusion of the building is performed on a decidedly smooth, flat surface. From the context of contemporary art, the *ichimatsu* pattern that creates the moiré phenomenon could be considered as an instance of Op(tical) Art—engaged by artists such as Bridget Riley in the middle of the 20th century—in the field of architecture. Op Art specialized in illusions borne out of geometric patterns, and attempted to graphically fuse art and science. The construction of the Louis Vuitton store in Seoul (2000), initiated by Aoki, produces similar visual effects, this through the application of mosaic tile and a metal mesh layer. Subsequent Louis Vuitton stores handled by Kumiko Inui, and Yuko Nagayama from Jun Aoki & Associates also draw from similar principles. Verner Panton's work comes to mind as crucial examples of spaces reminiscent of Op Art. Generally known for stackable, colorful chairs featuring a sleek fluid curve, or an inverted conical structure, he had also handled interior designs that made use of repeating patterns of circles and squares. What he produced were hypnotic decorations that incited a mild visual vertigo. A hallway on the fifth floor of Louis Vuitton's Omotesando flagship store also features a repeating rhombus, creating a space that was perhaps inspired by Panton, even by M. C. Escher.

For his Louis Vuitton store in Roppongi Hills (2003), Aoki, while using different materials throughout, covered the exterior and interior of the building with the repeating motif of identically scaled, 10cm-diameter circles. The outer wall is a screen of about 30,000 glass tubes, and on the walls, the ceiling, and even in the partitions inside, the identical circles repeat themselves. The reason why he chose the particularly small circle was to avoid scaling the circles to a size close to the products on display, so that they would not clash with the spatial design. Compared to the era of Op Art or Panton, the Louis Vuitton buildings are careful to increase the degree of transparency of their ornamental surfaces, resulting in a highly sophisticated design.

Following the success of Louis Vuitton, Nagoya, Aoki developed a variation of the same pattern for the frontage of the Louis Vuitton shop in Ginza's Matsuya department store (2000), and went on to deploy different variants for branches in Omotesando, Roppongi Hills, Ginza's Namiki Dori (2004), as well as New York's Fifth Avenue (2004). Each store reflects a concern for perfecting visual and spatial phenomena that can only come to life in a specific place. The success of these experiments owe no small debt to Louis Vuitton's meticulous standards of architectural production, in which a life-size mock-up is first created, from which several adjustments are made until the desired results and variations in effect are achieved. As the *ichimatsu* pattern saw broad use in Louis Vuitton stores located elsewhere in Nagoya, as well as in outposts in Tokyo's Shinjuku, Sendai, Singapore and Seoul, the style became a signature device—but one that retained significant thematic flexibility.

The first Nagoya store could really be seen as the opening salvo in the revival of the luxury boutique in the late 1990s. Heralding an important shift in Louis Vuitton's architectural program, the success of the store even goaded competing brands to employ a house architect of Aoki's dexterity. These initial collaborations between Aoki and Louis Vuitton enhanced the reputations of architect and patron in equal measure, and the subsequent boutiques in Kochi, Kyoto's Daimaru Department Store and Nagoya's Midland Square (respectively by Kumiko Inui, Yuko Nagayama and Takayoshi Nagaishi) made their young authors much sought after throughout Japan.

ARCHITECTURES OF SUPERFLAT

When I first saw the Louis Vuitton store in Nagoya, a certain concept that best explains the cultural evolution of contemporary Japan came to mind: Superflat.[1] A catchall term coined by Takashi Murakami in an ambitious attempt to make sense of the diversity of contemporary Japanese cultural production, he wrote in 1999 that Superflat exists "within a spatial consciousness of super-flatness. The world is never a self-contained sphere. It can be said that it is an infinite space of limitlessly flat, ever-expanding horizon."[2]

The philosopher Hiroki Azuma's critique of Murakami's *Mr. DOB* series cites a number of general tropes that emphasize the graphic nature of Superflat—that would later be pressed into the service of Louis Vuitton: "Their numerous contorted spheres that float above a flat surface, their disavowal of the concept of single 'space' in the vein of perspective drawings, and their lack of depth. The pictures are also without a central locus, and a myriad number of symbolic eyes drift about. Here, the way of looking at a picture that has been standardized by the spatial expression of contemporary perspective drawings does not exist. This concept takes its clues from the world of *anime* and *manga*."[3]

This general inclination towards the Superflat have corollaries in various art and design disciplines, including those of film and photography. In graphic design, for example, there is Groovision's ubiquitous invocation of Chappie, its emblematic *kawaii* character. In photography, there is Hirmoix, the *shojo* photographer. In other examples, there are the architectural models that tend toward horizontal establishment as opposed to vertical massing.

This flexible interpretation of Superflat opens itself up to architecture as well, and herewith Jun Aoki's Louis Vuitton store can be considered. Clearly, architecture does not exist in a two-dimensional world; it could even be argued to exist far beyond the scope of this very concept of dimensionality. And yet at the same time the architecture cannot be limited to a literal flatness. Murakami himself considers the three-dimensional figurines of *anime* characters to belong to the realm of the Superflat that lacks a normal sense of 3-D. By focusing first on the expressions of the façade which functions as a membrane of a building, I would like to define the architecture of Superflat to be designs that sport a 2.5-D spatiality. In other words, the architecture characterized by its thinness and lightness, or those that lack the traditional depth of three-dimensionality. Secondly, the Superflat architectures suggest a building that breaks down the hierarchy of programs and function.

Jun Aoki's Louis Vuitton, Nagoya, showcases a moiré effect brought about by the interference of its double *ichimatsu* patterns. The setback of the entrance, displays, and lightings are installed inside the 111mm gap created by the building's outer glass wall and the inner structural wall. The electrical lights at night turn these into a visual wonder, while under sunlight the glass outer wall reflects the clouds in the sky, the buildings across the street, as well as the *ichimatsu* pattern in overlapping layers. Because the Louis Vuitton store at Ginza's Matsuya department store (2000) was a renovation of a pre-existing building, the depth of the double-skinned wall is even less at 70mm, but by using an *ichimatsu* pattern of different sizes and thereby creating a triple layer of patterns, the building creates alternating scales of the moiré phenomenon from the point of view of passersby.

While traditional perspective drawing limits the field of view in which such optical effects can be experienced, the moiré, borne out of the double façade, depends on movement to take full effect. This can be compared to the argument between "literal transparency" and "phenomenal transparency" suggested by the architectural critic Colin Rowe. According to Rowe, the Bauhaus school, with its spatial gaps of glass, falls into the former category, while Le Corbusier's manipulation of structure, as evidenced in his facades featuring overlapping multiple patterns, is placed in the latter. This is because the surface transparency of Le Corbusier's work makes itself known *ex-post facto*. In this sense, Aoki's Louis Vuitton constantly requires the movement of the viewer to be effective, and at the point in which one registers the transparency of its exterior skin the strongest, the building can be said to possess a "phenomenal transparency." Yet at the same time, it contains a "literal transparency" as suggested by its dependence on the materiality of glass.

It is interesting to compare the building to Bramante's Santa Maria Presso di San Satiro in central Milan. Because the site of the church lacked depth, the plan to construct a Latin cross was aborted; it only had enough space to allow the shape of a "T" at best. Bramante, however, employed a new technology of proportion and perspective that was perfected during the Renaissance. By adding an imaginary depth to the inner wall of the "T," Bramante created the effect in which the structure looks like the Latin cross when seen from the church's entrance. For the Louis Vuitton store, Aoki on the other hand focuses on the surface's inherent lack of depth, and disregards altogether the need for the sense of depth in the three-dimensional convention. Where Bramante attempted to visualize a depth that did not exist, Aoki desired to create a surface that compels the viewer to imagine a depth that cannot be seen. In the October 2004 issue of *Japan Architect*, Aoki wrote, "The outer wall creates the spirit of space that does not exist in reality."

On the other hand, some examples that befit my second definition of Superflat architecture are Aoki's Louis Vuitton store in Omotesando, that eschews the construction of

hierarchy among structure, furniture, and finishing touches; as well as the stance of Kuma Kengo (also a Louis Vuitton collaborator) that attempts to release architecture from the heavy constraints of object art, proposing it instead as something to be understood as an aggregate of particles.

RETHINKING THE "DECORATED SHED"

Recently, and largely through the vehicle of luxury brand boutiques, the design of surfaces has become increasingly radicalized. In architectural history, traditional structures such as temples, churches and palaces were the principal typologies since the dawn of civilization through the 19th century. With the advent of modernity, public and commercial institutions such as museums, city halls, train stations and office towers—as well as private domiciles became the locus of change, but retail design was paid scant regard. Even now, university courses in architecture tend to overlook this particular sector. This lingering academic bias makes the current reversal that has resulted in the ascendancy of retail spaces particularly interesting. According to the relationship of structure and decoration, the following two trends can be distinguished today:

First, the integration of structure and decoration in retail spaces is evident. In traditional architectural designs, the structure defined the building, with decorative flourishes added later. However, the development of computer graphics, and the accompanying advancement in mathematical learning have made complex structures that incorporate figuration (or ornament) possible. For instance, consider the concrete façade of Toyo Ito's Tod's Omotesando (2005) building that mimics the branches of trees, or the rhombic frame of Prada Aoyama store designed by Herzog & de Meuron (2004).

The second trend comprises architectures, like those of Jun Aoki, that consider the structure and decorations to be separate entities. When Aoki first took on the work of Louis Vuitton, he was reluctant as an architect to undertake what seemed like mere surface design, but gradually begin to see decoration in its own light, and grasped its inherent possibilities. The Louis Vuitton spaces designed by Kengo Kuma, Kumiko Inui and Yuko Nagayama can all be placed within this shared genetic lineage.

Such categorization is consistent with the great work on postmodern architectural theory by Robert Venturi and Denise Scott Brown in *Learning From Las Vegas*. Upon researching the sprawling development along the Las Vegas strip, they cited the importance of signs over structures, and coined the concepts "Duck" and "Decorated Shed." The "Duck" signify the architectural style in which the structure itself is distorted to give the effects of a billboard. On the other hand, the style of "Decorated Shed" separates the billboard (sign) from the box-shaped body (shed), and considers its design strategically. In

actuality, the commercial institutions call for a façade that draws the eye. In an era where postmodern architecture acts as a conveyor of information, it was inevitable that architects should turn towards designing stores.

Venturi's team inclines towards the symbolic "Decorated Shed" over the Modernist "Duck," which requires the structure of a building to represent its inner functions. The latter proposes the integration of structure and decoration, while the former applies to the autonomy of decoration. Aoki's Louis Vuitton store in Ginza's Namiki Dori (2004), which was a remodeling and expansion of an existing building, fuses the box with the sign while also hiding the interior by wrapping the entire building. Moreover the store, outfitted with differently sized openings and translucent marble that permit and modulate the amount of natural light, makes it difficult to distinguish the individual floors, as similar windows never align on the same floor. This suggests a disparity from a typical function of a billboard that attempts to directly represent the interior. The building, wrapped entirely in GRC (Glass Reinforced Concrete) panels, helps to increase the mysticism of the store and the brand as it prompts the viewer to fantasize about the space that exists inside.

Jun Aoki remains sympathetic to the concept of the "Decorated Shed," but he has questioned the communication theory that suggests a billboard should convey the internal substance of the building[4]. He maintains that modern architecture has suppressed decoration, and while Venturi has attempted to release them, his work has not been a complete rehabilitation of the decoration in the most fundamental sense.

The façade design of Aoki's Louis Vuitton stores does not exist to communicate the internal meaning of the edifice, nor does it exist independently as an outer wall. While separated from the actual materiality of its internal spaces, by serving as a form of disguise, the decoration tempts the viewer to imagine an interior space that that does not really exist. The concept is similar to the function of fashion in relation to the body. Aoki calls such a style the "Absolute Decoration."[5]

THE TEXTURE OF THE DIGITAL AGE

In 1914, the Louis Vuitton store that appeared on 70 Avenue Des Champs Elysées, bore an Art Nouveau façade. In essence, it was a design that separated itself from the styles of the past, commanding a newer style composed of flowers, plants and other nature-inspired designs.

Let's consider for a moment *Ornament and Crime*, a critical essay against superfluous decoration proposed by the influential modernist architect, Adolf Loos. Loos proclaimed that "The evolution of culture marches with the elimination of ornament from useful objects," paternalistically

comparing surface decoration to the tattooing of Papuan aboriginal peoples. Loos believed that while in the past it was necessary for people to show their individuality through ornate and colorful clothing, the psychological and moral development of mankind has made such ornamentation unnecessary. Reflected in this stance is his moralistic philosophy of the civilized world, which views ornamentation as a type of degenerate pathology.

The bleached white surfaces of high modernism designated a space as healthy, or perhaps even sanitary. Yet more importantly, as such surfaces became the symbolic representation of the expulsion of ornaments, it also served as a blank canvas against which the abstract manipulation of structure could stand out.

The postmodern architectures at the end of 20th century are most notable for their manipulation of vibrant palettes, lively decorations, and florid structures. Comparatively, the current luxury brand stores exhibit subdued colors on simple, one-volume boxes, with the attention given primarily to the membranes that surround them. The graphic architecture of postmodernism had envisioned the "architectualization" of billboards. But the contemporary glass facades, overlapped with graphics or made of transparent designs through which one can see the interior, seem to be patterned after the computer screen. In reality, the transparency of the image on the screen can be freely adjusted.

The psychiatrist Tamaki Saito has criticized the abrupt turn from "structure to texture" seen in contemporary culture.[6] In other words, the introduction of computers has allowed 3-DI skeletons (structures) to be modeled first, so that the surrounding textures can be adhered after. The result has a lot in common with texture mapping. Nowadays, the technology of texturing rather than structuring is more prominent in the sites of production.

Just like the futuristic Asian city depicted in Ridley Scott's *Blade Runner* (1982), there are instances in which architecture itself plays the role of a huge screen on which images can be projected. What matters now is the surface layer, and tactile forms begin to disintegrate. The complexity of the exterior wrapping, rather than the differences of form, aids the creation of an image that is essential to determining the brand value of a commercial product. The frequent uses of transparent glass, the deployment of visual effects, imitations of computer screens, and the deprivation of form—these proclivities define the architectures of surface layers that bear the image of the information age.

The Louis Vuitton stores of Inui and Nagayama also exhibit similar inclinations. The Louis Vuitton store in Osaka Hilton (2004) relies entirely on the designs of its surface. Therefore, Inui decided to incorporate a solid, three-dimensional pattern of stainless steel between the outer glass wall and the decorated inner wall. Both the graphic designs on the inner wall and the stainless steel grids expand diagonally at the same angle as the logos "L" and "V." Moreover, the stainless steels is burnished to work as a mirrored surface, so that it reflects the diagonal latticework drawn on the inner wall in a complex interaction. As a result the sense of depth of the wall is distorted, giving off the illusion that the space beyond the glass wall is full of a transparent substance (such as water or clear jelly) that create innumerable refractions of light.

Following the Aoki stores in Nagoya and Omotesando, Inui also took on what would be the third freestanding store, Louis Vuitton Kochi (2003). As with the other locations, the architect was chosen through a competition. The Kochi store, in keeping with the Louis Vuitton strategy, was established on a corner facing a central street. However, Inui felt a certain reservation against building a piece of contemporary architecture in quaint Kochi. As a solution she decided to incorporate stones as the building's primary material, as they evoke a more ancient mood. Yet the way she set about using the stones is strictly digital-age. Against a huge wall with a height of 11.5m and the width of 30m, Inui strung over 14,000 blocks of limestone like a rattan blind. Instead of layering the stones from the bottom up, she used the stones to create a contiguous surface of the most delicate texture.

When the lights inside the building come on at night, the Damier pattern seems to float behind the stone screen. True to Inui's expression of "something that exists between texture and graphic," the exterior and interior of the building are not unified in a 1:1 relationship. In an interview in the May 2003 issue of *Japan Architect*, to Inui, the stone "a material of particular naïveté, does not fall under any of the original patterns when linked into a single pattern, and while it resembles the Damier fabric, it is never reduced to a graphic nor to a texture, existing forever in between the two." The aim of the building, therefore, was a creative process that did not value the assumed heft of the stones, but their lightness in a manner similar to texture mapping.

Yuko Nagayama's Louis Vuitton store in Daimaru department store in Kyoto (2004), creates an opaque, black but lightweight latticework by affixing a polarizing plate on the glass wall. According to Nagayama, before the development of the Monogram and the Damier pattern, a stripe pattern know as the *rayée* was used for Louis Vuitton's trunks and suitcases. The vertical louver that appears as a shadow is an homage to this vintage pattern.

LUXURY ARCHITECTURE AS PAVILIONS

Throughout the years the streetscapes of Tokyo's Omotesando and Ginza have undergone a rapid transformation, and what lines the streets today in both

places are luxury boutiques designed by luminaries like Toyo Ito and SANAA. In both neighborhoods, the vanguard of the trend has always been Louis Vuitton. The former president of Louis Vuitton Japan, Kyojiro Hata, wrote, "As a concoction of luxury brands, fashion, and architecture, it is safe to say that the new cityscape of Omotesando has become in no way inferior to the European streets lined with high fashion brands—a vision that I could only yearn for when I first welcomed Louis Vuitton's retail store in Ginza's Namiki Dori. Louis Vuitton in Omotesando building might well be called the culmination of retail stores built as architectural art."[7]

Overseas, there have been such monumental works such as Christian de Portzamparc's LVMH building in New York City (1999), but in terms of the sheer number of works built for Louis Vuitton, Japan remains a world apart. The remarkable domestic sales result, as well as Japan's dominance in the brand's total sales no doubt contributed to this fact. In addition, the inaugural publication of *Casa Brutus*, a groundbreaking monthly magazine that combined architecture with fashion, served as a catalyst for the trend as top-shelf store designs proved to be an advertising force in and of themselves. If one reads the press releases for new Louis Vuitton stores, the emphasis placed on the explanations of the architecture become immediately palpable. Just as Jun Aoki valued the upmarket appeal of the Omotesando branch's location, the uniqueness of each store in relation to its environment helps to associate the brand with a kind of authentic value. For the faithful, the architectures of Louis Vuitton have become the sanctuaries of their pilgrimage.

It is interesting to compare the current phenomenon created by Louis Vuitton to how, Disney employed such postmodern architects as Robert Venturi, Michael Graves and Arata Isozaki to build their headquarters and other related facilities around 1990. However, Jun Aoki is quick to distinguish the difference between what Disney and Louis Vuitton did. "What is important in fashion is the creation of a fantasy. I do not speak of Disney-esque fantasy that is completely unfounded in reality; I mean the kind of fantasy that allows one to look at the entirely different aspects of a preexisting material. A fashion brand that succeeds in creating this fantasy will be considered highly valuable. So perhaps you could say that the tricks used to accomplish this is the very definition of fashion."

Let's now return to Louis Vuitton Nagoya, which has always served as the origin of the movement. When faced with the challenge of building what would become the first freestanding store for Louis Vuitton Japan, Kyojiro Hata, placed a premium on originality and organized an architectural competition ."With a brother-in-law who is an architect and who also served as a chairman of The Japan Institute of Architects, and a significant number of architect

friends, I was already ensconced in an environment where architecture felt significant, and I myself possessed an immense interest in the field."[8] Hata has also remarked: "I had seen the Louis Vuitton store in Paris, and I knew that in order for the true value of a brand to be comprehended, it is imperative that its history, tradition, inherent skill and aesthetics are communicated to the consumer, and I was sure that a store could serve as a great place to represent all of it." His determination served as a key factor in the transformation of the brand into an architectural force.

It is perhaps inevitable that luxury brands should invest in architectural design as their primary source of outdoor advertising. As customers seek authenticity, Kumiko Inui has said that architecture is starting to become as much a part of the brand as the luxury goods themselves. Clearly, the bigger the budget the more appealing the work becomes for the architect, but according to Inui, the architect is more drawn to the particular mystery inherent in fashion. A piece of clothing can distort the body, incite the imagination, and create a mystery. Inui feels that although being symbolic is commercially advantageous, "What Louis Vuitton seeks today is not the directness of self-expression, but the representation of a product's premier qualities in ways that are not symbolic."[9]

In other words, like the Kochi store she designed, the equivalent of the act of cherishing the product's delicate textures must also be sought in architecture. Luxury retail design today serves the same purpose as the pavilions of global expositions. Both architectures are considered ephemeral, but they share a similar tendency to adventure. Indeed, the expositions in the past were responsible for introducing such revolutionary architecture as the Crystal Palace and the Eiffel Tower. But as expo designs are largely in the past, the luxury architecture of high fashion brands must now carry the torch. As fashion-conscious Omotesando and other shopping precincts function as the showcase for radical architectural pursuits, it is no wonder that, according to the architect Eric Carlson, Louis Vuitton is ever on the lookout for young, rising stars unafraid to explore uncharted terrain. As we progress further into the 21st century, retail design, with its constant quest for the new, will lead the way for the rest of architecture.

1 Igarashi, Taro in "Superflat and Japanese Subculture," Kira, Moriko ed. *Japan: Towards Totalscape*. Amsterdam: NAI, 2000, pp. 96-101
2 Murakami, Takashi. *DOBSF: DOB in the Strange Forest*. Tokyo: Bijutsu Shuppan-sha, 1999, n.p.
3 Murakami, Takashi. *Superflat*. Tokyo: MADRA Publishing, 2000, pp. 138-151
4 Aoki, Jun. *Jun Aoki Complete Works 1, 1991-2004*. Tokyo: INAX, 2004, n.p.
5 Aoki, Jun. *Japan Architect*, October 2004. Tokyo: Shinkenchiku-sha, 2004, pp
6 Saito, Tamaki. *graphic/design*, February 2006. 44-46
7 Hata, Kyojiro. *Louis Vuitton Japan: The Building of Luxury*. New York: Assouline, 2004, n.p.
8 Hata, Kyojiro. *Louis Vuitton Japan: The Building of Luxury*. New York: Assouline, 2004, n.p.
9 Inui, Kumiko, as quoted in Louis Vuitton Japan. *Logic/Visual—The Architecture of Louis Vuitton*. Tokyo: Louis Vuitton Japan, 2003, n.p.

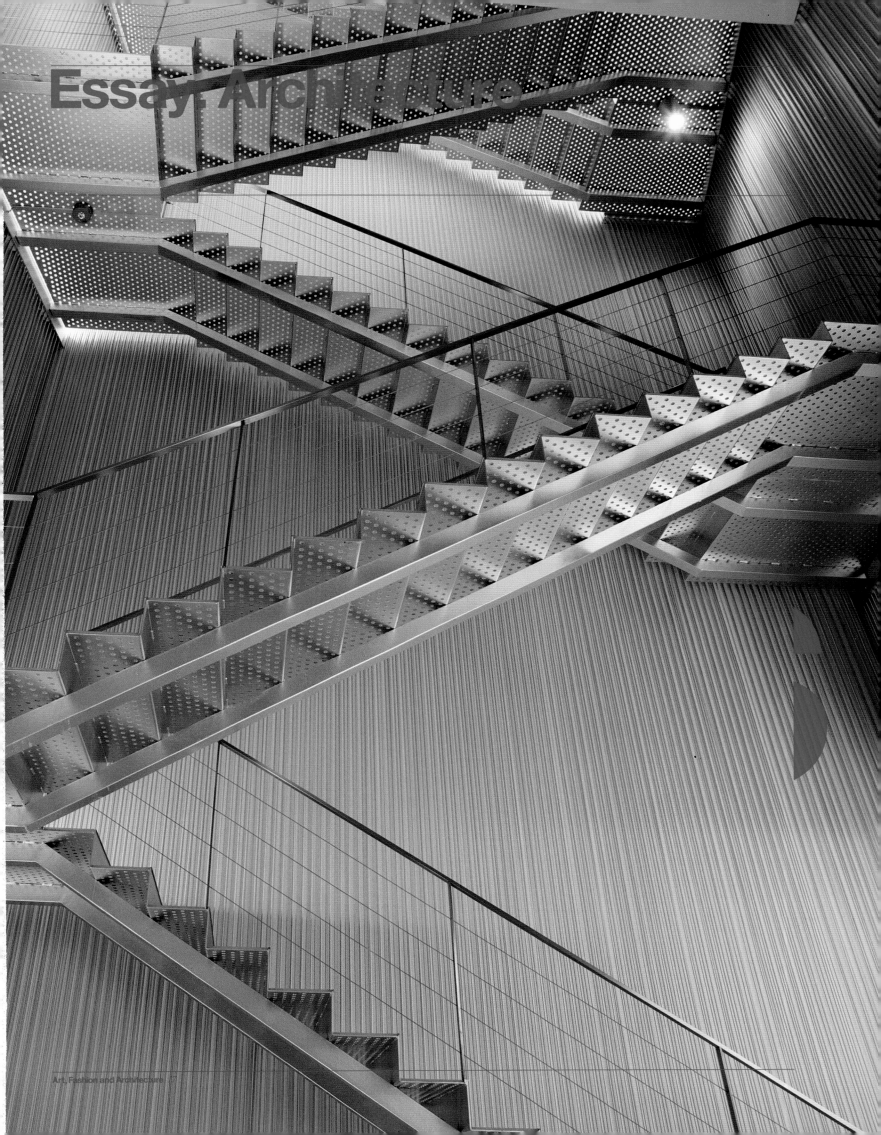

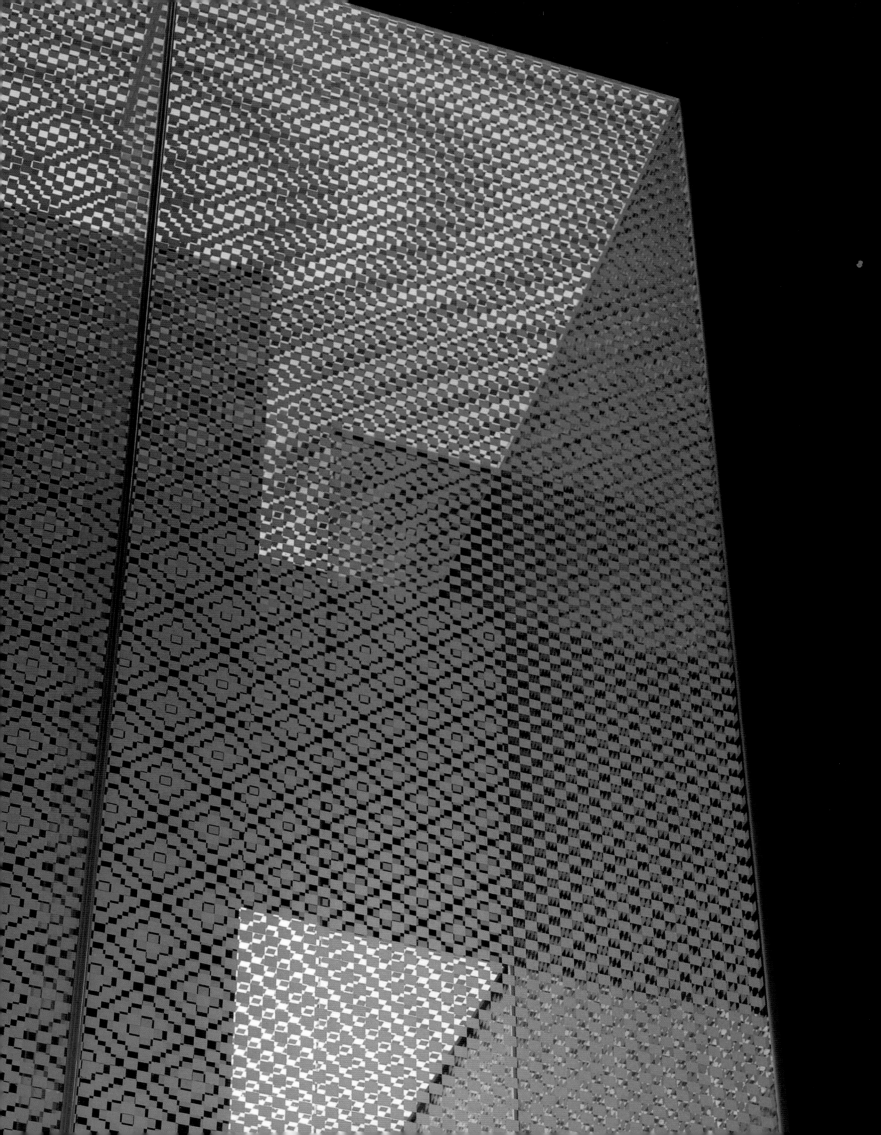

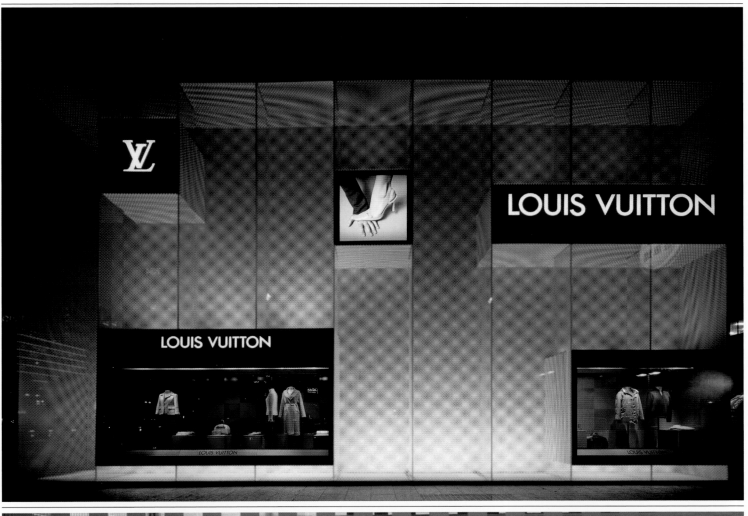

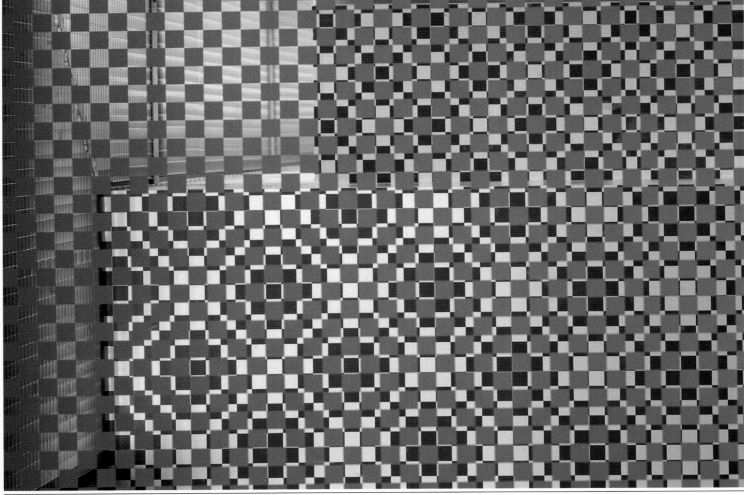

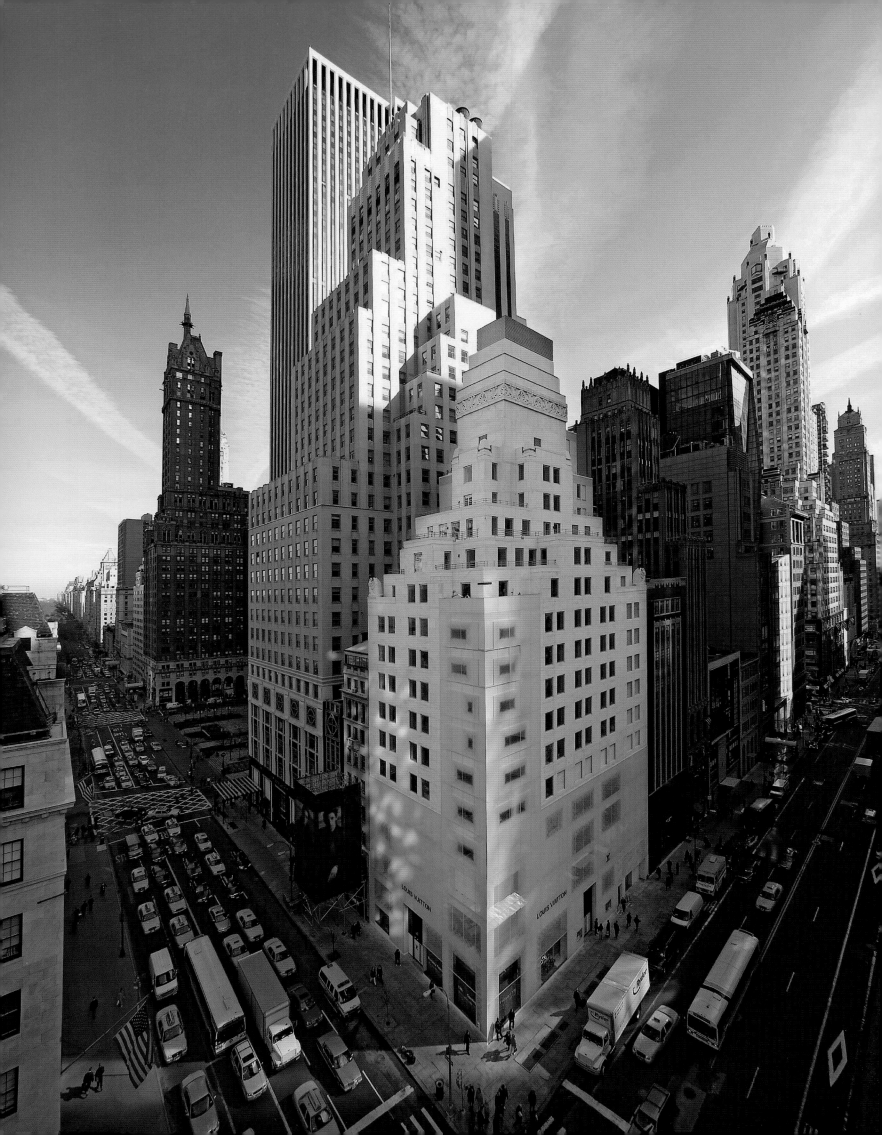

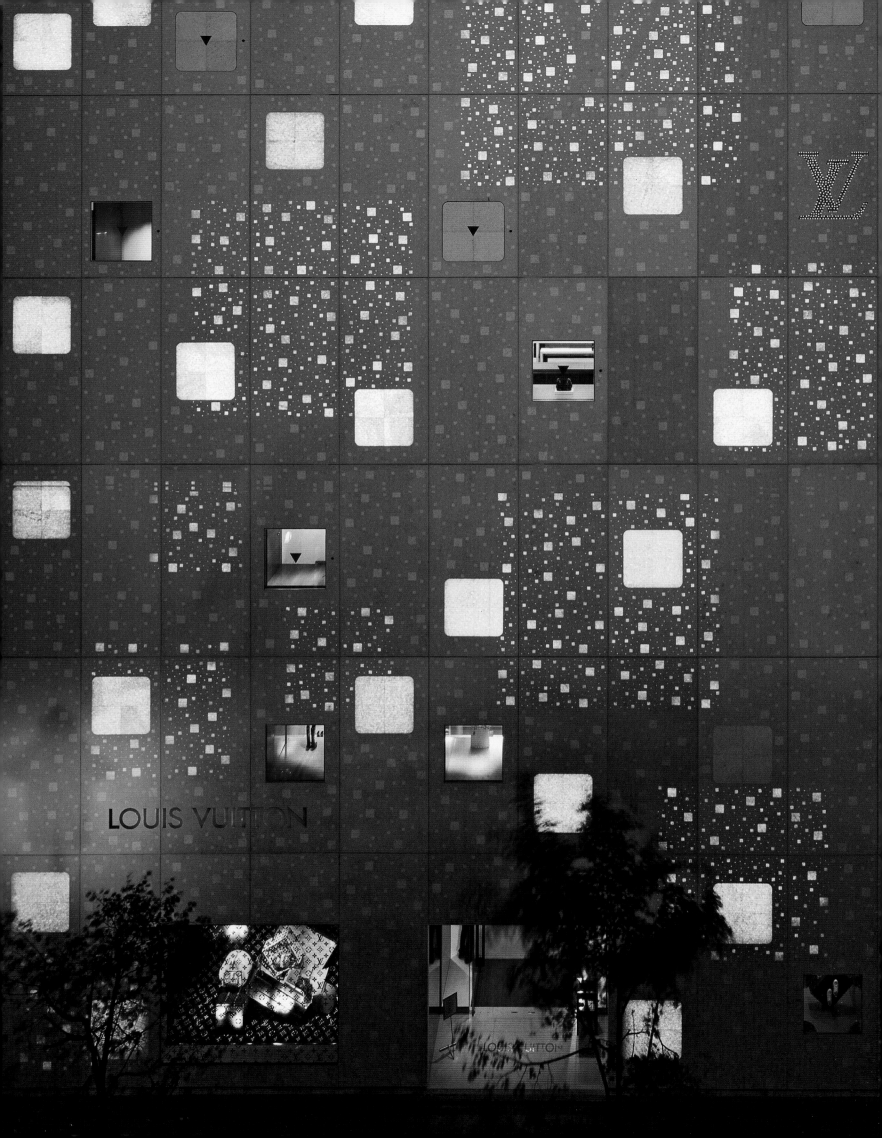

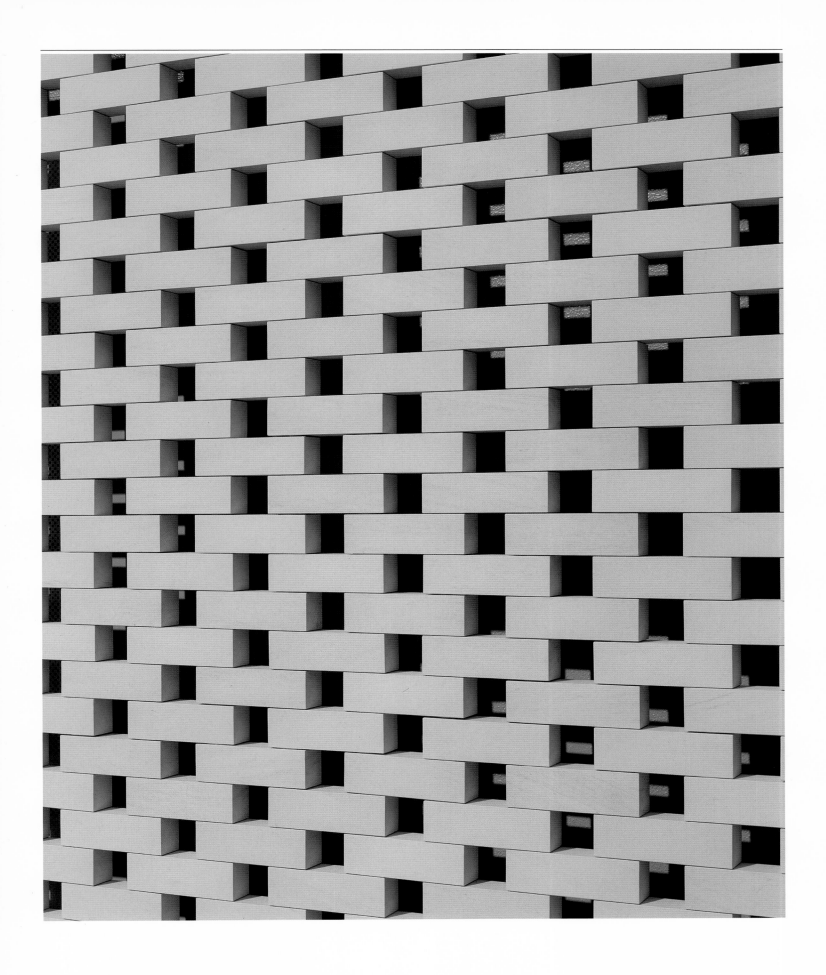

p.8, 17 Interior view of the headquarters of Louis Vuitton Japan, One Omotesando Building (2003), by Kengo Kuma. p.18-19 Views of exterior and façade details, Louis Vuitton Nagoya Sakae (1999) by Jun Aoki & Associates. The Damier pattern is etched between the outer and inner walls to create a third pattern. p.20 Maison Louis Vuitton New York (2004), Fifth Avenue and 57th Street: renovation of the exterior by Jun Aoki; interior design by Peter Marino. p.21 Exterior view of Louis Vuitton Roppongi Hills, Tokyo (2003), designed by Jun Aoki & Associates, Eric Carlson and Aurelio Clementi. The Roppongi Hills tower is reflected on the boutique façade, which is composed of 30,000 glass tubes. p.22 Exterior view of Louis Vuitton Ginza—Namiki Dori, Tokyo (2004), by Jun Aoki & Associates. The glass-reinforced concrete façade of the boutique is cast with white marble inserts. Flush with the wall and appearing opaque to passersby during the day, these translucent membranes modulate the discharge of artificial light from within the store. p.23 Detail of Louis Vuitton Store in Kochi, Japan, by Kumiko Inui (2003). Screening the façade are 14,000 blocks of limestone.

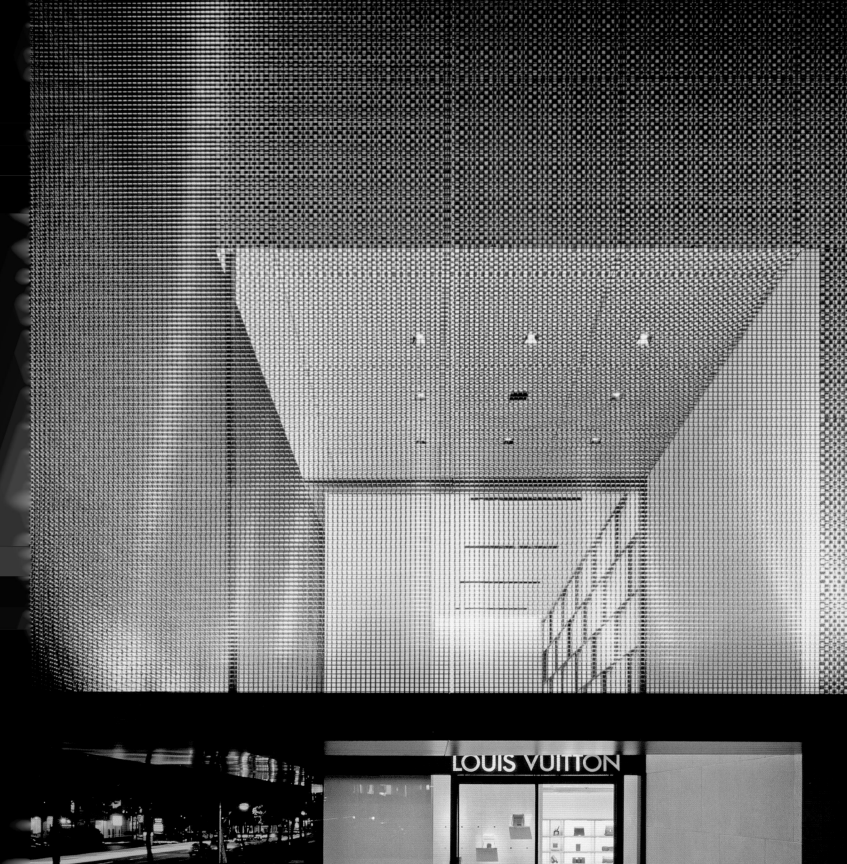

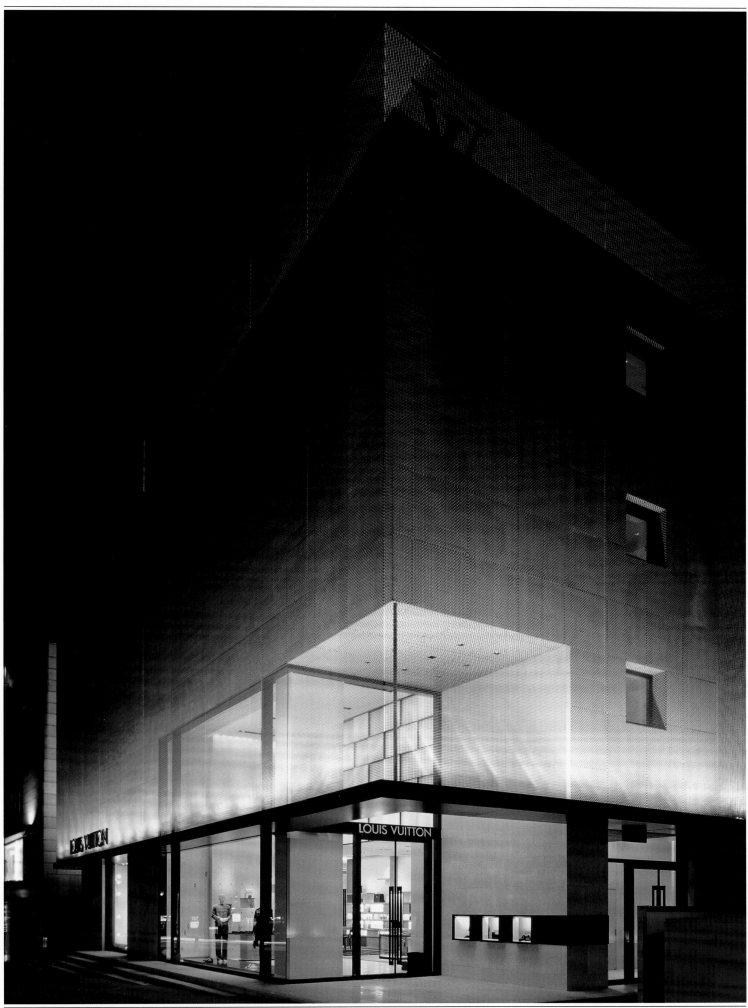

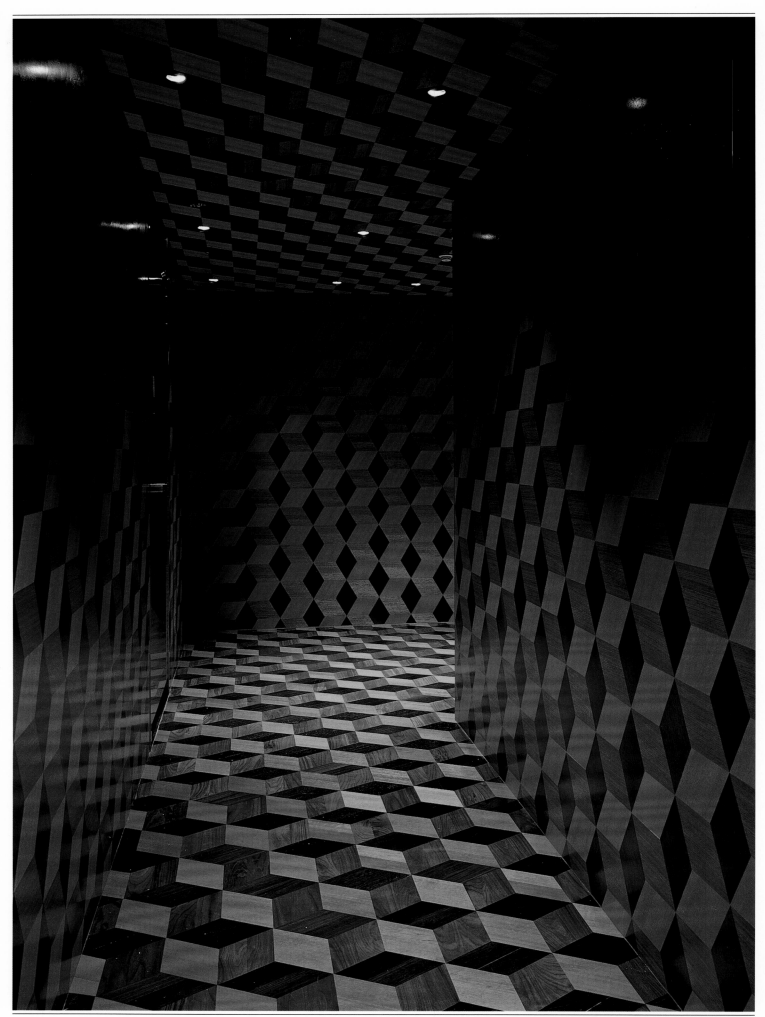

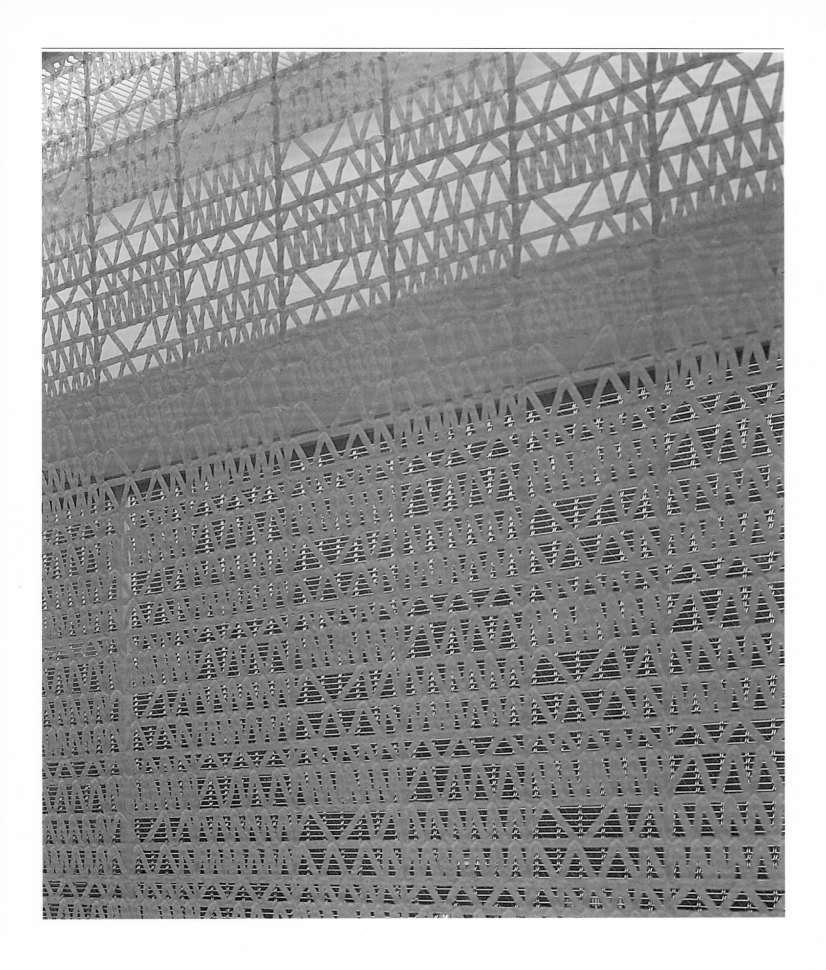

p.24-25 Exterior views of Louis Vuitton Seoul Building, Chungdam-dong, Kangnam-ku, South Korea (2000), by Louis Vuitton Architecture Department. p.26-27 Louis Vuitton Omotesando, Tokyo (1999) by Jun Aoki & Associates. Views of the parqueted corridor on the fifth floor (left), and of the woven fabric—designed by Yoko Ando—in the multipurpose hall on the seventh floor (right). p.28-29 Views of the Louis Vuitton Lee Gardens Store, in Hong Kong SAR (2005), by Louis Vuitton Architecture Department. p.30 Detail view of the metal Damier pattern on the interior wall of Kobe Kyoryuchi Store (2002) by Barthélémy & Griño. p.31 (top) Detail view of the Monogram pattern inlaid in wood on the interior walls of the Louis Vuitton Roppongi Hills (2003), designed by Jun Aoki & Associates, Eric Carlson and Aurelio Clementi, (bottom) Maison Louis Vuitton, Champs-Elysées (2005): detail of the Monogram screen flanking the main escalator. Interior design by Eric Carlson & Peter Marino.

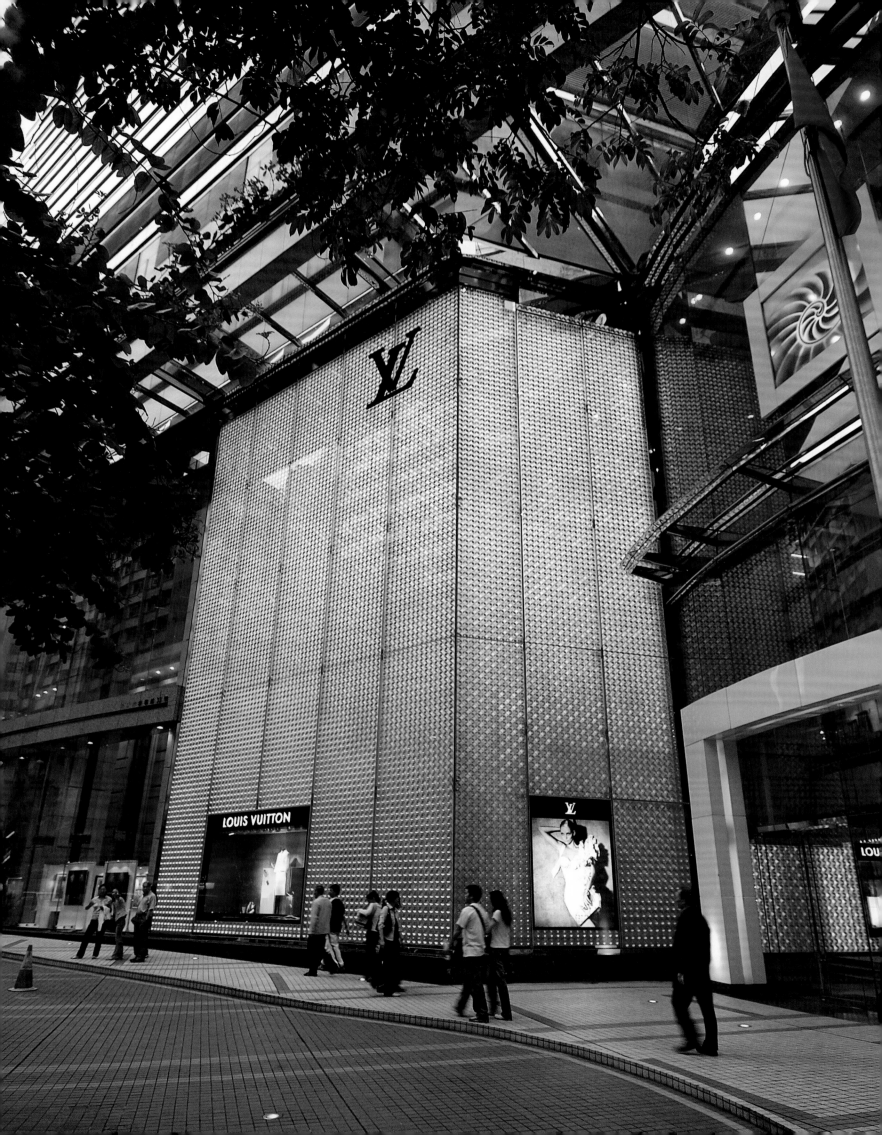

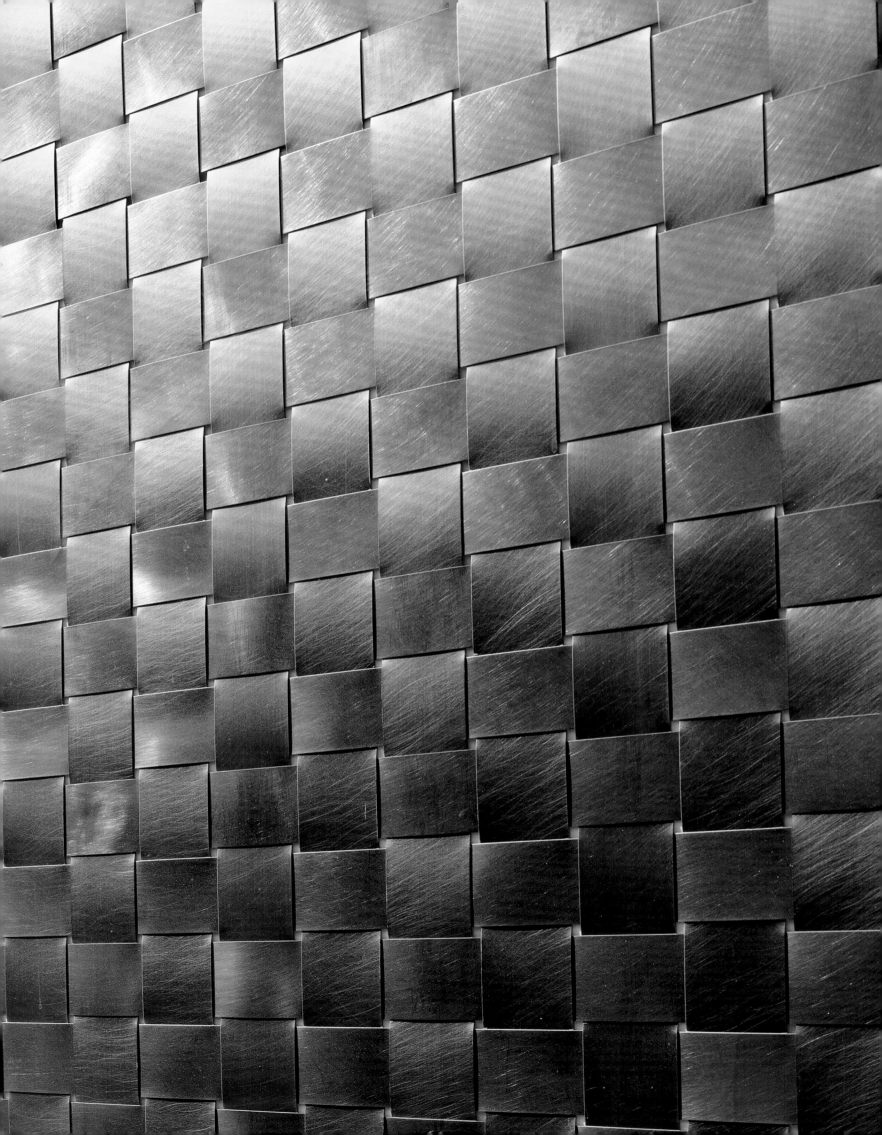

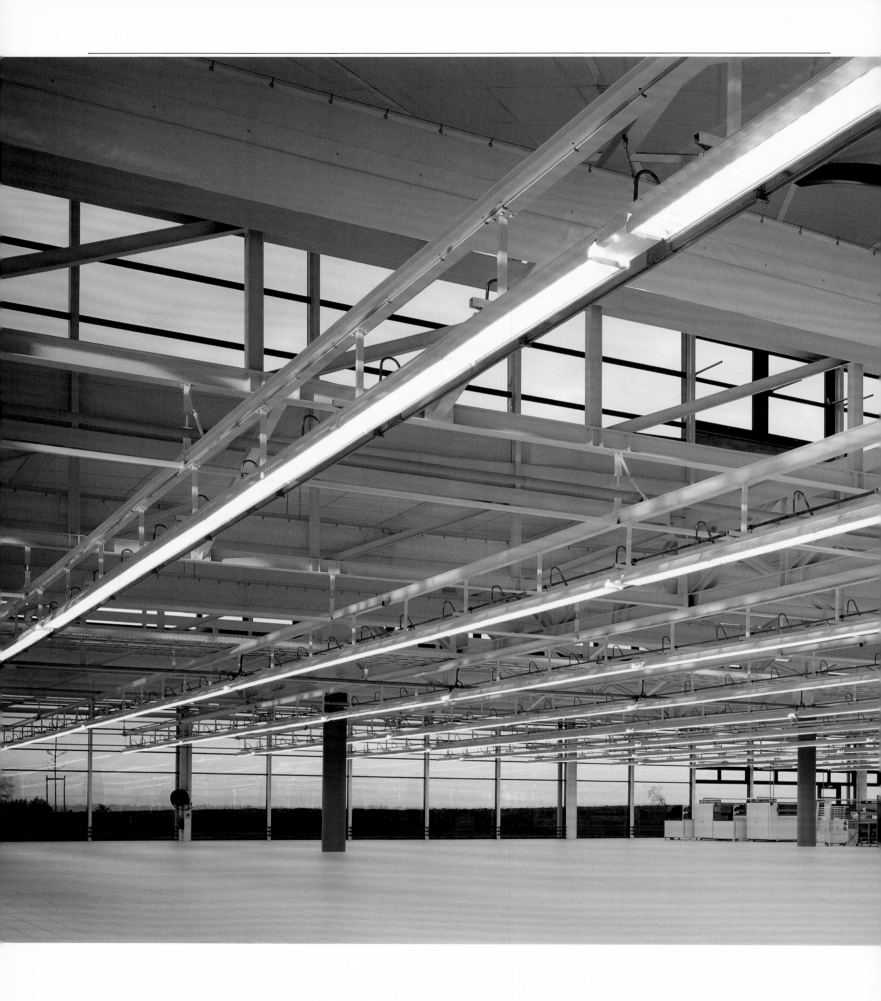

p.32-33 Interior view of Louis Vuitton Production Workshop Ducey I (2002), Ducey Commune, Manche Department, France. Designed by Gilles Carnoy. **p.34-35** Interior view of Nagoya Midland Square Store (2007), by Takayoshi Nagaishi and Eric Carlson of Carbondale.

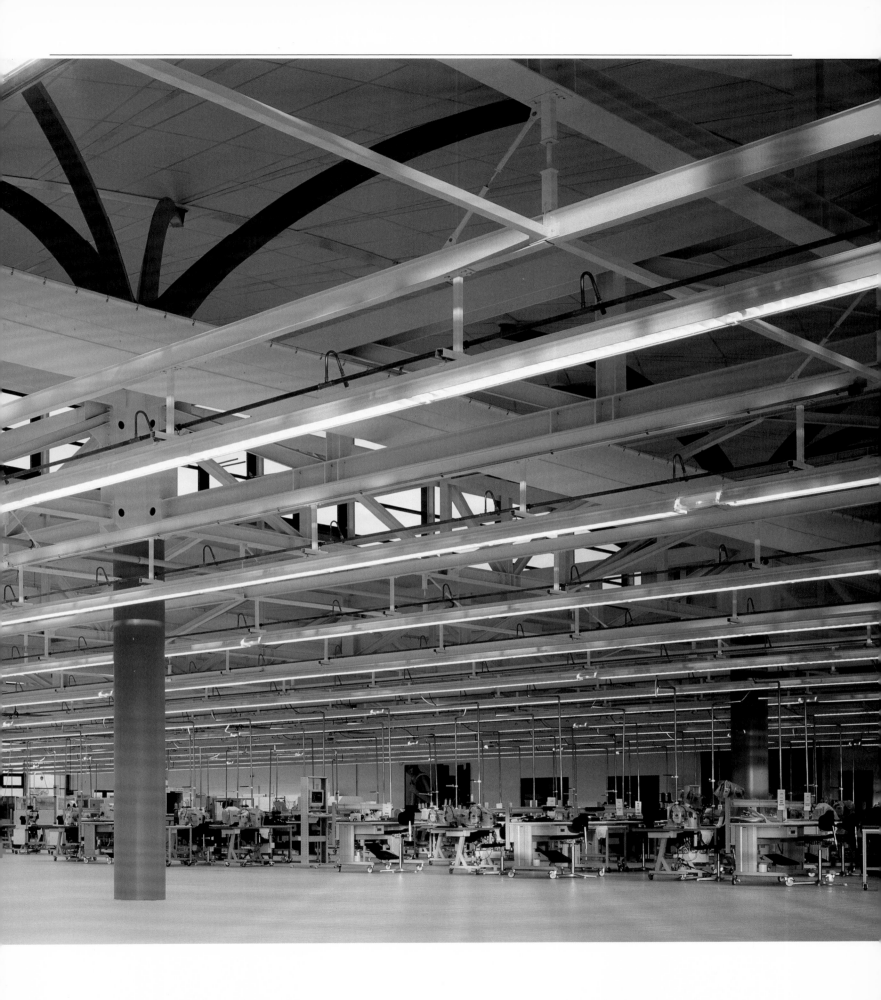

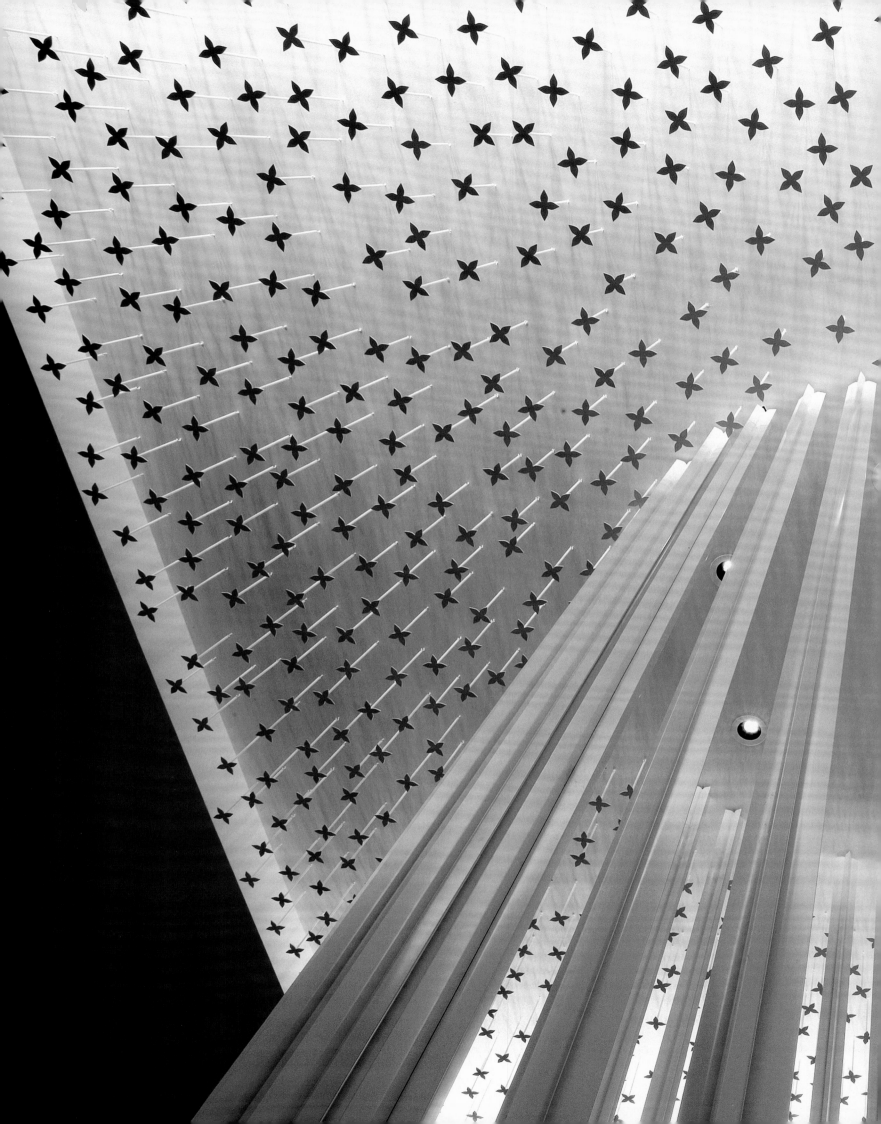

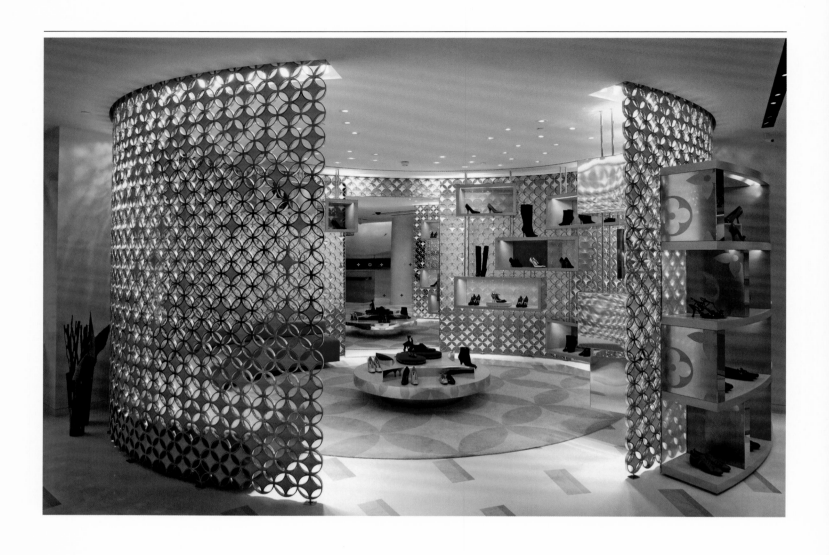

p.36-37 Maison Louis Vuitton, Champs-Elysées (2005): Women's shoes department. Interior design by Peter Marino, enclosed by a stainless steel Monogram screen. **p.38-39** Panoramic view of Maison Louis Vuitton, Champs-Elysées (2005) by Eric Carlson & Peter Marino.

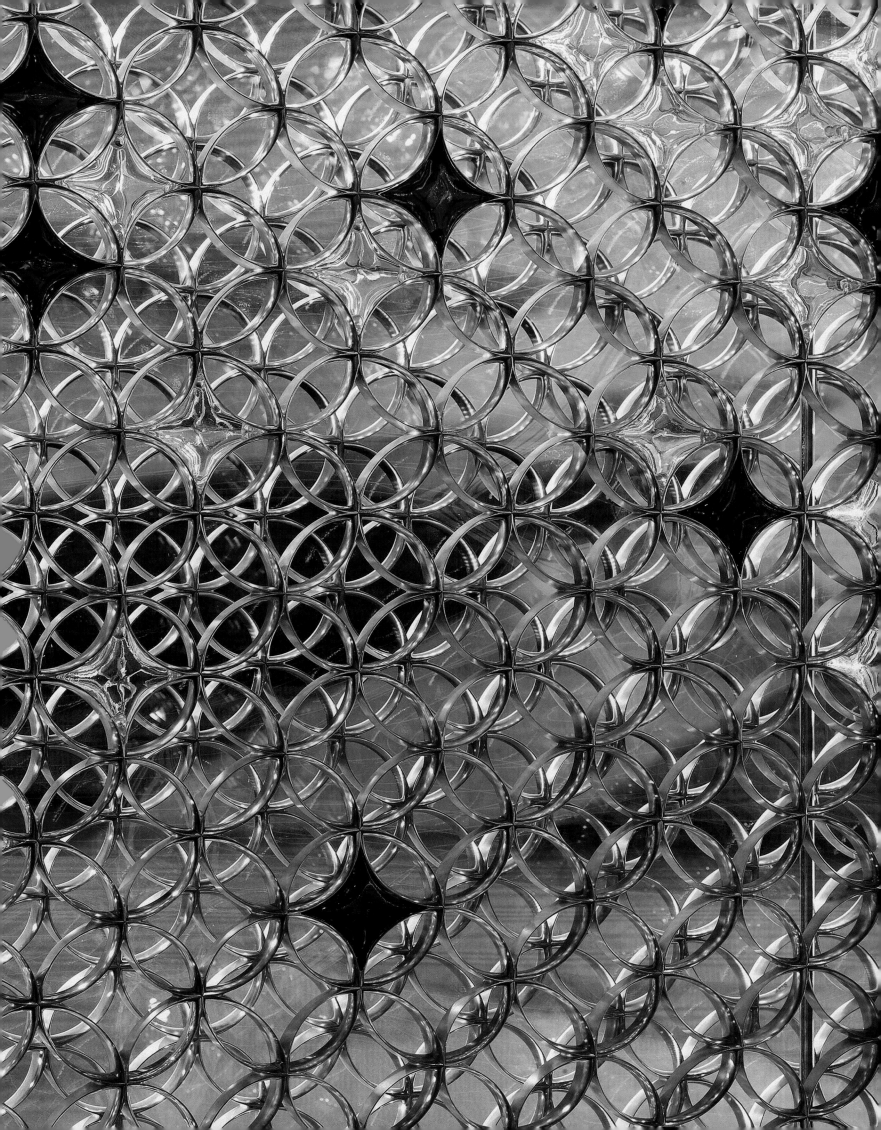

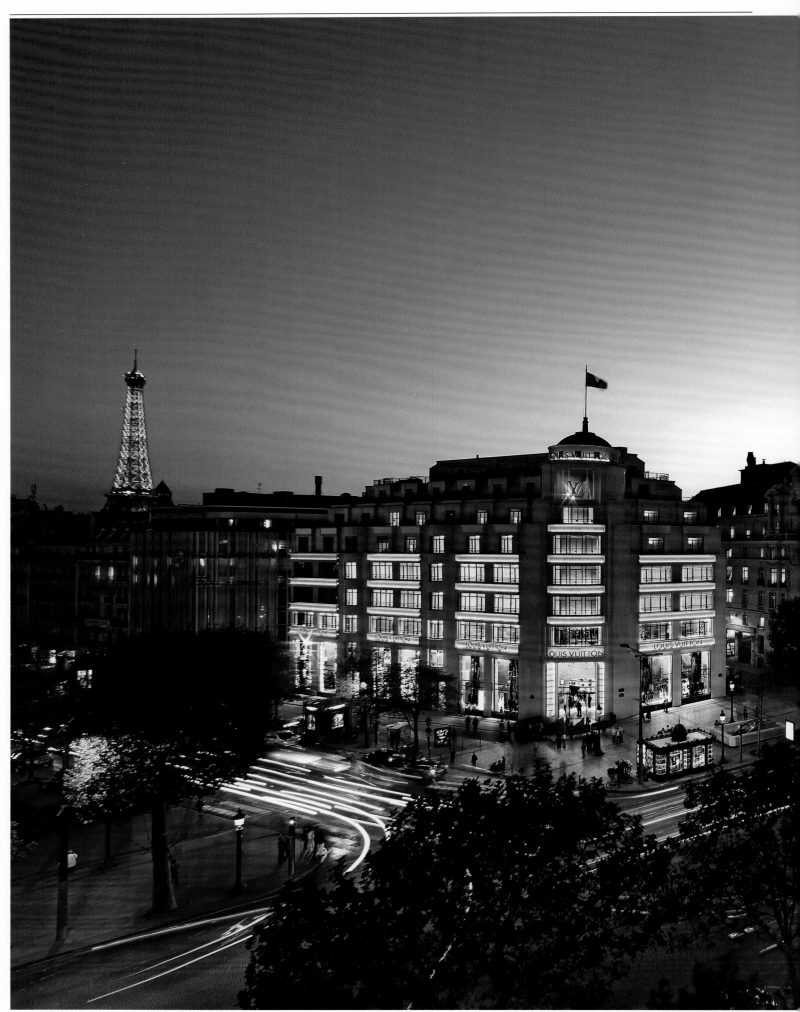

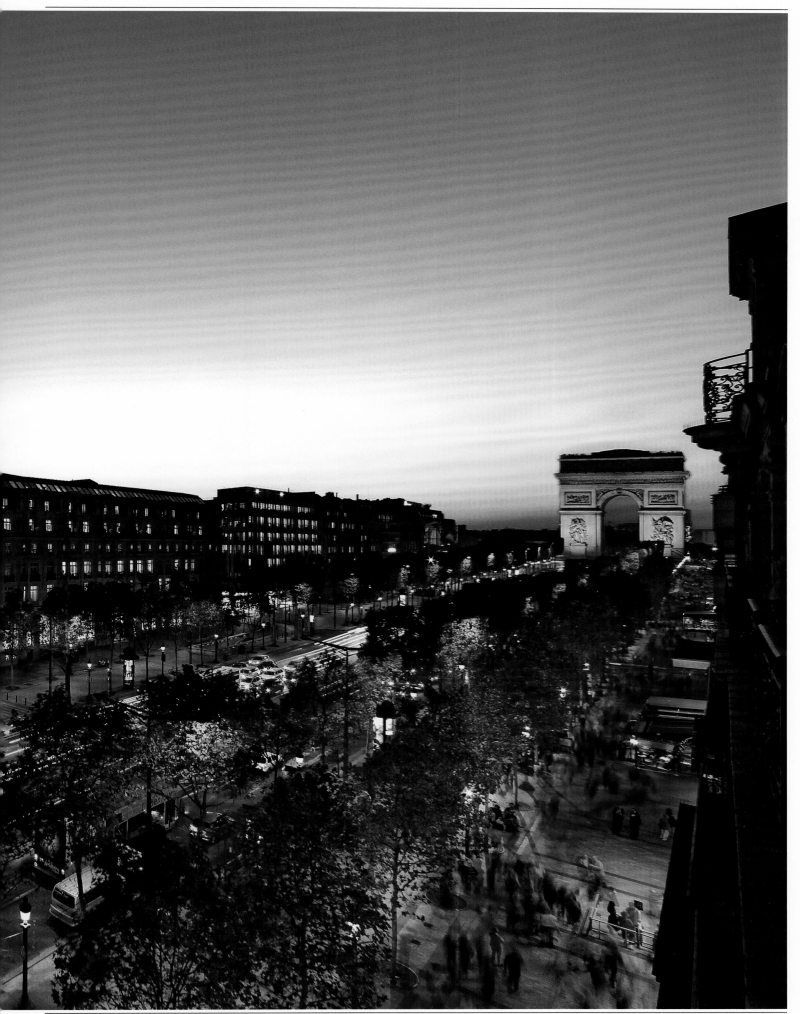

Louis Vuitton

by Jill Gasparina

33 co

33

33 colors
by Jill Gasparina

At a "bag meeting" held in early 2006 to prepare for Louis Vuitton's Spring-Summer 2007 collection, Marc Jacobs was struck by a sudden insight. As the firm's artistic director sorted through all of the season's materials, a fresh idea flashed through his mind: "It might be a good idea to use last year's topstitching but do it in ivory this time. We could use that on the gathered part of the bag and add denim and even change the graffiti design to white on brown. Then [...] add a bit of appliqué...We'll just use a little of everything."[1]

A few days later a small miracle emerged from the workshop: the "Louis Vuitton Tribute Patchwork Bag," cobbled together from fourteen different materials. Only twenty-four were made, and the retail price was $45,000. The technical teams had no hesitation in declaring it the strangest bag they'd ever been asked to produce. In no time, it was a media obsession, with photos blanketing countless magazines, and it was touted in fashion blogs as "the world's most expensive handbag." Really, though, its "look" was even more extravagantly outrageous than its price. Each was crafted from fourteen different components: the Louis Vuitton Tribute Patchwork Bag is actually a composite of handbags, an enormous sampler. It's a kind of memoir that summarizes and condenses innumerable stories, beginning with the tale of the house of Louis Vuitton, as told by Marc Jacobs

using an abundance of freshly updated materials. Almost haphazardly pieced together, the bag includes cubist collage, cut-outs, and conceptual art. It gives the impression of being first and foremost an idea, a concept. Perhaps it is even a provocative rejection of the visual impulse that inspired the creation of such a bizarrely sumptuous object.

The Patchwork Bag probably had the capacity to disturb and shock because few were ready to accept that leather goods could be conceptual, and that their functional properties were secondary. The bag is beautiful, but not in a conventional sense. The abundance of fine materials makes the handbag luxurious, but it is the concept guiding its creation that is its most luxurious attribute: Marc Jacobs's intuitive vision, the product of a moment. His concept was the arbitrary, inspired point of departure, an original whim that demanded all the ingenuity and perseverance of the technical teams to respond to the challenge of its design.

Inspired. A word now very out of fashion in the art world. Although this object is not a work of art in the conventional sense, it nevertheless has all the aspects commonly associated with art. It is an artist's creation, clearly identified as such by its signature and style. The incongruity between the initial expectation ("You were

olors

looking for a handsome piece of leatherwork, you're getting something bizarre") recalls the *modus operandi* of the *avant-garde*. The price—beyond extravagant—is utterly divorced from the bag's useful purpose (although after taking into account the amount of work required for its production and the value of its fine materials, the price may not seem so outrageous after all). The Louis Vuitton Patchwork Tribute Bag could reasonably be considered as a handbag masterpiece. But the real debate does not reside in language games and definitional disputes. The issue is how the phenomena of equivalence and symbolic exchanges that have always existed among the worlds of art, fashion and luxury and, even more specifically, between a luxurious fashion accessory and a work of art, coalesce in this handbag.

The production process for Louis Vuitton collections, so ably captured by Loïc Prigent in his documentary *Marc Jacobs and Louis Vuitton*, may thus be especially disconcerting for a viewer who has already seen an artist at work. In the film, we observe a process that converts intuition into reality, by selecting an "accident," and understanding its potential aesthetic significance and power. Chance and randomness are constants of creativity. André Breton invented automatic writing in his sleep. Brian Eno was on bed rest when he suddenly grasped the potential of ambient music. Remember the story of how Newton discovered gravity. The history of the arts and sciences is replete with anecdotes demonstrating that invention in its purest form does not really exist. Creation is frequently the fruit of accidental, fortuitous manipulations of materials and ideas. This stupendous handbag creation, which consumed the attention of the fashion world for an entire season, is indeed a metaphor for creativity. However, despite its successful demonstration that any intuition can have value, Marc Jacobs categorically asserts: "The important thing is not that the bag gave me pleasure or amused me, but that our clients actually bought the product of our work."[2] Loïc Prigent does not obscure these paradoxes in his film, which raises some very good questions on connections between art and fashion. How does an artistic director actually work? How does he reconcile business responsibilities with aesthetic choices? How can he replenish his creative energies under the relentless pressures of seasonal collections? Prigent gives a very straightforward answer when his film shows Marc Jacobs, in search of inspiration (and of ideas for his own collection), strolling through the *Frieze Art Fair*, the major contemporary art show held every October in London's Regent's Park. It's a reminder of how, long ago, Louis Vuitton was closely associated with Charles Frederick Worth, the inventor of *haute couture*.

A SHORT HISTORY OF
LOUIS VUITTON AND ART

The history of the house of Louis Vuitton is the tale of a growing passion for art that culminated with the reopening of the maison on the Champs-Elysées in 2005. Eric Carlson's architecture and Peter Marino's interior design welcome the visitor to a totally reimagined space that integrates art into architecture, both literally and figuratively. One of the most striking innovations is on the building's top floor: the Espace Louis Vuitton, an independent exhibition space set apart from the sales areas. The interior designer has created a luxurious ambience in the lower floors, and the architecture provides some breathtaking experiences, including Carlson's vast atrium that irradiates and diffracts sunlight into the heart of the store. Three artworks were temporarily installed. Tim White-Sobieski's video installation transforms each visitor who climbs the main staircase into a traveler. A bit further on, James Turrell's light installation slowly changes colors. Finally, at the store's geometric center, Olafur Eliasson's *You're Losing Your Senses* gives the visitor an experience of absolute darkness and silence in an elevator ride up to the Espace Louis Vuitton. This space is a sort of ephemeral antidote to the bustle of urban life, a momentary suspension of experience and a brief interlude of inward focus. Perhaps the most exquisite aspect of these installations is their subtlety; the art is completely integrated into the architecture. Many visitors come and go without even noticing. But art lies at the heart of the design. As visitors leave the store through the door leading to the Champs-Elysées, they pass between piles of red trunks that recall Donald Judd's *Stacks*, Louis Vuitton's parting homage to art.

Since 1854, Louis Vuitton has seamlessly coordinated its visual identity and symbolic tradition with business considerations. The story of the materials first used by Louis Vuitton is itself quite revealing. The design of the Damier canvas, followed by the Monogram pattern, arose both from an economic challenge (making changes intended to combat counterfeiting attempts) and aesthetic considerations. Georges Vuitton himself designed the four elements of the Monogram pattern with these concerns in mind, combining motifs drawn from contemporary art with others drawn from the history of decorative arts, including the Romanesque and Japanese graphic traditions. From the very outset, the firm embraced the concept—postmodern before its time—that the creative world is a symbiotic universe of activity, where divisions among the arts have little meaning. This idea has since become a received truth in the art world, and distinctions among various art forms have been gradually abandoned since the 1960s. The same perception is also widespread in fashion, where designers take an increasingly conceptual approach,

making no effort to distinguish themselves from visual artists. Jean Touitou, founder of A.P.C., declared, "I don't believe that a fashion world exists apart from the art world. There's one general, creative world overall."[3]

Since its establishment, the Louis Vuitton name has been synonymous with a life of luxury and travel, enjoyed by a cultivated elite. Its creations have always reflected the spirit of their time, maintaining a dialogue with contemporary aesthetic sensibilities. During the 1920s and 1930s, Colette and Cocteau paid tribute to the luggage maker's craft. Then, in the "swinging sixties," Louis Vuitton increasingly embraced the "Pop" look, once again in step with the period's artistic style. Pop culture was ubiquitous, and Louis Vuitton products seemed to take their natural place amidst the new international jet set.

But it was really not until the 1980s that Louis Vuitton began to establish ongoing ties with the most prominent French and international artists. In 1988, a series of silk scarves was commissioned from Sol LeWitt, Arman, James Rosenquist, and Sandro Chia. This was an era when fashion won recognition in the museum world, and interactions between art and fashion proliferated: Yohji Yamamoto and Comme des Garçons opened stores that resembled art galleries; Jean-Charles de Castelbajac invited Robert Combas, Annette Messager and Hervé Di Rosa to paint dresses shown at *FIAC* in 1983, and Keith Haring collaborated with Vivienne Westwood. It now seems natural for these two worlds to intersect, since both shape our visual universe on a daily basis. Again, the important aspect of such collaborations was creativity in the broadest sense.

In the 1990s, there was an even more vigorous and intense *rapprochement* with the art world. "Magazines blithely combined visuals, editorial content and layouts to connote 'art',"[4] wrote fashion historian Florence Müller. Louis Vuitton also accelerated its crossovers with the creative world. In 1996, seven designers, including Vivienne Westwood, Azzedine Alaïa, Manolo Blahnik and Helmut Lang, took turns playing with the Monogram, creating a variety of hybrids. When Marc Jacobs became artistic director in 1997, he established strong ties with the contemporary art world, developing collaborations that generated increasingly spectacular media events. Artists Stephen Sprouse (in 2001), Julie Verhoeven (2002), Takashi Murakami (2003), and Richard Prince (2008) each created leatherwork collections inspired by their own art, and all of them were immediate hits. Louis Vuitton store windows were sometimes transformed into exhibition spaces. In 2004, Ugo Rondinone designed a series of Christmas windows with the theme "a winter journey." Two years later, Olafur Eliasson designed *Eye see you*, a luminous solar eye that observed passersby

and concealed product displays from their gaze; it was displayed throughout Louis Vuitton's global network. Based on the model of the Champs-Elysées flagship, a number of other stores now house artworks on a permanent basis, like the works by James Turrell, Olafur Eliasson and Robert Wilson in the flagship store location. Michael Lin worked on the Taipei store in 2004, with the luxuriant floral motifs characteristic of his work. More recently, the San Francisco store installed Teresita Fernandez's *Hothouse (blue)*, a large work in translucent blue glass overlaid with thousands of cabochon reflecting mirrors. Other examples abound, including Zhan Wang's strange biomorphic sculpture in the Hong Kong Landmark store and Fabrizio Plessi's dazzling video works in the Hong Kong Canton Road store.

Whether commissioning artworks for installation in stores, designing window displays, or taking part in exhibitions, Louis Vuitton has exponentially increased its artistic collaborations over the last decade: Olafur Eliasson, Sylvie Fleury, Zaha Hadid, Bruno Peinado, Nicolas Moulin, Shigeru Ban, James Turrell, Vanessa Beecroft, Takashi Murakami, Claude Closky, Robert Wilson, Richard Prince, Juergen Teller and James Rosenquist, as well as young artists from Russia, China and most recently South Korea who have had the opportunity to collaborate with Louis Vuitton by displaying their works and producing commissions for stores and windows, in addition to exhibiting in the Espace Louis Vuitton.

AESTHETIC CAPITALISM AND APPROPRIATIONS

The list of artists participating in these collaborations would arouse envy in the heart of any exhibition curator. The museum strategy is being carried forward another step with the Fondation Louis Vuitton's sponsorship of Frank Gehry's "cloud" structure, which will open in the heart of Paris's Jardin d'Acclimatation in 2011. Curators are however well aware that a list of prominent artistic names does not suffice to create a successful show, or even assure the quality of a collaboration. Not much is accomplished by casual name-dropping.

We should note at the outset that there has been a gradual, undeniable increase in the audaciousness of Louis Vuitton's commissions, culminating in the near *carte blanche* given to Richard Prince in 2008. The artistic freedom allowed to designers seems to be on the rise. The collaboration with Murakami was the most intensively media covered event, but Marc Jacobs radicalized the principle of a collaborative invitation to the maximum with an American artist. The Prince works, which were based on his *Joke* paintings, with their misogynistic jokes and blurred monogram, were without a doubt the most daring of all collaborations, from both an aesthetic and a business perspective. Eliasson's creation for all the 2006

Christmas windows was no less bold: the solar *Eye see you* blocked the passerby's view of every article, product and piece of merchandise. This notion was audacious, to say the least, during the holiday season of feverish consumption. And what about Murakami's *Multicolor Monogram* of 2003? The Monogram print's new look in 33 psychedelic colors swept the fashion world, achieving spectacular commercial success in just a few months. However, we should not underestimate the initial shock of this proposal for a firm whose identity was based on its traditional heritage and ultimately on the iconic Monogram print itself. Louis Vuitton is indeed one of those brands that "base their strategy on intensive use of a recognizable logo or monogram"[5] —to the point where altering this logo in any way is to take a tremendous business risk that could threaten the firm's very identity.

Vivienne Westwood added a mischievous dimension with her false fanny bag (literally, *Faux Cul*), and Azzedine Alaïa combined two materials and two universes—the Monogram pattern with a leopard print. Helmut Lang designed a DJ bag, and Prince painted a liquid, pastel-dripping version of the monogram, while Murakami transformed the Parisian firm's symbol into a *kawaii* fantasy on acid. Vanessa Beecroft used female bodies to create a major distraction from the Louis Vuitto logo, literally invading the Champs-Elysées flagship with a horde of naked models, posed like so many objects among the traditional trunk displays (*VB 56*, 2005 performance). These combinations and other startling superimpositions have radically modernized the brand's image. There remains a risk, however, of undermining the brand's reputation. The legendary Monogram symbolizing the Louis Vuitton tradition has been defaced, tattooed, chopped, glued, covered, coated, annihilated, colored and discolored. This approach to the symbol—the Louis Vuitton icon—recalls *Icônes*, the title of the 2006 exhibition organized by Hervé Mikaeloff in the Espace Louis Vuitton, which was devoted to reinterpretations by artists of various historic Louis Vuitton handbags, such as Sylvie Fleury's Keepall and Bruno Peinado's Speedy. The show radiated a sense of fierce energy, a radical desire to appropriate the Louis Vuitton concept, pushing innovation to the limit. In 1996, Vivienne Westwood emphasized the significance of cultural history and how she absorbs it into her work: "Looking backward is the only way to create the future. My memory is like my refrigerator. I don't invent anything. Everything is taken from books."[6]

This comment is directly applicable to the British designer's working methods. She often plays with historical influences and adapts them into her clothes. But she also emphasizes that anyone who plays this game must always be ready to confront articles redolent of myth, historic forms and objects. The first collaboration

with Sprouse opened the floodgates to Marc Jacobs's innovations. It was a manifesto for this approach, and its graffiti designs thrust themselves violently and intrusively into the world of Parisian *chic*.

Perhaps the projects of Prince, Murakami, Eliasson and even Beecroft can actually be interpreted as a sophisticated, updated form of institutional criticism, in the tradition of artists such as Daniel Buren and Hans Haacke. Has cultural creation within major capitalistic corporations become the most subversive movement of all within the art world? It is difficult to push the analysis quite this far. The logic of collaboration is at least in part derived from a communications strategy in which debate on "risk" plays a major role.

In his *Capitalisme Esthétique,* Olivier Assouly provides a closely reasoned analysis of the processes underlying the industrialization of taste. He argues that such collaborations are based on a broader trend: "To be effective, marketing techniques must embrace everything that lies outside the limits of the traditional economy, including private life, personal existence, the physical relationship with intimacy, the sacred, the symbolic, aesthetic pleasure, moral values, ethics, community ties and societal and individual liberation."[7] Art naturally has a place in this system. It spontaneously integrates various creative processes. Most interactions between art and fashion are based on the use of art purely for the purposes of design, since design can embellish products to appeal to changes in fashionable taste, thus generating constant emotional tension. The luxury products industry skillfully draws upon "the capricious nature of aesthetic experience."[8] Whether the links to the artistic world are overtly commercial, or more subtly expressed (like the exhibitions in the Espace Louis Vuitton), they are always motivated by marketing concerns. Investment in aesthetics plays with the immaterial and symbolic nature of objects. Denying this connection would be naïveté, pure and simple. Louis Vuitton has developed many clever publicity campaigns, all revolving around the theme of travel, using collaborations with individuals who may not be all that artistic but who embody a kind of existential experience. Examples include work with Pharrell Williams, Nigo, Takashi Murakami and collaborations with celebrity photographers (Annie Leibovitz, Jean Larivière, Jean-Paul Goude) and celebrities such as Andre Agassi, Steffi Graff, Mikhail Gorbachev, Keith Richards, Catherine Deneuve and Sean Connery.

These various examples do not exhaust the debate on the issue, and have nothing to say on the quality or luxury of the objects themselves. In the 1960s, Andy Warhol, the self-proclaimed "business artist," demonstrated that the commercial nature of artworks did not necessarily represent a contradiction to their artistic validity. Many of the artists involved in collaborations with Louis Vuitton over the last ten years cultivate a post-Duchampian aesthetic, straightforwardly raising questions in their work on the ambiguous relations between art and commerce, particularly their role in "cultural industries." Claude Closky, for example, created a sculpture for Louis Vuitton based on *Beautiful Faces*. The artist reproduced images from fashion advertisements in this book, made to look like a magazine (2001), but he transferred each image symmetrically onto facing pages. The perfect, mathematical equilibrium of the bodies and faces bordered on the grotesque. Advertising was both hailed for its visual power and criticized for its excessive manipulation. Ugo Rondinone raised similar questions with his *I don't live here anymore* in 1995, a series in which he used photographic manipulation to toy with an icon of fashion magazines. Since the early 1990s, Sylvie Fleury has explored the logistics of "branding," transforming her own creations into a mocking celebration of the visual power of brands. There are many other artists who have not worked with Louis Vuitton but who address the same concerns in their art, including Elmgreen and Dragset's *Prada Marfa* (2005) and Tom Sachs's "branded" sculptures for Chanel. Artists have used fashion and luxury items as effective metaphors to make their own comments on the postmodern confusion of art, luxury, lifestyle, aesthetics and commerce.

"IT'S NOT JUST MY OWN WORK, IT'S A COLLABORATION."

It is completely legitimate to confront the questions that are often raised when art encounters the world of fashion and luxury goods, even if it is only to dismiss them from further consideration. Are these collaborations really art? How are we to describe the objects and events so produced? To what extent should an artist's work be driven by commissions? Another relevant question: what are the appropriate roles for art and commerce? And how should the right balance between them be assessed?

These are not simple questions. The objective is not to establish a hierarchy but rather to analyze the nature of the relationship between these two areas of visual culture. This debate clearly demonstrates how far these issues are superimposed, telescoped, and combined, without ever really defining the nature of the product itself. It is altogether possible to produce a commercial product that is also an artistic product, if not a work of art itself.

Takashi Murakami offers his own response to this litany of questions. He emphasizes the "principle of collaboration," and perhaps that is the answer: "Our contract is really

interesting. When people look it over two hundred years from now, they'll see it as art. It's a beautiful contract. It's not my own work. No, it's collaboration. It isn't about the multi-color monogram, it's a concept. If it were made public, people would be very impressed. It's really beautiful, but not visually. It's just a very beautiful concept."[9] In his rather enigmatic fashion, the Japanese artist describes this collaboration as a conceptual work of art, emphasizing its contractual aspect. He thus reminds us of the contracts used in the past by Lawrence Weiner, Robert Barry and much more recently by Tino Sehgal. Most importantly, he gives us the key to understanding the nature of the work produced: "It's not my own work. No, it's a collaboration." Murakami emphasizes the hybrid nature of the enterprise, which blends creative freedom with external constraints and an artist's vision with Louis Vuitton's business requirements.

Marc Jacobs has his own answers, modestly explaining that: "A designer who works for an international firm has to make a tremendous number of creative choices, but his situation is different from that of an artist who has to defend his own deepest commitments."[10] He represents a singular type of collaboration. In addition to being an influential patron, who both sponsors artists and places orders, he is also a true art lover, whose intimate understanding of artworks often guides his choice of collaborators. A collector of contemporary art in his own right, Marc Jacobs explains that he discovered Murakami on his own, by reading articles and visiting his exhibition *Kaikai Kiki* at the Fondation Cartier in 2002.[11] He also cultivates genuinely close relationships with artists. His collaboration with Richard Prince was founded on a profound understanding of his work, an understanding that is evident when Jacobs discusses how they work together. "Richard had done a series of pictures of Sponge Bob Squarepants on the back of bank checks. They were quite abstract, like floral designs. That's why we made the "Video Reader Bag," broadcasting Sponge Bob videos at the end of the show. Everybody was totally surprised---you really had to understand Richard's work to get the point."[12] They collaborated closely and cleverly, echoing the artist's work, but never subjecting it to expropriation. The *Joke Bags'* ironic logic reflects the tone of many of Prince's works: "Some of the jokes we printed on the bags were plays on the old cliché of extravagant women. I took a rather perverse pleasure in seeing just such a woman carrying one of these bags," explained Marc Jacobs when the collection was introduced in early 2008.[13]

Visibly amused by the irony of the situation, Jacobs rendered homage to another of Prince's series in his 2008 winter show, the *Nurse Paintings*. These liquid-escent, raw, Bacon-esque canvases, both erotic and mystical, show nurses seemingly transfigured by the pictorial veils that cover them. Stephanie Seymour, Naomi Campbell, Eva Herzigová, and about fifteen other supermodels, all sporting a "total nurse look" (transparent white blouses and jaunty little caps) presented Richard Prince's collection of bags. This sexy, ironic opening to the show was all the more *à-propos* for those who knew that Stephanie Seymour is one of Prince's muses, as well as one of his leading collectors.

The association between Jacobs and Murakami is also consistent with the work of the Japanese artist, who has always functioned with a conscious business orientation. This approach is a legacy of his interest in Warhol's work, as well as Japanese tradition, where the relationship between art and commerce is more straightforward than in Europe. The process was similar with Sylvie Fleury and Stephen Sprouse: Jacobs's intimate knowledge of the artists' work drove his desire for collaboration. In Fleury's case, her existing silver plate *Keepall* sculpture (exhibited in *Icons* in 2006) led to the production of a limited edition of silver-plated Keepalls. Stephen Sprouse, a fashion designer himself, was a close friend of Marc Jacobs.

THE INVENTION OF POP CULTURE LUXURY

From Arthur Rimbaud's cry of longing to "change life itself" to Allan Kaprow's invention of "happenings" in an effort to bridge the gulf between art and daily existence, the longstanding dream of the avant-garde has been to integrate art into everyday life. Whether elevating prosaic trivia from daily reality to the realm of art, or using the reverse approach of forcing art into quotidian existence, this dream is based on a powerful dichotomy, with art on one side of a great divide and reality on the other. This binary thought process is also prevalent in fashion, where luxury and *haute couture* remain associated with values of scarcity and elitism that had always defined modern art. However, these borders have become more porous than modernistic thought might have imagined possible. Theodor Adorno actually described such parallel functioning as a threat to art, writing in his *Aesthetic Theory* that the complicity of art and fashion was intrinsic to artistic modernism and represented a dangerous source of confusion. Jean Baudrillard likewise foresaw the emergence of a post-Warhol art that would perhaps be indiscernible from fashion trends.

The birth of Pop Art, first in England and later in the United States, completed the breakdown of the hierarchical distinction between high and low art. A comparable milestone was reached in fashion with the emergence of *prêt-à-porter* (at about the same time that Pop culture appeared elsewhere). These collaborations produced a strangely confused situation. The myth of the *avant-garde* was reborn in a new guise blending the purest form of modernism with its exact opposites, experimentalism

and commerce. Art was now accessible to all areas of visual culture, and the great objectives of the modernist movement were accomplished. "Fashion and art are now united within Pop culture," wrote the art critic Michelle Nicol in 2007.[14]

Thus, the history of the relationship between art and commerce (even in its Warholian form) is no longer an issue when we consider collaborations among art, luxury, and fashion today. With the mass proliferation of Pop style, the notion has lost its radical associations. The real significance of the crossovers introduced by Marc Jacobs and the house of Louis Vuitton is their transformation of the world of luxury and fashion, a transformation of historic significance.

To clarify the issue, consider one simple fact: Marc Jacobs loves contemporary art, but what he loves best is Pop Art. His collection includes fresh, glamorous portraits by Elizabeth Peyton and Karen Kilimnik, the provocations of Richard Prince, the baroque fantasies of Rachel Feinstein and the photographic series of Ed Ruscha. These works are "Pop Art" because of the traditions they call into question, and their solutions are far from traditional. The artists selected by Jacobs are Warhol's direct artistic descendants. Sprouse was active in the underground New York scene in the 1980s when Warhol reigned as king. Murakami is a Japanese version of Warhol, in terms of his production methods (the Hiroppon factory, a factory workshop based on Warhol's Factory) and his open acceptance of commercialism in art and media success. Critics agree that Richard Prince is a kind of spiritual Californian Warhol descendant.[15] Jacobs, a lover of Pop Art, had a brilliant sense of how to transpose some of its devices into fashion design. This inventiveness, or rather transferral, allows Jacobs's work to address Pop Art's longstanding artistic challenges. His designs offer a new relationship with luxury, combining classic materials and the tradition of fine workmanship with stark modernity in the choice of subjects and motifs. These collaborations were almost immediately recognized as historic landmarks for both art and fashion. Marc Jacobs, together with Louis Vuitton, has invented Pop Culture luxury.

Even counterfeiting may have a role to play in this story. Isn't a logo's success measurable by the number of copies it generates? The proliferation of forgeries could be considered a measure of success, a final triumph of the Pop program, transposed into fashion, a world apart. But perhaps, despite all these collaborations, stories and connections, there is a real boundary between the art and fashion worlds that is impossible to cross. This truth is still difficult to accept in the universe of fashion, "a world that is obsessed by the figure of the auteur, the authenticity of his products, and the economic damage caused by counterfeiting,"[16] as Eric Troncy writes.

So let's leave the last word to Elizabeth Peyton who spoke about Marc Jacobs: "He's had an effect on the world. He was already part of it (the art world) with all his ideas. When he introduced his collection, he knew what he wanted…he's really in sync with the culture and he's remaking the world in his own image, sending hordes of girls out in sequined ballet flats and purple velvet. I think that's terrific—it's so powerful that he has such an effect on the world just thanks to his own will power. That's what artists do: they create the universe through their own work."[17]

Using fashion to influence daily life through product distribution, Marc Jacobs has created a genuine mass market for luxury items at Louis Vuitton. He said as much when speaking of Richard Prince's bags, calling them "another way of reaching the real world and people who can't afford to buy a thirty or forty thousand dollar painting."[18] The instantaneous explosion of Murakami colors on sidewalks all over the world just days after the introduction of *Eye Love* can be interpreted in the same way. This popularization of luxury items and the desire to put them within everyone's reach represents more than a simple longing for democratization or search for popularity. It represents a continuing utopian theme in the *avant-garde* movement, an effort to "change life itself".

1 Loïc Prigent, *Marc Jacobs et Louis Vuitton*. Arte Video, 2007
2 —*Libération*, Marc Jacobs: "Nous avons les mêmes références," February 29, 2008
3 Florence Müller, *l'Art et la Mode*. Paris: Assouline, 1999, p. 18
4 Ibid, p. 16
5 Selvane Mohandas du Ménil in "La critique de l'ostentation appliquée à la marque de luxe," *Mode de recherche 3 (Marques et société)*, Institut français de la mode, January 2005, p. 16
6 Vivienne Westwood, in *Sept Créateurs en Louis Vuitton en Monogram*. Paris: Louis Vuitton, 1996, p. 48
7 Olivier Assouly, *Le capitalisme esthétique, essai sur l'industrialisation du gout*. Paris: Cerf, 2008, p.108
8 Olivier Assouly, "La conversion économique de la création et du gout," *Mode de recherche 10 (Le management de la création)*, June 2008, *IFM*, Paris, p. 57
9 Loïc Prigent, op. cit.
10 —*Libération*, Marc Jacobs: "Nous avons les mêmes references," February 29, 2008
11 Loïc Prigent, op. cit.
12 —*Libération*, February 29, 2008
13 Ibid.
14 Michelle Nicol, "There is no outside of fashion," in *Double Face*, JRP, 2007, p. 21
15 "Richard Prince est un bébé, un enfant de Warhol qui ne sortira jamais de ses langes", Thierry de Duve, in *L' époque, la mode, la morale, la passion: aspects de l'art d'aujourd'hui, 1977-1987*, Edited by Bernard Blistène, Catherine David, Alfred Pacquement. Paris: Centre Georges Pompidou, Musée National d'Art Moderne, 1987, n.p.
16 Eric Troncy, "La vérité brutale," *Numéro 75*, 2006, n.p.
17 Elizabeth Peyton, in Loïc Prigent, op. cit.
18 *Libération*, op. cit.

p.40, 49 Detail, *Eye Love SUPERFLAT Black* (2003) by Takashi Murakami. Acrylic on canvas mounted on board, 120 x 120 x 6 cm (47 x 47 x 2.3 inches). Louis Vuitton Collection: Gift of Takashi Murakami, Louis Vuitton Museum. **p.51** Limited-edition Patchwork Tribute Bag and transparent custom case. S/S 2007. **p.52** This "groom" opened the show for the S/S 2001 collection. He bears a number of bags in the *Graffiti Monogram* designed by Stephen Sprouse, including a Keepall bag, the Alzer suitcase and a wine case. **p.53** Louis Vuitton Tribute to Stephen Sprouse held at various venues in New York City, January 8, 2009. Entrance of the Bowery Ballroom.

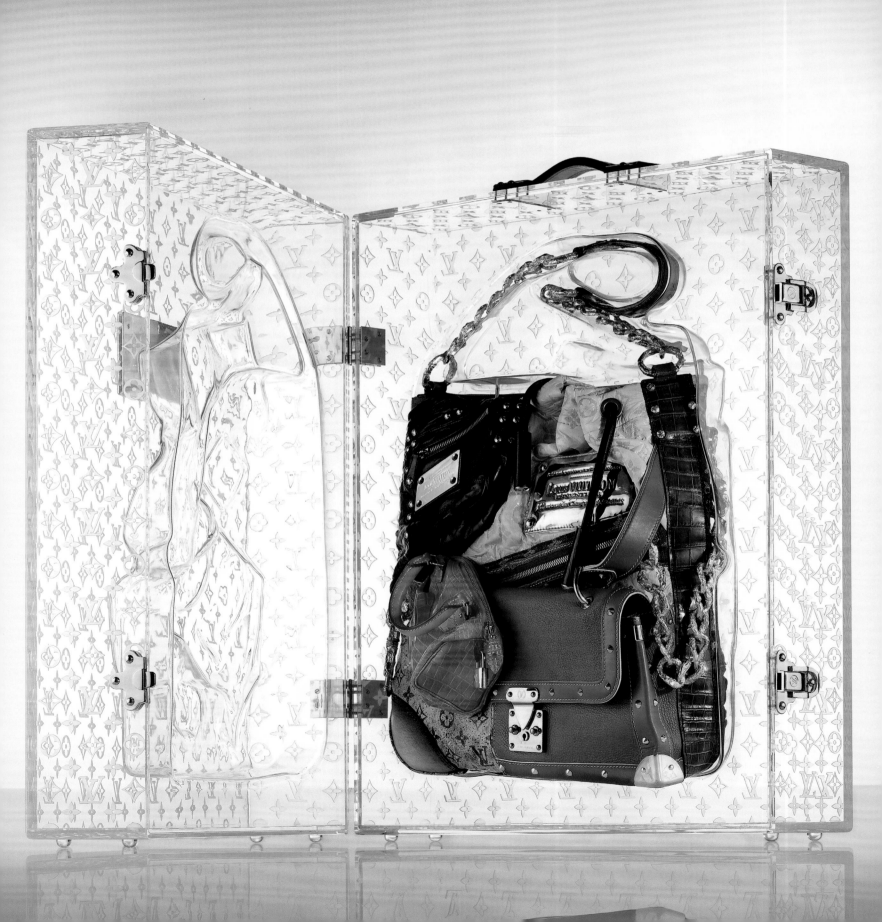

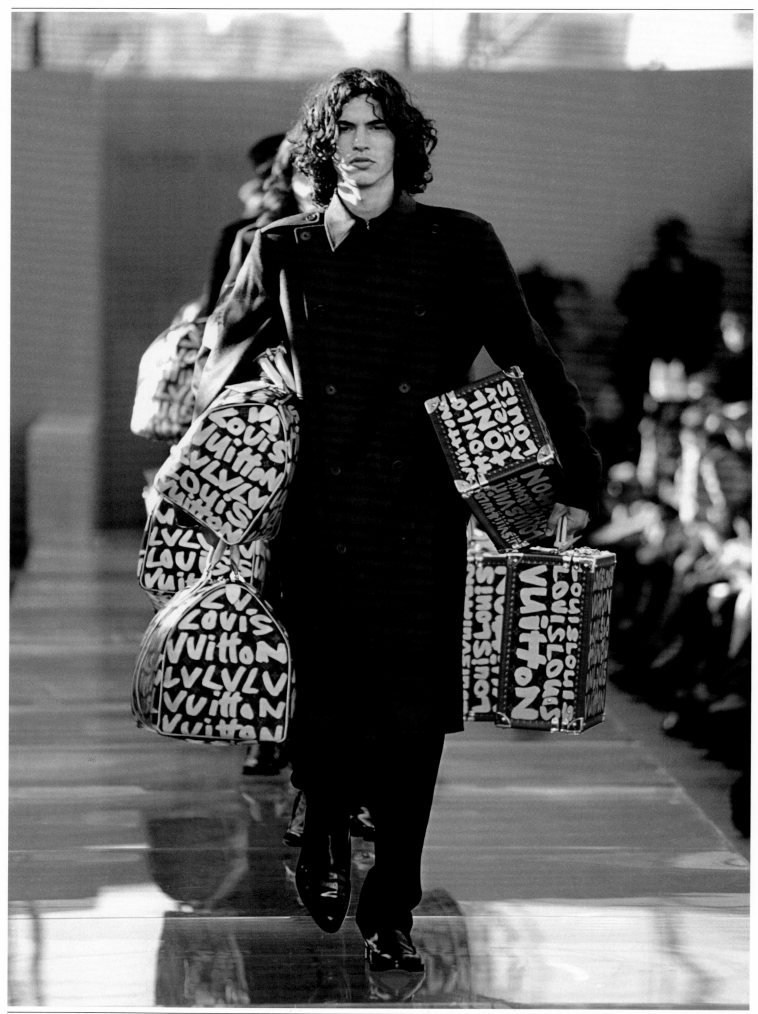

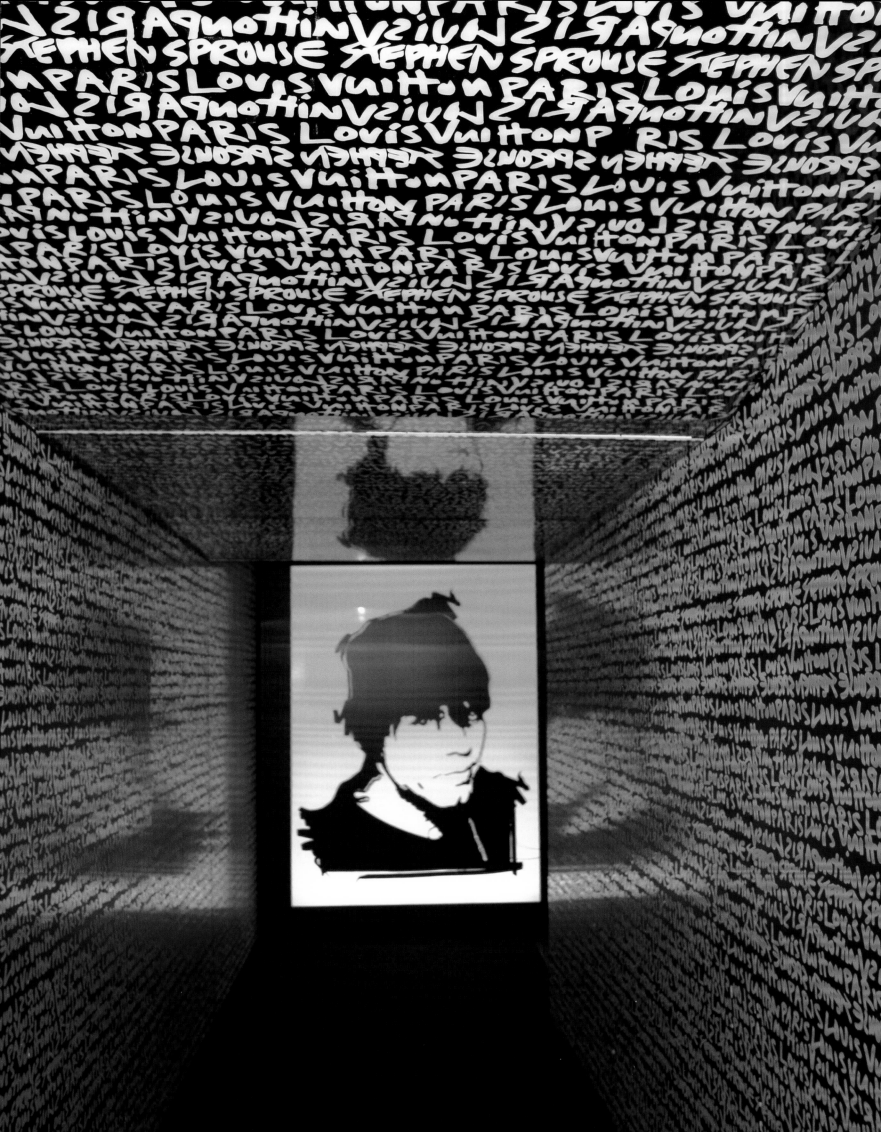

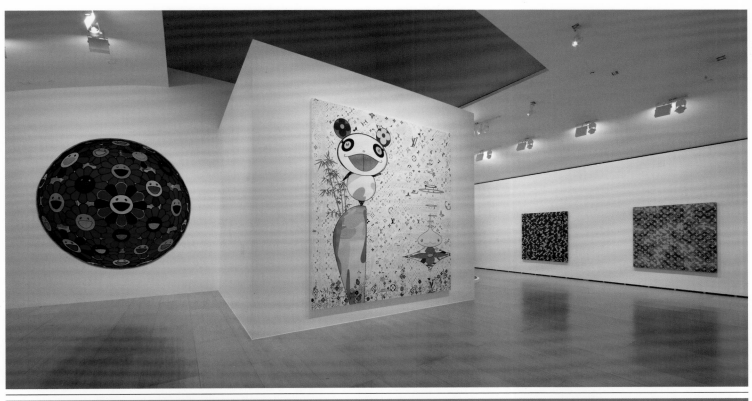

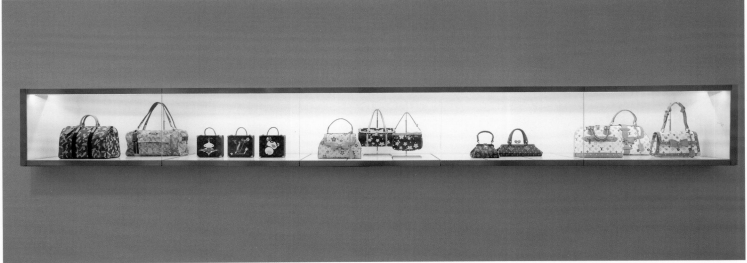

p.54 Cotton bandana in *Cherry Blossom Monogram* (2003) by Takashi Murakami. **p.55** Detail of *Cherry Monogram* (2004) by Takashi Murakami. **p.56** *Monogramouflage* Denim (2008) by Takashi Murakami, Editioned canvas on chassis, 40 x 40 cm (16 x 16 inches), Louis Vuitton Collection. **p.57** Interior views of the Exhibition ©*MURAKAMI* at The Guggenheim Museum Bilbao, Spain, February 2009.

p.58-59 *Study* (2008) by Richard Prince; acrylic on treated canvas, 111x87 cm. Louis Vuitton Collection. **p.60** *Untitled study* (2008) by Richard Prince; photograph, dimensions unknown. Louis Vuitton Collection. **p.61** *Untitled study* (2008)) by Richard Prince. Collage and acrylic on canvas, 91.5 x 61 cm, (36 x 24 inches). Louis Vuitton Collection. **p.62** *Eye see you* (2006) by Olafur Eliasson, installed in the windows of Louis Vuitton Olso for Christmas 2006. **p.63** View of Maison Louis Vuitton New York, with a building-height holiday window installation by Murakami based on the *Multicolor Monogram*, 2008.

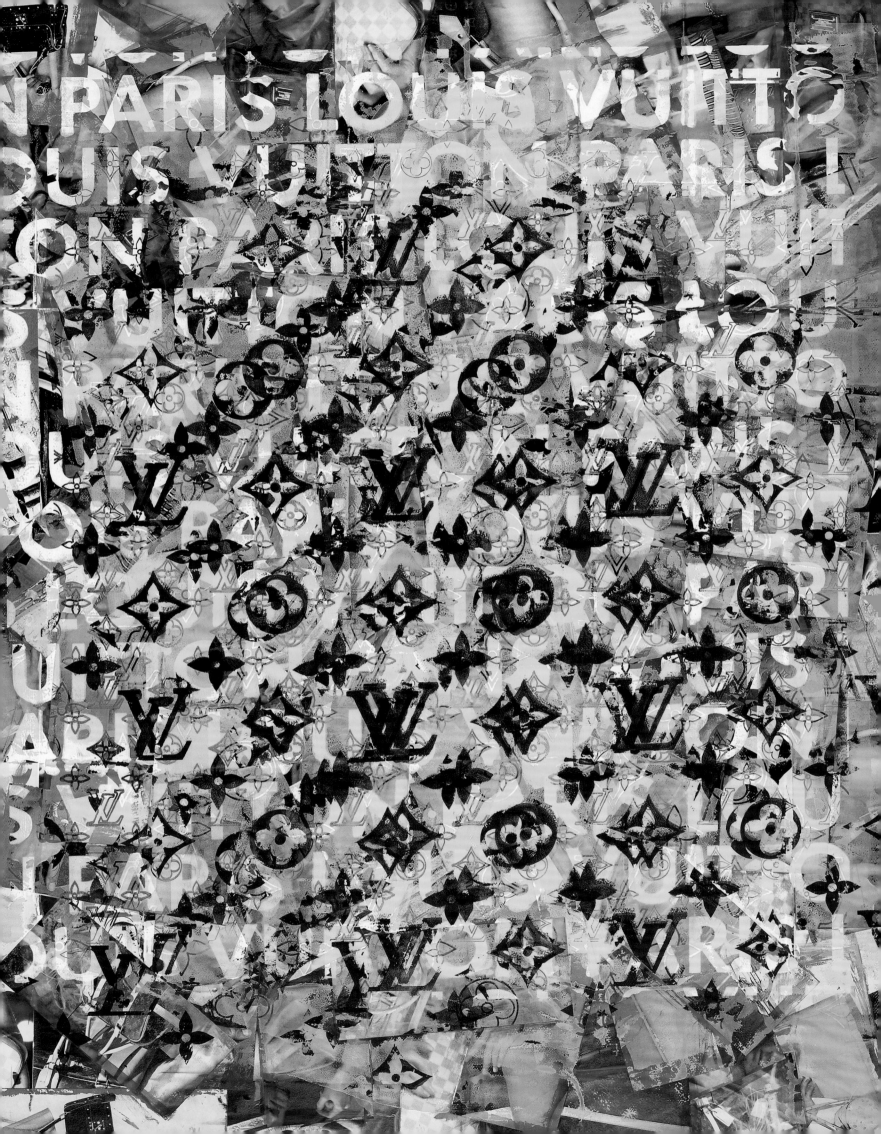

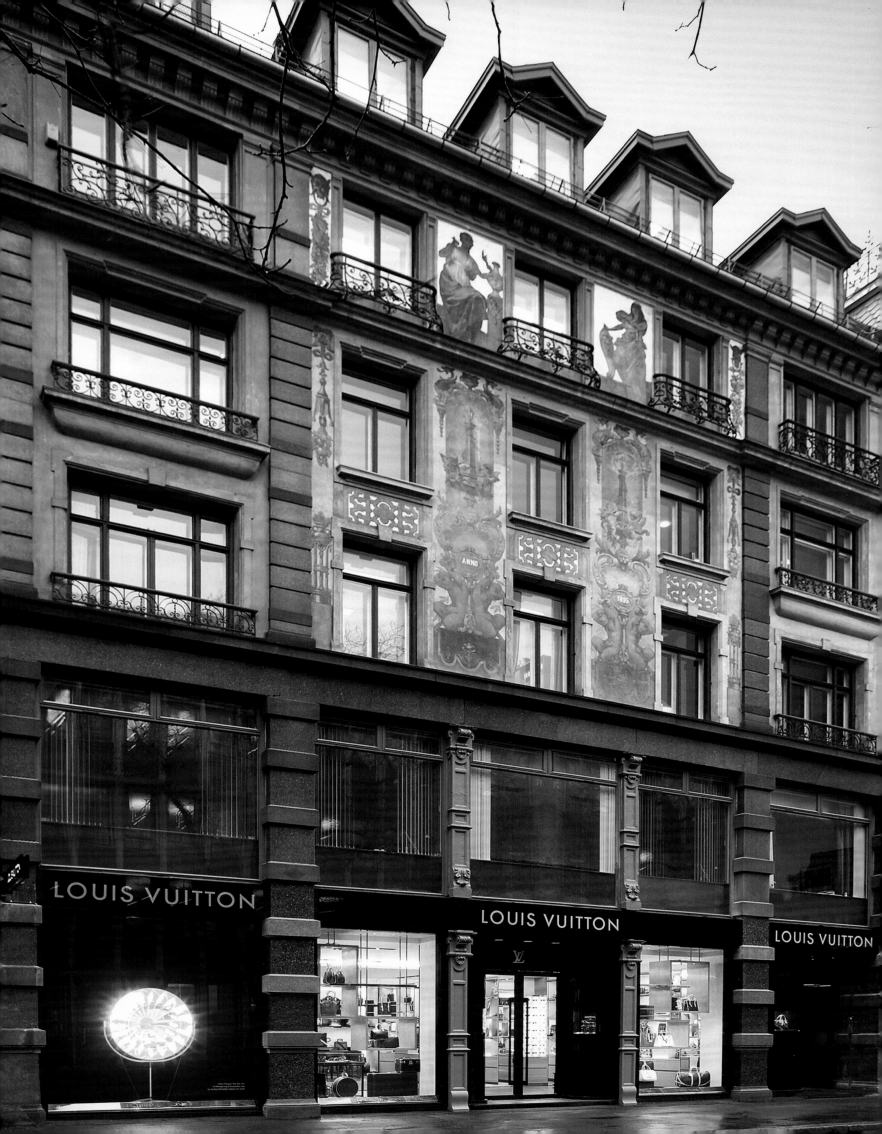

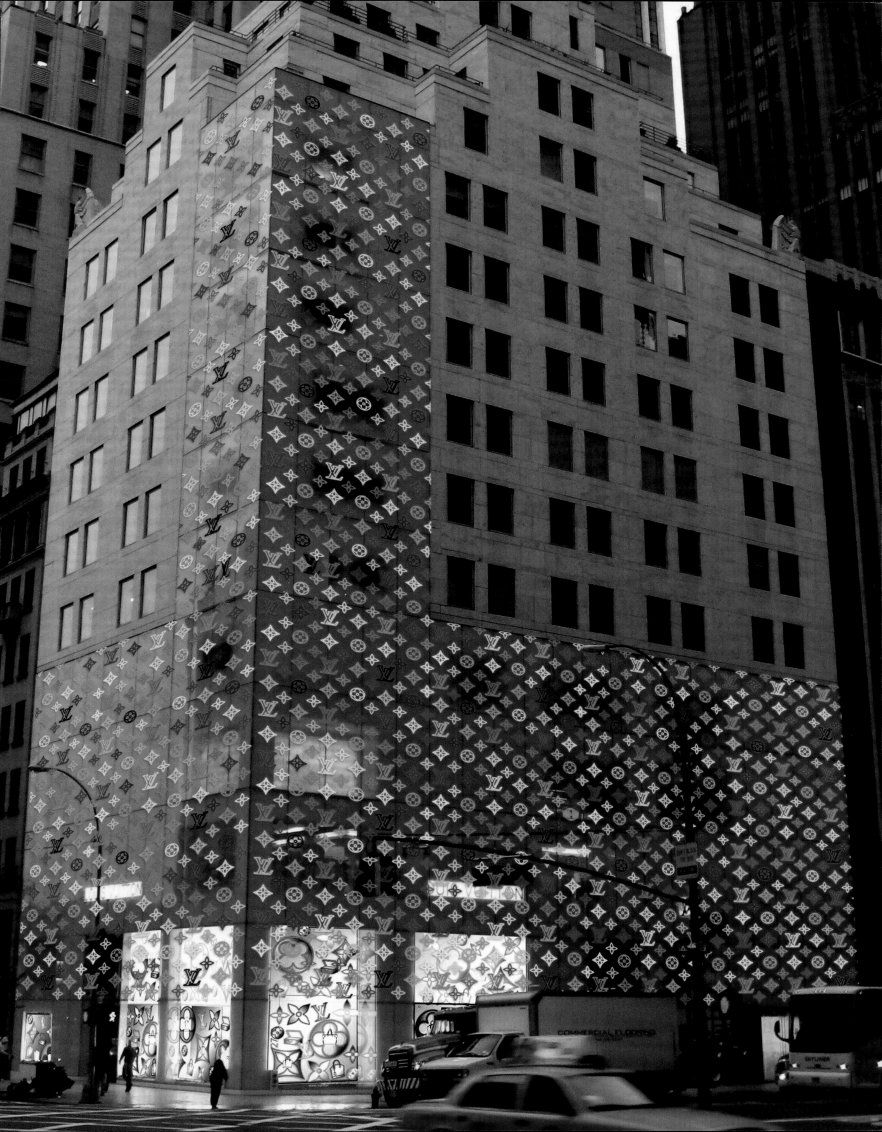

Louis Vuitton

by Olivier Saillard

by Olivier Saillard

The e
of sig

mpire

ns

The Empire of Signs
by Olivier Saillard

Those who follow the history of fashion will be delighted to learn of the developments that have taken place in a discipline that still, in this day and age, encourages the emergence of talented, self-taught individuals. Indeed, history books reveal that in the early 20th century, a fashion designer was considered to be no more than a supplier to well-heeled women. One wouldn't have dreamed of inviting a fashion designer, even a renowned one, to dinner much more than one would have invited one's butcher or baker, as Jacques Doucet liked to reiterate. In fact, even the suppliers of fabric and embroidery shone brighter than the master tailor, who was confined to an executive role until the end of the 19th century. There was no rivalry between the clients of *haute couture* and those who modeled them—known then as "look-alikes"—because it was the model's duty to try to resemble and appeal to the client and not the other way around, as would be the case at the end of the 20th century.

At times, fashion would be cause for joy, and at others, distress. But as its forms and conventions evolved, all agree that an open-minded sensibility existed around the trade, and willed out the talents that were representative of each period. No unsung designers suffered from a lack of recognition and visibility, as was the case at times in other disciplines. At no time in the entire history of fashion was there ever a Van Gogh whose style went overlooked.

Mirroring the larger world, fashion is governed by cycles of boom and bust, of hype and obscurity. But the Louis Vuitton brand—*"Marque. L. Vuitton déposée,"* as its trademark first appeared on a canvas in 1888—never fell victim to these fluctuations. The house of Louis Vuitton evolved to become a lot of things throughout its history. But as its interests, activities and material language diversified, none of its constituent parts were in conflict with each other; rather, they all contributed to making Louis Vuitton a noble material in itself, the continued revitalization of which is an integral part of the brand.

Louis Vuitton was a peer and friend of the Englishman Charles-Frederick Worth, who, among other things, invented *haute couture*, the concept of seasonal collections, and modern principles of exhibiting and distributing wares. Vuitton founded his house on 4 rue Neuve des Capucines in 1854. Not far behind, Worth inaugurated his first fashion house on 7 rue de la Paix in 1857. Favorites of the European courts, both men owed their careers to royal patronage, with Worth the protégé of Princess Pauline de Metternich, as Vuitton was of Empress Eugénie. They were both pioneers of what is known today as the "luxury industry." And both had the unprecedented idea of placing their signature on their creations, which was certainly a deliberate attempt to protect themselves from contemporary imitators. This contributed symbolically, and later very significantly, to the widespread and artistic recognition of the respective careers of two kindred souls: the self-proclaimed "dress composer;" and the miller's son from Franche-Comté.

From around this period, a loop of fabric stitched with the name of the designer was tucked by seamstresses inside the waist of clients' dresses, authenticating them as original creations. Likewise, in 1888, Louis Vuitton's Damier or checkered pattern, which alternated small brown and beige squares punctuated with *"Marque. L. Vuitton déposée,"* displayed calligraphy that seemed rendered by hand. The introduction of this trademark reinforced the former apprentice trunk maker's ever-increasing desire to guarantee the quality and origin of his company's creations. It was also what motivated the milliners that preceded them in formally labeling goods. Annoyed that hats from other designers were being returned to them, some proprietors came up with the idea of affixing the names and addresses of their company on their articles. For Louis Vuitton's founder and his descendants, the implementation of similar measures came in distinct waves, and with the expansion of the brand's product line, brought about profound changes.

In 1854, Louis Vuitton specialized in the production of travel trunks, replacing the traditional leather trim with a water-resistant "Gris Trianon" canvas. In order to avoid counterfeiters, in 1872 he created a unique red-and-beige striped canvas and then changed the design in 1876. Finally, he introduced the Damier canvas in 1888, and entered it in the Universal Exhibition in Paris in 1889. In 1856, Louis Vuitton's flat-bottomed, stackable trunks, reinforced by varnished beechwood slats and equipped with removable interior frames, began to be seen in the carriages of what was then the newest form of transportation—steam-powered trains. The celebrated Wardrobes created in 1875, or the nesting trunks with compartments that could contain exactly "5 suits, 1 overcoat, 18 shirts, 4 pairs of shoes, 1 hat, 3 canes

and 1 umbrella" modernized travel. But their success spurred incessant counterfeiting despite the quality of the materials that made them unique.

In 1896, four years after Louis Vuitton died, his son Georges created the Monogram canvas, partially breaking with the tradition of geometric patterns, which were so easily imitated. In it, he incorporated four ornaments, including three floral motifs and the intertwined initials of the house. The simplicity of this essential design not only reflected the modernization of the company but was also a further attempt at thwarting counterfeiters. These stylized symbols were based on *Japonisme* and Art Nouveau designs, which in turn, had their origins in traditional fine art, decoration and printed graphics. The house of Louis Vuitton created new styles of luggage and handbags to meet the needs of the new century. The Monogram canvas would become a genuine fashion symbol, not merely an ephemeral pattern, and would never fall victim to its success. Louis Vuitton created a wide range of bags in the first half of the 20th century. The Steamer Bag in 1901, a precursor to many "soft" bags, was an extra piece of luggage that could easily be folded and stored. The 1930 Keepall Bag, initially made of cotton and later released in Monogram canvas, was even more lightweight and versatile, and introduced a more convenient way to travel. The Noé Bag, from 1932, was designed to transport five champagne bottles. Its 1959 version, made of soft Monogram canvas, established it as a must-have accessory. These examples, to state just a few, reveal how Louis Vuitton brought together invented forms with reinvented materials. One design preceded the other without anyone knowing which specifically succeeded the next. In all, Louis Vuitton emphasized forms suited to their function, as well as to their respective, genuine materials. Realized with unsurpassed craftsmanship, the house gave rise to some of the true classics in the history of fashion.

The house of Louis Vuitton is well over a hundred years old, but the latter half of the 20th century is clearly associated with some of the more provocative uses of its unique visual language. Bernard Arnault—having assumed controlling interest in LVMH in 1990—sought to remake his flagship brand as the fullest expression of contemporary luxury, focusing on its fundamentals as an accessories house while opening a gateway into fashion. This modernization regime insured the longevity of the brand, and heralded a new period of creative achievement.

With the centennial of the Monogram canvas in 1996, a group comprised of art consultants and figures from the fashion world—including Jean-Jacques Picart—organized a birthday celebration. They invited seven fashion designers to reinvent the illustrious Monogram canvas by adding their own personal touch. Azzedine Alaïa conceived a handbag that had a patch of leopard skin tied harmoniously around monogrammed canvas. Helmut Lang created a DJ case with a chic, urban finish for the globe-trotting DJ. Spanish designer Sybilla proposed an innovative curved backpack with a built-in umbrella. London boot maker Manolo Blahnik designed a small, curved trunk with pink leather lining—a real jewelry box for shoes, toiletries and an evening dress. Isaac Mizrahi created a transparent, minimalist shopping bag enhanced with natural leather details. Romeo Gigli drew inspiration from an amphora and a quiver to produce a feminine, romantic backpack. Vivienne Westwood came up with the amusing yet functional "false-fanny" bag. The event led to an exhibition, and however atypical these "designer bags" were, their singular character and modernity signaled the Monogram's resurgent appeal. Their success laid the foundations that ultimately led to the 1997 appointment of New York designer Marc Jacobs as creative director of the brand, which would subsequently include seasonal ready-to-wear lines that were, at once, audaciously chic and thoroughly studied. Gaston Louis Vuitton had turned to Art Deco during the 1920s and collaborated with designers such as Legrain, Puiforçat and Lalique. Following this precedent, Marc Jacobs initiated a series of creative partnerships that have become legendary in the history of contemporary fashion.

With Marcel Duchamp's *L.H.O.O.Q* from 1919 as a ready precedent—in which the artist drew a mustache on Leonardo da Vinci's *Mona Lisa* to create a work within a work—Marc Jacobs established a principle of reference by inviting several artists to alter the Monogram canvas or the forms of the bags themselves. In line with his personal vision and in step with an age that was on the verge of sanctifying the handbag as an absolute archetype of fashion, Marc Jacobs—with Louis Vuitton CEO Yves Carcelle—invented a new vocabulary that made the desire for reinvention a constant, an engine capable of affirming and sustaining the history of the house. The first of these well-known collaborations was with Stephen Sprouse in 2001. Sprouse deliberately scrawled on a Louis Vuitton bag like a graffiti artist tagging a wall. Predictably, the irreverence of this act drew astonished and scandalized reactions, but it was a strong creative breakthrough that proved very influential.

Other collaborations included artists such as Julie Verhoeven, who produced poetic patchworks (2002), Sylvie Fleury, who created bags that seemed to have been cast in bronze, gold and mirrored silver (2000-2006), and Richard Prince, who lent his Joke Paintings to a line of bags (2008). Further events

spurred temporary collaborations with artists like Ugo Rondinone, Bruno Peinado, Robert Wilson and architect Zaha Hadid, notably in a 2006 exhibition that paid tribute to iconic pieces of Louis Vuitton luggage.

Among these many collaborations, all a credit to a creative director who understood the intimate essence and the public impact of the brand, there was one association which distinguished itself significantly from the others through its incredible success. When Marc Jacobs discovered Takashi Murakami's work during an exhibition of his work at the Fondation Cartier in Paris in 2002, he knew he wanted to work with the Japanese artist. In 2003, the first Murakami bags for Vuitton called for a multicolored Monogram canvas, for which the artist created 33 colors, printed through 33 silkscreens, on a black or white background. In addition, he created the *Cherry Blossom* bags, the *Eye Love* bags, a watch and three pendants for his fine jewelry collection. The Louis Vuitton job propelled Murakami's international reputation. To the sheer delight of his fans, the bags boosted the pop and *kawaii* images of an artist who considered by-products as important as the original work itself. Their spectacular media and commercial success, on the other hand, was enough to become an annoyance to those who saw this association between art and commerce as an aberration, a deviation from accepted norms. In years following, critics would know soon enough that no sector of the fashion industry would be able resist the charms of contemporary art.

But no other fashion house has wielded as much influence on the work and reputation of an artist in the way Louis Vuitton cultivated its highly visible relationships. Indeed, Louis Vuitton adapted its requirements to better accommodate the artistic commitment of each artist for these projects, which will forever remain key passages in the long union between art and fashion. These projects represent more than a mere contract for services, as is the case with other collaborations in the fashion industry between a designer and an artist that may produce a particular pattern or dress. Louis Vuitton, however, invited artists as full participants in the creative process, and with every partnership, codifying the process.

An unprecedented relationship between art and commerce was rekindled in 2008. Once again, it brought together Louis Vuitton and Takashi Murakami, in a celebration of his work at MOCA, the Los Angeles Museum of Contemporary Art, which later moved to the Brooklyn Museum in New York, and then to venues in Germany and Spain. The artist caused a scandal by inviting Louis Vuitton to install an actual store that was part of the exhibition, in which visitors could purchase bags created specially for the occasion. "It is up to the artists to determine the limits of art," some may nobly say. Others may even question what they believe to be the highly explicit commercial dimensions of Murakami, failing to reconsider the work of Claes Oldenburg who, in the 1960s, opposed the middle-class concept of the museum. Taking into account recent contemporary history, this association, which some consider startling, is simply a step in the development of prescient, interdisciplinary, post-Warhol systems. In an essay dedicated to Andy Warhol, Cécile Guilbert sets out to substantiate the artist's prophecies.[1] She cites "the complete absorption of the art market into luxury," the proliferation of "business artists," and affirms Warhol's prediction that "all department stores would become museums and all museums would become department stores." The author, rightly and accurately, is quick to confirm that this "phenomenon has been deemed true." She cites architects that have been commissioned to design boutiques, such as "Koolhaas (Prada), Piano (Hermès) and Portzamparc (LVMH), that are visited as seriously as museums which, in turn, devote an increasing number of exhibitions to couturiers."

These intersections, as Cécile Guilbert correctly recalls, were presaged in the 1960s and can no longer be denied. Their development and proliferation are crucial to the histories of both contemporary art and fashion. Their presence testifies to a moment during which Warhol also said that art would become "artistic fashion." The latest collaboration that Louis Vuitton inaugurated with Rei Kawakubo of Comme des Garçons—a designer whose uncompromising, visionary style has been respected widely since the 1980s—may yet prove to be a poetic and necessary point of suspension in this endeavor to bring the worlds of art and fashion together, an exercise in which the mark of Louis Vuitton will always remain the noblest of emblems.

[1] Guilbert, Cécile. *Warhol Spirit*. Paris: Grasset, 2008, n.p.

p.72-73 Advertising campaign by Steven Meisel (2009); Madonna is wearing S/S 2009 Prêt-à-Porter, with a Kalahari GM bag in the Monogram canvas, shot at Café Figaro in Los Angeles. p.75 Watercolor by Ruben Toledo of a procession depicting the seven bags commissioned for the 1996 centennial of the Louis Vuitton Monogram, from the sketchbook "How Louis Vuitton came into the world of fashion" with Paul-Gérard Pasols (2005). The bag designs, from left to right are by Azzedine Alaïa, Manolo Blahnik, Romeo Gigli, Helmut Lang, Isaac Mizrahi, Sybilla & Vivienne Westwood. p.76 Collection Louis Vuitton Prêt-à-Porter S/S 2001. Printed on silk taffeta, the roses on the skirt were by Stephen Sprouse. The collection marked the first collaboration between the artist and Louis Vuitton. p.77 Speedy bag in the Rose Monogram (2009). The canvas pattern is a tribute to original designs by Stephen Sprouse.

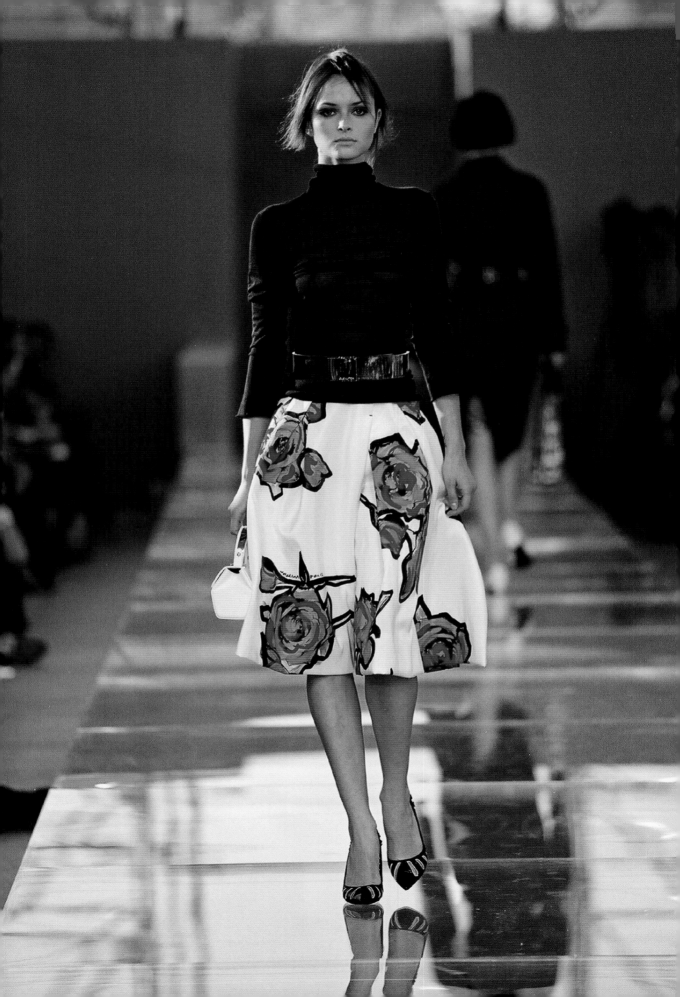

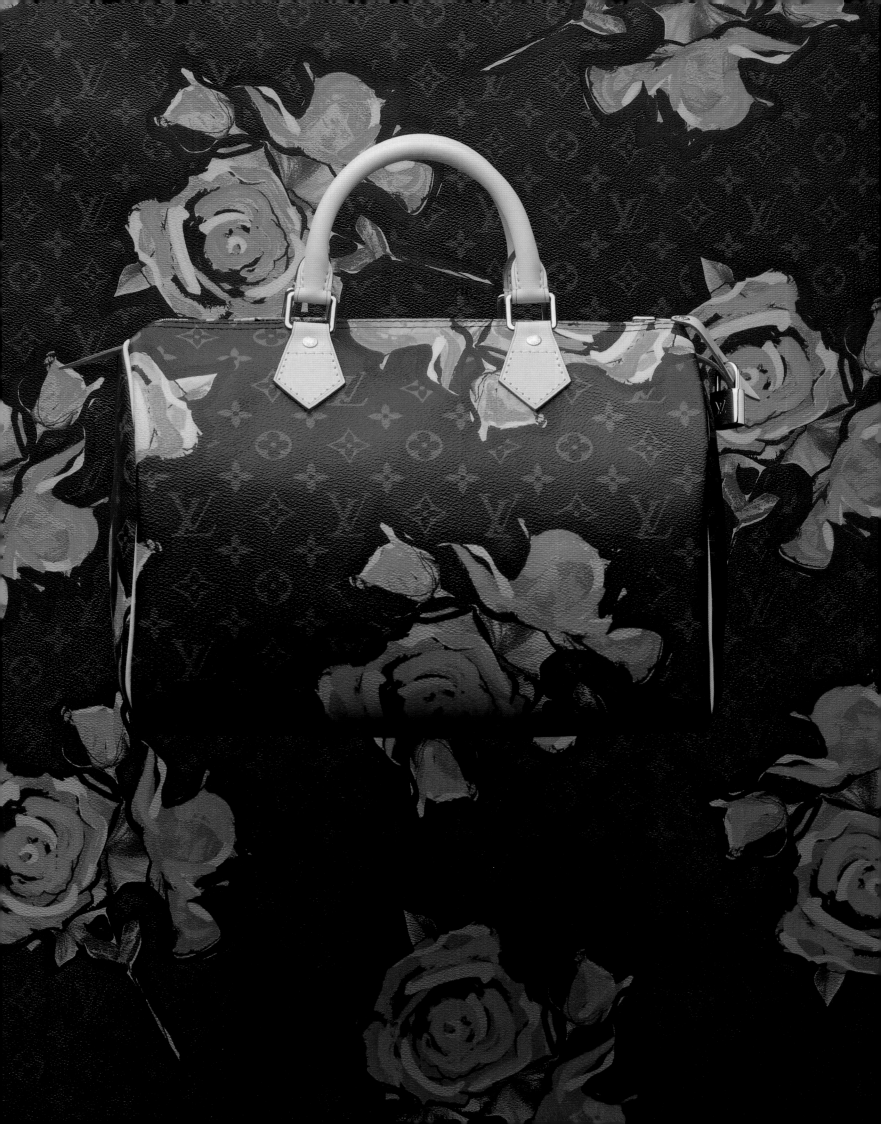

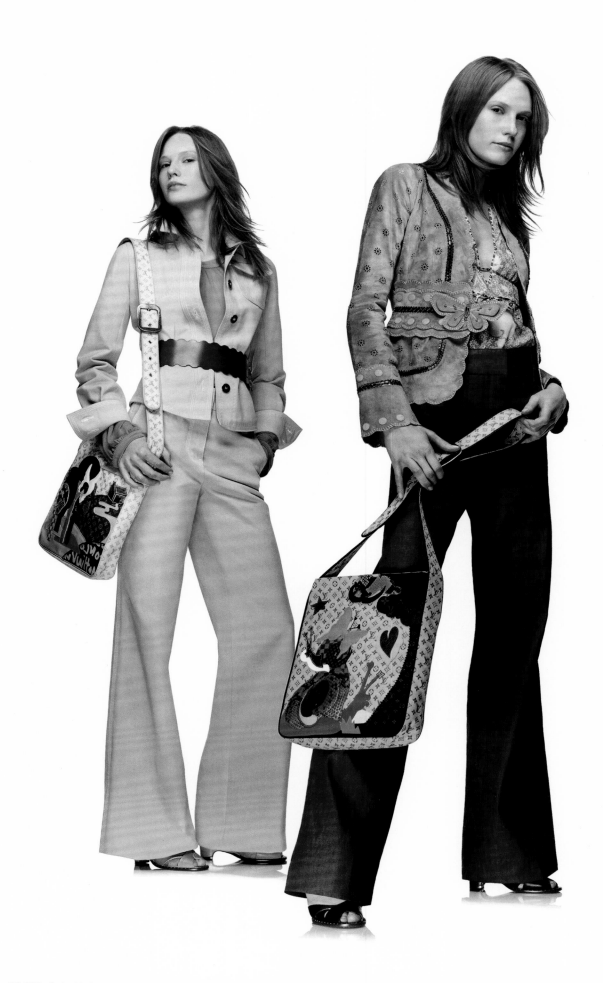

p.78 Looks from S/S 2002 with shoulder bags from Julie Verhoeven's Fairy Tales series in treated fabric, appliquéd in cow leather and snakeskin. Landscape bag (left) and Garden bag (right). p.79 Twilight shoulder bag from Julie Verhoeven's Fairy Tales series (2002) in treated fabric, appliquéd in cow leather and snakeskin. p.80 Marilyn Trunk in the Multicolor Monogram (2007) by Takashi Murakami, containing 33 Marilyn handbags in each of the Monogram's 33 colors. p.81 Collection Louis Vuitton Prêt-à-Porter F/W 2006-07. The model sports a mink bag in the Multicolor Monogram by Takashi Murakami.

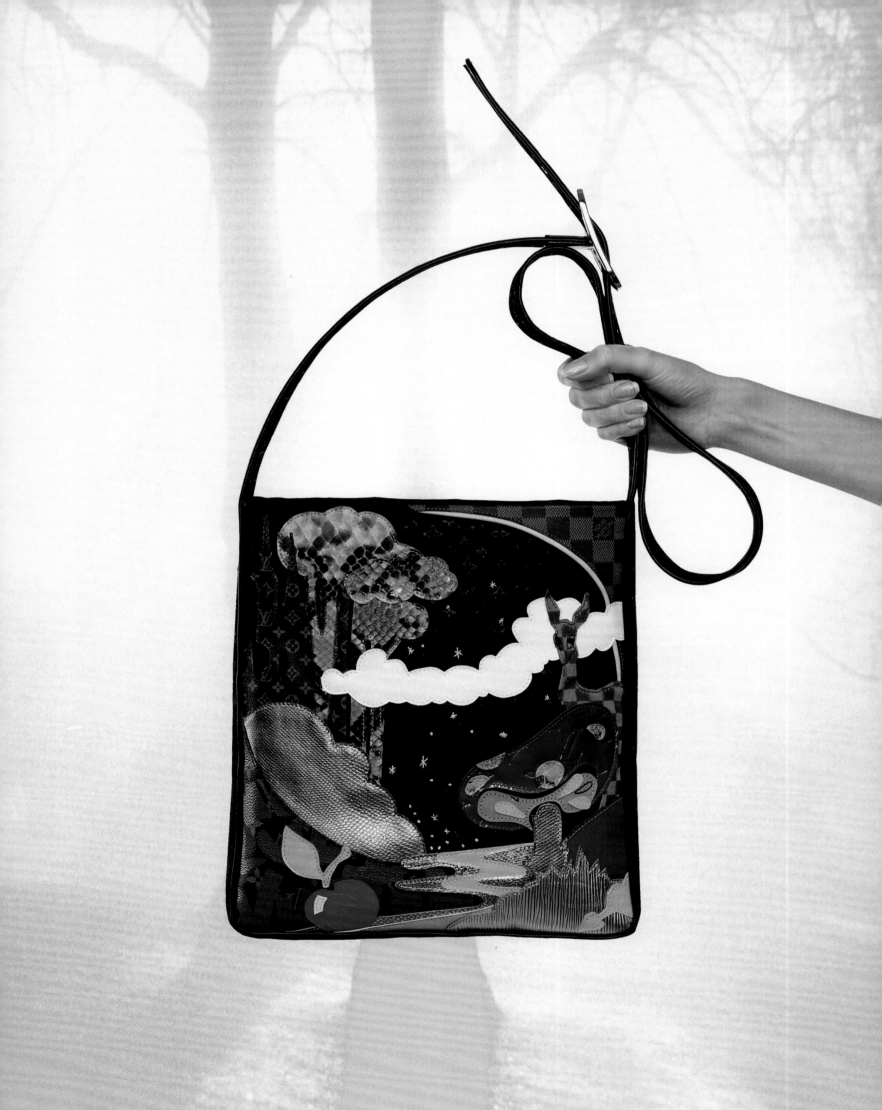

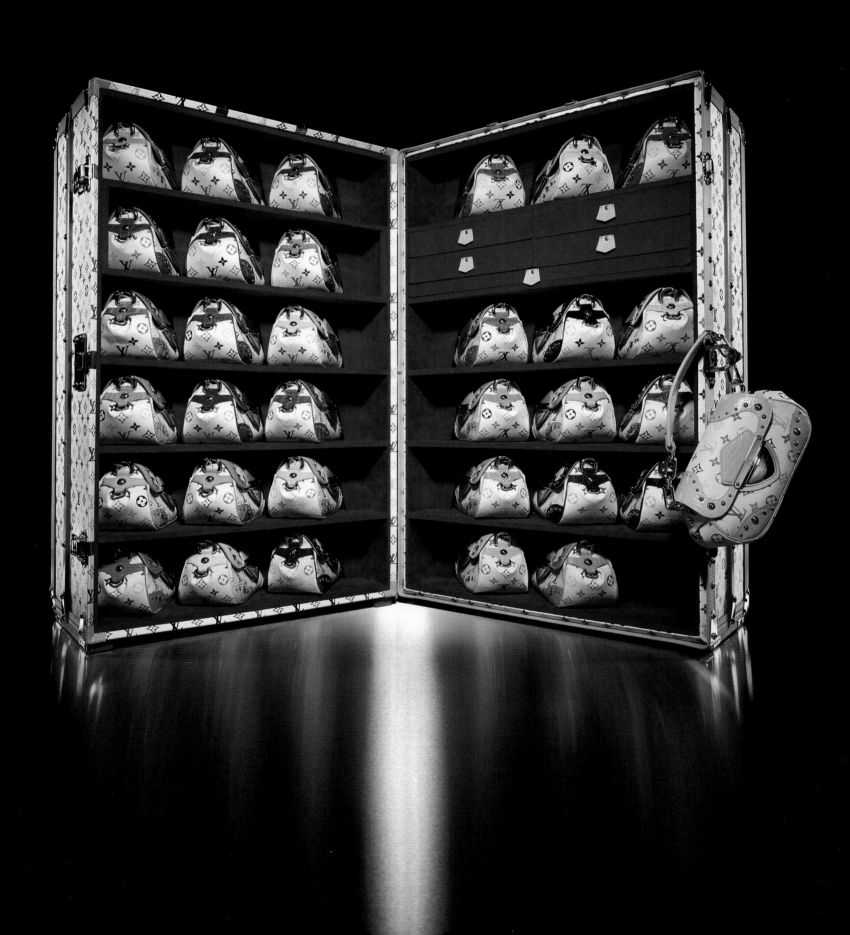

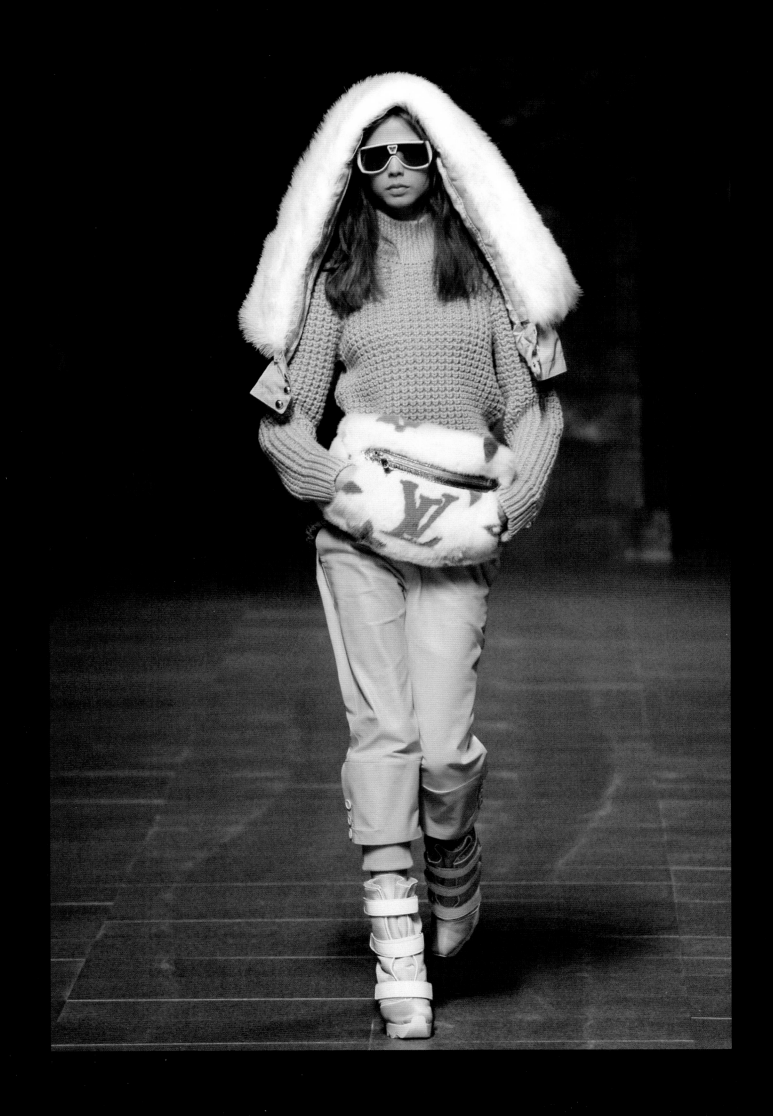

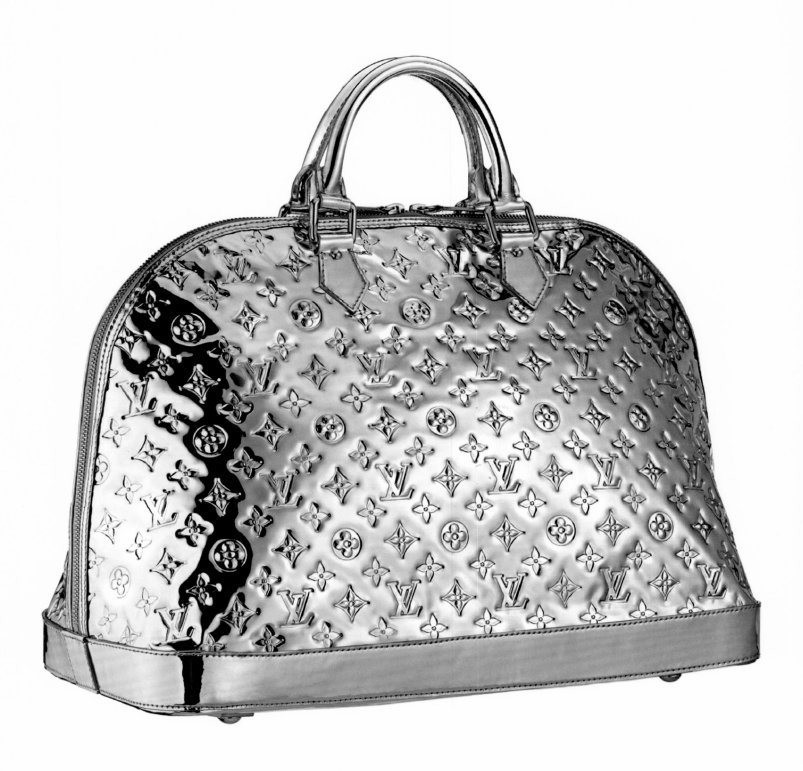

p.82 Alma GM bag in the Mirror Monogram (2006) inspired by an original artwork, the *Keepall* sculpture by Sylvie Fleury (2000). p.83 Collection Louis Vuitton Prêt-à-Porter F/W 2006-07. The Super Keepall in the Mirror Monogram, inspired by an original artwork by Sylvie Fleury. p.84-85 Ad campaign Spring 2008, by Mert Alas & Marcus Piggott, featuring (from left to right) Angela Lindvall, Claudia Schiffer, Naomi Campbell, Natalia Vodianova, Eva Herzigovà and Stephanie Seymour with bags in the Monogram Jokes pattern by Richard Prince: Mancrazy, Graduate, Heartbreak and Duderanch. p.86-87 The design team at Louis Vuitton (2006), photographed by Norma Jean Roy, on the roof of the former La Belle Jardinière department store, now the corporate headquarters of Louis Vuitton, 2 Rue de Pont Neuf, Paris.

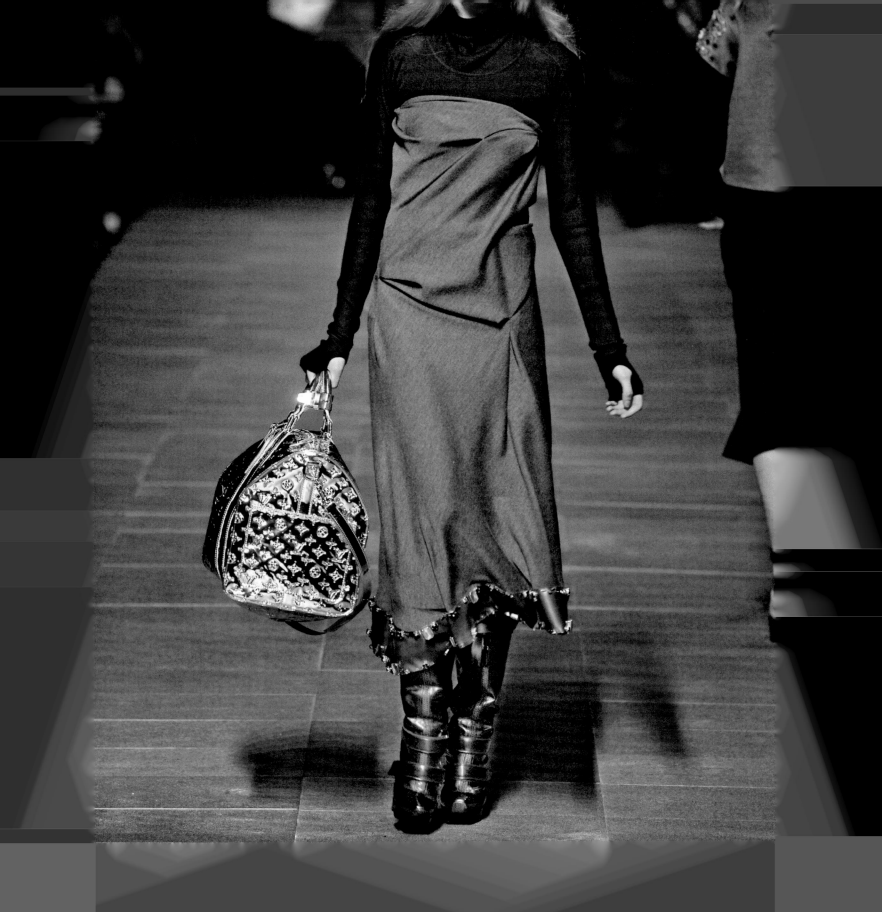

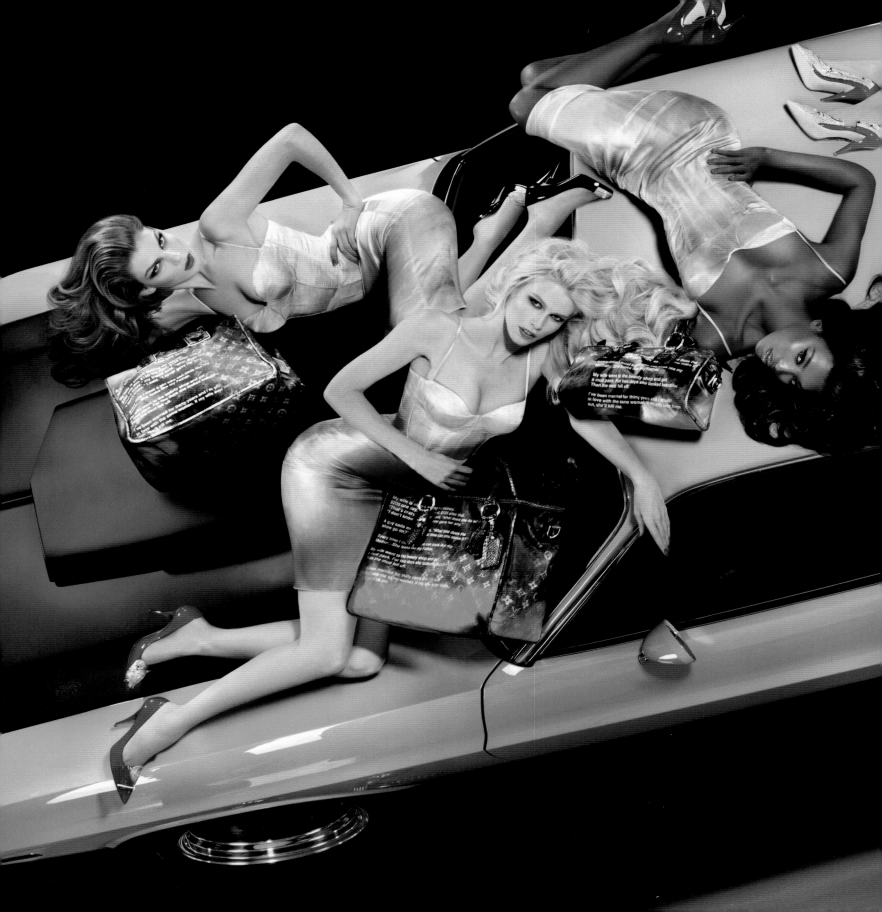

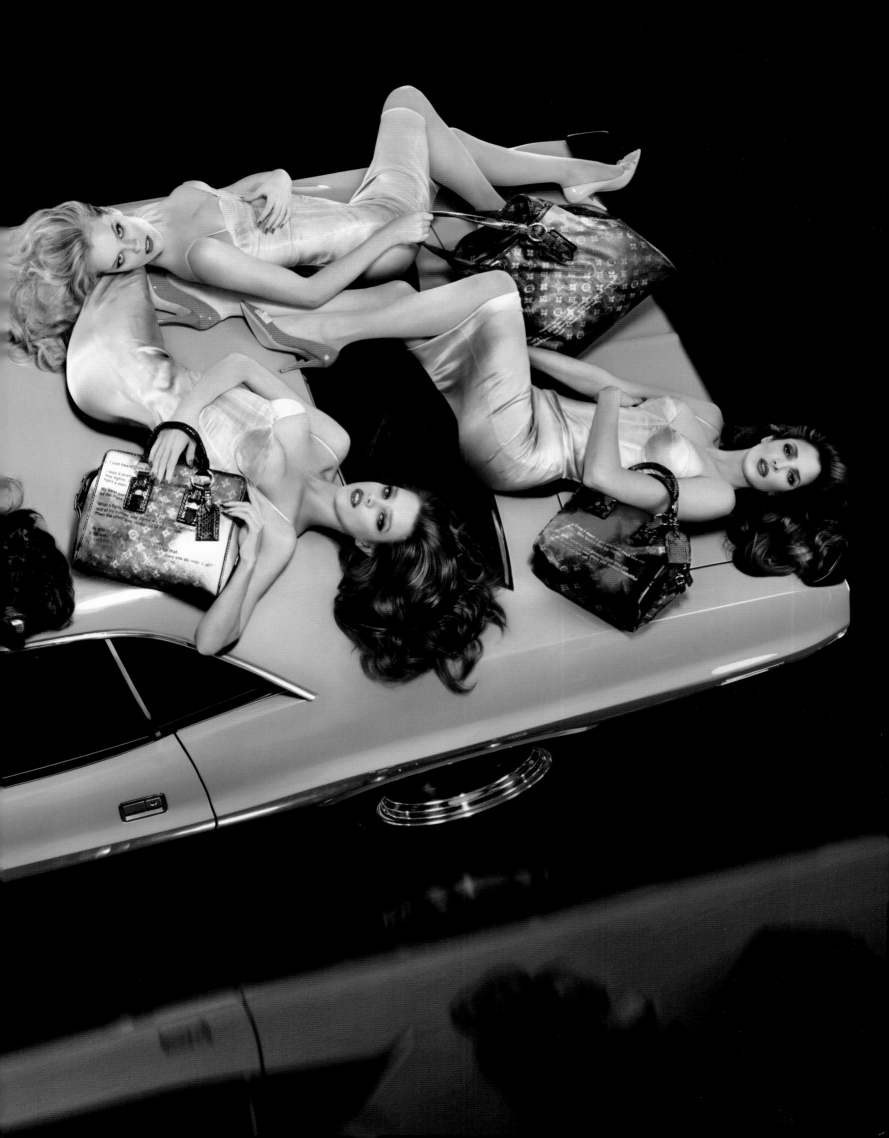

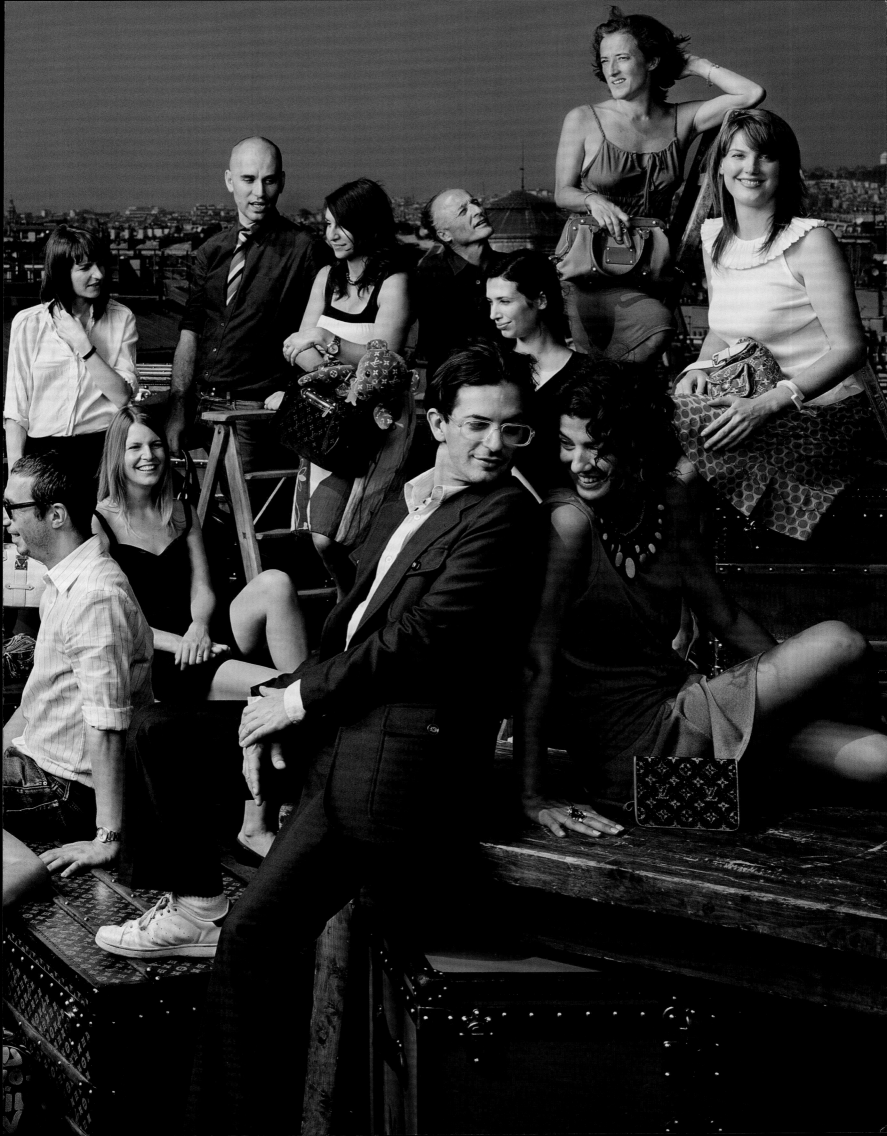

A
**Akakçe, Haluk
Alaïa, Azzedine
Alas, Mert
& Piggott, Marcus
Aoki, Jun
Arad, Ron
Arman
Aulenti, Gae**

Akakçe, Haluk

artist
text by Marie Maertens

Born in Turkey in 1970, and currently living in New York, Haluk Akakçe was one of the first artists to contribute to the reopening of the maison on the Champs-Elysées. After extensive renovation, the flagship incorporated an artistic and cultural dimension, luring visitors with inducements and amenities other than the ones usually on offer from the shopping god. The present boutique sports a bookstore, and notably includes permanent and revolving collections of art. A video, which is changed every two years, follows visitors up and down the store's main escalator. After Tim White-Sobieski, Akakçe was the second artist to take on this commission.

Akakçe's imaginings approach something like reality through a number of audiovisual media. Expressed in animation, video art, murals and soundcapes, his abstract, mutating forms—inspired by influences as varied as Celtic and Islamic architecture, Art Déco, science fiction, and American comics and fashion—offer alternate perspectives on the real world. Generated on the computer, these projects invariably explore the intersection between society and technology. *Moving Through the Looking Glass*, the original video created for the Champs-Elysées boutique achieves forward movement by manipulating Louis Vuitton's initials. Other projects for the house include *The Unheard Melodies* (2007), a sculpture for the shop windows which draws on biomorphic, hybrid forms that have become recurring motifs in his art.

p.88-89 Exterior view of Louis Vuitton Ginza—Namiki Dori (2004), detail, by Jun Aoki & Associates. **p.91** A digital study for *The Unheard Melodies* (2007) by Haluk Akakçe, a sculptural installation intended for the windows of Maison Louis Vuitton, Champs-Elysées. Suggesting a transparent cathedral door, the work is an attempt at unifying the building's interior and exterior, its illusory effect evoking a state of "ephemeral transition."

90 **Louis Vuitton**

Alaïa, Azzedine

designer
text by Olivier Saillard

Azzedine Alaïa's creations defy the work of historians and biographers.

His clothes are true archetypes of modernity, and because there are so few such genuine instances in fashion, his work instantly made redundant all the ways we have used to describe the development of a talented artist. Since he arrived in Paris in the 1950s, Alaïa has tamed and perfected a very particular conception of the fashion world. In nurturing a private clientele that includes major names—Arletty, Louise de Vilmorin and even Greta Garbo —he broke into fashion with the confidence of one who'd completely mastered it. When he presented his collections in the 1980s and when the "Alaïa phenomenon" was at its peak, the designer inspired a fanatical loyalty—even addiction—among his female fans. Alaïa perfected every stage of design and construction. His technical knowledge of knitwear and pattern-making are unrivaled. In this regard, he can be compared to Madeleine Vionnet, a key figure in fashion history, whose rediscovery and appreciation he launched to a very large extent.

Wielding a pair of scissors like a sculptor, Alaïa radically transformed the female silhouette, and his innovations have become classic and canonical. Flouting collection schedules and unimpressed by the accelerated demands of modern manufacture, he obstinately developed a timeless, formal vocabulary inflected with references from the 1930s and 1950s. Far from mere nostaligia, he made the markers of these bygone era his own, and this return to glamour proved a valuable precedent to younger generations of designers.

When he was invited to celebrate the centennial of the Monogram canvas in 1996, the designer, with his customary sense of humor in force, created an extremely feminine handbag that was sensuously tied with leopard skin. Inside this primal composition, the spotted material also covered an array of smaller purses and cosmetic cases.

p.93 On the centennial of the Louis Vuitton Monogram in 1996, Azzedine Alaïa created the Leopard bag in Monogram canvas, calfskin leather and natural materials. Louis Vuitton Collection.

92 **Louis Vuitton**

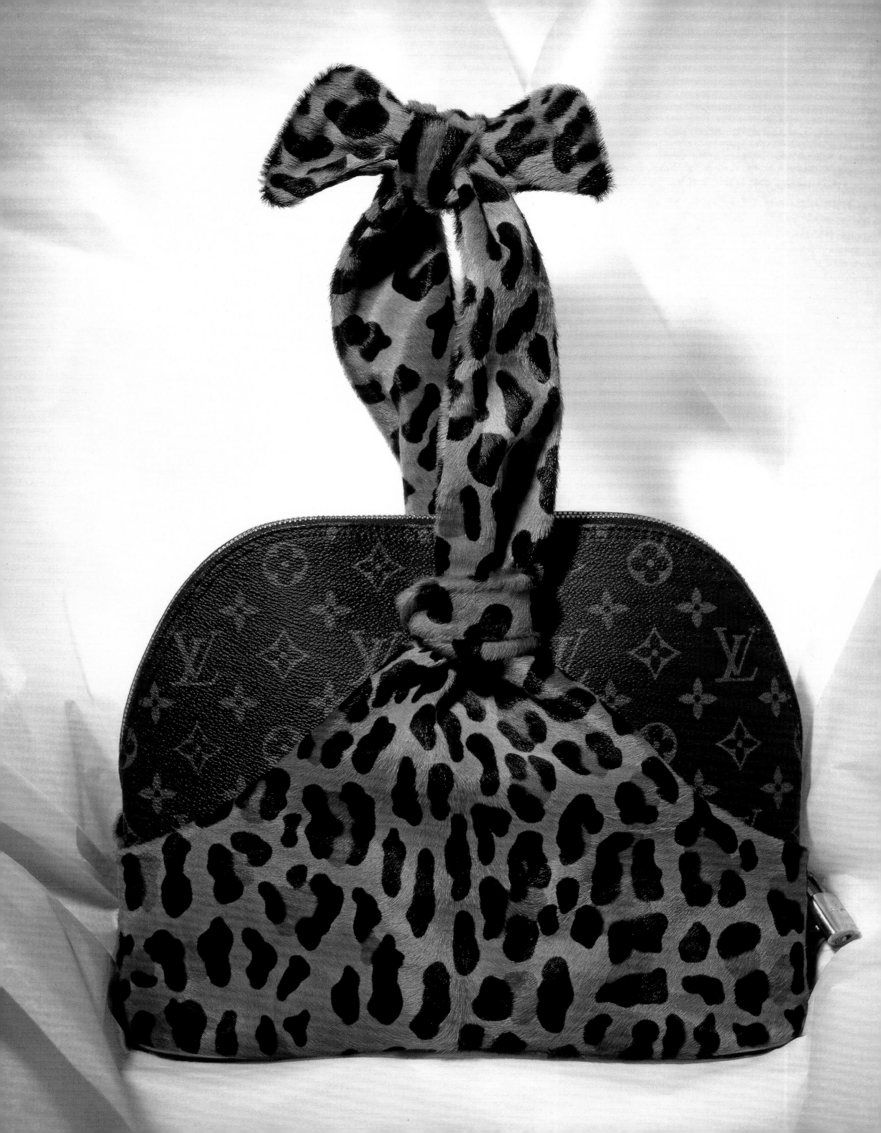

Alas, Mert & Piggott, Marcus

photographers
text by Emmanuel Hermange

In the wake of Pierre and Gilles, Guzman, Inez van Lamsweerde and Vinoodh Matadin, Mert and Marcus are one of the latest duos to emerge in an increasingly crowded field that brings together fashion, advertising, and art.

Born in 1971 in Istanbul and 1970 in Bangor (Wales), respectively, Mert Alas and Marcus Piggott met in London in the mid 1990s. Following his studies in classical music, Mert was then working as an assistant photographer. Marcus, having studied graphic design, was already working in fashion photography as a set stylist. They promptly decided to work as a team and presented their first collaborative photos to Jefferson Hack and Rankin, creators of the magazine *Dazed and Confused*, who immediately offered them the cover. It wasn't long before magazines and the biggest names in luxury were attracted to their unique style, which broke with the 1990s.

Drawing inspiration from a network of artistic influences chiefly from the 1930s—Hans Bellmer, Man Ray, Balthus and Guy Bourdin—the Mert and Marcus universe revisited various female stereotypes. By turns, they portrayed their idealized woman as either self-assured with her powers, overcome with exaggerated narcissism, or displaying a cold seductive air. The resulting compositions, the poses of the models and the lighting also evoked the 1930s, displaying the affected, somewhat stilted appearance so common in the fashion photography and celebrity portraiture of the period. The most striking quality, however, is the incredibly slick textures within the images, so much so that often it is difficult to determine whether one is looking at a model

"in the flesh or made of silicone," says Dennis Freedman, Creative Director of W magazine, who has commissioned their work a number of times. Roland Barthes writes in his book *Mythologies* (1957), "It is well known that smoothness is always an attribute of perfection because its opposite reveals a technical and typically human operation of assembling: Christ's robe was seamless, just as the airships of science-fiction are made of unbroken metal." Accordingly, Mert and Marcus's essential focus is a certain quality of appearance so that their images prefigure what science-fiction, and also contemporary art and philosophy, call post-human. "We spend most of the time in the make-up and hairstyling rooms, focusing more on the look than on more technical aspects," says Alas. Relegating an actual photo shoot to a mere recording of a composition of bodies and objects, they spend considerable time on the post-production of their images, supported by a team comprised of the best specialists in digital retouching. Their skillful, subtle, and many alterations of light and hue, of highlights and shine are not complete until they have achieved that glamorous wax-like sheen that has prompted celebrities such as Björk, Madonna and Charlotte Rampling to commission a portrait from them.

Since 2002, Mert and Marcus have done a number of Louis Vuitton's advertising campaigns for their ready-to-wear collections. For

instance, they have revisited the world of fairy tales as well as reenacted train scenes from certain Hitchcock films with Eva Herzigová. For the 2008-2009 Fall-Winter collection, the top model once again posed in New York in front of the *Unisphere*, a giant globe sculpture located in Flushing Meadows erected for the 1964 World's Fair. Their campaigns are unique in that, for the first time, they introduced actresses such as Jennifer Lopez, Scarlett Johansson, Chloé Sévigny, Uma Thurman and Christina Ricci to Louis Vuitton's print ads.

In 2007, their work was on view in the exhibition the *Face of Fashion* at the National Portrait Gallery in London. At the same time, under the supervision of Creative Director Marc Jacobs, they produced all of the mainly black and white photographs for the 52nd issue of the ultra luxurious publication, *Visionnaire*, in which Naomi Campbell, Giselle Bündchen, Lou Douillon and even Evandro Soldati are served up in an exceedingly sophisticated erotica. It was entitled *Private* and was released in a mirrored gold case impressed with the Louis Vuitton Monogram pattern. With the volume, Louis Vuitton acknowledged the important contribution of the duo in the development of the brand's image in recent years. Missoni, Giorgio Armani, Roberto Cavalli, Fendi, Miu Miu, Gucci, Yves Saint Laurent, Givenchy and Lancôme are just some of the brands who count among Mert and Marcus's prestigious clients.

p.94 Advertising campaign Spring 2002 by Mert Alas & Marcus Piggott: Cinderella from the Fairy Tale series. The model wears a printed silk muslin dress and a Papillon sandal.

Art, Fashion and Architecture 95

Aoki, Jun

architect
profile text by Taro Igarashi (page 100)
project descriptions by Ian Luna (page 106)

Born in 1956 in Kanagawa Prefecture, Japan, Aoki graduated from the Department of Architecture of Tokyo University in 1980, followed by a Master's degree in 1982.

Aoki worked at Arata Isozaki & Associates from 1983 to 1990, until he established his own Tokyo-based practice, Jun Aoki & Associates in 1991. His teaching posts include Tokyo University, Tohoku University, Tokyo University of the Arts, and Japan Women's University. After becoming independent, a succession of groundbreaking projects ensured Aoki's rapid ascent on the Japanese and international scene. Aoki gained a reputation for being a thoughtful practitioner, with an unmatched capacity to articulate new and challenging ideas—many of which diverged from those of his mentor Isozaki. Some of Aoki's honors include the Architectural Institute of Japan Annual Award, the JCD (Japan Society of Commercial Space Designers) Award and the Yoshioka Award.

In 1994, Aoki began a residential architecture series in which he allotted one letter of the alphabet as the formal inspiration for a number of single-family homes. H House, built in 1994, consists of a single room in which every program space, from the bedroom to the dining area, are linked by a contiguous, peripheral hallway. In

lieu of the usual compartmentalization of space, Aoki suggested the concept of "flow line form" (*dousentai*) sensuously connecting heterogeneous spaces to each other. Other notable works by Aoki include the Mamihara Bridge (1995), a configuration of moving space; as well as the L Residence (1999), which utilized an angular form that kept the particular character of Aoki's ambivalent spaces intact.

From the late 1990s, Aoki took on projects for public facilities to revolutionary effects. The Yusuikan (swimming pool) in Toyosaka City, Niigata prefecture (1997), bears a spatial expression that successfully combines two entirely different worlds. When one ascends the exhibition room that continues in spiral form inside the inverted conical structure of the Fukushima Lagoon Museum (1997), the museum transforms instantaneously into a gallery from which the spectacular view of the surrounding lake can be observed. In 2000, Aoki won the international competition for the Aomori Museum of Art. Drawing tectonic inspiration from the Sannai-Maruyama archeological site nearby, Aoki dug into the ground to mimic the trenches of the

Neolithic site, and crucially combined *pisé de terre* or rammed earth walls with concrete floors to form the exhibition areas.

But it is the string of Louis Vuitton boutiques from 1999 onwards that introduced Aoki's achievements to the world. With nearly a dozen freestanding and in-store shops in Asia and North America, this partnership with Louis Vuitton has allowed Aoki to explore and restate ornamentation.

Aoki's monographs include *Jun Aoki Complete Works 1, 1991-2004* (INAX, 2004) and *Jun Aoki: Atmospherics* (TOTO, 2000). He has also co-authored *Jutakuron—12 no Daiarogu* (*Housing Theory—12 dialogues*, for INAX, 2000) among many others. In his most seminal work, *Harappa to yuuenchi* (*Vacant Lot and Amusement Park*, for Ohkokusha, 2004), Aoki suggests two types of space: the "amusement park" is equipped with every desirable artifice and function, but the blank space of the "vacant lot" lends itself to the subjective uses of its proprietor. Aoki critiques the former, while consistently seeking out the potential of architecture in the latter.

p.101 Louis Vuitton Roppongi Hills (2003), designed by Jun Aoki & Associates, Eric Carlson and Aurelio Clementi.

100 **Louis Vuitton**

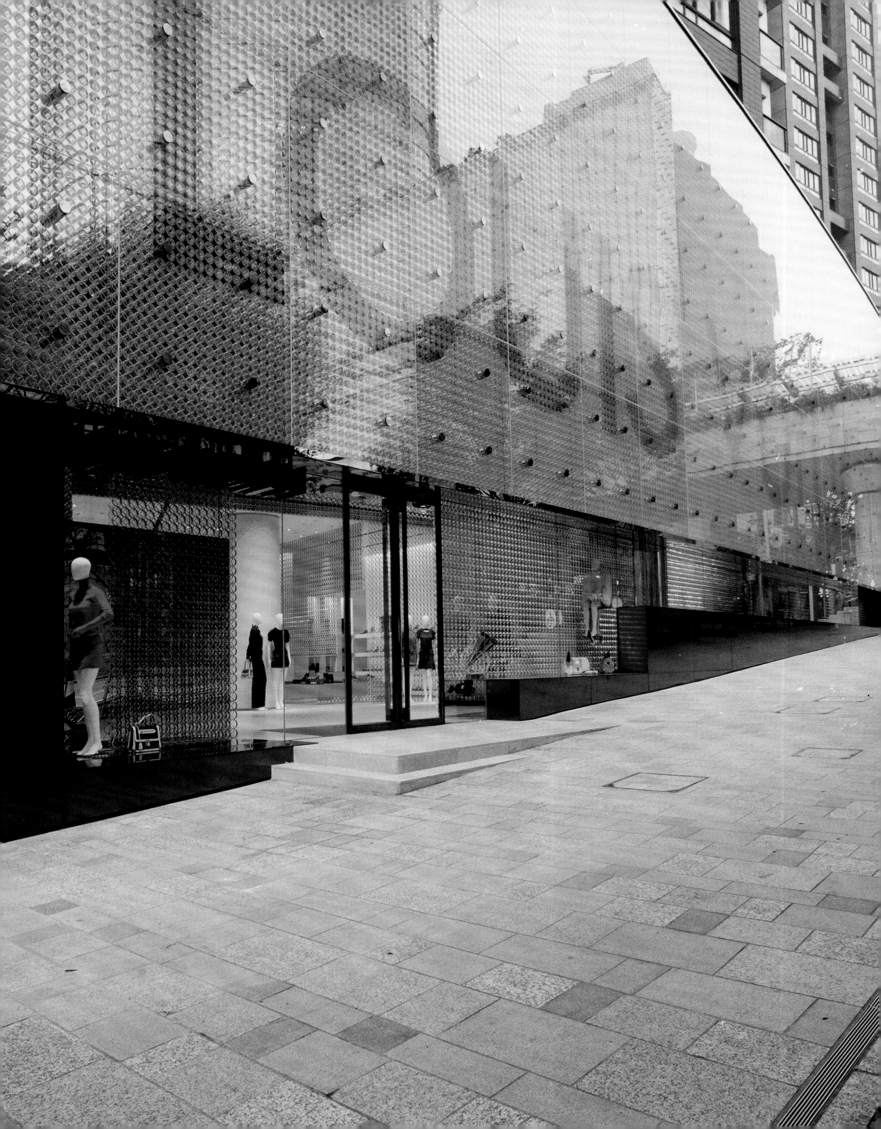

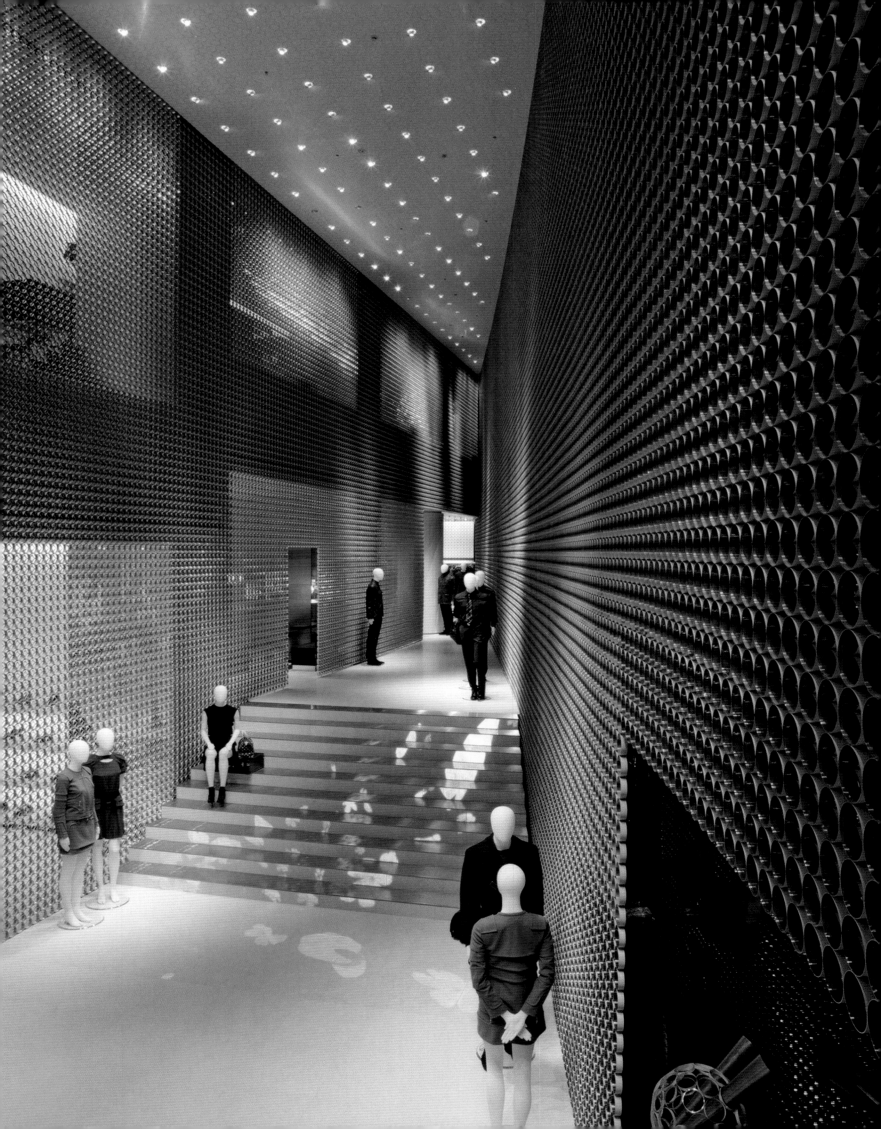

p.102 Louis Vuitton Roppongi Hills (2003): Interior view of the interior stainless steel screen. **p.103** Louis Vuitton Roppongi Hills (2003): Ground floor plan (top); second floor plan (middle); detail view of the glass tubes that make up the principal façade.

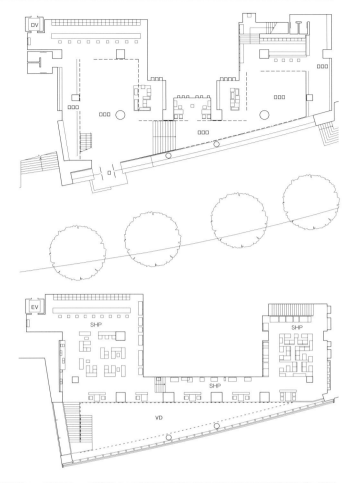

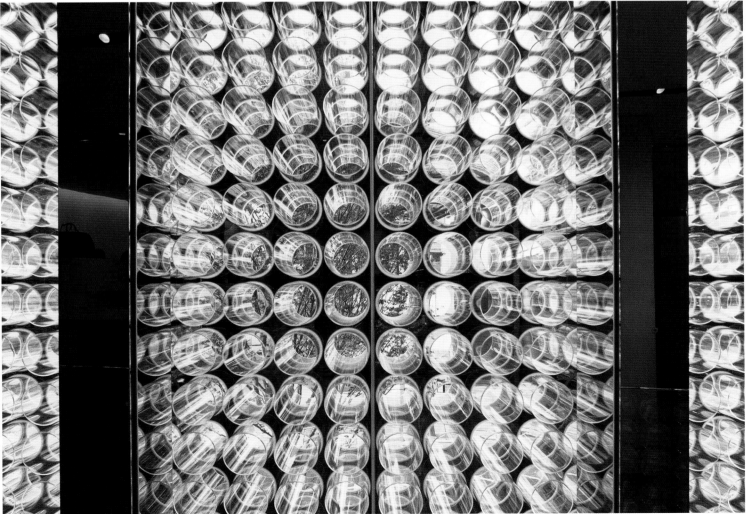

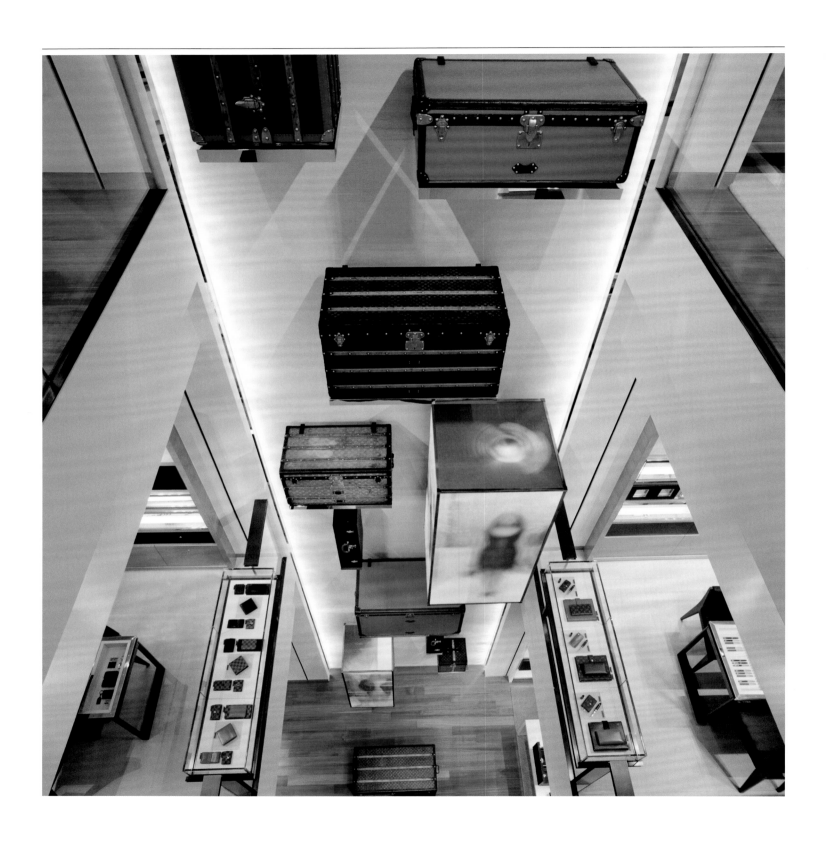

p.104 Interior view of Louis Vuitton Ginza—Namiki Dori (2004), by Jun Aoki & Associates. View looking down the wall of trunks. **p.105** Maison Louis Vuitton Omotesando (2002) by Jun Aoki & Associates. The building is designed as a collection of "trunks" varying in size, proportion and texture, a reference to Louis Vuitton's origins. Each "trunk" is purposely misaligned in both plan and section.

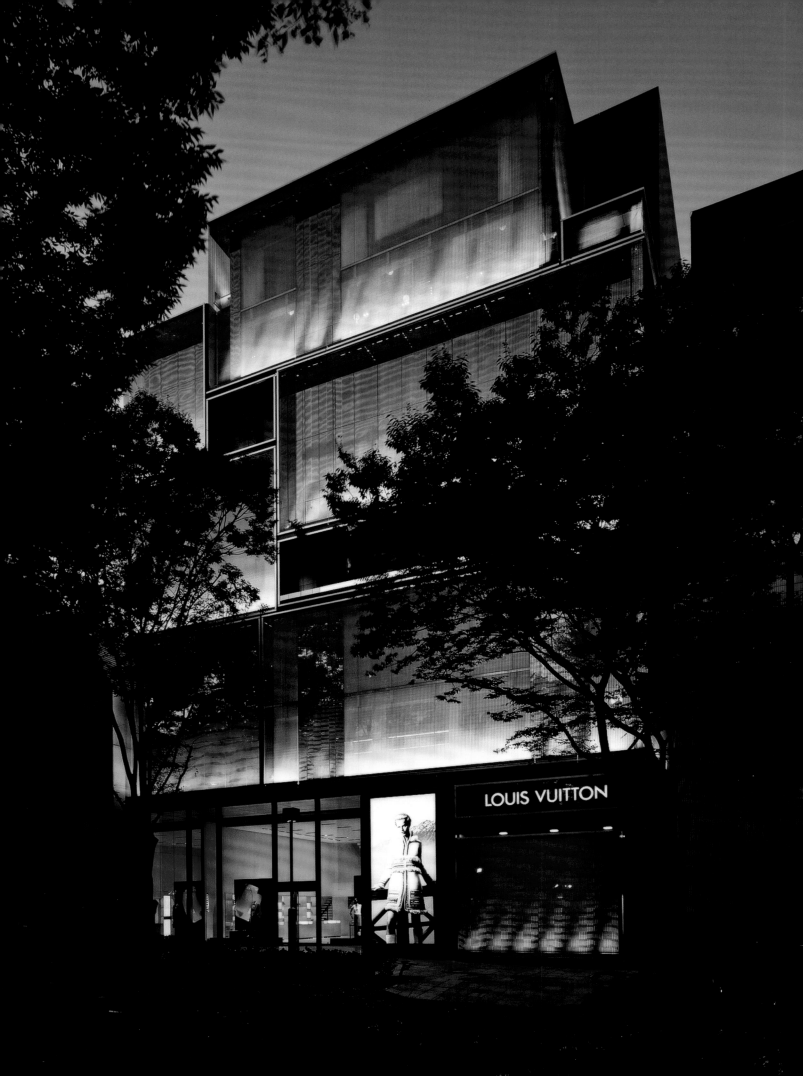

Jun Aoki's relationship with Louis Vuitton began in earnest with a one-story glass cube in Nagoya's Sakae district. Opened in 1999, the store features a simple steel frame clad in a double wall of glass. Fritted in dissimilar patterns, the two surfaces optically meld to create a third, eliciting varied perceptions of the building perimeter. The architect reiterates this curtainwall concept, "a bordering surface that could be seen but not experienced," in a number of his other Louis Vuitton projects, including the Ginza boutique at the foot of the Matsuya Department Store (2000), the New York flagship (2004, with interiors by Peter Marino & Associates), and the Landmark store in Central Hong Kong (2007).

Aoki generates a more complex formal device for the Louis Vuitton flagship store in Omotesando. Addressing Tadao Ando's Omotesando Hills complex *en face*, the retail component of this nine-story modernist palace takes up the first four levels, with the upper five devoted to office and mechanical functions. The store set a single-day sales record for Louis Vuitton the day it opened in September 2002, dispensing some $1 million in bags.

The massing strategy applied here simulates a pile of steamer trunks imprinted in trademark Damier patterns. To distinguish between volumes, the surface of each is articulated with a distinct textural treatment. Boasting an elaborate material palette, Aoki unfurls bolts of steel mesh, woven in a diversity of patterns and suspended twenty inches in front of either clear, fritted, or copper-tinted glass. Open-air terraces appear as gaps in the "luggage" with fitting-out of the commercial function largely delegated to Peter Marino and Louis Vuitton's in-house designers. Taking after the "Magic Room" atop the LVMH headquarters building in New York by Christian de Portzamparc (1999), a triple-height private event space on the seventh floor basks in the soft white glow of a knit fabric sheath designed by Aoki collaborator Yoko Ando.

A few kilometers to the south, the attempt by one of Tokyo's leading developers to create a vertical city-within-a-city in Roppongi has proved a bonanza for luxury retailers. Crowding the base of the iconic Roppongi Hills tower operated Mori Building Company, an assortment of shops is organized on hilly terrain. Louis Vuitton's contribution to the development is at the foot of a gentle incline, facing a massive TV station by Fumihiko Maki.

In concert with Eric Carlson and Aurelio Clementi, Jun Aoki devised a dynamic north facade for the two-story building composed of 30,000 glass tubes, each four inches in diameter. Protected by glass panes held together by a point-support system, the composition is shrewdly inlaid with a massive Louis Vuitton sign. The dense patterns on the exterior curtainwall are replicated inside with interlocking steel rings forming screens that both clad and demarcate space. The program was inspired by nightclubs that populate the immediate context. With the triangular central void standing in for a dance hall, the effect is completed by abstract images projected from the ceiling onto the floor. A wooden staircase leading to the second-floor shopping area ascends along the east wall, leading to a "Bag Bar" and "Luggage Lounge." On the same level, an enclosure is stashed with jewelry and other sumptuous accessories, at once recalling a bank vault and a private VIP hangout.

In a shopping-crazed metropolis, critical engagement with the retail type takes a multiplicity of guises, and in some instances, the insistent demands of novelty transform signature formal and material vocabularies. Aoki's airy glass-and-steel compositions become the counterpoint for what at first appears to be a blocky freestanding store in Ginza. Subverting the banal forms of the neighborhood's department-store vernacular, the concrete—actually glass-reinforced aggregate—facades of Louis Vuitton Namiki Dori (2004) is cast with white marble inserts. Flush with the wall and appearing opaque to passersby during the day, these translucent membranes permit the entry of natural light into the store, and modulate the discharge of artificial light from within at night. In a skillful manipulation of materials, these openings facilitate the building's near-miraculous transformation from heavy to light during the course of the stores' opening hours, transforming what appears to be a blank grey box in the day into a delightful, kaleidoscopic lantern at dusk.

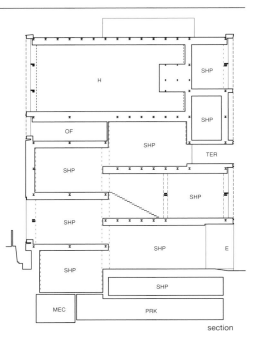

section

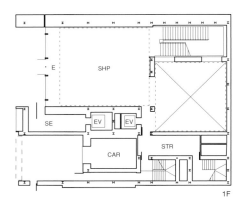

1F

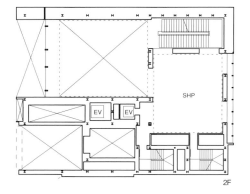

2F

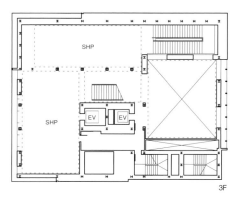

3F

p.106 *(left column)*, **p.107** *(right column)* Maison Louis Vuitton Omotesando (2002): Section and floor plans. **p.107** *(top right)* Maison Louis Vuitton Omotesando (2002): scale model describing the massing strategy of stacked trunks. **p.107** *(bottom right)* Maison Louis Vuitton Omotesando (2002): interior of the Louis Vuitton Hall at the seventh floor, clad in the woven fabric screen designed by Yoko Ando.

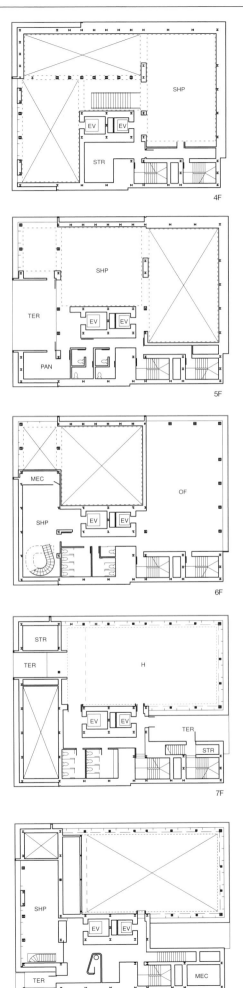

4F

5F

6F

7F

8F

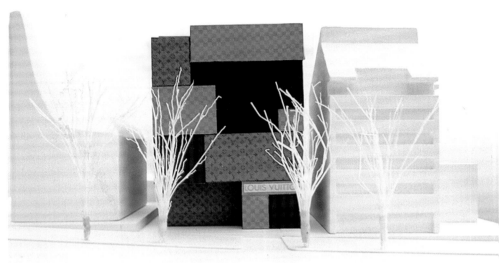

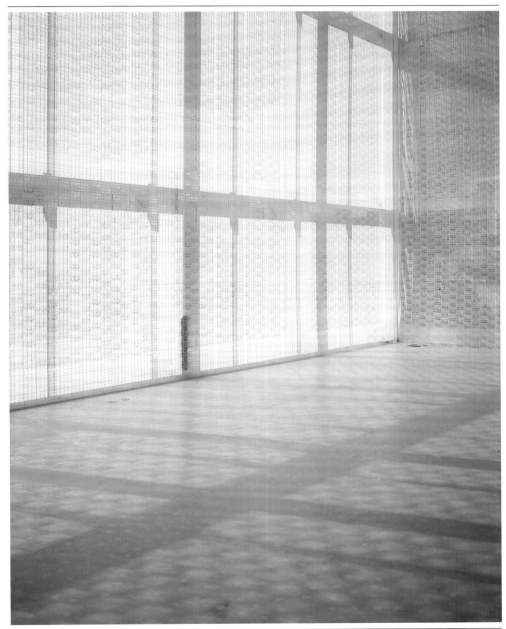

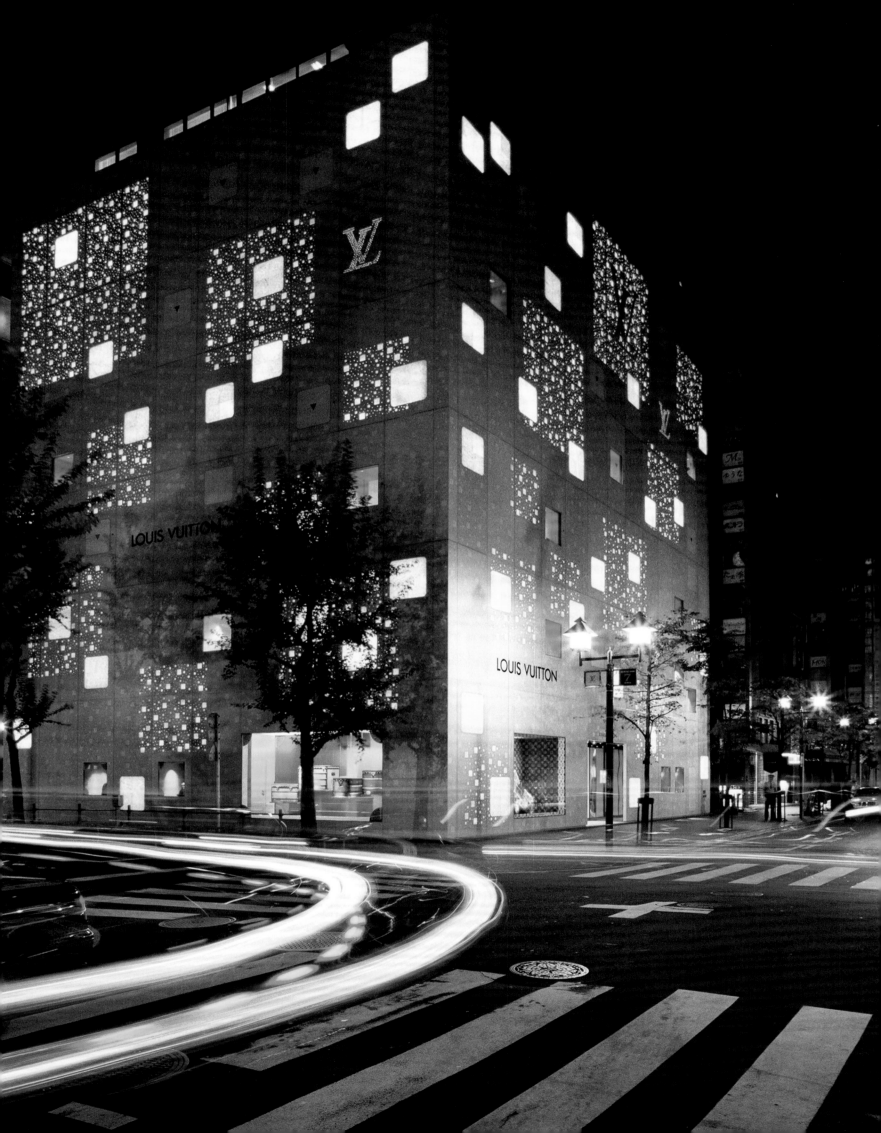

BASEMENT FLOOR 1/300

1ST FLOOR 1/300

p.108 Exterior view of Louis Vuitton Ginza—Namiki Dori, Tokyo (2004), by Jun Aoki & Associates. A terrazzo façade is embedded with translucent marble squares. **p.109** Louis Vuitton Ginza—Namiki Dori: section, plans and elevation.

2ND FLOOR 1/300

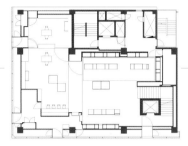

3RD FLOOR 1/300

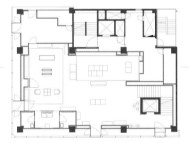

4TH FLOOR 1/300

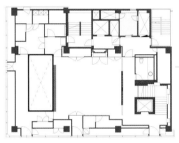

5TH FLOOR 1/300

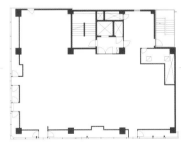

6TH FLOOR 1/300

7TH FLOOR 1/300

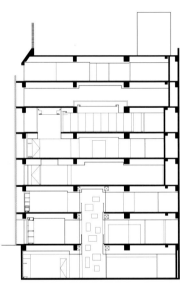

SECTION 1/500

ELEVATION (DAYIME) 1/500

ELEVATION (NIGHTTIME) 1/500

p.111 Maison Louis Vuitton New York (2004), Fifth Avenue and 57th Street: design of the exterior by Jun Aoki; interior design by Peter Marino. A part of the existing façade is replaced with a white glass wall that gradates from opaque to transparent. p.112-113 *(bottom)* Interior view of the "Wall of Trunks" in the Louis Vuitton Hong Kong Landmark Store, Hong Kong SAR (2005), by Jun Aoki and Peter Marino. p.113 *(top)* Louis Vuitton Hong Kong Landmark Store (2005), by Jun Aoki and Peter Marino. Creating a Damier pattern, 7,000 stainless-steel louvers—alternately polished, brushed, mirrored and whitewashed—compose the glazed interlay on the facades.

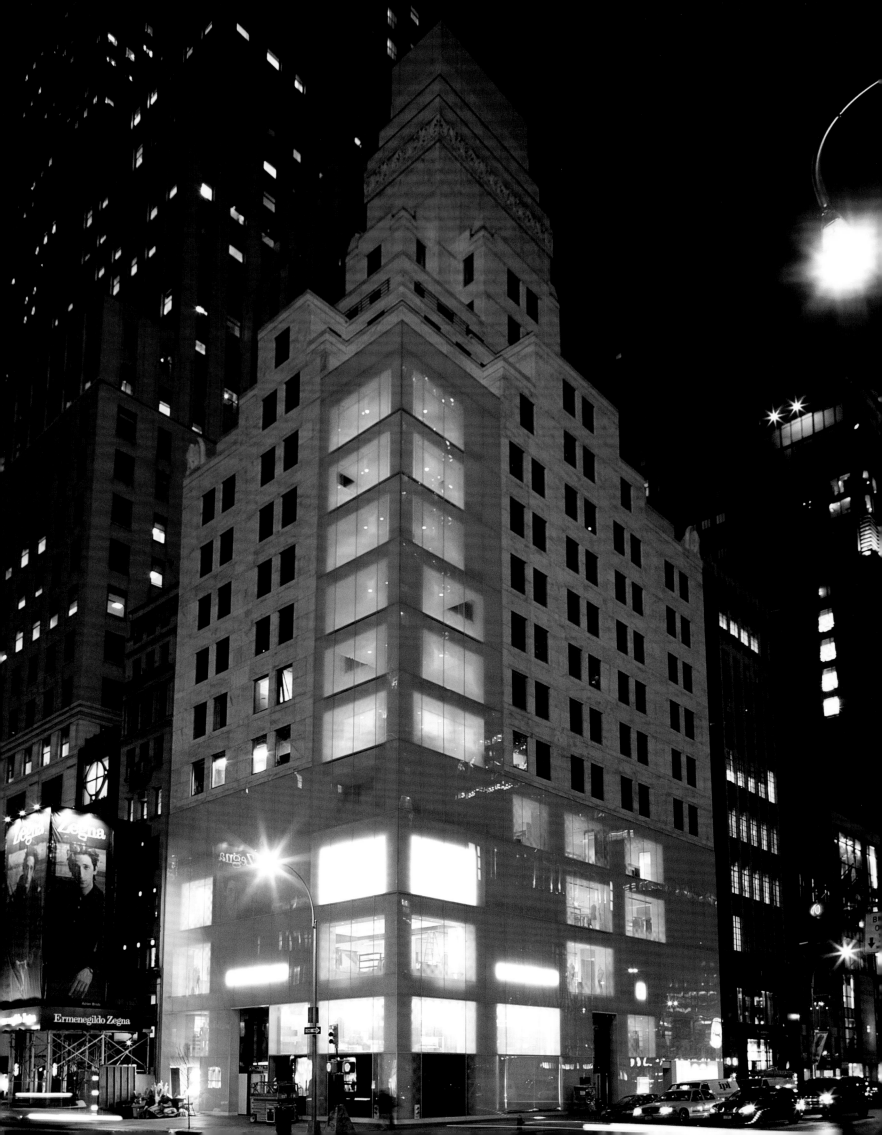

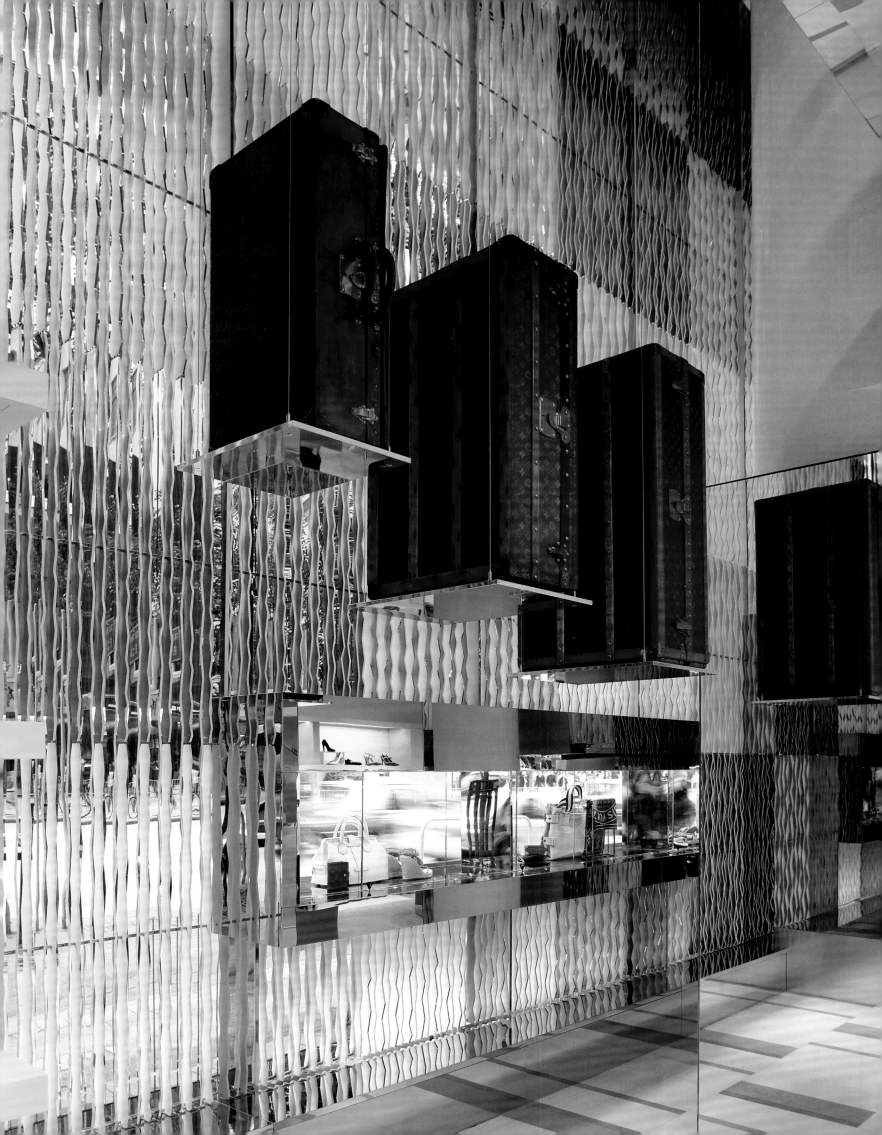

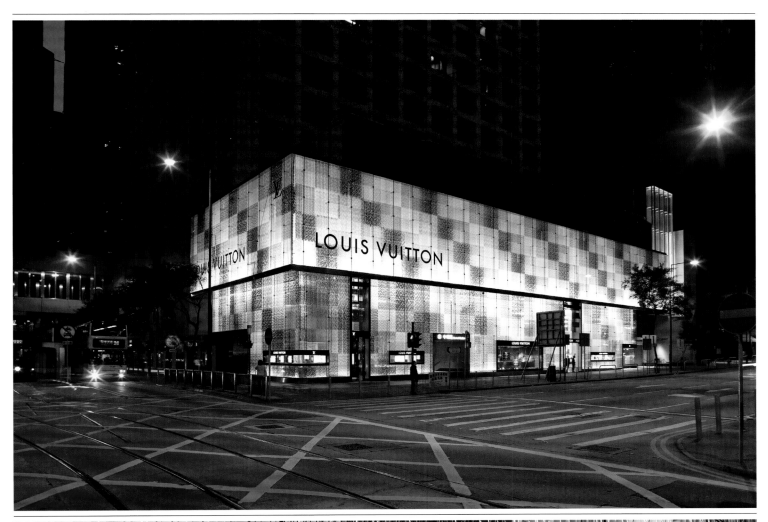

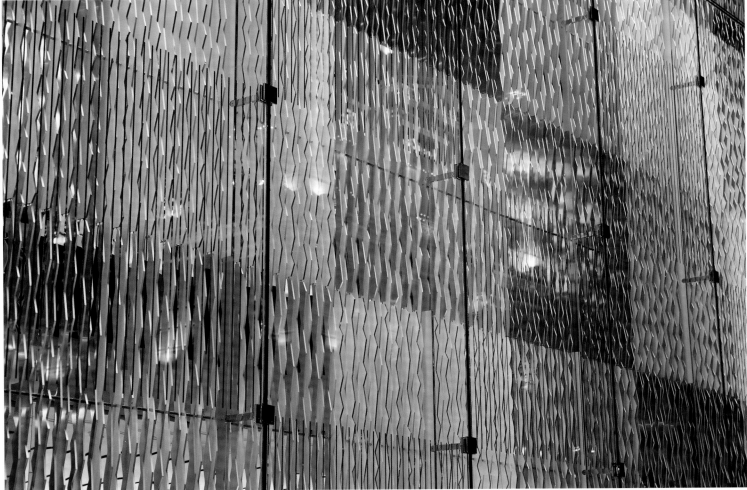

Arad, Ron

designer
text by Cédric Morisset

Born in Tel Aviv in 1951, the designer Ron Arad garnered considerable attention for his one-off creations and limited-edition objects beginning in the early 1980s.

His truly surprising objects are made from the unusual materials he salvages and reuses, typified by the *Rover* chair made from an original car seat. More passionate about form than function, the designer has never shied from harnessing the latest technologies, using high-precision machines and cutting-edge research applications to craft sculptural objects. Starting in London in the early 1970s, his formal experiments intentionally blurred the boundaries between architecture, industrial design and contemporary art. The resulting icons of contemporary industrial design developed by his studio (the *Bookworm* shelves for Kartell, the *Tom Vac* chair for Vitra) parallel a number of monumental pieces Arad created for the art market, that fetch prices at auction more in keeping with the business models established by Damien Hirst and Jeff Koons. Arad does not clearly want his work to be classified in one discipline, and he refuses to show his recent work at design-only fairs.

Ambiguous, paradoxical, infuriating, talented, adored and detested, this unclassifiable figure has become one of the major designers of the end of the twentieth century. For this reason, the Centre Georges Pompidou invited him in 1987 to participate in the exhibition *Nouvelles tendances: les avant-gardes de la fin du XXe siècle* and then presented a large retrospective of his work at the end of 2008. For the event, the designer brought with him a compacting machine, from the belly of which emerged compressed Louis Vuitton bags, an homage that echoed the formal freedom and experimentation of the late 1980s. The remains that came out of the machine were transported in metal crates and stored away at the museum as if it was a mortuary. Arnaud Sompairac expounded on Arad's position in the exhibition catalogue: "There is too much furniture, and there is a lot of beautiful furniture. Why make one more piece? Furniture is different from other objects like clothing. Perhaps it should be consumed like the latter. One could take, for example, furniture by Le Corbusier or Rietveld and make César-like compressions."

p.115 *Compression* by Ron Arad (1987); in treated fabric, leather, brass and steel; 28 x 44 x 20 cm (11 x 17 x 7.8 inches). Louis Vuitton Collection.

Arman

Called *The Silk Road*, this series brought together Arman, Sandro Chia, Arata Isozaki, Sol LeWitt and James Rosenquist.

The scarf by the French artist Arman, who was born in 1928 and died in 2005, masterfully adopts the theme of travel that has been associated with Louis Vuitton since it was founded. Against two monochromatic backgrounds—white or black—he wrote words scattered playfully in all directions: "travel," "train," "via," "airport," "gare," "aéroport" or "voyage," for example, all scrawled straight from paint tubes. Another square has paint tubes spilling their contents to create arcs of primary colors. The scarves fit into Arman's œuvre, especially the period in which color became so important, to the point that he employed streaks of solid paint. Approaching Louis Vuitton with humor and a certain impishness, he named the work *The Painter's Monogram*. He filled the square completely—there is no left, no right, up or down. It can be appreciated in every direction, bursting with brilliant colors. Yet, despite an apparent randomness, these two scarves present a rigorous sense of composition. Arman always insisted on the fact that, unlike the Dada artists, he placed importance on the plastic result of his pieces, as did César and Jean Tinguely, other figures of *Nouveau Réalisme*.

Looking back, it is amusing that Arman was even considered for the Louis Vuitton commission. Through a famous series of "accumulations" and "destructions" dating from 1956, the artist's systematic need to conserve and destroy "the object," effectively denounced the

In 1988, Louis Vuitton asked five artists to focus their attention on the fascinating and luxurious material, silk.

relationship our contemporary society has with consumer goods. Embracing the extremes of devotion and utter disgust, he established what certain critics at the time called a "discourse on the method of the object." Arman mined the contemporary world, as if to create an archeology for future generations to use. He simultaneously combined an impulsive creativity with the rigor and rationality of a quasi-sociological art. Declaiming that more objects had been produced in the 1960s than in the entire history of mankind before that period, he stated that he had foreseen the invasion and wanted to testify as a witness. He spent his entire life locked in an embrace with the object. Faced with this "accumulation syndrome"—let us remember that Arman was a great collector and that his father was a secondhand goods-dealer—his friend

Yves Klein once said to him: "You are the chief exponent of 'quantitavism.'" When he collected refuse to create his *Poubelles* (garbage cans), the artist quipped that he "loved to hunt and search." He must have desired the most minor objects, they must have spoken to him. He, after all, was responding to the technological, industrial, fame-obsessed urban reality of the latter half of the twentieth century.

In 1998, there was another collaboration between Louis Vuitton and Arman named *Luxury, Fury and Pleasure*. It involved soccer balls stamped with the Monogram neatly arranged within the cubicles of a shelf. Again, the reduction of an object, its exploitation for symbolic shock and the provocative fusion of two worlds proved very effective.

p.116 *La Route de la soie* (The Silk Road) silk square (1988) by Arman (Armand Pierre Fernandez), 90 x 90 cm (35.4 x 35.4 inches). Louis Vuitton Collection. **p.117** *Le Monogramme du peintre* (The Painter's Monogram) silk twill square (1988) by Arman (Armand Pierre Fernandez), 86.5 x 87 cm (34 x 34.25 inches). Louis Vuitton Collection.

Aulenti, Gae

text by Cédric Morisset

Born in 1927, Gae Aulenti is a tutelary figure of Italian design.

She is known as much as an architect as she is a designer or scenographer. The creative mind behind the iconic *Pipistrello Lamp*, one of the best known lamps in the world, or the ingenious table with wheels she created for Fontana Arte, she distinguished herself during the 1980s overseeing the renovation and transformation of the Musée de la Gare d'Orsay in Paris (1980-86), followed by the restoration of the Centre Georges Pompidou (1982-85). The collaboration between Louis Vuitton and Gae Aulenti is one of the company's most prolific partnerships in the world of design. It began in 1978 with Aulenti's first model of a suitcase elaborated with innovative "soft-touch" paint. Although the suitcase was not developed, some ten years later Gae Aulenti conceived two models of fine watches. They were a new chapter in a long story that began in 1919 when Louis Vuitton introduced the first small travel clocks to accompany travelers on their journeys; these timepieces were manufactured with the finest, most exceptional instruments intended to defy fashion and time. Boasting an 18-karat gold watch case, the center of the LV I watch is decorated with a starry sky that indicates the time, the date in different time zones, as well as the current phase of the moon, all crafted in the tradition of fine watchmaking. The travel-themed face was also adapted to a silk twill square scarf with hand-rolled edges, which was part of a large collaborative project with well-known figures from the worlds of design and art.

The revolutionary LV II watch, the fruit of Louis Vuitton research, is one of the world's first ceramic watches. Its case is in zirconium oxide, a ceramic that had recently been discovered and was used for its exceptional durability. It is scratch-resistant, completely waterproof, and anti-magnetic. Gae Aulenti designed a sapphire crystal on the case capable of resisting abrasion with a Mohs hardness of 9 (compared to 10 for a diamond). Between 1988 and 1991, the designer continued to create travel accessories derived from horological projects. The first was a gold-plated fountain pen with a depiction of the quatrefoil monogram. This was accompanied by a pump-action perfume spray that was totally innovative in the perfume industry; not only did it have a swiveling telescopic opening, it was also made of ceramic and its design called to mind that of the fountain pen. Although this product, unfamiliar to the general public, was never manufactured, it remains one of the symbolic pieces of Louis Vuitton *savoir-faire*, combining luxury, technology, aesthetics, and innovation.

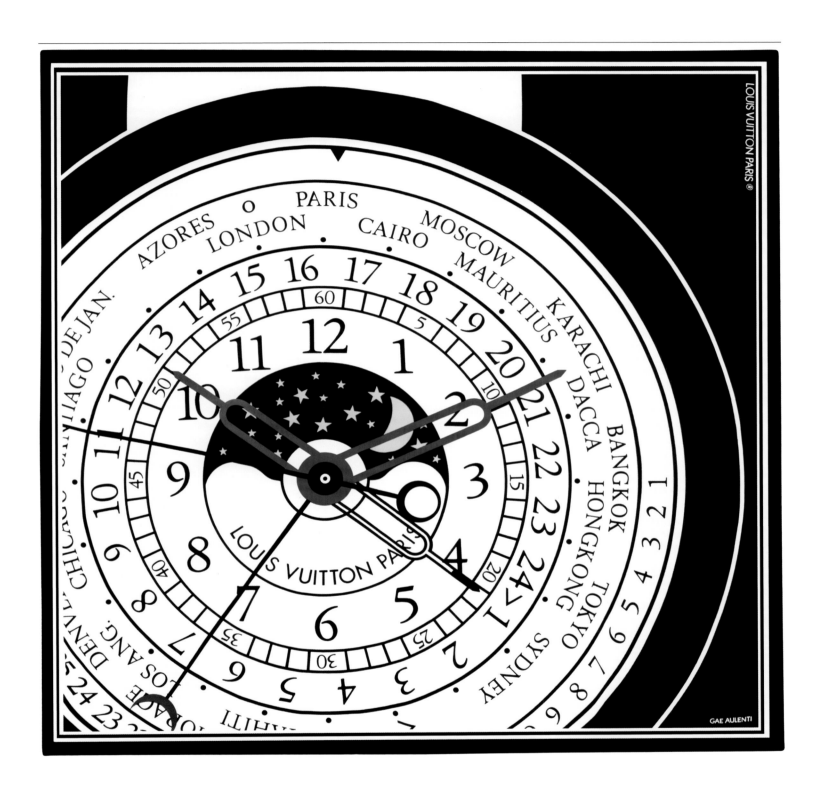

LOUIS VUITTON PARIS ®

GAE AULENTI

p.118 *LV II* ceramic wristwatches (1988) by Gae Aulenti. Zirconium oxide & leather, limited to a numbered series of 2000. Louis Vuitton Collection. p.119 *Le Temps du voyage* silk square (1988) by Gae Aulenti, 90 x 90 cm (35.4 x 35.4 inches). Louis Vuitton Collection.

B

Ban, Shigeru
Barthélémy, Philippe
& Griño, Sylvia
Beecroft, Vanessa
Blahnik, Manolo

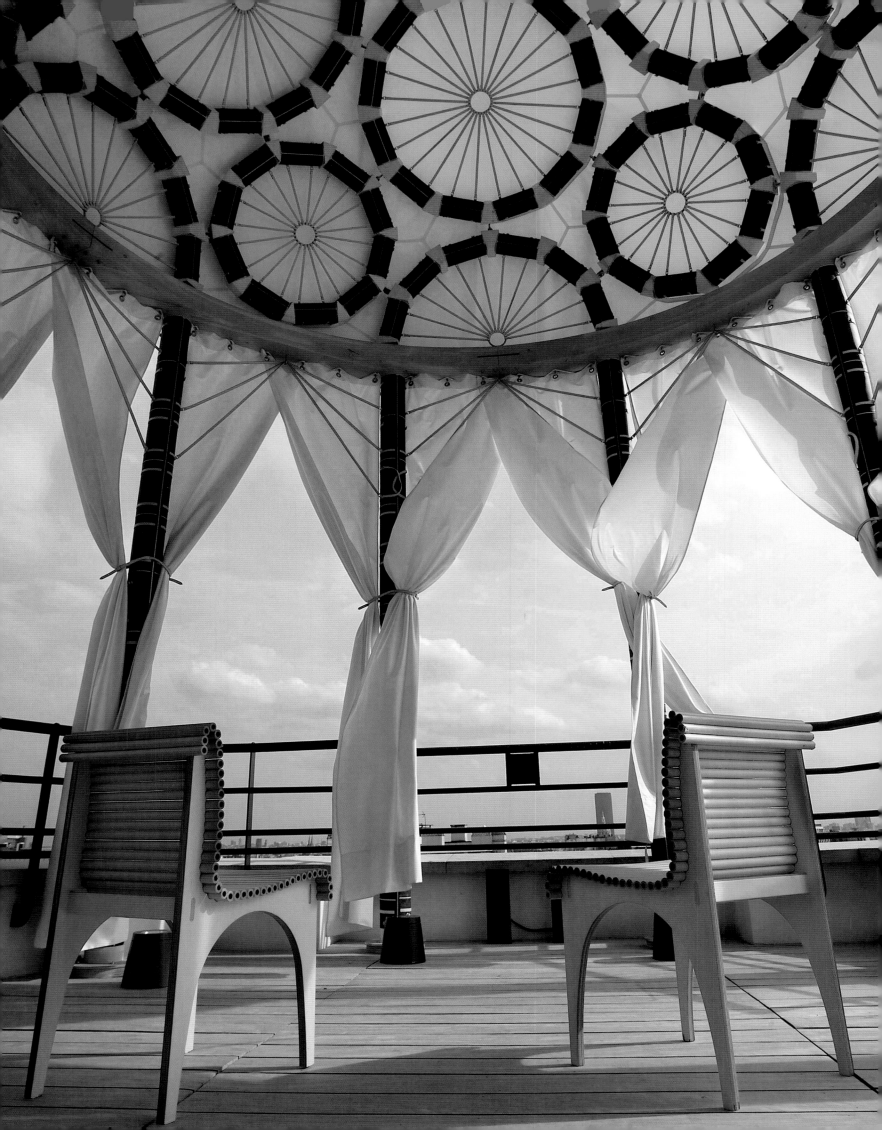

Ban, Shigeru

architect
text by Ian Luna

Shigeru Ban's innovative use of paper as a principal structural element in architecture forever transformed international building codes.

His studio—an early, practical advocate for using renewable resources—uniquely harnessed the materiality of paper. With a portfolio spanning nearly three decades, Ban demonstrated that cardboard tubes could transcend their workaday use as molds for concrete columns, to form the interior and exterior cladding of a building, or even constitute a building's entire frame.

In structures both permanent and temporary, these paper projects showcase the variety of possible applications for paper and its derivative forms, celebrating its delicacy, and at once, proving its tensile and durable properties. Ban's singular use of paper knowingly references the traditional uses of the material in vernacular Japanese buildings, as it advances modern construction technology and reduces its environmental impact. Flexible as it is adaptable when used in tandem with other locally sourced building materials (mud-brick and timber) or post-industrial surplus (maritime shipping containers), paper tubes were even used to fabricate Ban's Paris office perched high above the Centre Pompidou.

Beginning with the interior design for an exhibition on the furniture designs of Alvar Aalto at Tokyo's Axis Gallery in 1986, prominent "paper architecture" from the last decade include the Nomadic Museums built in New York, Los Angeles and Tokyo, the new Centre Pompidou in Metz, and the Papertainer Museum in Seoul. Paper is also the crucial element in the humanitarian projects his studio has undertaken for the United Nations High Commission on Refugees and other NGOs. Inexpensive and rapidly deployable, these include temporary and permanent housing for tsunami victims in Sri Lanka, earthquake survivors in Turkey, India and Japan, and emergency shelters for war-ravaged communities in Rwanda and the Democratic Republic of Congo.

In the Summer of 2006, Louis Vuitton approached creatives from a variety of artistic disciplines—including Zaha Hadid, James Turrell, Robert Wilson, and Ugo Rondinone—to create environments inspired by the *malletier*'s iconic bag designs. Serving a function far removed from his relief work, Ban's *Papillion Pavilion* owes at least a formal and tectonic debt to these earlier and much humbler structures.

Ban requisitioned what must have been a season's stock of Papillon bags to create a folly on the Paris flagship store's seventh-floor terrace. Eight dense cardboard pylons—arranged in a circular plan and opulently sheathed in stacks of handbags—support a PVC dome. Similarly protected by monogrammed canvas, paper tube circles linked by a wooden joint system comprise the roof, utilizing the bag's handles as tension elements. This composition mimics a coffered effect, and with long white curtains providing shade, this twenty-first century Pantheon supplied visitors of the Espace Louis Vuitton with imperial views of the city below.

p.120-121 Interlocking elements in precast stone suggest the initials of Louis Vuitton, from the screen surrounding the store in Tumon Bay, Guam, the US territory of the Northern Marianas. Design by Barthélémy & Griño (2006). p.122 *Interpreting the Papillon bag*, installation (2006) by Shigeru Ban for the *Icons* exhibition at the Espace Louis Vuitton, Fall 2006, built on the roof terrace of Maison Louis Vuitton, Champs-Elysées. Louis Vuitton Collection. The side chairs, in wood and paper tube, are from the Carta Series by Cappellini (1998), also designed by the architect. p.124-125 View of the pavilion's roof, supported by rings consisting of paper tubes sheathed in Papillon bags. The handles are stretched to form tension elements.

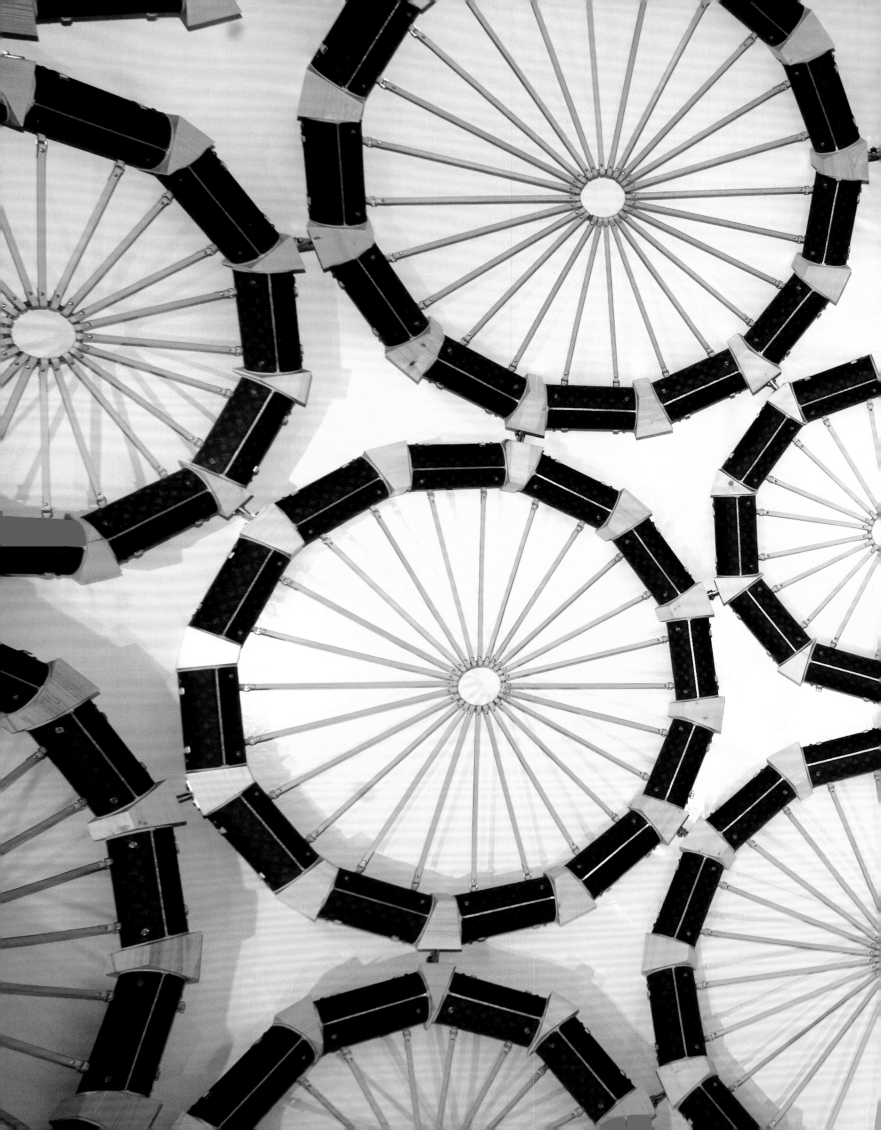

Barthélémy, Philippe & Griño, Sylvia

architects
text by Philippe Trétiack

Philippe Barthélémy, a native of France's Vosges department, taught in London; his companion and partner, Sylvia Griño, was born in Montevideo, Uruguay.

Their territory is international, and together, they have deployed a creative activity oriented to all corners of the earth. Houses, schools, art galleries, stadiums and distinctive homes are among their achievements, as are luxury boutiques.

So is it the result of having spent his childhood in the textile producing valley of eastern France that Barthélémy developed his tactile sense of fabrics? Perhaps. But he certainly didn't need anything more in order to be in tune with the house of Louis Vuitton, which, from architectural projects to the opening of boutiques in Asia, has been pushing the art of metallic weaving to its highest level. With Griño he first worked on the Louis Vuitton boutique in Rio de Janeiro, Brazil. "We wanted to avoid reproducing an architecture of a box covered in silk-screened facades," says Barthélémy. "And, in this climate, we didn't want any architecture that would result in heavy air-conditioning." So they proposed making wide use of open-worked stone, to transform the space into a checkerboard of shadow and light-play. But the project remained in the dark, existing only in portfolios and bits of computer memory.

It was elsewhere, in Kobe, Japan, that they managed to put their approach to commercial architecture into practice. This time the Louis Vuitton boutique was supposed to be slipped under a parking lot. The architects designed the whole of the little building, giving it the look of a unitary metallic box. A system of aluminum slats allowed them to install fins on one facade. Its kinetic appearance was inspired by the works of Agam, an Israeli artist who was quite well known in the seventies. These slats, with their variable angles, allow for the formation of pop-art images—or deployable billboards.

The construction of a second boutique took them to the island of Guam, which has a particularly severe climate and routinely falls prey to formidable typhoons. So it was necessary to design an envelope capable of resisting the tremendous pressure of the winds. Always faithful to the double-skin that is characteristic of the facades of the Louis Vuitton boutiques, and wanting to explore plays of shadow and light, the architects devised a facade in an experimental material—a marble aggregate pieced together with resin. Worked and open-worked, the facade is enlivened by a repetition of the

Monogram etched into the double layering—and the high relief is magnificent.

Experienced at jumping from scale plans, and able to operate both comprehensively and in minute detail, Barthélémy and Griño then participated in the development of the Louis Vuitton Globalstore in Seoul, before overseeing the flagship store's construction on the Champs-Elysées. With Eric Carlson and Peter Marino as the design architects, this management task was quite a challenge, because on top of the usual technical preoccupations, it required them to mediate among a number of strong-willed personalities. This proved a key undertaking, and after having built a stadium and a gymnasium, they were recently commissioned to do a makeover of the vast buildings of INSEP, the center for sports studies in eastern Paris.

Architecture is a decidedly complex discipline—both intellectually and materially. Barthélémy and Griño, who earlier designed the architecture of fashion photographer Paolo Roversi's studio, have just proposed a series of skyscrapers for Paris. Those who know how to refine details can also afford to think very big.

p.127 Exterior view of the Louis Vuitton Hangzhou Tower Store, Hangzhou, Zhejiang, China. Design by Barthélémy & Griño (2005).

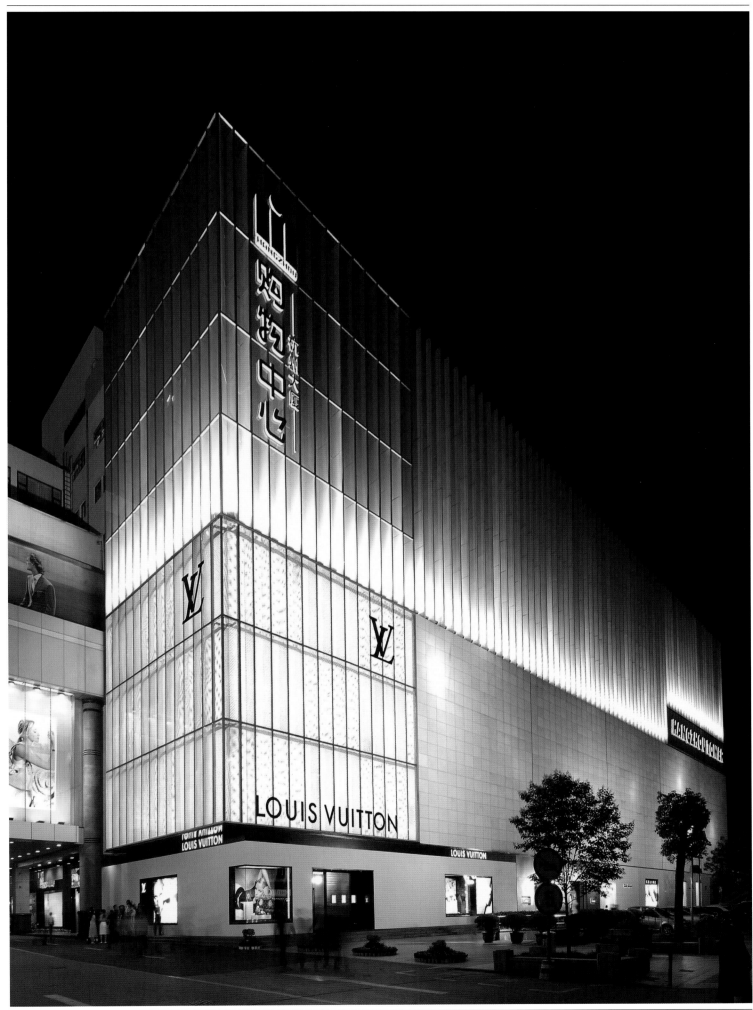

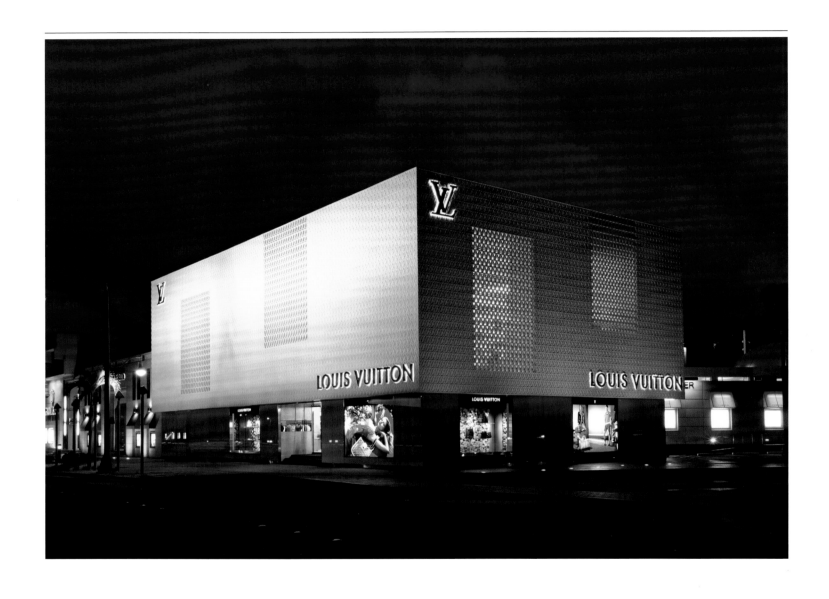

p.128-129 Exterior and interior views of Louis Vuitton Guam (2006), designed by Barthélémy & Griño (2006). The boutique is located in the resort area of Tumon Bay, just west of the main city of Hagåtña, in the US Territory of the Northern Marianas. Here the trademark initials—abstracted as repeating patterns on the exterior wall—assume a new form, that at once signifies and shelters, a continuation of the brand and its architectural collaborators' ongoing research into the interaction of light and shadow.

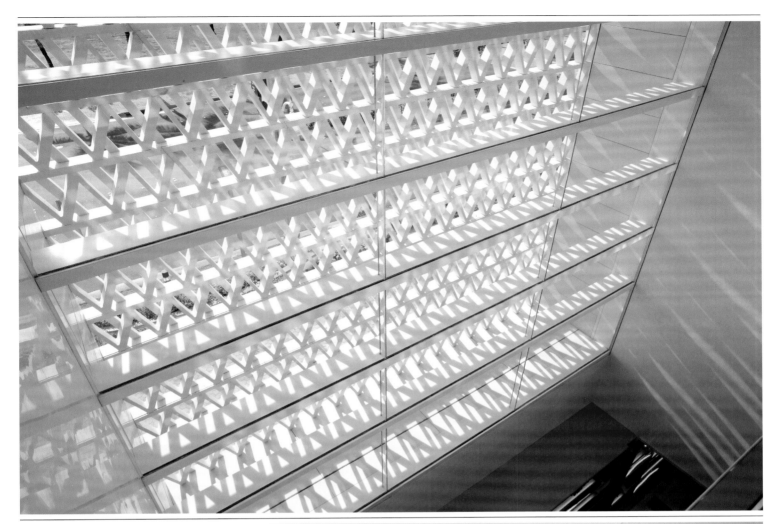

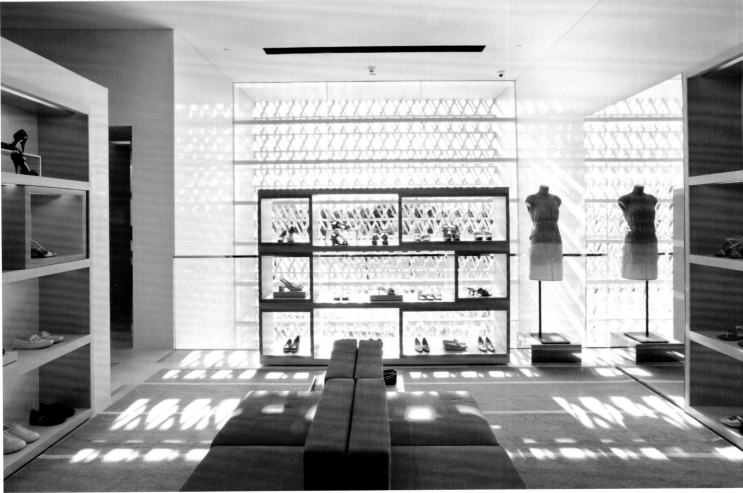

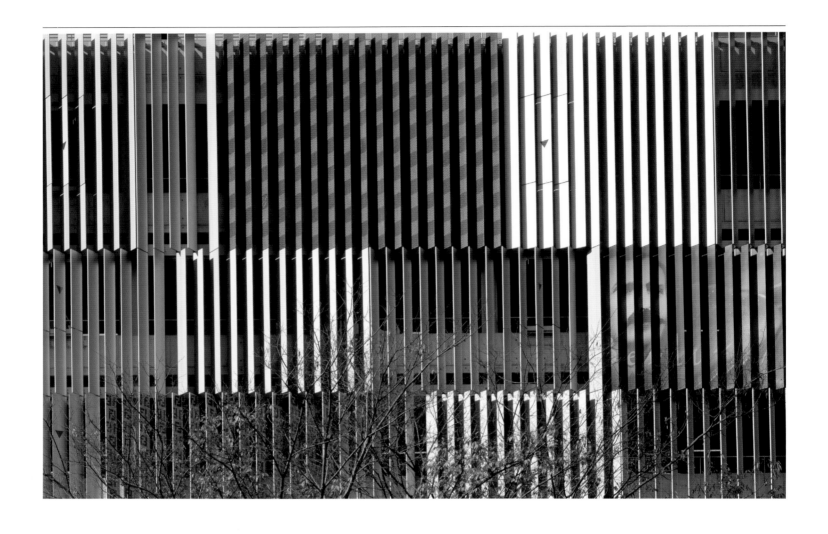

p.130-131 Views of Louis Vuitton Kobe Kyoryuchi (2002) by Barthélémy & Griño. The Damier patterns applied on the façade screen a multilevel parking structure.

130 **Louis Vuitton**

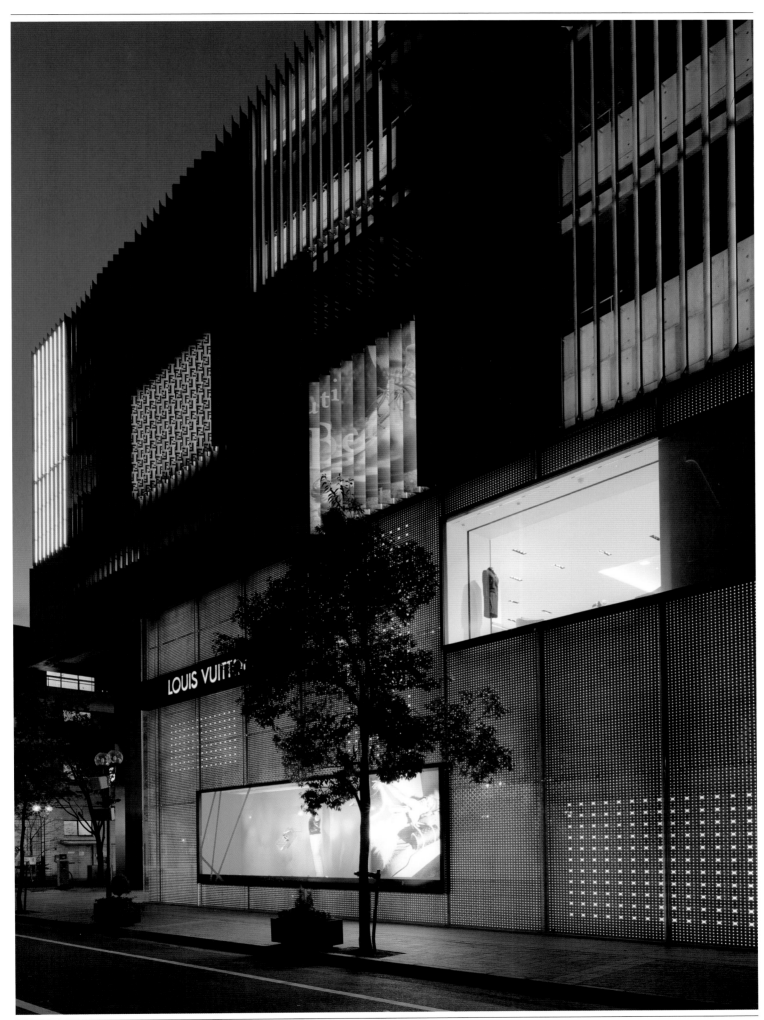

Beecroft, Vanessa

artist
text by Emmanuel Hermange

Born in Genoa in 1969, Vanessa Beecroft carved herself a place atop the international art scene for an ongoing series of elaborate provocations, the most infamous of which involved the public display—for several hours at a time—of nude female models.

Dating back to her first installation in Milan (*VB01*, 1993), the artist cast models for each performance by paying particular attention to their physical attributes, their makeup and the accessories that would complete the desired effect. The scenography is sometimes minimal, with the appointed space—most often an art institution—left largely untouched by the presence of so many bodies. At other times, there is clearly more narrative. At the 2007 Venice Biennial, for instance, she made a pointed reference to the civil war in Darfur by arraying a group of black women on the floor and bathing them in red paint (*VB61*). Invited to create two performances for the reopening of the Louis Vuitton flagship on the Champs-Elysées in October 2005, Beecroft chose thirty models, some black, some white, and arranged them on the shelves of the atrium, their contorted forms strewn among the traditional trunks at the core of the luxury brand's storied history (*VB56*). For an event organized by the *malletier* at the Petit Palais at around the same time, another group of women appeared in a more typical configuration—standing sentinel in the middle of a great room. An image was projected behind them in which the brand's initials were formed by women's bodies – white for the L and black for the V (*VB57*). The complete name written in the same way appeared in a series of photographs mounted in the exhibition space on the eighth floor of the building. Inspired by an old magazine the artist found at a flea market in New York, this *Alphabet Concept* is reminiscent of the "human alphabet" that the fashion illustrator Erté developed in the late 1920s. On regarding it, Roland Barthes remarked that "it is [...] an illusion to think that fashion is obsessed with the body. Fashion is obsessed with that other thing that Erté discovered, with the extreme lucidity of the artist, and that is the Letter, the inscription of the body in a systematic space of signs."

Although they are engineered, Beecroft's performances do not move along a specific choreography. The models receive only a few directives: be natural and plain, don't talk, don't act, don't smile, don't sit, move all at the same time. "They get tired, they start to look at us, they don't know what to do anymore, how to endure the effort. That is beautiful. I don't instruct them on these aspects." Because their bodies often conform to a lanky fashion ideal, the artist often enlists designer creations as accessories. Beecroft's work has often been seen through the lens of fashion and the increasing affinity the discipline shares with fine art. Yet, in her interviews, she has repeatedly stated that she has little interest in this discourse, and that she selects a certain pair of shoes or a certain make of undergarments solely for their photogenic qualities. Since her performances are all one-time events exposed to a select audience, it is precisely her documentation of them that typically ensures her work is widely known. The fact that she removes viewers from most of the photographs she exhibits indicates that the artist is more interested in the promotion of the image than creating a document.

While Pasolini, Visconti and Fassbinder are the sources of inspiration Beecroft most often cites, her work has a significant autobiographical component. In her early years, she was deeply impressed by a certain category of girls who "wouldn't eat in public, they were too tall or too thin, or they wore colors that were too bright. Some looked as if they were suffering," adding that "they were at once sensual and frigid." Feeling that she could not achieve enough realism when she attempted to represent them, she decided to bring them "into the work as a raw material." Her performances allude to models at academic painter's studios, beauty contests, the fake communities of "savages" that were mounted as ethnographic exhibits during colonial-era world's fairs, promenading whores, and group portraits in 17th-century Dutch art. Far from being incidental, this profound ambiguity—revealed during her interviews and arguably exemplified by her portrait of a Madonna breast feeding two malnourished black babies in 2006 at around the same time she was in the process of adopting two Sudanese children—is at the heart of Beecroft art.

p.133 To celebrate the opening of Maison Louis Vuitton, Champs-Elysées, Vanessa Beecroft's, *VB 57* was held at the Petit Palais, on the evening of 9 October 2005. **p.134** *(top)* Photo installation of Vanessa Beecroft's, *VB 56* at Espace Louis Vuitton, the 7th floor gallery of the Champs-Elysées flagship store, January 2006. Louis Vuitton Collection. **p.134** *(bottom)*, **p.135** Performance of Vanessa Beecroft's, *VB 56*, held at the the atrium of Maison Louis Vuitton, Champs-Elysées, 9 October 2005.

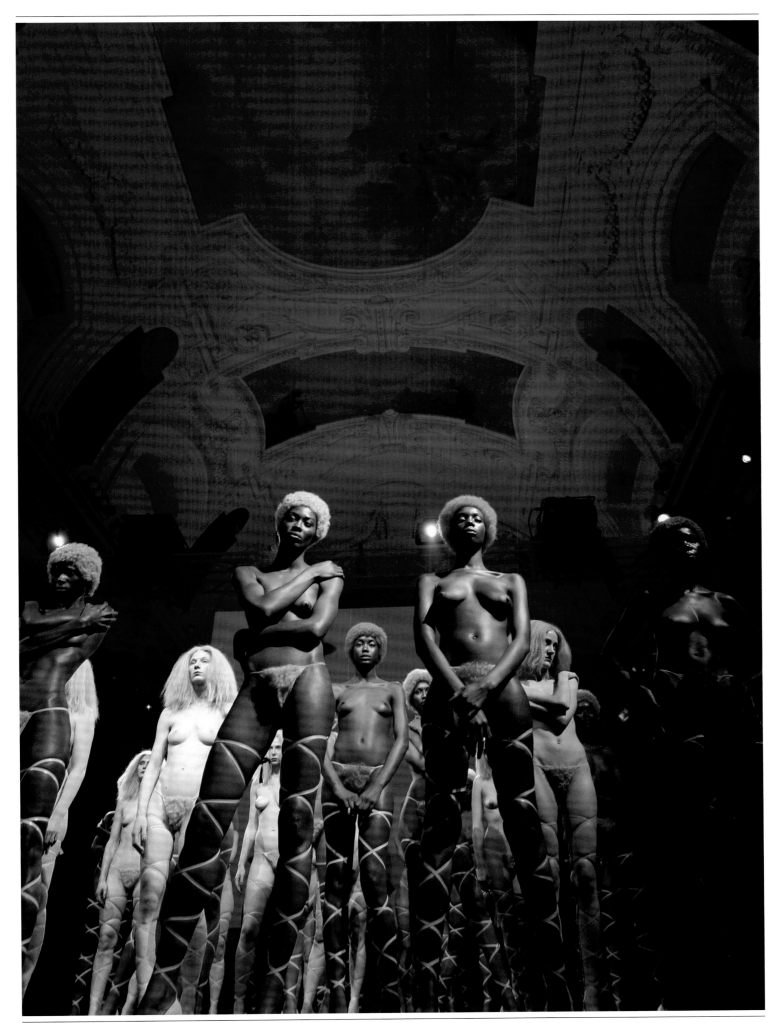

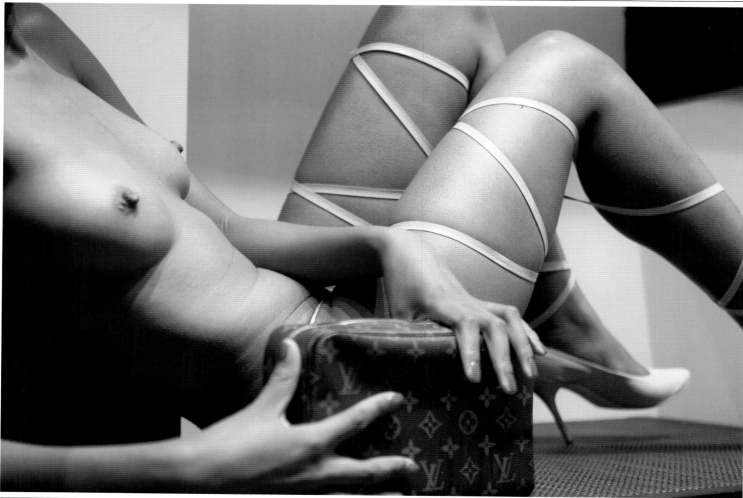

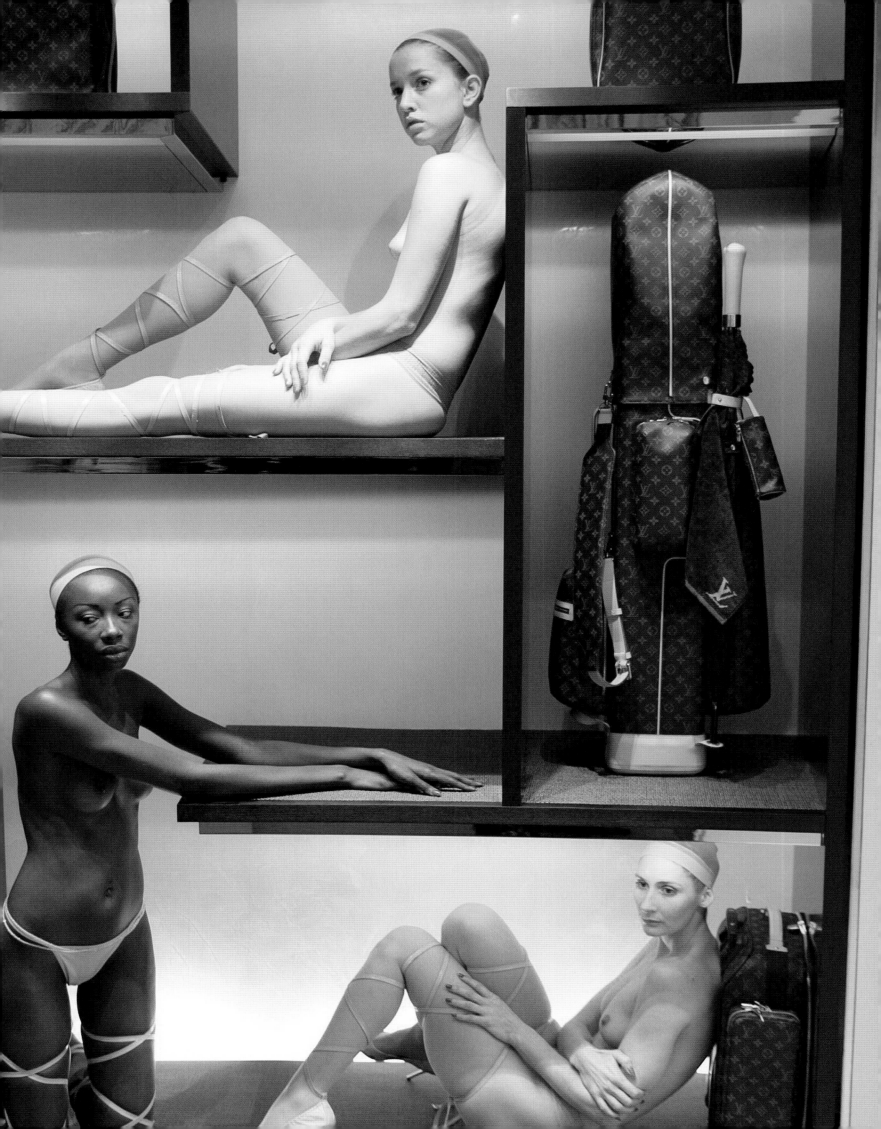

Blahnik, Manolo

designer
text by Olivier Saillard

A Spanish shoemaker, the house of Manolo Blahnik was founded in 1971. But neither the origins of the names Manolo or Blahnik, nor the countless books and dictionaries on the history of fashion, must allow for any confusion: Blahnik is a shoemaker in the classic, English sense of the word—even if the shoes are made in Italy. And it is for the greatest happiness of womankind that he practices his expert craft.

His inimitable style rests on perfection, applied in equal measure to an exquisitely classic shoe or on a whimsical sandal. Shoe lovers from all over the world have prized his handiwork for their harmonious design, their graceful heels and their impeccable curves. Despite the multiplicity of forms, materials and colors, Blahnik's creations are distinguished by a perfect balance of proportions, and a certain sensuality.

On the occasion of the Monogram canvas's 1996 centenary, Blahnik applied his seductive formula to the design of a simple, curved briefcase. Upon opening, the case revealed compartments lined in pink leather, with just enough space for a toiletry bag, a little evening dress—and of course, a killer pair of shoes.

p.137 On the centennial of Louis Vuitton Monogram in 1996, Manolo Blahnik created the Overnight bag in Monogram canvas, wood, leather, brass and synthetic materials. Photograph by Guzman. Louis Vuitton Collection.

C

Carlson, Eric

architect
text by Philippe Trétiack

Eric Carlson's practice dominates Paris's Place des Victoires. Louis XIV, who was the sponsor of Versailles—an exceptional client if there ever was one—sits enthroned there on horseback. From his office, Carlson can take the king as an example or scrutinize him carefully—a great luxury. Nothing could be more natural, particularly considering that Carlson's firm Carbondale, specifically chose to set upon this luxurious district—a domain in which nearly unlimited budgets permit the agency to constantly surpass itself. While his colleagues strain themselves to build something economical and durable, to recycle, to cut costs, to trim here and there, to find beauty in that which consumes the least, Carlson can claim exemption, make the kind gesture, drink in the nectar. "When someone calls on us," he says, "it's always to create the exceptional, the custom-built." Eric Carlson is to retail architecture what top designers are to fashion: among its elite.

Graduating from an American university he then underwent architectural basic training at the studio of Rem Koolhaas, the Dutch master; then Oscar Tusquets, the very post-modern Catalan. He drew from this double lineage a relaxed attitude that allows him to take on weighty commissions without too much anxiety. Carlson refined his skills at the very heart of Louis Vuitton's in-house architecture office. Alongside David McNulty and his team, he secured projects and store openings, primarily in Asia. He then turned Japanese. One of his early achievements, a collaboration with Jun Aoki, went up in Roppongi, the once-again chic section of Tokyo. This commercial space's entire architecture was rethought for Louis Vuitton; and not just its interior design

but, even more, its layout—the overlapping of its box-shaped volumes. Logos—the symbols of the brand—became the key connective element of the space's detailing. This symvocabulary served as a basis of reflection during the development of the flagship store on the Champs-Elysées. The sleek metallic sliver displayed in the Roppongi store became, in Paris, a super-sized hunk of gold.

If, for Louis Vuitton, architecture always told a story—that of a family, a house, a passion, a certain know-how—for the little TAG Heuer 360° museum, in La Chaux-de-Fonds, Switzerland, had to express for Carlson the avant-garde, the zeitgeist; it was the least that architecture could do for a watchmaker. "We wanted to break out from the window displays in which watches are typically presented," Carlson says, "So the entire space became a window display. The main room—12 meters (39 feet) in diameter—is an extrapolation of a watch face you can walk over. The floor is in reflective ceramic, like a sea of black oil. Openings leave us to imagine the pulsating movements under our feet. Everything contributes to our loss of bearings. With its liquid appearance, the floor reflects the ceiling, and animated images sweep across our field of vision."

Eric Carlson went back to Japan in 2008 to develop two sumptuous apartments there. "It was a tough gamble for us because we didn't have a definite client. We just had to imagine two super-deluxe penthouses, like urban country houses, unique second homes." Faithful to his method, he expanded the spaces. A visual continuity between the interior and the exterior is assured by a vegetal

ceiling that coats the canopy of the rooms and the terrace. "The Japanese are big collectors. So we created niches by digging material out of the inner walls; we sculpted them." At the meeting point of the American and Japanese cultures, the Carbondale method consists of marrying traditional spaces from the two. "In the West, we design a quadrilateral, and we place furniture in it: tables, chairs….In Japan, the floor is covered with tatami mats and the walls have recesses for decorative objects. We mix these two approaches." In the end, the apartment captivated a rich owner of forests in New Zealand. He commissioned Carlson to create furnishings entirely out of wood. It proved too tender, though, so the architect hatched the idea to harden it through compression. The result is magnificent. "Some imagine having to be an ascetic to manage to sit in these chairs or sleep on these sofas, but they are actually very comfortable. This compression technique is still too costly to be in wide use, but it looks promising. After ten years, a tree's wood is still tender; it takes thirty years to achieve the desired solidity. But compression allows you to use exclusively young trees."

Carlson has just signed on to develop Escada's headquarters in Munich. In this instance, an architectural material creates boundaries woven from three types of metal: polished, brushed, and heavily brushed. Zig-zag outlines recall the aftermath of a tailor's large scissors. Here again, the space reverberates, disrupts your vision, and comes to life. "For us," Carlson says, "the difference between design and architecture doesn't exist." In his world, furniture is born from walls, and walls are made of glass.

p.138-139 Maison Louis Vuitton, Champs-Elysées (2005), designed by Eric Carlson and Peter Marino. At a height of 20 meters, 1,900 stainless steel rods are suspended over the store's atrium. p.141 Exterior view of Maison Louis Vuitton, Champs-Elysées (2005) by Eric Carlson & Peter Marino.

140 **Louis Vuitton**

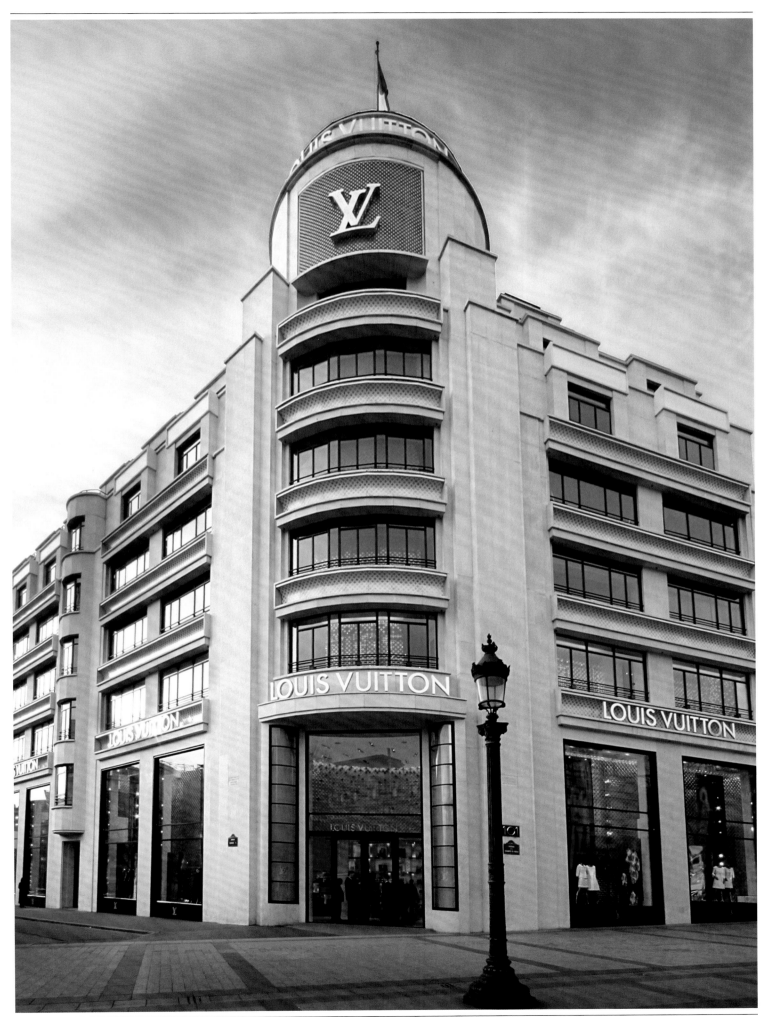

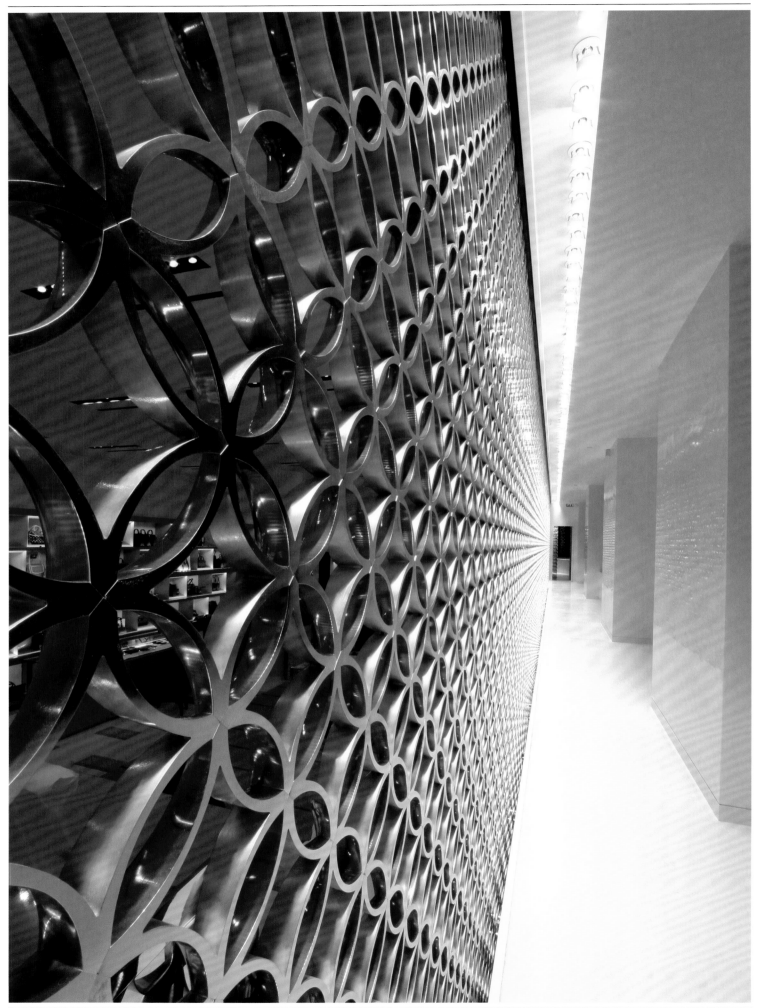

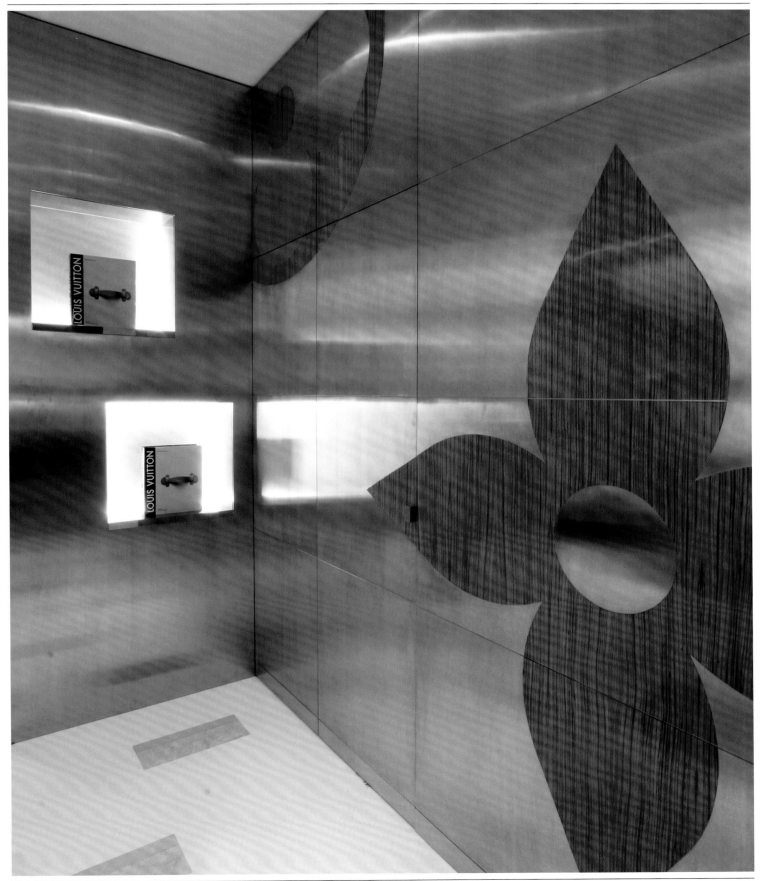

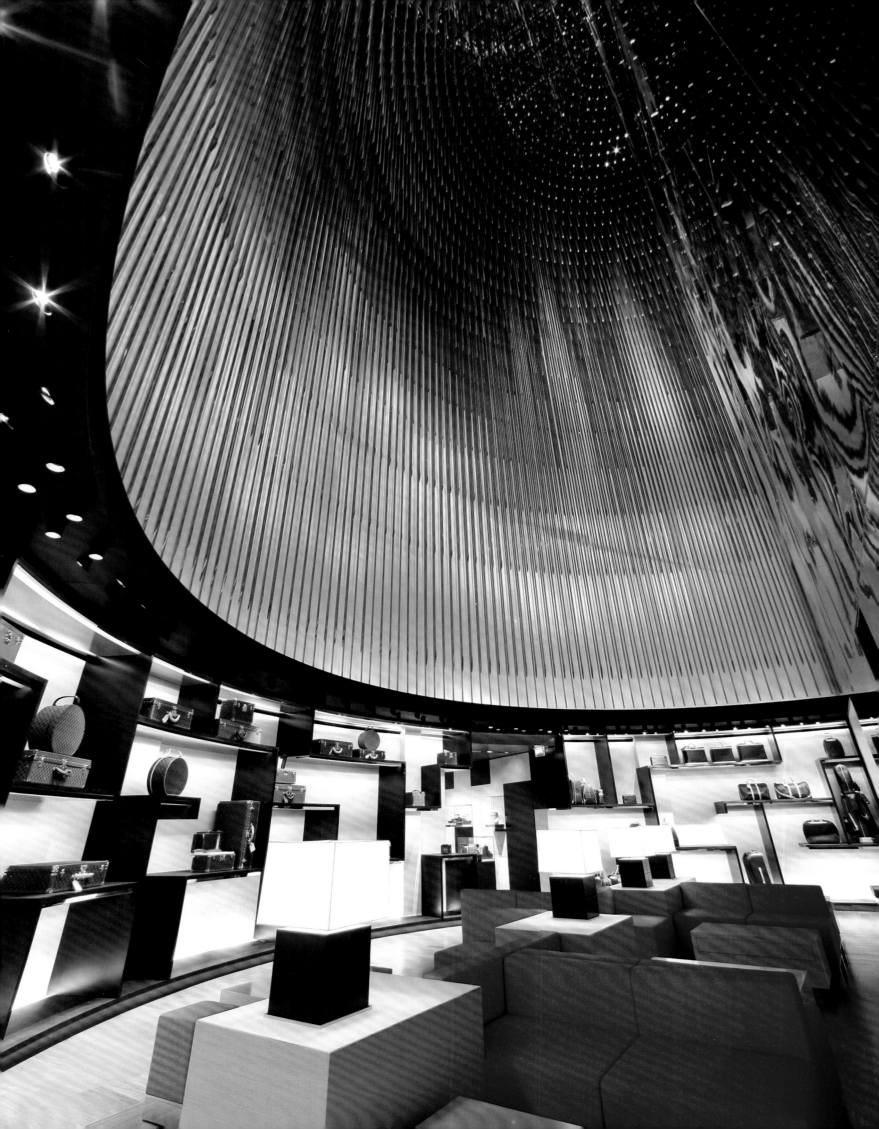

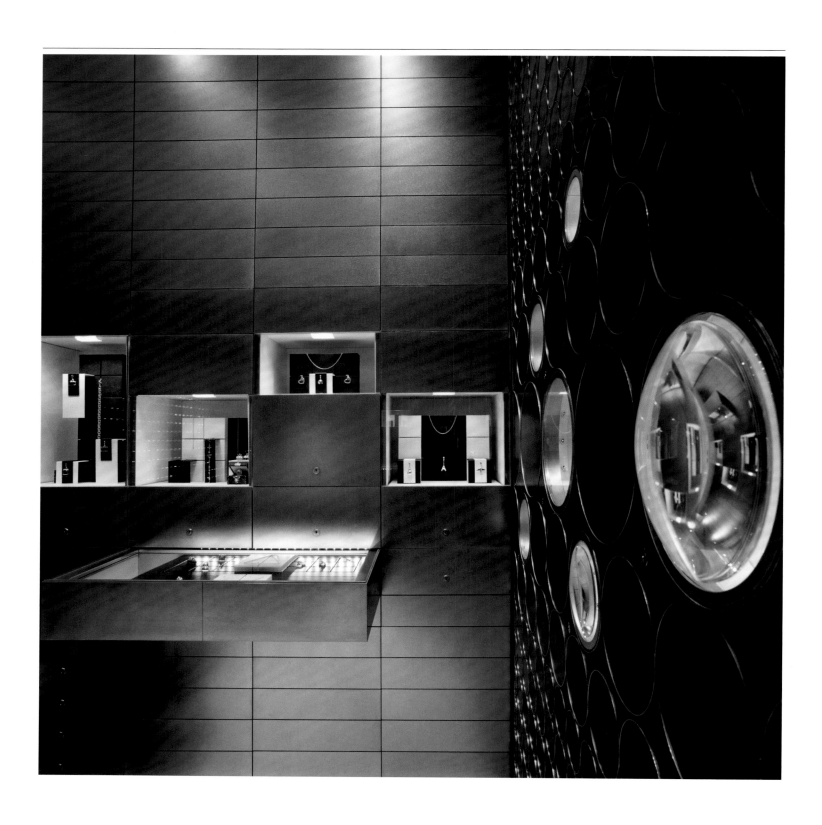

p.142-143 Maison Louis Vuitton, Champs-Elysées (2005): views of the interstital Monogram screens, and the inlaid wood-and-stainless-steel wall in the bookstore, and the main retail floor. p.144-145 Maison Louis Vuitton, Champs-Elysées (2005): views of the main retail floor, and the store's atrium. p.146-147 Louis Vuitton Roppongi Hills (2003), designed with Jun Aoki and Aurelio Clementi: views of the watches and jewelry space.

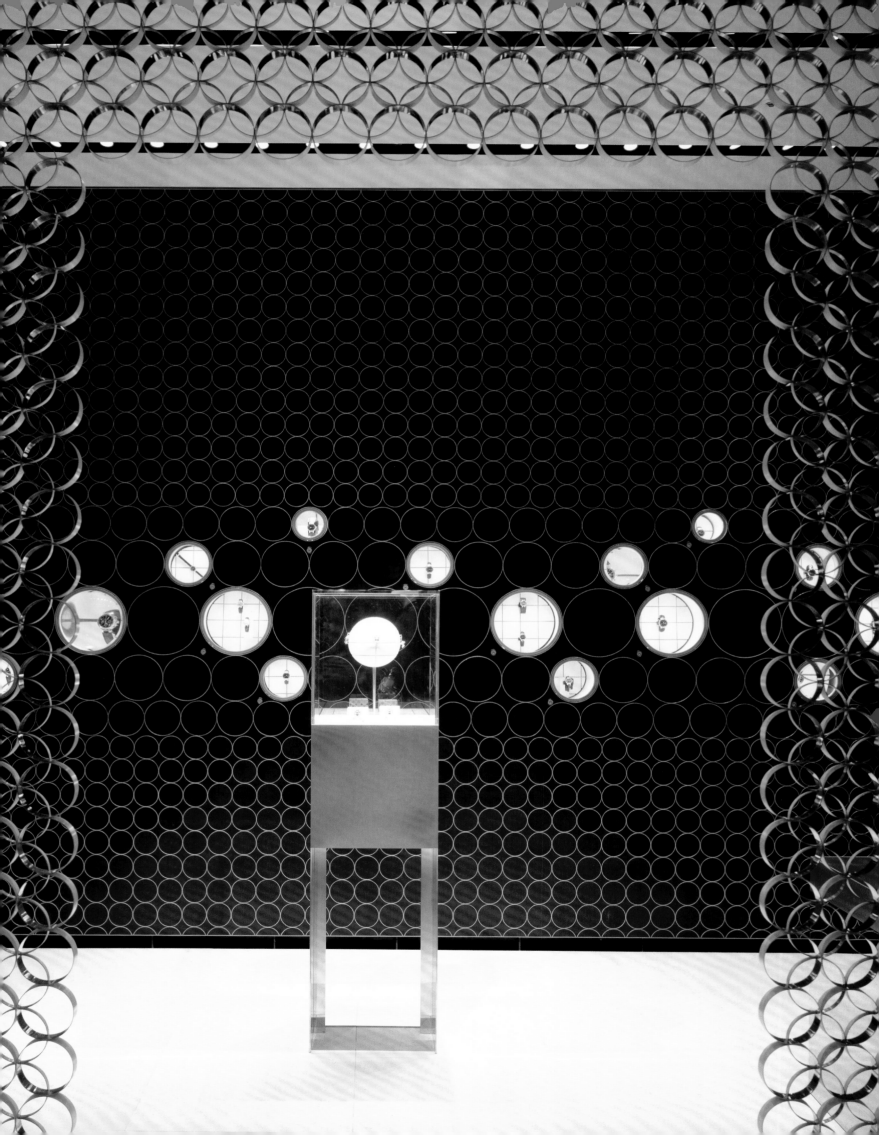

Carnoy, Gilles

architect
text by Philippe Trétiack

Breton, sailor, and navigator, the architect Gilles Carnoy passed away in 2006. He bequeathed Louis Vuitton a veritable fleet of industrial buildings, production studios and workshops.

A lover of the sea and its vast expanses, he also understood a sailor's longing for home, for the dry docks, for the interior. And into the *bocage*, the countryside, he had inserted metallic structures whose glassy facades absorbed their pastoral surroundings.

Born in 1951, Carnoy was raised in Belgium in order to get his architecture degree there. An ace of freehand drawing, a lover of wash drawing and watercolor, disdainful of computer-generated plans, he joined the tradition of artisan builders. He could have constructed cloisters and chapels; he knew what it took to put a wall up straight. In a time of inflated egos, he stayed simple; he worked.

The mission was unchanging: always a plot of five hectares (twelve acres)—8,000 square meters (86,000 square feet)—of which half was assigned to the workshops, a quarter to the offices and social facilities, and a quarter to stock. Carnoy laid out his plans precisely in a square—and facing north, so that the light would be steady across the pieces of leather and metal to assemble. He cared, too, about the view. So today, when a leather craftswoman lifts her head in Ducey, by the bay of Mont Saint-Michel, or in Sainte-Florence, in the Vendée, her gaze meets the clouds, lights up with the sky or bathes itself in rain. In Ducey, Carnoy envisioned placing the company cafeteria above the workshops. The result: everyone lunches with the English Channel and the abbey of Mont Saint-Michel in their line of sight. And Carnoy immersed himself in the details; he chose the plants, the seeds, the grasses that would populate the sand dunes he pulled up to the ground floor of his metallic facades. He was a landscaper, and he sowed as an artist paints.

He loved wood and metal. He was an artist at crafting frames, a refined rationalist, a believer in clean forms—square, circle, right angle. Carnoy began slowly. He started at the bottom of the Louis Vuitton universe, first tackling the restoration then the expansion of part of the Louis Vuitton Museum site, in Asnières. He next created workshops topped with classic skylights. And one day he had the idea to apply his passion for ships; he, who at 16 years old had crossed the Atlantic aboard a freighter, dressed the workshops' roof with the inverted hulls of ships. The sea inspired him; he drew his force from it, and the trade winds billowed his pencil.

Gilles Carnoy was, above all, an architect who believed in the importance of dialogue. He had understood very early in his career that a project's success depended upon the client's involvement. He planned his buildings like a captain leads his ship—with a firm hand, but in a collegial manner. He explained each project's difficulties at great length so that client and architect could resolve them together. Seventy percent of the Louis Vuitton production studios were born this way. In a sense, Gilles Carnoy worked on the series like the most contemporary of artists; he plowed the same furrow, followed the same currents.

He loved to go for long walks and crossed deserts to better observe the galaxies. He knew everything about constellations. He was born under a lucky star. It sparkles in the metallic shine of all his workshops.

p.149 View of the interior skylight in Louis Vuitton's workshop at Asnières-sur-Seine, designed by Gilles Carnoy (2004). One of the walls is adorned with a backlit metal mesh whose lines evoke the Damier canvas.

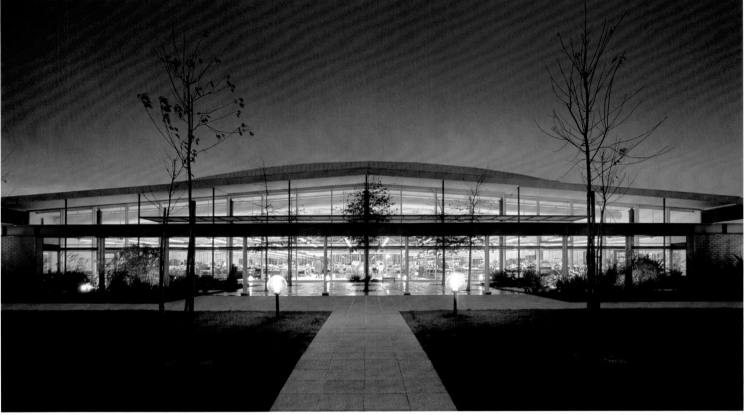

p.150-151*(top)* Built in 1859, the workshop at Asnières-sur-Seine was the first industrial building erected by Louis Vuitton. Since 1993, it has undergone several phases of renovation and enlargement, directed by Gilles Carnoy. The architect oversaw its transition into a modern facility as well as a principal archive and museum for Louis Vuitton, updating its interiors while preserving its original facade.

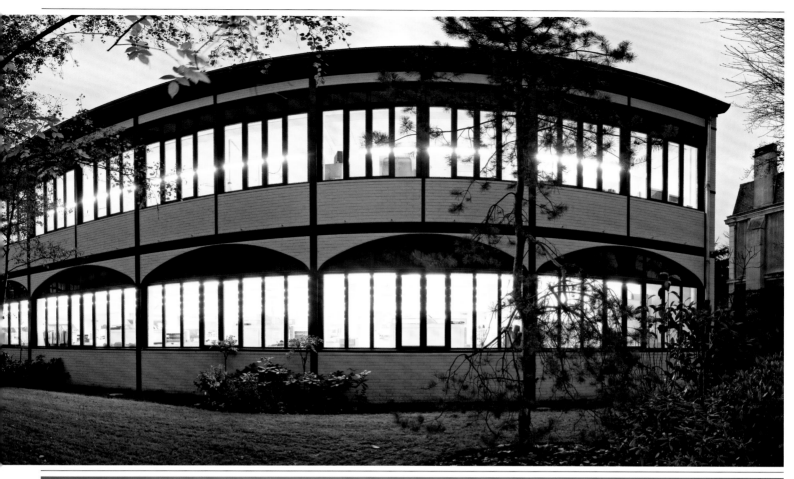

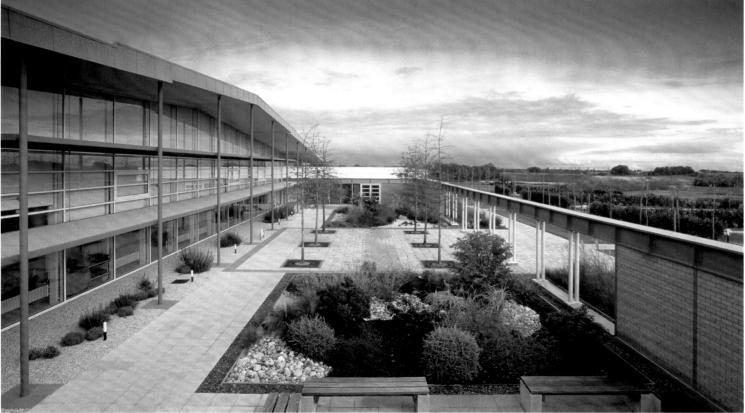

p.150-151 *(bottom)* Views of the patio and glass bays of the Louis Vuitton workshop (2001), Sainte-Florence, Vendée Department, France.

p.**152-153** General view of the Louis Vuitton workshop in the middle of the countryside, Ducey (2002), Manche Department, France.

César

artist
text by Marie Maertens

Everybody knows César.

Actually, in our minds, César's image is just as vivid as his work: his protuberant beard, his strong accent from Marseille—which he kept until the end—and his relationship to showbiz. As for his work, it made a strong impression on the public as early as the mid-1950s. He said that he got interested in scrap metal because marble and bronze were too expensive. At the same time, he rejected these more tradtional materials, as they had been used for too long at the Ecole des Beaux-Arts. He was close to the "miserabilist" aesthetics of the post-war period, to which he added a lot of humor, and took a liking to anthropomorphic and zoo-morphic shapes. This ensured him immediate success at his first exhibition at the Galerie Lucien Durand. César liked to make himself accessible to the people and encouraged the participation of the public. For his first *Expansions*, some viewers were lucky enough to take home some pieces that the master had chopped off with an ax during the openings. The following expansions benefited from a surface treatment with vinyl gloss to guarantee their conservation in time and to allow them

to acquire their specific color. César loved to experiment with heating, assembling, pulling and manipulating the material. He once wrote: "I make love to the material." He alternatively took advantage of all its languages, manipulating the heat and the cold, one after the other. *The Compressions* were also one of his trademark works, and even became, in bronze, the symbol of French cinema. The first of these "compressed" cars was given to him by the Viscountess of Noailles: a brand new Zil from the Soviet Union. There was only one such model in Paris. After some "body work," César sent her back the car, compressed, with a loss of volume of over ninety percent.

If César endeared himself to the public, it is also because of his interest in the mythology of everyday life. From a formal point of view, his experiments ended as geometric and simple constructions, in which some people saw relations, and even a prefiguration of minimalism. The sculptures are to be apprehended through their rhythms, even though colors are also very present in some works, and despite the fact that

the artist has been associated with a crafts trend because of the quality of his textures. Starting in 1961, César implemented the notion of directed compression. In other words, he was able to anticipate the effects he could get from the machine (through his choice of the materials to be compressed, their nature, their color and his knowledge of the compression process). Therefore, he was able to reintroduce personalization and the conscience of the artist into a process, which by then seemed entirely mechanical.

With his fiery personality intact, he would later design for Louis Vuitton "compressions" on silk, with a delicate trompe-l'œil effect and muted colors. These shades correspond perfectly to his declaration: "I don't really like aggressive colors. I prefer things that remind me of dawn. It's not an aggressive light. It's always sensual. It must make you feel like caressing them." These soft pinks, these watery greens and these light blues could almost give us another idea of this explosive artist... The crumpled metal now becomes crumpled fabric and the silk carré seems to multiply in cotton cloth.

p.155 *Impressions mêlées (Mixed Impressions)* silk square (1988) by César (César Baldaccini), 90 x 90 cm (35.4 x 35.4 inches). Louis Vuitton Collection.

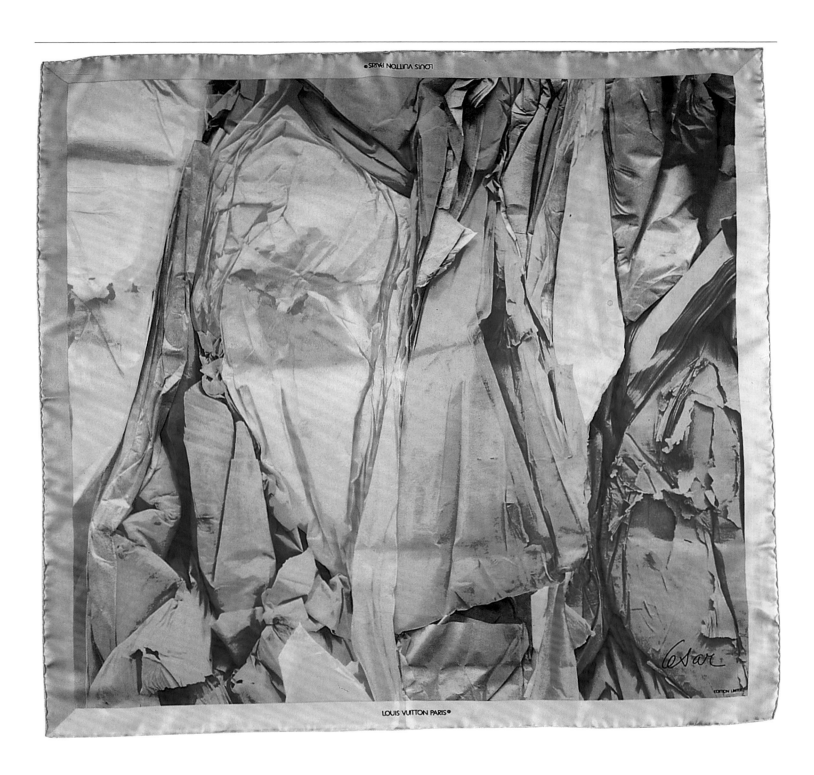

Chard, Jaime

photographer
text by Emmanuel Hermange

Jaime Chard was born in Salt Lake City in 1969. He became interested in photography at the University of Utah where he studied film, which he believes is the most progressive form of mass media. He directed a few short films in which he experimented with combinations of film and still life photography techniques. Convinced that an artist feeds primarily off of his environment, he settled in New York in the late 1990s to work where the most diverse forms transpire, in the maelstrom of high and low culture. Having to meet the immediate financial demands of the city, he extended his experience in still life photography to the fields of advertising and illustration for fashion and interior design magazines.

Today, he collaborates most frequently with *Surface* magazine. Created in San Francisco in 1994, the magazine set up shop in the heart of SoHo. Promoting a "Substance + Style" formula, *Surface* has made its mark by placing itself at the crossroads of fashion, architecture and design; three fields that engage in an increasingly subtle dialog within the global sphere of art. Photography plays a significant role in the magazine, which regularly encourages its contributors to submit new ideas for depicting contemporary objects. In this framework, Jaime Chard suggested that the magazine showcase designer products as objects portrayed in an archeology-of-the-future scenario. The magazine liked the idea and commissioned him to do a series of seven images, each spotlighting a product: a Louis Vuitton bag, a Chanel no. 5 perfume bottle, a Cartier bracelet, a Converse shoe, a pair of Levi's pants, a Lacoste polo shirt and a Tourneau watch.

Jaime Chard had already photographed designer products by highlighting their silhouette so as to portray their classic shapes and uphold the iconic status of their time. On several occasions, he had also created still lifes in which luxury objects (a watch, a jewel, a bag, a shoe etc.) were set against a background of floors, walls and deformed pipes, all distressed by the passage of time,and in a seemingly industrial environment. The artist drew his inspiration from man's footprints on the moon as well as those of prehistoric plants and animals that made their way to the present in the form of fossils. Accordingly, the series published by *Surface* marked a new stage in the research Jaime Chard is conducting on the representation of designer products and the relationship they foster with their generation.

In order to preserve the imprint of the products on a surface similar to the thick layer of dust that makes up the lunar surface, Chard used plaster powder. However, the imprint of an object, even one that is very well known, is not as recognizable as its silhouette—except to the manufacturer. In fact, the "Stephen" bag that the artist cited in the photo caption, was identified by Louis Vuitton as an "Adele" bag, which is quite similar and belonged to the same 2006-2007 Fall-Winter collection. Although this authentication of the imprint by the manufacturer fell short of the series' intended goal, one must look past Chard's "error" in his desire to reaffirm the homage that Marc Jacobs paid to New York artist and designer Stephen Sprouse, who passed away in 2004, by dedicating one of his creations to him.

Making use of the strong connections between the signature, the brand and the imprint, Chard has, a number of times in his series, superimposed the logos of the brands on the imprints of the products; for instance, the engraved padlock for the Louis Vuitton bag, the label for the Chanel perfume and the crocodile for the Lacoste polo shirt. The opposite, however, was done with the watch and the bracelet, which were displayed as such and positioned at the wrist on the imprint of a forearm. Portrayed in a spatial-temporal continuum between fossils and man's first steps on the moon, the products all appeared to be in a world where life no longer existed. Jaime Chard thus suggested the inherent contradiction of luxury products; they evoke both a timeless and archeological dimension, while also laying claim to the present. In fact, this precise paradox is the basis on which philosopher Giorgio Agamben, in one of his recent books, defines the very nature of contemporary.

p.157 *Stephen Bag by Louis Vuitton* (2007), photograph by Jaime Chard for *Surface* magazine, of the impression left on plaster powder by what is actually an Adele bag, also from F/W 2006-07. Print, 30.5 x 40 cm (12 x 15.7 inches). Louis Vuitton Collection.

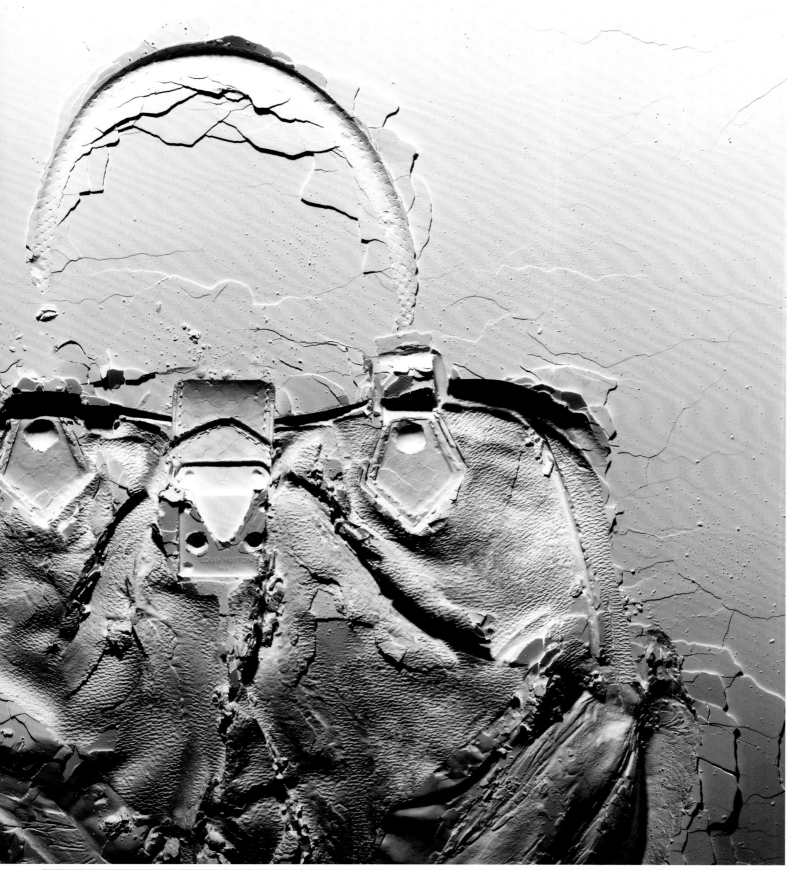

Chelushkin, Kirill

artist
text by Marie Maertens

For the group exhibition Moscopolis, *the Russian artist Kirill Chelushkin revealed the extent of his passionate interest in the city.*

A video of a bustling Moscow was projected onto cut polystyrene. For a more recent installation, he cast Paris as his main actor. Although the choice of these cities is not insignificant, the artist, who studied architecture, claims to consider space first. And yet Moscow has certainly been one of his main sources of inspiration. First there was *Moscow Mood*, which depicts a dirty and foggy city, then *Darkness* (2006), then *Distortion* (2007), presenting a view of the Russian capital drawn on canvas. Since 2008, he has been inspired by the French capital, although not as much by its artists, whom he finds too individualistic. For Chelushkin comes from a place where work results from the exchange and confrontation of ideas, where nothing can blossom in isolation. This philosophy is strongly influenced by the artist and theorist Dmitri Gutov at the Livchitz Institute, who was a great advocate of socialist realism and who Chelushkin met in the late 1990s. Kirill learned his basics then: practicing a visual art, but always directed at reality. His disobedient nature stems from his Russian soul. But, according to him, it's very easy to be seen as disobedient in Western Europe because the rules are so strict. He sees himself more as a romantic. And a wild one, we might add.

p.159 *Distortion* (2007) by Kirill Chelushkin; Video projection on sculpted polystyrene; 360 x 227 x 150 cm (141.7 x 89.4 x 59 inches). Installed at the Espace Louis Vuitton for the exhibition *Moscopolis* (Fall 2007). Louis Vuitton Collection.

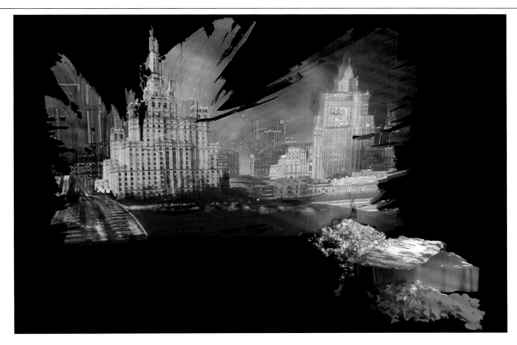

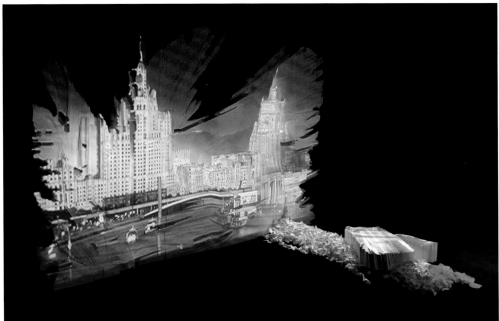

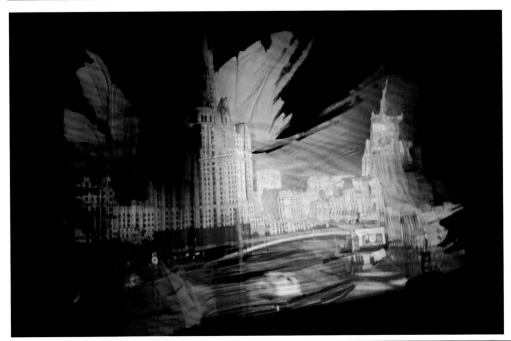

Chia, Sandro

artist
text by Marie Maertens

The silk square by the Italian artist Sandro Chia is fiery, ill-tempered and powerful.

Deep red, intense blue and golden yellow materialize into mostly unidentifiable forms, but, through them, one can perceive phantoms, especially when one considers the given title: *The Phantoms of Montalcino*. Montalcino is a hill town in Tuscany, the region where this artist was born in 1946. Sandro Chia was first recognized in the 1980s for being one of the most influential figures of the Italian Transavantgarde movement, which called for a return to pictorial values. Reacting in particular to Minimalism and Arte Povera, this movement celebrated free and spontaneous creation, rediscovered color and announced a resurgence of personal technique. The artists who participated, including Francesco Clemente and Mimmo Paladino, drew heavily on a legendary past and a national tradition. Inspired by Italian classical art, Chia has never apologized for paying homage to the great masters. Passionate about painting, he is obsessed with a mythology that is both personal and universal, inhabited by single characters, heroes or men, who he depicts as entirely carnal. But subject, it seems, is often only a pretext for Chia, who has said, "It's not the idea of representing that interests me. I do not want to represent anything but painting itself." Moreover, he has always objected to the idea of return in painting, for, to him, it has never disappeared.

p.161 *Les Fantômes de Montalcino* (The Phantoms of Montalcino) silk square (1988) by Sandro Chia, 90 x 90 cm (35.4 x 35.4 inches). Louis Vuitton Collection.

160 **Louis Vuitton**

Closky, Claude

text by Emmanuel Hermange

Born in 1963, Claude Closky began his career as part of Les Frères Ripoulin, a collective established in 1984 by a few young artists (including Nina Childress, Jean Faucheur, Pierre Huyghe and Stéphane Trois Carrés), most of whom graduated, as he did, from the Ecole Nationale Supérieure des Arts Décoratifs. Interested in graffiti and the urban art of Americans Keith Haring and Kenny Scharf, these young artists were formulating various strategies for the short-term occupation of public spaces in Paris, and in 1985 they were invited by the Tony Shafrazi Gallery to stage an intervention in New York. In this context, the forms that Closky was developing were already reflecting the influence of corporate logos and advertising logic on which he later essentially built his own work.

When the group disbanded in 1988, his interest in industrial products and finish incited him to abandon painting and turn to drawing, photography, video, sound art, books and computers. This array of media and technical tools also corresponded to a new way of thinking about the very notion of activity in general, which came to resemble non-activity: "I wonder really what I can do…" He confided to Olivier Zahm,

"I tell myself that I really don't have any idea, and that's my starting point: I'm going to show that I really don't have an idea. And I'll use this incapacity to do anything at all just to be able to do something…"[1] In an environment saturated with signs and advertising images, Closky therefore chose to line this form of ennui and postmodern melancholia with the decomposing elements that constitute the ordinariness characterizing what the philosopher Gilles Lipovetsky calls the "era of emptiness." Rather than propose a new discourse in order to contradict the models governing our daily life, he preferred to follow the reigning logic until it became absurd. In this sense, Closky was at once renewing a logic that belonged to the avant-garde and also updating what Rimbaud was doing in Paris (*Album Zutique*, 1872) by stringing together label names and patronymics taken from posters or newspapers in order to empty them of their meaning and encourage a pure sound, something the poet considered to be the ultimate zone of resistance. For his retrospective at the MAC/VAL (Musée d'art contemporain du Val-de-Marne) in 2008, Closky in fact chose to transpose all his work into a sound mechanism. Wearing a headset, the viewer walked through the exhibition and

heard pieces as he approached one of several hubs in the space. Counting, adding, subtracting, swapping signs and things without any practical reason are all recurring gestures one encounters in Closky's work: *Toutes les façons de fermer une caisse en carton* (All the Ways of Closing a Cardboard Box, 1989), *240 allumettes* (240 Matches, 1993), *200 bouches à nourir* (200 Mouths to Feed,1994), *1000 raisons de compter jusqu'à mille* (1000 Reasons to Count to a Thousand,1997). Seen as a whole, there emerges a tautological aesthetic that is continually inspired by the rhetoric of advertising. In this sense, one of his most emblematic pieces is certainly *Beautiful Faces* (2001). For a publication resembling a fashion magazine, he appropriated advertisements and pieced together faces made from the same half to create a monstrously perfect symmetry. The series included an image Lamsweerde and Matadin produced for a campaign Louis Vuitton launched for its line of pens. The fact that the luggage maker purchased this piece therefore constitutes a tautological *mis en abyme*. In sum, the artist was able to program a perfect loss of meaning.

[1] *Purple Prose*, Number 7, 1995, n.p.

p.163 *Beautiful Face* (2001) by Claude Closky; glass, wood and brass, with images appropriated from ad by Inez Van Lamsweerde & Vinoodh Matadin for Louis Vuitton (1997); 29.2 x 33.5 x 22.3 cm (11.5 x 13 x 8.8 cm). Louis Vuitton Collection.

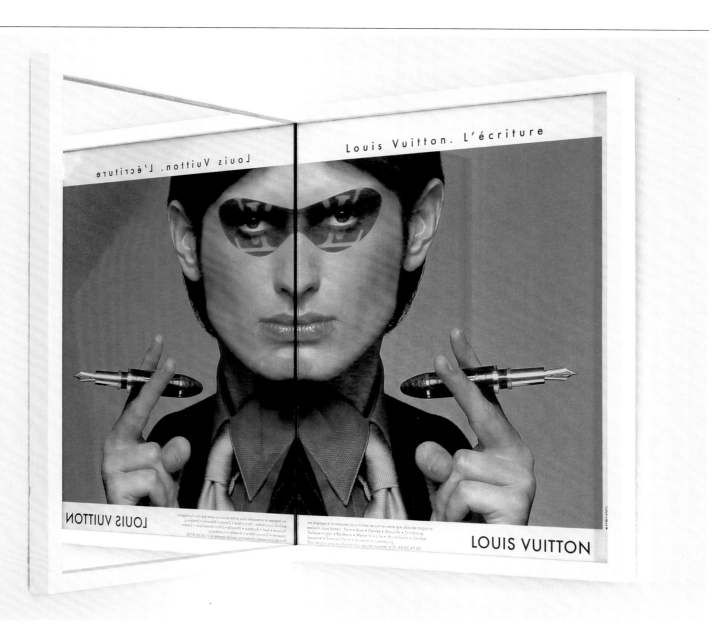

D–F

Debré, Olivier
Demarchelier, Patrick
Dubourg, Vincent
Eliasson, Olafur
Fernández, Teresita
Fleury, Sylvie
Fritz Hansen™

Debré, Olivier

artist
text by Marie Maertens

In November 1989, Louis Vuitton donated a stage curtain painted by Olivier Debré for the Hong Kong Cultural Center's Grand Theater, the present site of Opera Hong Kong.

The *malletier* had just begun to play an active role in the creation of contemporary music, and the institution received support from the Louis Vuitton Foundation for Opera and Music, which was established in 1986 to promote emerging talent.

Because of his interest in transforming space, it comes as no surprise that this French artist accepted the challenge. Born in 1920, Debré began painting in a relatively naturalistic manner. It is said that Picasso discovered one of his pieces in a dealer's window and exclaimed: "But he paints like an old painter!" Olivier Debré took some offense, but after his classical period, he gradually discovered the importance of "the sign" in expressing his emotions. Consequently, his painting began to flirt with abstraction. He started with muted and earthy colors inspired by Courbet and Braque. He then turned to Matisse who he has said gave him the feeling of endless space and vastness, both in the smallest of his paintings and in the majestic Vence Chapel. Debré also wanted to communicate a sense of total immersion. He focused his investigations on the importance of gesture in painting's development, and little by little, understood that color itself played a role in constructing space. But Debré was not one to throw himself into his pieces, nor did he give in to wild movement. He started as a student in architecture and considered structure to be of prime importance. To him, "All painting is structure." The role of space was so important to him that in 1973 he wrote a text entitled *L'espace et le comportement* (Space and Behavior). His color therefore became structural. Its role in paintings in which all figuration had disappeared and in which form and background were interlaced, was to create a direction, a dynamic, a movement. What's more, upon careful observation, one will notice that Debré's paintings also give the impression of elevation, of being pulled upward. The movement generally goes from the bottom left to the top right. The material is fluid, the color palette is reduced, almost monochromatic. This color's role is also to attest to an emotion, one that is felt before nature, which Debré has studied intensely. And because he fully absorbed Picasso's lesson, instead of reproducing nature, he analyzed his experience in front of a landscape. His work became more and more about environment and encompassing the viewer so that he felt the same emotion and placed himself in the same corpus as the painter.

Because of his vision of space enveloped in color, Olivier Debré's approach has often been compared to that of the American painters belonging to the Color Field movement. But more than direct influence, it was probably a matter of similar thought processes emerging at the same moment. Debré also sought to learn about the psychological reactions that color produced. For example red, which is often found in theaters, is associated with passion; yellow, also present in his curtain, evokes the spirit. Debré was furthermore attracted to how large spatial formats directly affected the body. He compared them to "a place where we can live like we inhabit a room." He even wanted the space to dominate his being and his own painting, as if on the brink of another reality. First he studied the space intellectually, but then he faced it physically. He therefore favored total, absolute space that combined different arts like painting, sculpture, architecture and dance. He made a first step towards this synthesis when he created a curtain for the Comédie Française in 1987, and tackling the experience again in 1989 for the Hong Kong opera. There, Debré let his passion take over the 45 by 30-foot (14 x 9-meter) surface. He attempted to "push, inhabit, and rouse" the gesture to the fullest extent. A gesture he had applied to smaller formats before transcribing it by grid, but with the same ardor and the same emotion.

p.164-165 Detail of the artist's signature on the *Keepall* sculpture by Sylvie Fleury (2000); chrome-plated bronze, 32 x 46 x 20 cm (12.5 x 18 x 7.8 inches). Louis Vuitton Collection. **p.167** Olivier Debré painted the curtain hanging over the stage of the Grand Theater of the Hong Kong Cultural Center—the present site of the Opera Hong Kong. The piece was donated by Louis Vuitton, and was installed in time for the opening gala featuring the Cologne Opera, 6 November 1989; 15 x 9 meters (49 x 29.5 feet).

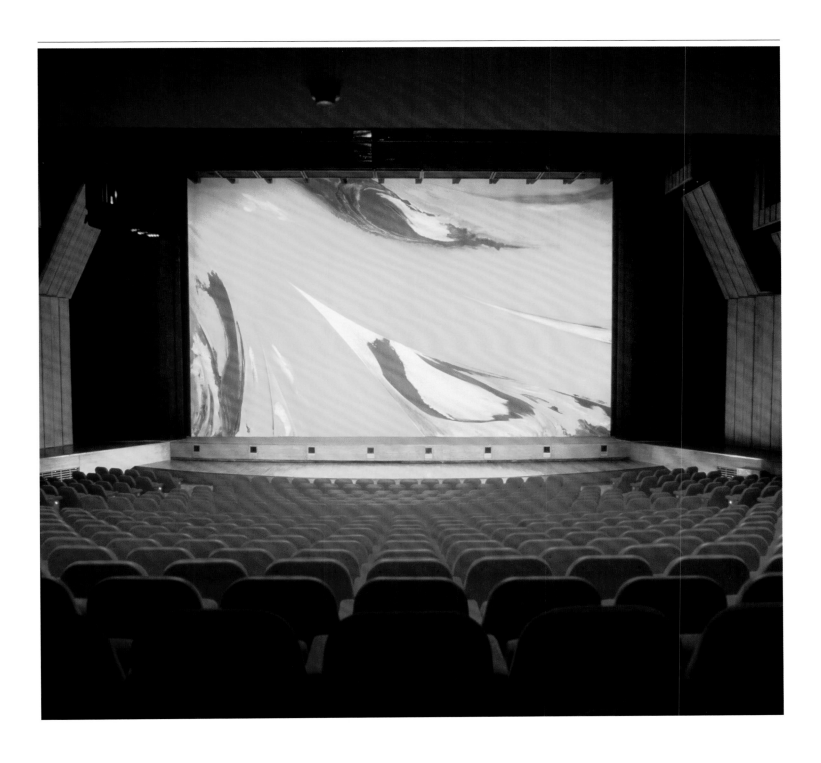

Demarchelier, Patrick

photographer
text by Emmanuel Hermange

Born near Paris in 1943, Patrick Demarchelier spent his childhood in Le Havre. When he was seventeen, his stepfather gave him a camera which sparked in him a passion for photography, as a mode of expression.

At the age of nineteen, he moved to Paris, determined to be a photographer. He first worked as an apprentice printer at Publicis. He was later hired as an assistant by Hans Feurer who was then a photographer and art director in an advertising agency. Feurer collaborated with magazines such as *Nova*, *Vogue* and *Elle* in the late sixties and was also famous for his pioneering use of the long focal lens. He was a pivotal figure in a universe of new images that were somewhere in between fashion photography and erotic imagery. It was at the time when *Lui* magazine (1963) and the Pirelli calendars (1964) were created. Feurer created the 1974 issue of the Pirelli calendar. This "liberation of the body," which gained more popular acceptance in the 1970s, strongly impressed Patrick Demarchelier. This is a thematic preoccupation in many of his photographs, for instance, the iconography of the infamous poster of the movie *Emmanuelle* (1974) reappearing in a series of photographs for the French edition of *Vogue* (February 2005), or the Pirelli calendars he made in 2005 and 2008. But to fully exploit this new approach, he had to prove his value to the magazines.

After a few of his photographs were published in *Elle*, *Marie Claire* and some low-budget ads, he left for New York in 1975. This was a turning point in his career. Without speaking a word of English, he landed a few test shoots and even though some people found his style "too European," he was able to convince his first clients. They all recollect today how professional he was and how he was able to meet their expectations every time, despite the language barrier—his nominal English has become legend in the American fashion world. Naomi Campbell, photographed by him numerous times, testifies today: "You feel so comfortable with him because you know you'll look exactly

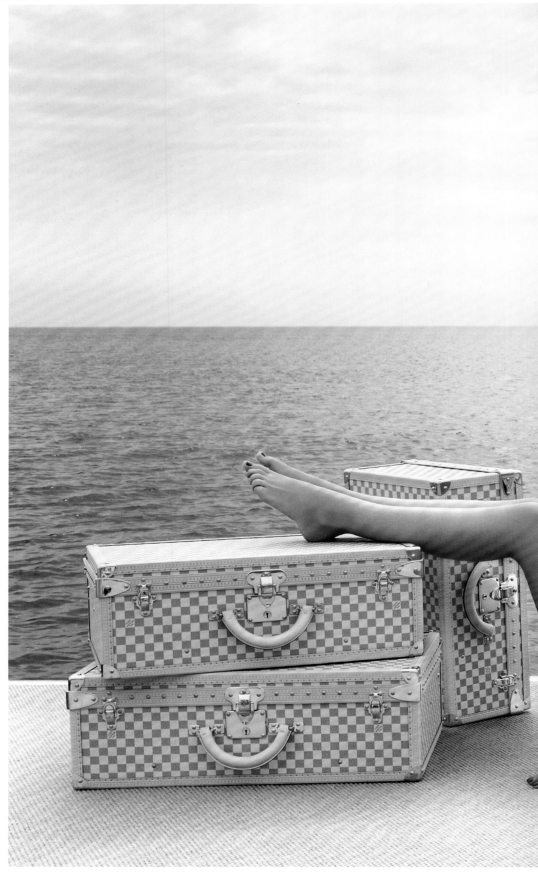

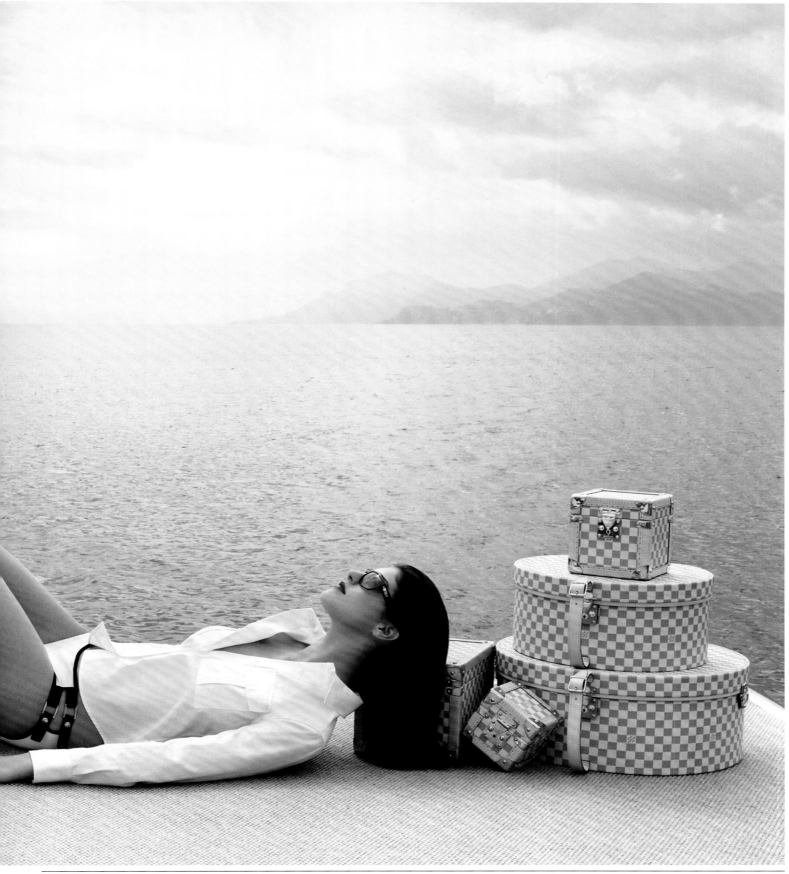

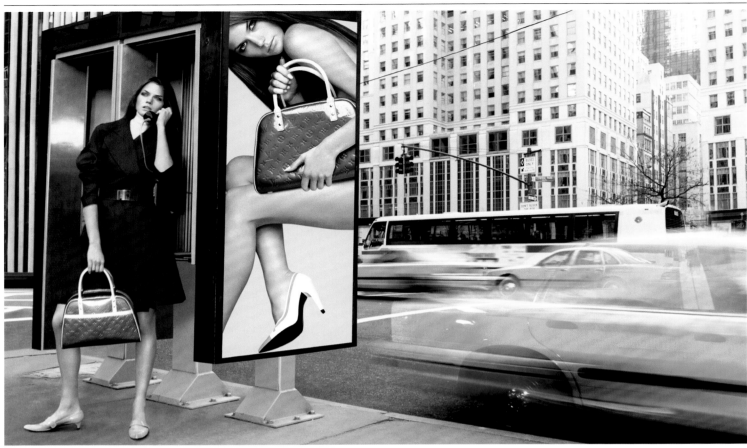

how you want to look." After *Glamour* and *Mademoiselle*, which put their faith in him first, an impressive number of fashion magazines, personalities and some of the most prestigious brands called upon his talent. In the eighties, he regularly published his photographs in *GQ, Rolling Stone* and the international editions of *Vogue* before becoming one of *Harper's Bazaar*'s main photographers from 1992 until 2004, when Condé Nast Publications offered him an exclusive contract.

Meanwhile, numerous actors, artists and political personalities came to his studio. Princess Diana appointed him as her official photographer in 1989. Calvin Klein, Prada, Gucci, Dior, Dolce & Gabbana, Giorgio Armani, Yves Saint Laurent, Chanel and others entrusted him with the image of their products. In 2001, he signed two ad campaigns for the Louis Vuitton ready-to-wear collections. As he often did for magazines and with great graphic impact, he placed the models in urban settings. These two campaigns put front and center the image of the woman in the city. While the woman is shown as a passerby, her image also appears on various advertising surfaces. Some of them, huge billboards installed temporarily on site, reveal the body at a monumental scale.

Sean Callahan, former editor of the magazine *American Photographer* noted that "Although his images have become familiar to even casual readers of fashion magazines and advertisements, his name is not widely known to those outside the fashion business." For a long time Patrick Demarchelier was reluctant to see his images appear outside the fashion world, but in 1995, when he accepted an exhibition offer from the Tony Shafrazi Gallery in New York, he finally consented to showing his work. Other exhibitions were organized, for instance at the Museum of Contemporary Art in Monterrey, Mexico and at the Pavilion of Contemporary Art in Milan. Some exhibitions were followed by books: *Photographs* (1995), *Exposing Elegance* (1997) and *Forms* (1998). In his recent exhibition at the Petit Palais in Paris in 2008, four hundred of his photographs were shown alongside the works of Fragonard, David, Géricault, Delacroix, Courbet and the Impressionists in the museum collections. One hundred and fifty luxury special-edition catalogues were published by Steidl for the opening.

From these exhibitions, it's clear that Patrick Demarchelier's inspiration widened to encompass the history of photography. Shown next to one another are portraits of artists, models, actors as well as non-professional models. Genres include nudes of various styles—from the classical studies, to more intimate compositions, and eroticism—fashion photography, family photographs, ethnographic images, landscape and wildlife. How can one recognize Patrick Demarchelier's style in such a diversity?

By looking at the composition of his images. His rigor and the search for purity in his lines betray him to a certain kind of formalism. It is the formalism exalted in Irving Penn's and Richard Avedon's representation of elegance that influenced Patrick Demarchelier so much as to become a fundamental feature of his work. He showed his admiration for Avedon by taking photographs of him in 1993. In one of these portraits, which was often published, the famous photographer, with his glasses on his forehead, standing next to a large format camera on a tripod, holds the flexible shutter cable in one hand while he extends the other, with a conniving smile, towards Demarchelier who is standing out of frame.

In 2007, Patrick Demarchelier received the prestigious Eleanor Lambert Award from the Fashion Designers of America for "his unique contribution to the fashion world" and was inducted into the Order of Arts and Letters by the French Ministry of Culture. These distinctions have crowned a career, which had long since contradicted the scathing assessment of his early work by Peter Knapp, who served as the creative director of *Elle* in the sixties and seventies. On reviewing Demarchelier's work in the 1960s, Knapp declared: "You have no future, no talent, no creativity. Do something else, you'll never make it."[1]

[1] *Portfolio*, nr. 17, 2000, n.p.

p.169 Advertising campaign for the Damier Azur luggage collection, by Patrick Demarchelier, Fall 2006. **p.170** Advertising campaign by Patrick Demarchelier, featuring Mimi Anden in S/S 2001 Prêt-à-Porter, with a bronze Tompkins Square bag. **p.171** Advertising campaign by Patrick Demarchelier, featuring Karolina Kurkova in S/S 2001 Prêt-à-Porter, with the Nolita bag, and open toe slingbacks in the Damier pattern.

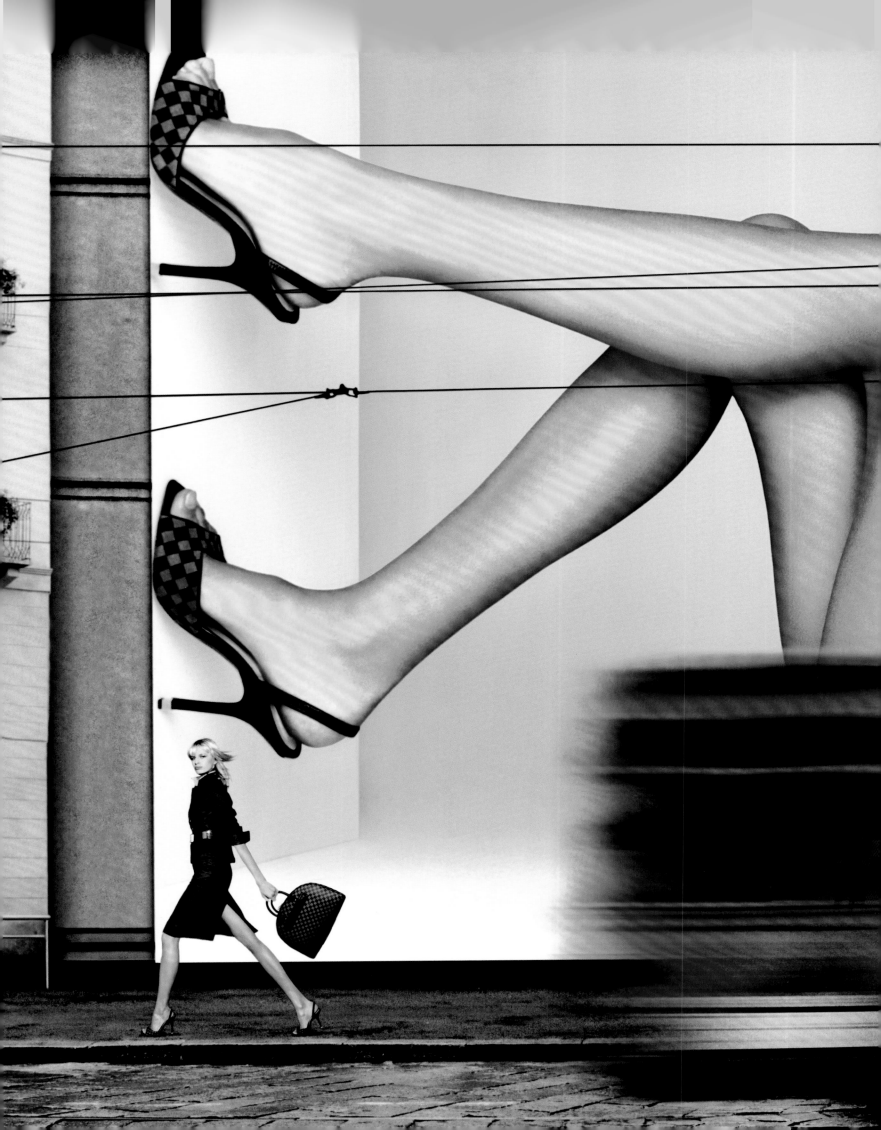

Dubourg, Vincent

artist
text by Marie Maertens

The ambivalent relationship between nature and culture is at its most relevant in the work of Vincent Dubourg. The young artist enters into dialogue with tree branches, which he handles like calligraphy. He twists them, contorts them, watches them shift and bloom when they are still tender and supple. Dubourg inflicts no harm on them. He lets nature take its place, "through the history of art, of forms and our education." He attempts to find a lost harmony. He claims that he tames wood. The natural element guides him. We imagine them—visualize them dancing together. And nature is certainly essential to him, since he divides his time between Paris and a huge studio located in the Creuse department in central France.

He likes to knot branches around onsumer objects. For the series *Exil* (Exile), developed in 2008, he created five pieces using a suitcase and then a bicycle; the branches were transformed into bronze and the objects into aluminum. His idea was to evoke a person in flight or fleeting existence. Yet, the message remains ambiguous. In *Valise en Exil* (The Suitcase in Exile), the work acquired by Louis Vuitton, the manufactured object and the natural element seem so intertwined that one wonders what could possibly escape.

Dubourg's projects are growing in scale; he is currently working on a staircase more than twenty-five feet (7.6m) high. "The idea of the ascension and scale of nature comes to the forefront, attaining the dimensions of a forest!"

p.173 *Valise en Exil* (2008) by Vincent Dubourg; bronze and aluminum; 86 x 86 x 95 cm (33.8 x 33.8 x 37.4 inches). Louis Vuitton Collection.

Eliasson, Olafur

artist
text by Simon Castets

"Enchanting," "unearthly" and "sensory" are words frequently used in articles on Olafur Eliasson.

Born in 1967 in Copenhagen to Icelandic parents, he studied at the Royal Danish Academy of Fine Arts from 1989 to 1995. He then settled in Berlin, where his studio is now home to three dozen scientists, architects, designers, and graphic designers. A true laboratory where projects of uncommon size and complexity are conceived, the studio's exacting work obtains high emotional appeal. Indeed, Eliasson's ability to produce convincing illusions while showing his hand have made him one of the most popular and critically renowned artists of his generation.

Over six months, two million visitors flocked to his installation inside the Turbine Hall at the Tate Modern. For *The weather project* (2003), Eliasson covered the 3,000-square meter (32,291-square foot) ceiling with mirrors and filled the room with heavy mist. At the top of one of the walls, some thirty meters (98 feet) above the visitors, a half sun made of two hundred light bulbs from street lamps cast the room in a light reminiscent of a Nordic summer night. Visitors would often lie down on the ground, and on observing the shapes they could create by moving closer together, they would form words and symbols that were in turn reflected by the mirrors. Their actions inspired a unique message in the exhibit's advertising campaign. Designed by Eliasson, it showed no images of the work itself, only a yellow backdrop etched with phrases like "does talking about the weather lead to friendship?"[1] In emphasizing perspectives and details that lesser artists could easily overlook, the meticulous attention exercised by Eliasson demonstrates the fundamentally generous nature of his work.

Aesthetic research based on cognitive phenomena, his works also become a succession of experiences for visitors. By pouring uranin (a non-toxic vegetable dye) into the waterways running through Stockholm, Tokyo, and Los Angeles (*Green river*, 1998), the public was given the opportunity to consider the changing characteristics of these rivers, which go unnoticed by everyday life. Given his penchant for the spectacular, he took a similar approach in constructing four giant Waterfalls along the East River in New York that released 130,000 litres (35,000 gallons) of water per minute between Brooklyn and Manhattan. *The New York City Waterfalls* (2008) were illuminated at night and stood as monuments to uselessness; the deployment of energies with no expectations of results other than creating wonderment.

The success of Eliasson's works could be measured by the impressions they leave in the minds of viewers he subjects to uncommonly forceful sensorial experiences. Such was the case with his installation for Utopia Station at the *Venice Biennale* 2003, where visitors where encouraged to press a button that triggered an intense flash of light. Playing on the phenomenon of retinal persistence, stunned visitors suddenly realized that the word "UTOPIA" appeared fleetingly every time they blinked.

Eliasson's participatory theatre continues with the *Eye see you* (2006) installations for Louis Vuitton. Glaring at passersby from the Christmas windows of Louis Vuitton boutiques worldwide, *Eye see you*, is a hybrid object in the form of a gigantic eye.[2] Composed of a reflective disc and a mono-frequency lamp, this solar oven's parabolic form simultaneously calls to mind a jet engine, a pupil, and a spotlight in a studio backlot. Eliasson's "eyes" reflect the image of the onlooker, which it enshrouds with an almost unreal light. Whether displayed in the windows or suspended like the *You see me* display in New York, spectators became actors in an impromptu show: "Here you are staged as an actor, and the rest of the street is the audience."[3] *Eye see you*'s light peering out through a pupil is reminiscent of a lesser known piece presented by Eliasson in his exhibit at the Musée d'Art Moderne de la Ville de Paris in 2002. In collaboration with Belgian scientist Luc Steels, *Look into the box* (2002) was an installation thoroughly in keeping with Eliasson's character, and consisted of mundane, commonplace elements that produced a spectacular effect. A box, placed on a tripod, was surmounted by a lamp that lit up an orifice. When a visitor approached to peer inside, the image of the onlooker's eye was simultaneously projected on the entire wall on the opposite side. This manipulation of curiosity, memorably captured in the Lumière Brothers'

short, *The Sprinkler Sprinkled*, is at the heart of the narrative sequence in *Eye see you*; the more the onlooker approached the installation, the more he caught the eye of another. Fixed between a gigantic fiery eye and curious passersby, the spectator became the central element of Eliasson's installation—a subject that was simultaneously an object. The reference to the Lumière Brothers suggests a cinematic dimension present in Eliasson's work.[4] Also evocative of the avant-garde experiments conducted by El Lissitzky, László Moholy-Nagy, and Duchamp as well as the environments created by James Turrell and Anthony McCall, *Eye see you* was also a marketing paradox. For a period of three months, the windows of a luxury store worldwide displayed a single work of art to represent its entire product range.

Eliasson's exploration of cognitive phenomena is often guided by his quest for the sensational. Although he may approach a project by successively adding more—more light, more volume, more height—Eliasson is also aware of the power of subtraction; the deprivation of senses rather than the saturation of them. This is precisely what he accomplished with *Your loss of senses* (2005), a permanent in situ experience created for the Louis Vuitton store on the Champs Elysées. A working elevator linking visitors to the exhibition hall, *Your loss of senses* plunges users into total blackness and absolute silence. By using a specific material that absorbs all sound waves, the black box cancels out all sound-based and visual stimuli and suppresses any trace of natural and artificial light. The twenty-second elevator ride seems like an eternity as the outside world disappears. In the same way as his first exhibit in Cologne in 1994 created a rainbow inside a building (*Beauty*, 1993), *Your loss of senses* produces a sensorial situation that is as unexpected as it is seemingly impossible. It transforms the epicenter of an intense, visually charged atmosphere into a black hole. As explained by the artist, "suddenly, other models become essential in determining our self-awareness."[5] Once again, Eliasson excels in the art of contradiction; by creating a void in a world of abundance, he transports patrons, literally and figuratively, in an individual cocoon of sensory deprivation.

p.174 *Eye see you* by Olafur Eliasson (2006); stainless steel, aluminum, colored glass filters, lightbulb. This project was unveiled at the New York Global store, November 11th 2006, and later installed in each of the over 350 Louis Vuitton boutiques throughout the world. The work consists of a lamp in the shape of pupil, which emits a yellow luminescence.

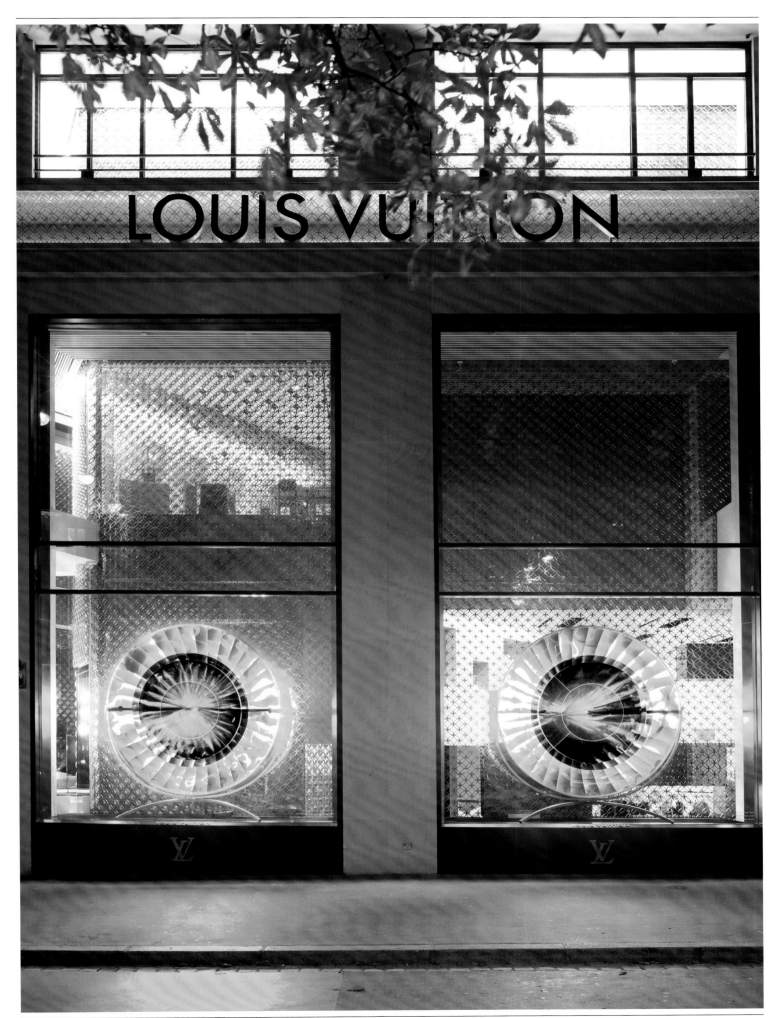

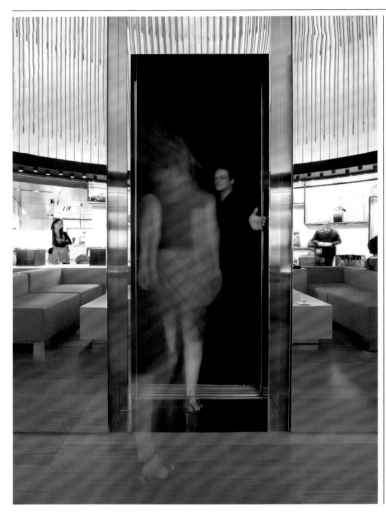

[1] Grynsztein, Madeleine. "(Y)our Entanglements: Olafur Eliasson, the Museum, and Consumer Culture" in *Take Your Time: Olafur Eliasson*.
San Francisco: SFMoMA, 2008, n.p.

[2] Eliasson also aimed at raising awareness about 121Ethiopia.org, a non-governmental organization that provides assistance for Ethiopian or-
phans to which he donated all of his fees, as well as the proceeds from the sale of thirty-three copies of his artwork.

[3] Browne, Alix. "An I for an Eye", *The New York Times*, November 5, 2006

[4] Eliasson's connections to cinematic processes were recently explored by the curators Klaus Biesenbach and Roxana Marcoci, largely through
the double perspective of the New Vision techniques and analyses of the 1920s, and the situational aesthetics of the 1970s.

[5] Biesenbach, Klaus & Marcoci, Roxana. "Toward the Sun: Olafur Eliasson's Protocinematic Vision" in *Take Your Time: Olafur Eliasson*. San
Francisco: SFMoMA, 2008, n.p.

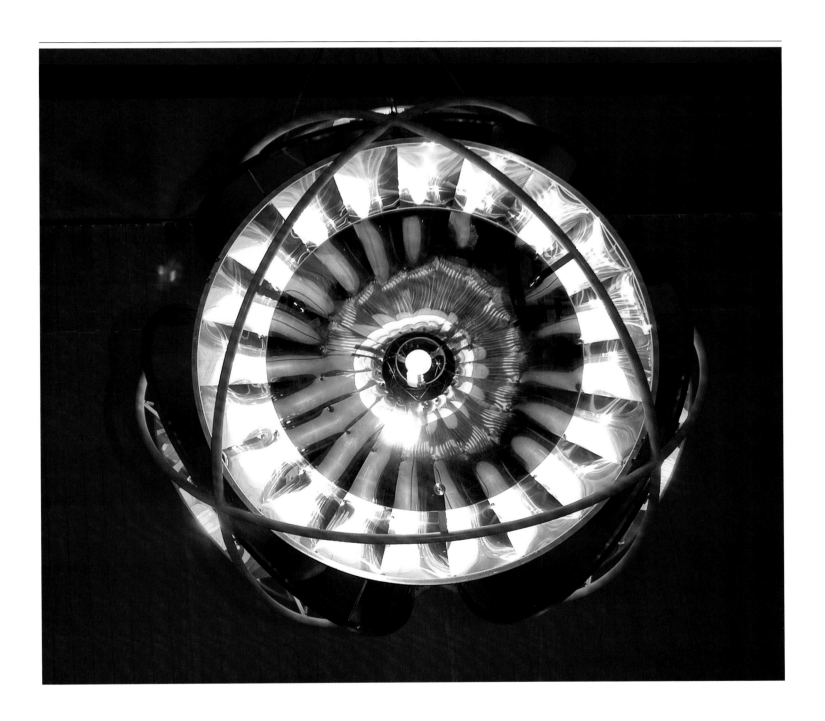

p.176-177 *Eye see you*, installed in the windows of Maison Louis Vuitton, Champs-Elysées, November 2006. **p.178** *Your loss of senses* (2005) by Olafur Eliasson: a permanent installation in the atrium in the form of a light and soundproof elevator that conveys passengers to the Espace Louis Vuitton on the upper floors of the Champs-Elysées flagship. **p.179** *You see me* by Olafur Eliasson (2006); stainless steel, aluminum, colored glass filters, light bulb. installed in the New York store. Louis Vuitton Collection.

Fernández, Teresita

artist
text by Marie Maertens

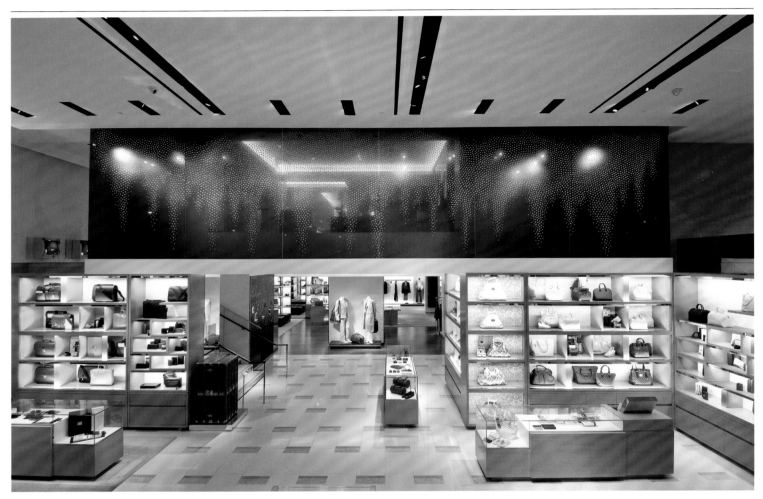

Born in 1968 in Miami, the artist Teresita Fernández creates work that's a far cry from the garish and spectacular images that can come out of a certain side of Florida.

A contrarian, she builds universes that are subtle, soft and subdued, almost withdrawn from the world and from sound. Her installations are outside defined physical and temporal space; they offer a soothing comfort. Honored with a Genius Grant from the MacArthur Foundation in 2005, she has always been interested in perception and the psychology of seeing. Through optical illusions, she raises questions about the recreation of a natural world. She draws on generic memories as models; for example gardens, rainbows, fires and sunsets. Using glass beads, she might then recreate the reflective surface of a sand dune or a waterfall. Although western culture is wary of enchantment, Fernández seeks to render the magic of the ephemeral. In 2000 she even took part in an exhibition entitled *Wonderland* in Saint Louis. Although her work is static, each piece evokes fluidity and movement. Viewers are asked to participate, as Fernández takes them to the same emotional point they face before nature. The illusion comes from the very minds of viewers as they allow the conceptual space to develop their imagination.

In 2008, for Louis Vuitton in San Francisco, she created a wall made from colored glass that resembles condensation trickling down a glass pane. The piece was created during the renovation of the boutique and became part of the architecture. *Hothouse* is not only an installed sculptural element, it is one with its environment. It sets apart a more intimate space for jewelry, something that corresponds entirely to the genesis of her work. The piece is hinted at from the outside of the store and is fully revealed when one is in the central large entry. On the second floor, when one passes behind it, one discovers another boutique through a more silvery back that evokes nocturnal mist. The artist manipulates our vision—but nicely—and enjoys exploring the subtle frontier between reality and fiction.

p.180-181 Views of Hothouse (Blue), by Teresita Fernández (Louis Vuitton Collection), a permanent installation in Louis Vuitton San Francisco, Union Square Store, 2008. Measuring 91.44 cm (36 inches) in length, it consists of translucent panels of blue glass studded with approximately 16,000 silver-plated cabochon mirrors, creating an infinite number of reflections.

Fleury, Sylvie

artist
text by Marie Maertens

Because it has been her practice for quite some time to marry art, fashion and luxury, Sylvie Fleury seemed destined to collaborate with Louis Vuitton. Asked several years ago to design a window project that was in the end never executed, in 2000 Fleury designed a metallic version of the famous Keepall. Yves Carcelle, president of Louis Vuitton found her bag at an auction, fell in love with it, and wanted to purchase it immediately. The story got even more interesting when Marc Jacobs rediscovered this bag and used it as the inspiration for his now ubiquitous *Mirror* collection. And on opening night of the *Icons* exhibition in September 2006, which featured nine emblematic Vuitton objects reinterpreted by nine artists and designers, Fleury arrived with the *Mirror* bag inspired by her own bag. An homage by one artist to her own, earlier work.

Born in 1966, in Geneva, Fleury's work has always favored objects that *a priori* have a strong aesthetic value, which she often pushes to a comical extreme. Among her favorite themes—almost fetishes—are shoes, with very high heels, if possible; American cars, very bright if possible; and giant lipsticks, flashy and not too phallic, if at all possible. As an artist interested in overplay and accumulation, she also likes to paint cars with makeup or cover objects with a synthetic, soft fur, leaving the viewer to make sense of her interventions. Fleury does not focus on anti-consumerism, and yet dances at its margins: shopping bags, and the present ubiquity of luxury-brand handbags, "represent the products of a system and the undergird of this system...." but, "it is important for me that there be several levels of interpretation."

This general ambivalence has also led many critics to raise the question of feminism in Fleury's work. She started her career at the end of the 1980s, during a period when contemporary art was invested in social and political issues. Always irreverent, refusing to reveal her codes, she defines herself as a "subject" of desire, and a "woman of luxury," neither a victim of fashion, nor that woman-object decried by classic feminist discourses. Fleury fills her language with "pleasure." She claims her right to consume, to hedonism, which she bases on a neo-feminist principle. Her œuvre is also characterized by a slick, shiny, impeccable finish that is characteristic of the Swiss school to which, for example, John Armleder also belongs. Everything is ordered, no detail is left to chance. The decorative process of these artists' work is over-emphasized. The works flirt with design and other sectors of industrial production, like music and beauty. Directions for use of anti-age creams are employed as injunctions elaborated in her exhibitions. Is Sylvie Fleury to be taken literally? Is she advocating artifice and superficiality? Is her work filled with consumerist desires and excesses? Up until now, the artist has escaped overly rigid discourse and unilateral interpretations.

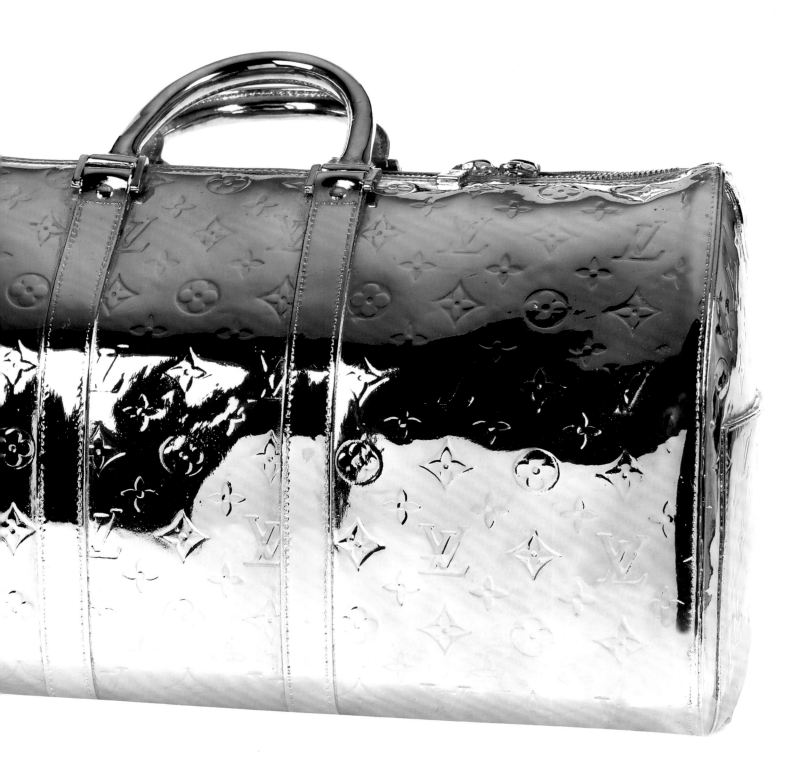

p.183 *Keepall* by Sylvie Fleury (2000); chrome-plated bronze, 32 x 46 x 20 cm (12.5 x 18 x 7.8 inches). The sculpture later became the basis for the *Mirror Monogram* series of city bags. Louis Vuitton Collection.

Fritz Hansen™

manufacturer
text by Cédric Morisset

The Series 7™ chair was designed in 1955 by Danish designer and architect, Arne Jacobsen (1902-1971).

A classic example of Scandinavian design, it was manufactured by Fritz Hansen, a Danish furniture maker founded in the late 19th century and world renowned for its creative furniture. The shell is composed of multi-layered veneer and cotton textile and rests on a base made of mirror or satin-chromed steel. Exceptionally durable, it is available in a variety of colors and has been highly prized by both individuals and corporations, which have propelled it to international recognition. Nearly fifty years after its introduction, six million Series 7 chairs

have been sold. A victim of its success, it has also become one of the most copied pieces of furniture in the world.

In commemoration of the fiftieth anniversary of the iconic chair, Fritz Hansen launched a charitable project for the fight against AIDS in 2005. Thirteen international brands and designers were asked to reinterpret the Series 7 for an auction, with proceeds going to the Danish AIDS Foundation. Louis Vuitton responded by producing a Series 7 swing seat

that could be hung anywhere. Made with welt-leather, based on traditional leather-forming techniques used for shoes, the seat was created in Louis Vuitton workshops from wood Series 7 shells and natural leather. The swing seat is a perfect melding between luxury and design, emphasizing quality, and favoring elegance to ostentation. A faithful homage to the iconic design of the Series 7, this piece also demonstrates the master trunk and case-making craftsmanship of Louis Vuitton, combining innovation and tradition.

p.184-185 Series 7™ swing seat prototype after Arne Jacobsen (2005), one-of-a-kind model created for Fritz Hansen™; auctioned for $18,000, with proceeds from the sale donated to the Danish AIDS Foundation. Louis Vuitton Collection.

G-K

Gehry, Frank
Gigli, Romeo
Goude, Jean-Paul
Guzman
Hadid, Zaha
Hemmert, Hans
Hempel, Anouska
Inui, Kumiko
Isozaki, Arata
Jacobs, Marc
Kallima, Alexey
Kawakubo, Rei

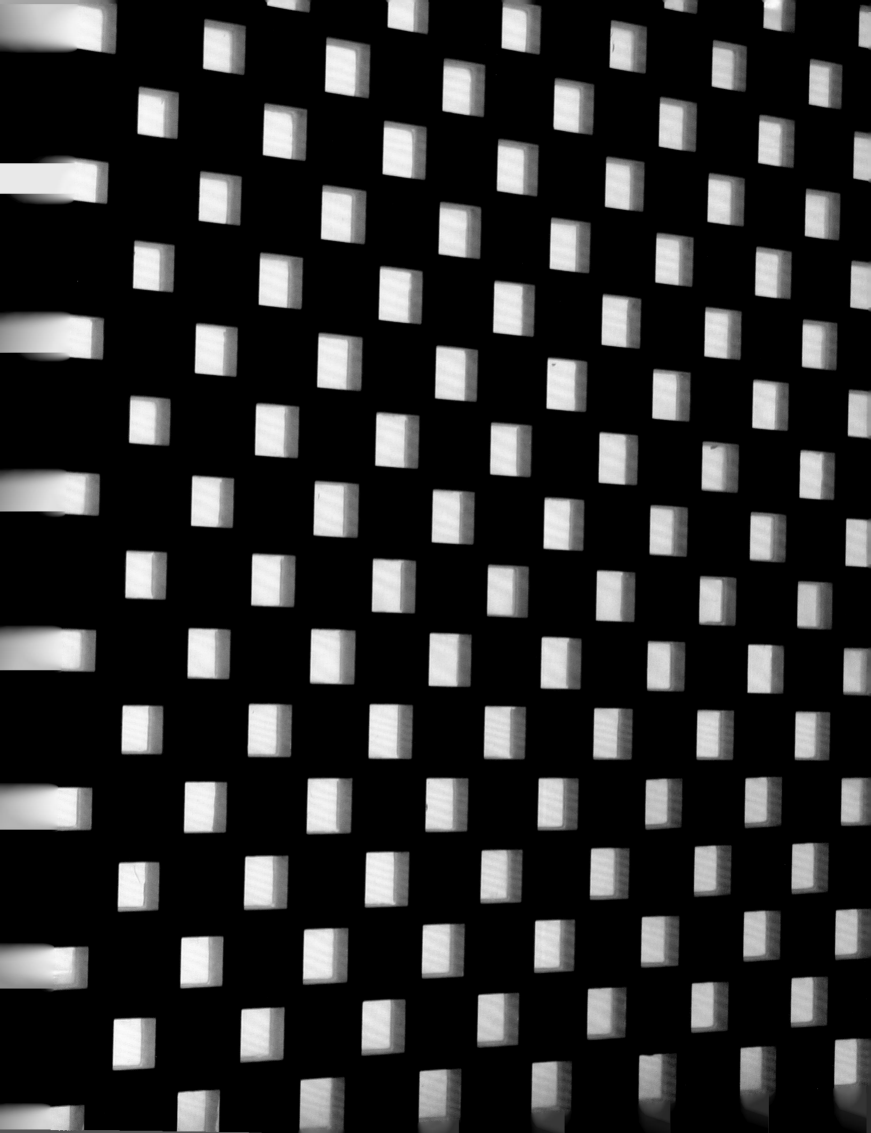

Gehry, Frank

architect
text by Philippe Trétiack

It's not often that a filmmaker as famous as Sydney Pollack turns his attention to a contemporary architect. That kind of attention says a lot about a particular architect's importance.

In making the documentary *Sketches of Frank Gehry*, the director of *They Shoot Horses, Don't They?* took fine measure of a twentieth-century giant, whose influence fully extends into the present.

Gehry shook the world with the Guggenheim Museum in Bilbao. Today, this seismic shift has a name, "the Bilbao effect"—the symbol of all urban renewal generated by an iconic architecture. Every region, every city, every bleak neighborhood dreams about it. A giant through his work, the affable Gehry is an enigma, because two architectural traditions meet in him: on the one hand, a doodler, a crumpler of paper, a manipulator of scraps of cardboard, an obsessive over low-cost scale models; on the other, an evangelist of high-performance computer programs, some initially developed for the aviation and aerospace industries. Without these tools and their power to make superhuman calculations, projects like the Walt Disney Concert Hall, in Los Angeles, the Experience Music Project in Seattle; the Neuer Zollhof apartment buildings in Düsseldorf, and many other projects would have never seen the light of day. The same goes for the imminent Fondation Louis Vuitton pour la Création in Paris. Conceived by an apostle of the curve and the countercurve, a manipulator of titanium, light, and reflection, the Gehry style has established itself like an Expressionist-Baroque fed on fractals and chaos theory.

A man of complex identities, Gehry is a Talmudist in his way of dissecting volumes of space—drawing threads from them like prayer boxes. Born Frank Owen Goldberg in Toronto in 1929, Gehry ultimately settled in Los Angeles. He lives in a house he bought and gutted. But in order not to destroy its original harmony, he enclosed it in another house, which he built around the first. Who knows why? A study on the need for protection? Empirical research on enclosures? cocooning?

The anticipation of the Big One—the cataclysmic tremor that will one day shake California into the Pacific Ocean—may perhaps further explain the chaotic in Gehry's process. Gehry would likely be awakened, half-crushed by his library, a quake having thrown down volumes from their shelves. In his spatial flights of fancy, everything is broken in advance—folded and wrinkled, in the style of Issey Miyake. Architects and fashion designers share a passion for wrapping and drapery. The house of Louis Vuitton's passion for architecture can be explained in part by this mutual preoccupation.

Gehry's style is at times judged harshly. Some consider that the master, crowned by the Pritzker Prize (the so-called Nobel Prize of architecture) in 1989, has by now been fully ensnared by his curves and fragments; in short, that he repeats himself—that he plays Frank Gehry like the actors Gérard Depardieu and Robert De Niro—who, by the way, would be perfect in the role of Gehry—play themselves. The reviews for his epic successes were so enthusiastic that some today are inclined to express some regret. Gehry weathers the storm—he's outlived many. This endurance is certainly the privilege of a great artist who met global success later in life.

His quest nowhere near its end, Gehry finds in each new material an opportunity to push his experiments even a little further, to crumple a little more paper, to capture a little more sunlight. It was with his cardboard furniture—on prominent display at the Vitra Design Museum, on the Franco-Swiss-German border—that he first got recognition. He designed buildings like Claes Oldenburg created art: as extrapolations, with one façade in the form of a pair of twins. In fact, Gehry and Oldenburg have worked together, and their most renowned collaboration was for advertising agency Chiat/Day's Los Angeles building—which features a giant pair of binoculars—that has become, appropriately enough, a popular attraction.

Gehry had wanted to be a boxer and studied karate. He can withstand a great deal. It is fitting that he even knows how to stay under water for long periods, since he was nicknamed "the fish" when he was a youth, and designed buildings in the form of fish. He designed the Fish Dance, in Kobe, Japan; and in Las Ramblas, in Barcelona, his metal sculpture defies the sea. For the 2008 *Venice Architecture Biennale,* he put up a tower of clay-covered wood in the Arsenale. This monument paid homage simultaneously to Vladimir Tatlin's Soviet Constructivism and the anonymous architecture of the African savannah's inhabitants.

If it is possible to regret that it was in Paris that Gehry built his least appreciated—or his least brilliant—building, the former American Center (since converted into the Cinémathèque Française, on rue de Bercy), it is also possible to take delight that thanks to Louis Vuitton, Gehry has the chance to redeem himself there. To defend the American Center, Gehry had a ready reply, full of humor and good sense: "I had wanted to construct a building that would be well-integrated into this ancient quarter of Paris. But between the beginning of work and its completion, the landscape all around the building had been turned upside down, and everything had begun to resemble the most boring of Dutch neighborhoods." And it's true. But this time, it is the Bois de Boulogne and its hundred-year old trees that will serve as the jewel box. The Fondation Louis Vuitton pour la Création will be an open, translucent vessel in woods, with operable "leaves" that can part to open it to its surroundings, and the inspiration provided by the nearby Jardin d'Acclimatation. The structure will feature a cascading curtain on stilts, somewhere between a greenhouse and a tree, composed of steel, glass, and wood, measuring 40 meters high by 150 meters wide, and set above a reflecting pool. It is appointed with galleries, comprising some 3,500 square meters of exhibition space, a resource center, a café, a bookstore, an auditorium—a permanent glass cloud, an iceberg of green. The architect, a great reader of Marcel Proust, has expressed satisfaction in finally building something in a place that the author of *Remembrance of Things Past* frequented. Frank Gehry... Proustian architect?

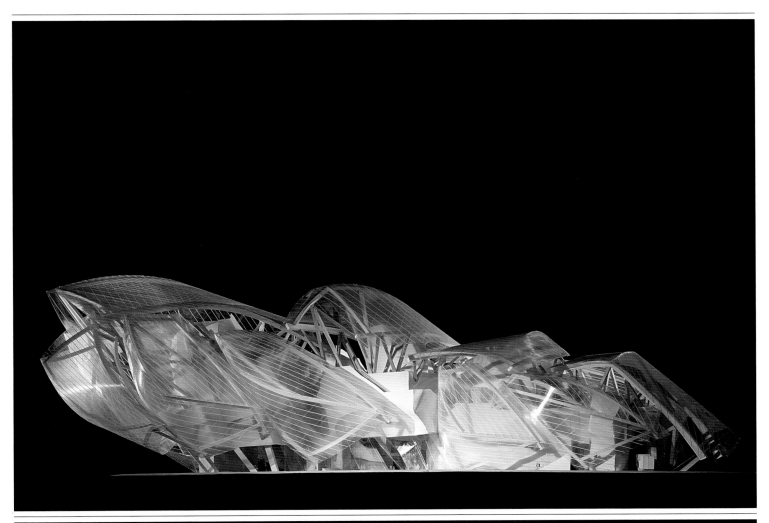

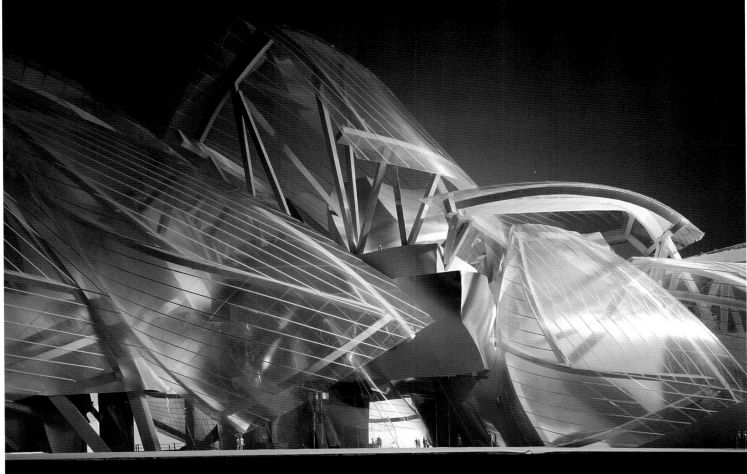

p.189, 191 Models of the Fondation Louis Vuitton pour la Création, Paris, designed by Frank Gehry (2008). The building is scheduled for completion 2012. Fondation Louis Vuitton pour la Création.

190 **Louis Vuitton**

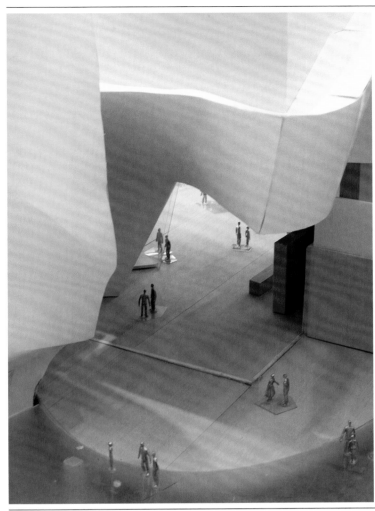
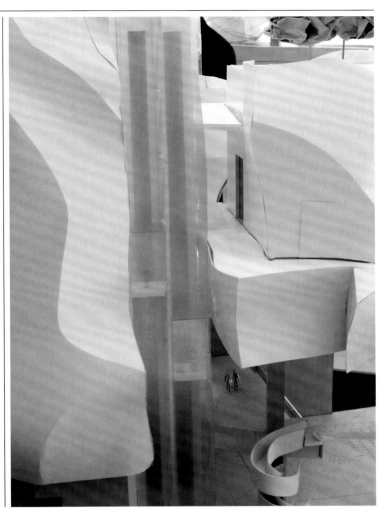
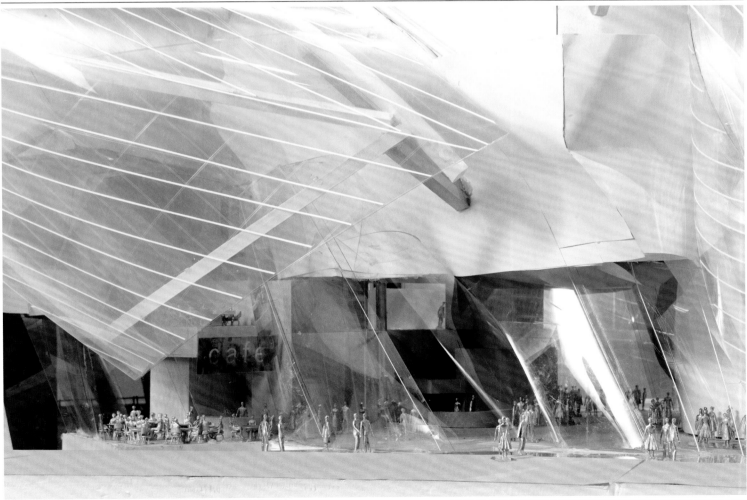

Gigli, Romeo

designer
text by Olivier Saillard

During the 1980s, when Romeo Gigli emerged as a talent, the principle of opposites took root.

A flesh-eating fashion, designed for a determined woman we might call the 9-to-5 girl, with broad shoulders and a dominating suit, was followed by a more temperate fashion. Smitten with philiosophies of naturalism and essentialism, this was a fashion that the Italian designer launched to a great extent. Raised in a family of antique and book dealers, steeped in architecture, which he chose to study, Romeo Gigli created his *prêt-a-porter* label in 1983. Going against optical fashions and emphatic shapes, he developed a look in which sinuous forms reigned. Infinite curves and warm or natural tones exalted a new femininity without any gimmicks. The Italian designer deconstructed, striving to create a new and more embellished wardrobe, proportionate to size—and to his own interest in primitive and classical art, and in travel. His enthusiasm for ethnic cultures also contributed to an overall softening of theme and form that characterizes his work.

Gigli enhanced the shapes of the body without excessively correcting them, by using stretch jersey, for example. He aimed to create the feeling of blossoming, to abide by the law of intimacy. His jackets and coats addressed the female muse. The echoes of Renaissance in his lines were paired with a loose pant, more wrapped than cut, transforming the woman wearing his designs into the heroine of a painting. Invited by Louis Vuitton to create a bag in honor of the centennial of the Monogram canvas, Gigli created a quiver or amphora-shaped backpack evoking a nomad aesthetic that he has strived to suggest in all his collections. Bedecked with wide leather straps, the bag is to be viewed from every angle and once again presents the overall softening of lines that has prevailed in all his work.

p.193 On the centennial of the Louis Vuitton Monogram in 1996, Romeo Gigli created the Excursion bag in Monogram canvas and leather. Louis Vuitton Collection.

Goude, Jean-Paul

photographer
text by Emmanuel Hermange

According to Jean-Paul Goude, "Advertising is not an art. It's a means of communication that sometimes allows an artist to express himself. But some ads are so beautiful that they can be considered works of art."[1]

Instead of the term "artist," he prefers the expression "artisan," which encompasses all kinds of artistic disciplines. "Any opportunity to express myself is valuable," he adds, "whether it's an ad or not. I produce visual metaphors. I think in terms of their ultimate impact. Whether it's a photograph, drawing or film, what matters is the pleasure that—I hope—the audience will experience." A graphic artist, photographer, advertising film producer, director, illustrator, costume designer and parade organizer (to name a few of his ventures)—the range of Jean-Paul Goude's creative activities is impressive. He seems to be striving to embrace the entire world of art, and it's undeniable that he came closest to achieving this objective with the parade he organized to celebrate the bicentennial of the French Revolution on July 14, 1989. For this event, he was able to mobilize all his talents to celebrate the image of an entire nation and even convey a universal message of liberty. This parade, a historic commemoration that was broadcast internationally, represented the high point of a career that began in the early 1960s.

Jean-Paul Goude's education was profoundly influenced by his mother's experience in musical theater. Even if his natural ability to draw pictures seemed to indicate a talent for graphics, Goude studied ballet under renowned teacher Nina Tikanova, while he was enrolled at the Ecole des Arts Décoratifs. Owing his first big break to the Printemps department store in Paris, who hired him to decorate the store with his drawings, Goude soon became a successful illutrator. A few years later, he moved to New York and became *Esquire* magazine's artistic director. In 1975, Goude turned to photography becoming more interested in New York subjects. His first story *America Dances*, an 8-page photoessay, reflected an interest in the structure of American communities and examined four demographic groups: *Gays* (Manhattan), *Blacks* (Watts, Los Angeles), *Whites* (Boston) and *Latins* (Brooklyn). He sought out models and singers who later became his muses and companions. He met the most famous of these, Grace Jones, in 1978. Goude's images of Grace Jones exerted a powerful influence on 1980s pop culture. Today it continues to inspire artists such as Lina Viste Grønli, who produced her *Grace Jones Sculpture Project* in 2008.

Goude's book *Jungle Fever*, released in 1982, drew admiration for the vitality of his forms and visual vocabulary, as well as criticism of his overt taste for the exotic, which was ironically perceived by some as a form of racism. In any case, the book was an entrée into the world of French advertising films. While continuing his activities as an artistic director by helping to launch *Le Monde Illustré,* he made numerous advertising films; some of the most memorable were produced for Kodak, Perrier, Dim, Crédit Lyonnais, Club Med and Chanel. Most won awards and were distributed internationally. Refusing to restrict himself to a single genre, Jean-Paul Goude continued his collaborations with the fashion world. He organized events for new collections and shot highly stylized portraits of designers. He has consistently photographed Azzedine Alaïa, a friend since the early 1980s. In a shot for Louis Vuitton, Alaïa is shown as the emperor of couture, draped like a Roman patrician and set against a background emblazoned with the brand's monogram.

Jean-Paul Goude's images have had a profound impact on advertising since the 1980s and have also left their mark on the visual culture of an era. It was this impact that Germain Viatte, director of Marseille's museums, wished to demonstrate when he devoted an exhibition to Jean-Paul Goude's work in the Musée Cantini in 1988. More recently, Béatrice Salmon, the dictor of the Musée des Arts Décoratifs invited Goude to stage a retrospective of his work.

[1] *Le Monde,* June 8, 1988. n.p

p.195 Portrait by Jean-Paul Goude of Azzedine Alaïa, 1996.

194 **Louis Vuitton**

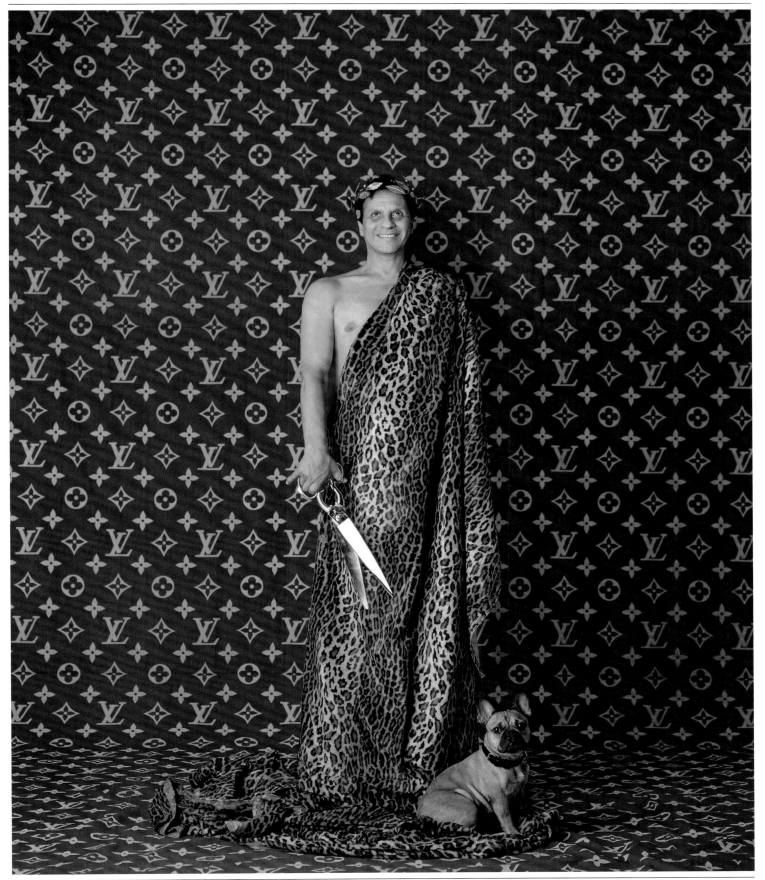

Guzman

In France, there's always an initial question about the name.

Often appearing in print as "Les Guzman," people are usually inclined to pronounce it "Less Guzman" before they learn that "*les*" is simply the plural definite article in French. In fact, the name belongs to two people, Constance Hansen and Russell Peacock, who met in New York in 1984. Today they oversee a huge studio on 31st Street in Manhattan's Little Korea neighborhood, where they have developed images for some of the most striking advertising campaigns in recent years.

In 1984, Constance Hansen was a still life photographer; this is the most challenging genre for advertising photographers because the scope for innovation is very limited. Russell Peacock, a sculptor by training, was hard up after a lengthy European tour and agreed to become her assistant as a temporary job. "The first thing she asked me to do," he recalls, "was to clean her oven." He then adds that she was in the midst of photographing a *soufflé*. This little scene anticipates the male/female role models that Les Guzman reversed in one of their best-known campaigns for Kookaï. "He was a very unsatisfactory assistant," she recalls, but he turned out to be a very good photographer. After all, sculpture and photography both involve abstraction. Realizing that his artistic training could be a real plus, she hired him again—on his own merits this—as an assistant. They soon became a couple and decided to specialize in portrait and fashion photography together, working for *Village Voice* and *Interview*. They photographed singers, including Debbie Harry against a backdrop painted by Andy Warhol for the cover of her album *Rockbird* (1986), which was designed by Stephen Sprouse. In the early 1990s, Hansen and Peacock were discovered by the French advertising world, which had a keen appreciation for their distinctive aesthetic with its American underground and rock influences. For a while they worked in Paris, where they developed expertise in retouching, then very popular in European advertising circles where it was used to inject a measure of acerbic humor. They are still admired for this technique, particularly because they tend to every last detail themselves.

Since they often photographed the same subject at the same time during shooting sessions, they jokingly invented "an imaginary auteur who is a little mysterious, a little exotic," whose name could represent them both. They used "Guzman" to answer the telephone and ended up adopting the name for their partnership. Behind this masculine façade, their advertising campaigns often portray a world where the woman is a dominatrix, although with the somewhat caricatured features of a Barbie doll. Men are in the background, ill at ease, and very much in the woman's shadow. Although Les Guzman show the influence of Helmut Newton, the perverse tone of these images has a humorous, ironic bent. It's pretty obvious that the reversal of the sexual roles in these photographs is just a mockery. More often than not, the woman's body is simply a vehicle for the merchandise, displayed to titillate the observer. Les Guzman are among the rare artists who produce portraits—including Matt Dillon, Missy Elliot, Jean-Baptiste Mondino and Courtney Love—and fashion and advertising photography for a broad range of media. In addition to Kookaï, whose campaign ignited a craze for what quickly became known as the *Kookaïettes* and launched Les Guzman's career in Europe, their images have been used to promote many different brands, ranging from Nike, Puma and Adidas to Givenchy, and including Evian, Arvie, Absolute Vodka, Kronenbourg, Dockers, Estée Lauder, Lancôme, L'Oréal, ING Direct, Samsung, Bausch & Lomb and others. They worked on several Louis Vuitton campaigns, and those of 1996 and 1997 were particularly outstanding. One was for the line of handbags commissioned from the most influential designers of the moment: Isaac Mizrahi, Azzedine Alaia, Vivienne Westwood, Helmut Lang, Romeo Gigli and Manolo Blahnik. The other was for the *Epi* line that included Louis Vuitton's first brightly colored leathers, which Les Guzman highlighted with a quirky style and a lighthearted sense of incongruity when posing the models. In 1997, the partners also produced a series inspired by various images from *The Thomas Crown Affair* (1968) — two years before John McTiernan's remake—to use as backdrops for a range of luggage products (the *Taïga* line). This "rerun" approach is a perfect illustration of how Les Guzman deploy iconic images of 1980s postmodern American art in their advertising photography. These pictures are reminiscent of Cindy Sherman's *Film Stills*, where the artist poses in the guise of movie characters who are emblematic of American film and culture.

p.197 Advertising campaign by Guzman for the *Epi* leather line (1997), with the Alzer suitcase in blue Toledo *Epi*.

196 **Louis Vuitton**

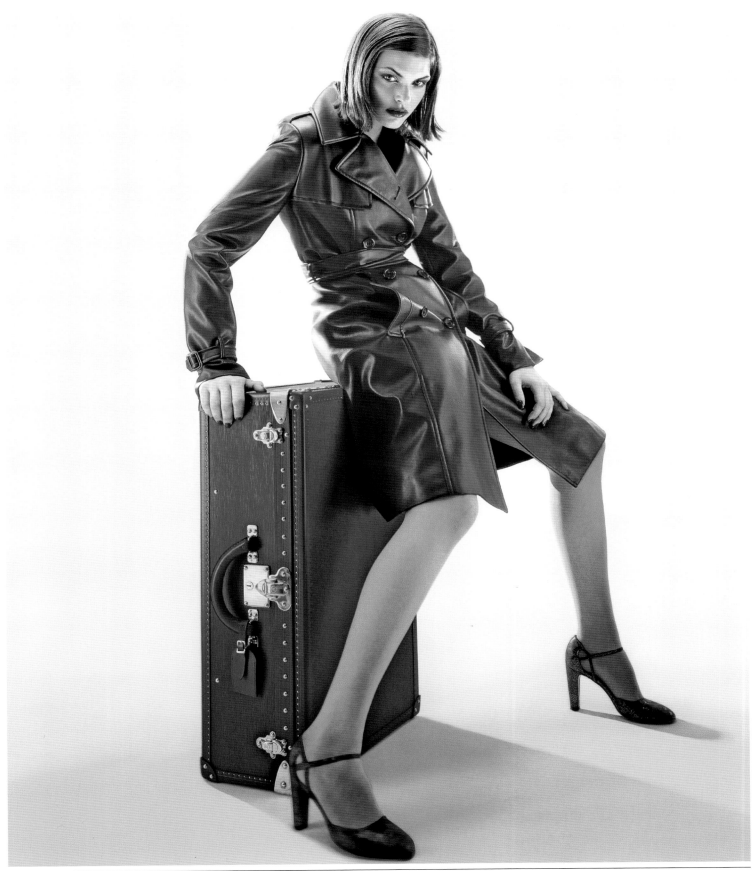

Hadid, Zaha

architect
text by Philippe Trétiack

She is everywhere: in art and architecture galleries, in museums, at auction houses, at the feet of skyscrapers, shuttling about in helicopters, devising urban-planning concepts from up high, for Istanbul, for Dubai… An architect, a product designer, a painter, and, above all, a diva—she is as a veritable Umm Kulthum of construction and building, a Bianca Castafiore, a superwoman. She is worshipped, envied, acclaimed. A star. At 57 years of age, this British architect, born in Baghdad, is the lone woman at the ranks of great names in contemporary architecture: Rem Koolhaas, Frank Gehry, Herzog & de Meuron, Jean Nouvel. Today she plots buildings from Bilbao to Moscow, from Nanjing to Abu Dhabi, via Glasgow or Nicosia. Every day, her Bowling Green Lane studios bring in new talent from Japan, Australia, Slovenia—from the ends of the earth. Hadid operates at a fever pitch, and she has the constitution for it. Clad in black, she has the energy of a revanchist, a returning exile. Ever dedicated to versatility, she is belligerent, a brawler with outsize talent.

It is quite a sight when she heads home to her studio redoubt, fresh from her conquests. Her progress is tracked with live coverage: "The car is en route….she's almost there….she's turning the corner of the street….she's here!" Immediately everything whirls, and everyone fusses over her. One person opens the door, another relieves her of her shopping bags, a third carefully prepares her coffee. Hadid is like Mick Jagger in reinforced concrete; she has a swagger, and an incredible sense of rhythm. And disciplined too. Dilettantes need not apply.

She did her studies in Beirut, Lebanon. Diploma in hand, she then left to enter the firm of a future giant of architecture, Rem Koolhaas. She got basic training there, and after learning all she could, started her own practice. It was a difficult challenge because Hadid would have to wait patiently for the world to acknowledge her abilities. Back then, the experts judged her work with undisguised condescension. During Hong Kong's prestigious Peak competition, in 1983, she completely ignored the project brief. Refusing to provide the anticipated plans and models, she perplexed the architectural world by turning in a series of pictures streaked with black and red lines. One can recognize the influence of abstract art, science fiction, a whiff of *Blade Runner*, an attraction to the night. Her drawings display tremendous violence, as if Piranesi's etchings of prisons had been tagged by spray-can wielding rebels from the Bronx. They are magnificent and seemingly impossible to build. This gift for theater proclaimed her a genius, she was named the winner, and the plan

was summarily shelved. The Peak would never see architecture by Hadid.

But this bravura performance bowled over the world of architecture. Day, night, perspectives and chaos—her worldview has impacted the work of her peers. All owe her something. Following Hadid, the conventions of architectural presentation were plunged in darkness; images of nocturnal structures covered in electric lighting supplanted traditional views and elevations. Architecture became aggressive; it picked up pace and ruffled its hair.

It was in Weil am Rhein, Germany that she left her first physical marker with the Vitra Fire Station, a structure all done in acute angles, sharpened points, diminishing perspectives, fragments and incisions. What was a flight of fancy took shape, and it was information technology that had come to the aid of her imagination. She'd seen far ahead of the technical possibilities, and when they finally caught up with her, Hadid held fast. She then engaged numerous design competitions—which she lost one way or another. In the case of the Cardiff Bay Opera House, she in fact won the competition only to see politics scuttle the project. Picking herself up, she changed scales. At last she is now building. She's scored points in France, first building a tramway terminal in Strasbourg, then winning a big competition for a cultural facility in Montpellier and finally launching the construction of an office tower in Marseille.

In 2004, Hadid was awarded the Pritzker Prize, the architectural equivalent of the Nobel. The recognition was well deserved, as her architecture of fragments and strips had become, for better or worse, much imitated. All of the great metropolises now desired the Hadid touch. Recently she delivered two major buildings in Germany: the BMW Central Building in Leipzig and the Phæno Science Center in Wolfsburg, with crucial support from Volkswagen. These two masterstrokes added to the success of the Rosenthal Center for Contemporary Art in Cincinnati, Ohio.

A pictorial architect, Hadid employs a symphonic palette of black, reddish and bluish tones. The somber BMW building testifies to the evolution of architecture in concrete. To unify the composition here, a fluorescent-blue ribbon traverses all of the spaces, recalling the automobile assembly line. Ramps, inversions of planes, the floor becoming the ceiling, the walls ignoring the baseboards, all complete the creation of an architecture of disorientation, of complete deconstruction. Faithful to color,

she is also faithful to the ascent of the ramp. In the Museo d' Arte Contemporanea di Roma which she is currently building in Rome, as in the extension of the Ordrupgaard Museum outside Copenhagen, Denmark, the ceilings and the floors curve like bobsled tracks, the walls like icebergs or over-cut diamonds. For Hadid movement is a material, as are light and space. Manifesting the same capacity for invention, she's devised a sharp ski jump (Innsbruck, Austria), and invested a hotel room (the Hotel Puerta America, in Madrid, Spain) with a soft delicacy and a quilted whiteness fit for a space capsule.

She now has more than thirty buildings under construction. In 2006, Hadid won two more international design competitions: one for a trio of skyscrapers in Dubai's central business district the other for the "Spiraling Tower," in Barcelona. When completed, the Dubai project will feature three "Dancing Towers" of fifty-two, sixty-five and seventy-nine stories with the center tower connecting to one at the base and the other along the top floors. A hotel tower will merge at the seventh floor with an office tower and, at the thirty-eighth floor, with a residential tower. It is a choreographic architecture. As for the "Spiraling Tower," it will resemble a pile of precariously balanced books, consisting of eleven stories covered with continuous bay windows serving as a platform between the worlds of business and higher education. Hadid jostles not only forms but also functions.

For Louis Vuitton, Hadid poured her heart out in redesigning the Bucket, the house's iconic bag. What emerged for her was something resembling a strange wineskin saturated with a red-raspberry interior. To arrive there, she subjected this referential accessory to the entire battery of actions to which she normally subjects her architectural projects; her famous shapes—hybrid, lively and fluid—are always born of a process of extraction, distortion, polishing and cutting. And she crossed the Bucket bag with other basic forms, like the purse, the bucket, the handbag, and the basket. In short, she approached the bag as she would have approached the scheme for a philharmonic hall, applying to the reduced scale the same creative scheme that she would to the most imposing of buildings; to produce even a minimum of exhilarating matter, a maximum of gray matter is needed. This piece of nomadic sculpture was unveiled during the *Icons* exhibition, organized in 2006 at the Espace Louis Vuitton in Paris. The bag was a small, indispensable contribution to the brand's universe, but even when operating at the margins, Zaha Hadid remains monumental.

p.199 *Interpreting the Bucket bag*, installation (2006) by Zaha Hadid for the *Icons* Exhibition at the Espace Louis Vuitton, Fall 2006, various materials. Louis Vuitton Collection.

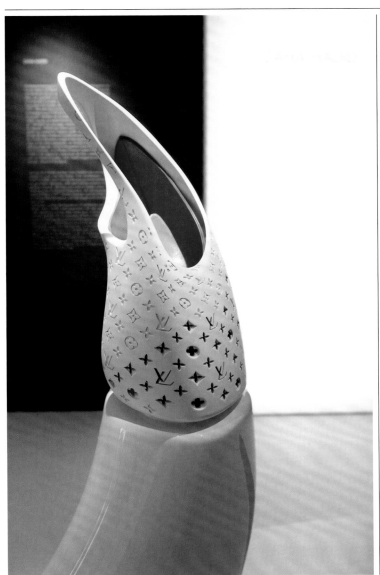

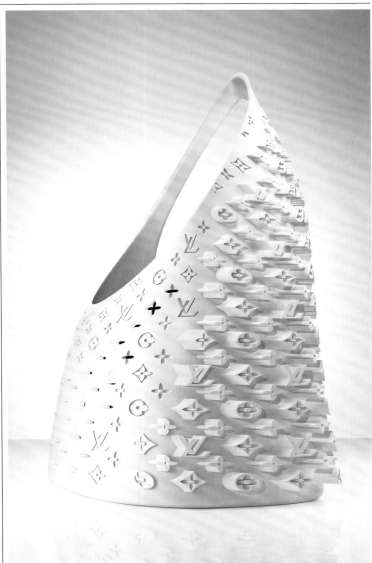

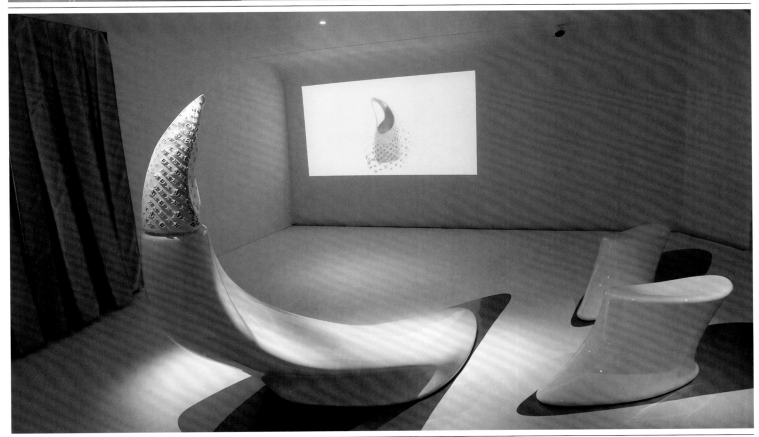

Hemmert, Hans

artist
text by Marie Maertens

Funny yellow balloons installed on furniture, sun-colored forms that become atypical bags... the world of Hans Hemmert seems to inflate and transform.

Sometimes the artist even films himself enclosed in his favorite balloon while the sculpture adapts to all the situations in his daily life. He inflates the membrane in his studio to the point of bursting and then has it star in videos or fill various places: for example his car, his living room or a gallery space. For Louis Vuitton, this German artist born in 1960, created a series of drawings that included accessories that are unusual to say the least. A backpack becomes a hip bag, with dangling purses. His mutant-women are wrapped in plastic bibs or jerry cans of water. A video, loosely based on Alfred Hitchcock's *Rear Window* was introduced in 2002 expressly for the Saint-Germain-des-Près shop, accompanied by his sketches.

While these pieces offer a new perspective on the banality and functionality of everyday objects, they also raise questions about exhibition space and the very status of sculpture. Should sculpture be imposing or should it adapt, should it explode or be enclosed? Hemmert's investigations become philosophical when they explore space, the physical, religion, the presence or absence of things. But, he always treats them with humor. He is, in fact, questioning his desire to participate in the world—and under which conditions.

p.200-201 A series of numbered drawings by Hans Hemmert, *0006/02/H. H. to 0029/02/H. H.* (2003), exhibited in Louis Vuitton Saint Germain. These drawings also appeared in a video inspired by Alfred Hitchcock's *Rear Window*, which was shown at the boutique during the exhibition Parcours d'Art contemporain de St Germain-des-Près, May 29th to June 18th, 2002. The pen-and-ink drawings (21.5 X 29.8 cm/8.5 x 11.7 inches) represent men and women sporting mutated objects. Louis Vuitton Collection

Hempel, Anouska

architect
text by Philippe Trétiack

Artist, designer and businesswoman, Anouska Hempel—a.k.a Lady Weinberg—has propelled herself to the interior design community's global elite, and being a former Bond girl certainly doesn't hurt. Born in New Zealand—"on a boat crossing from Papua New Guinea to New Zealand," as she likes to clarify—she left for Great Britain at the height of the Swinging Sixties. In 1969, she appeared *On Her Majesty's Secret Service*, directed by Peter Hunt. Playing an angel of death, the statuesque blond with her runway looks took the London scene by storm. She then secured parts in three films, including a scorcher by Russ Meyer, the cult auteur of the *Vixens* series. Transitioning into a full time designer in 1978, she opened what would become the legendary Blakes Hotel in South Kensington. Rock stars, actors, and the international jet set soon made it their headquarters. She soon inaugurated another and this time under her own name. The Hempel, showcases the breadth of her style, which balances a cool minimalism with warmth and opulence. Work concluded on her third establishment, the Warapuru, which faces the Atlantic Ocean in Itacaré, in Brazil's Bahia state. The architecture of Warapuru openly references Brazilian modernism, with rectangular volumes, sharp, graphic lines, and wide bay windows.

For Louis Vuitton, Hempel lent her signature style to the house's third Parisian boutique—the smartest of all, situated as it is in the heart of Saint-Germain-des-Prés. The woodwork and the luster of polished glass are dedicated to the insistent presence of the Existentialists—especially Jean-Paul Sartre, Simone de Beauvoir, and Juliette Gréco. Hempel found inspiration in the dark paneling of the great brasseries adjoining the boutique. The spirit of Les Deux Magots and Café de Flore bathes this space in diffused light. The depth of mahogany, the brilliance of finished steel, the richness of tortoise-shell, the simplicity of raw cotton, all imbue the boutique with a sense of well-being—a profoundly European brand of luxury, where the know-how of the artisan meets the imagination of the poet. Not coincidentally, Hempel also designed a line of pens for Louis Vuitton—Cargo, Doc, and Jet—precious tributes to the legend of Saint-Germain-des-Prés.

p.203-205 Interior views of Louis Vuitton Saint-Germain-des-Prés (1996), design by Anouska Hempel.

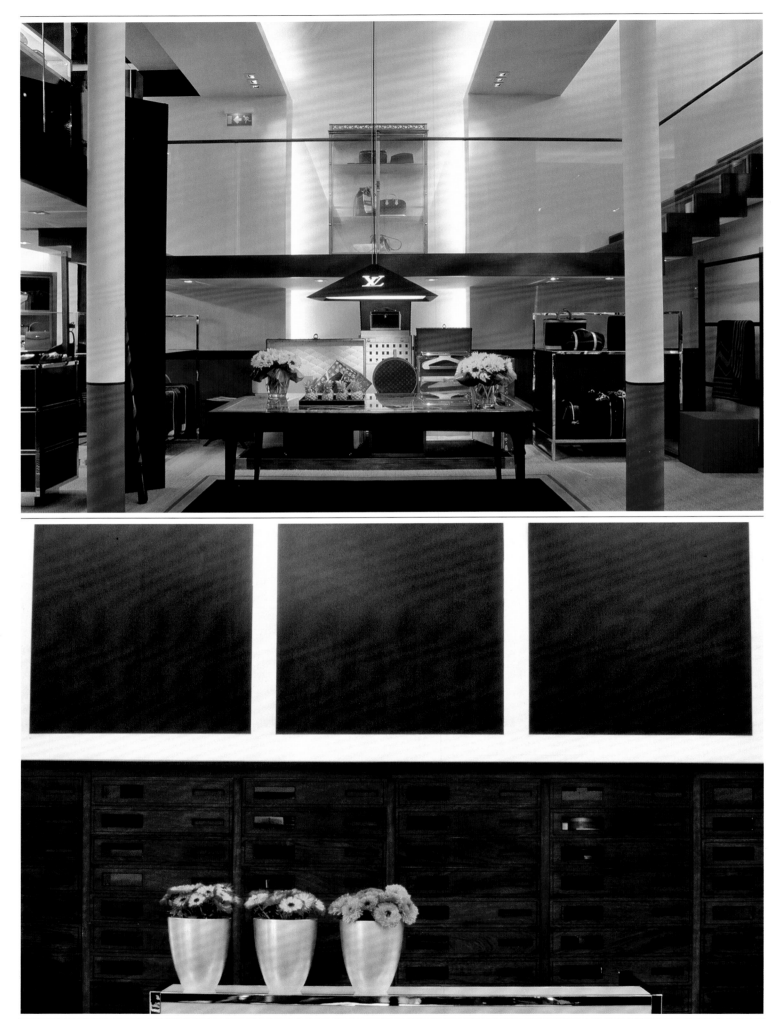

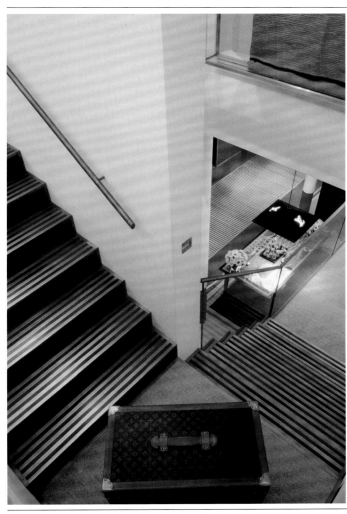

Inui, Kumiko

architect
text by Taro Igarashi

Born in 1969 in Osaka Prefecture, Japan, Inui graduated from the Department of Fine Arts, Architecture and Planning of Tokyo University of the Arts in 1992. In 1996 she completed a Master's degree from Yale School of Architecture in 1996. She apprenticed for Jun Aoki & Associates from 1996 to 2000 and later established the Office of Kumiko Inui. From 2000 to 2001, Inui was a Teaching Associate at the Tokyo University of the Arts. Her posts as non-permanent faculty include Kyoto University of Art and Design and Showa Women's University. While her interest in the ephemeral phenomenon of space derive chiefly from her experience at Aoki, Inui's exploration of intricate design that manipulates the conditions of light and shadow is entirely her own. She was an honoree of *Architectural Record*'s "Design Vanguard" in 2006, followed by the 24th Shinkenchiku Prize in 2008.

While Japanese architects customarily tackle residential homes at the beginning of their careers, Inui embarked on her practical journey designing interiors, facades and undertaking renovations. The overarching theme of her work has always been the control of visual effects. For the renovation of Kataokadai Kindergarden (2001), for example, Inui inserted vertical latticework into its exterior wall and painted horizontal stripes on the inner wall. When these are layered together, a checkered pattern surfaces. The distinctive look of the Jurgen Lehl store in Marunouchi (2003), on the other hand, is made possible through a subtle application of colors on the interior walls, creating an entity independent of the existing building's plan or form. Finally, the subtle use of "color design" seen in the Gotemba branch of Meleze (2003) generates shadows where they would normally not

exist—without the presence of a light source. Louis Vuitton in Kochi (2003), a project Inui won through a competition, was an entirely new building, but suggests a shell hewn out of an existing rectangular solid.

The Louis Vuitton boutique in the Osaka Hilton, as well as the Dior boutique in Ginza (both from 2004), showcase layered surface designs. Contrasting with the incised, diagonal grooves of the Dior store, the exterior wall of the latter features a double-pane polka dot pattern. The monument she designed in front of the new bullet train station for the city of Yatsushiro, in Kumamoto prefecture, is a pavilion with no discernable function. It is shaped like a house, but with 4,300 holes of varying size on its surface, it yearns to exist somewhere between the material and the nonmaterial. When seen from afar the structure resembles a private house, but when seen up-close, it is transfigured into a wall shot through with holes, thereby disintegrating all preconceptions about a traditional monument.

The Louis Vuitton Taipei (2006) also features a design focused solely on a façade—not a representative work of architecture. But Inui's imposition of an elaborate logic within the confines of a brief focused on surface effects is not only defined as "architectural," but it expands its very definition. In recent years Inui has begun to tackle freestanding residences as well. From Apartment I (2007), an attempt at stacking up one-room homes on a narrow site, to Small House H, a square-shaped structure cut off into four rooms with diagonal lines, Inui's architecture diverges from the traditional realms of living space, and continues to seduce the most delicate of senses.

p.207 Louis Vuitton Taipei, Taiwan (2006), by Kumiko Inui. The façade is composed of limestone panels that have 100,000 square dots inlaid with clear resin. The dot layout recreates the Damier pattern and the sizes change gradually, appearing to merge into the surrounding foliage.

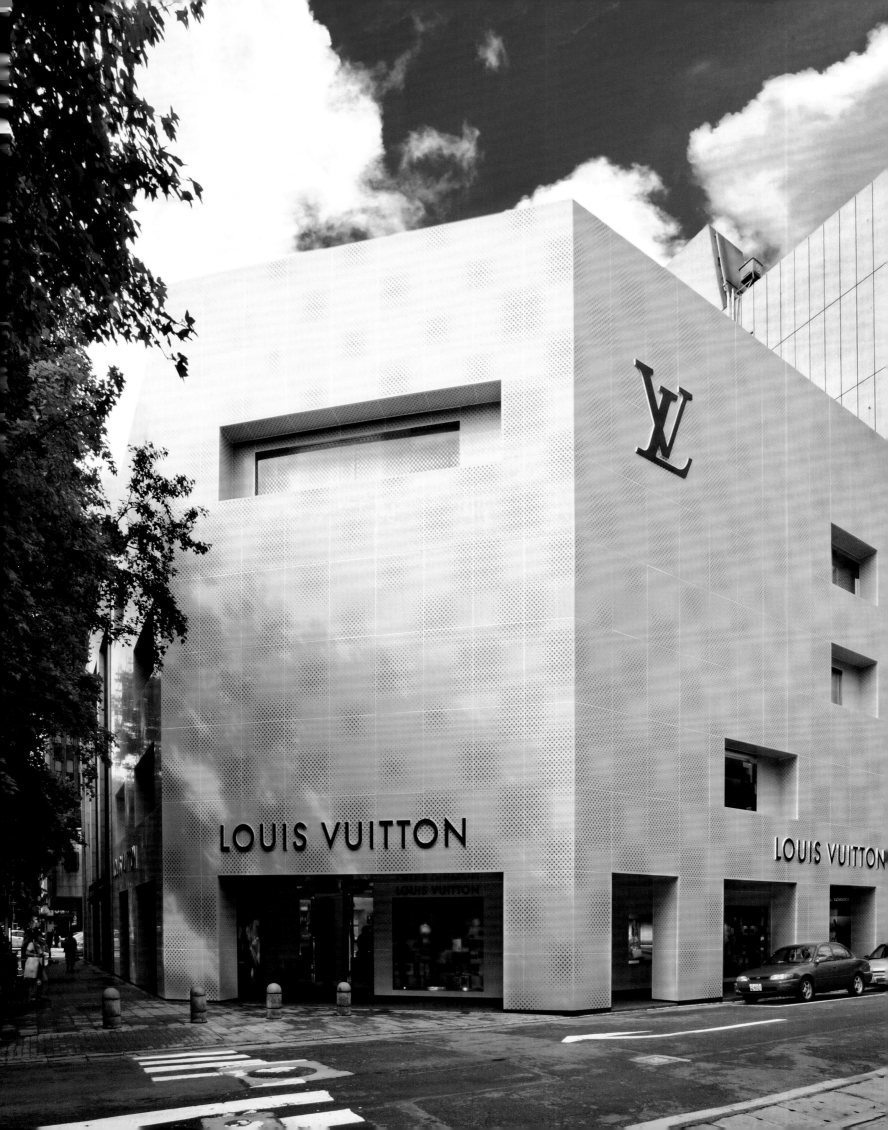

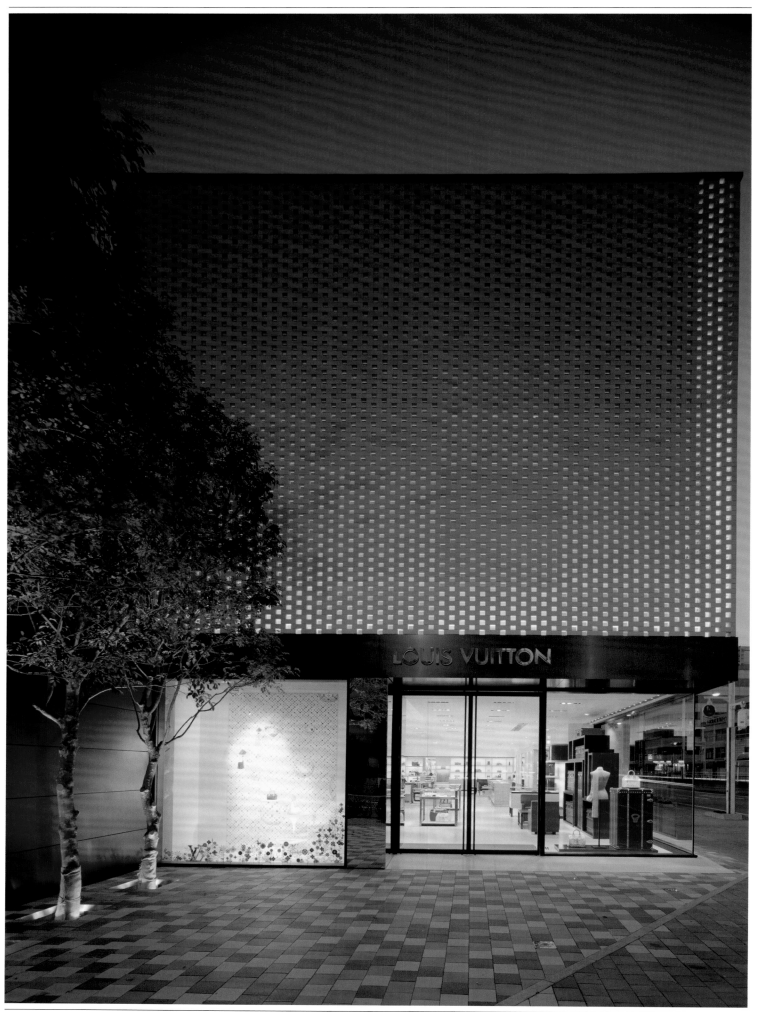

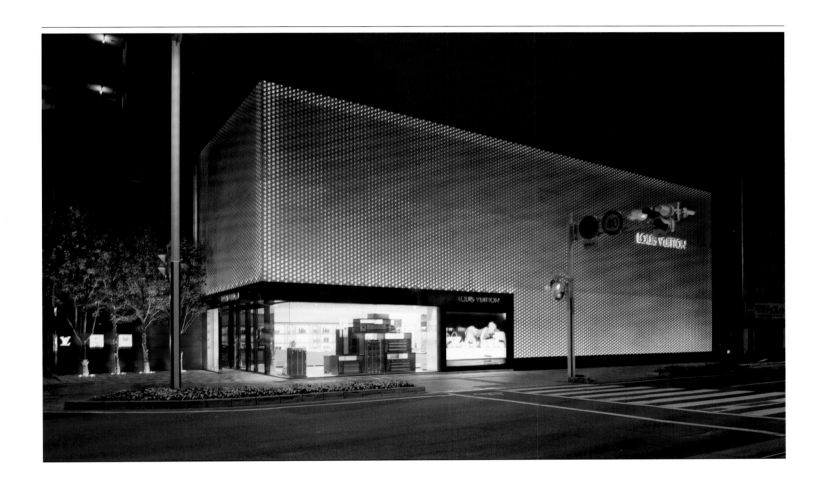

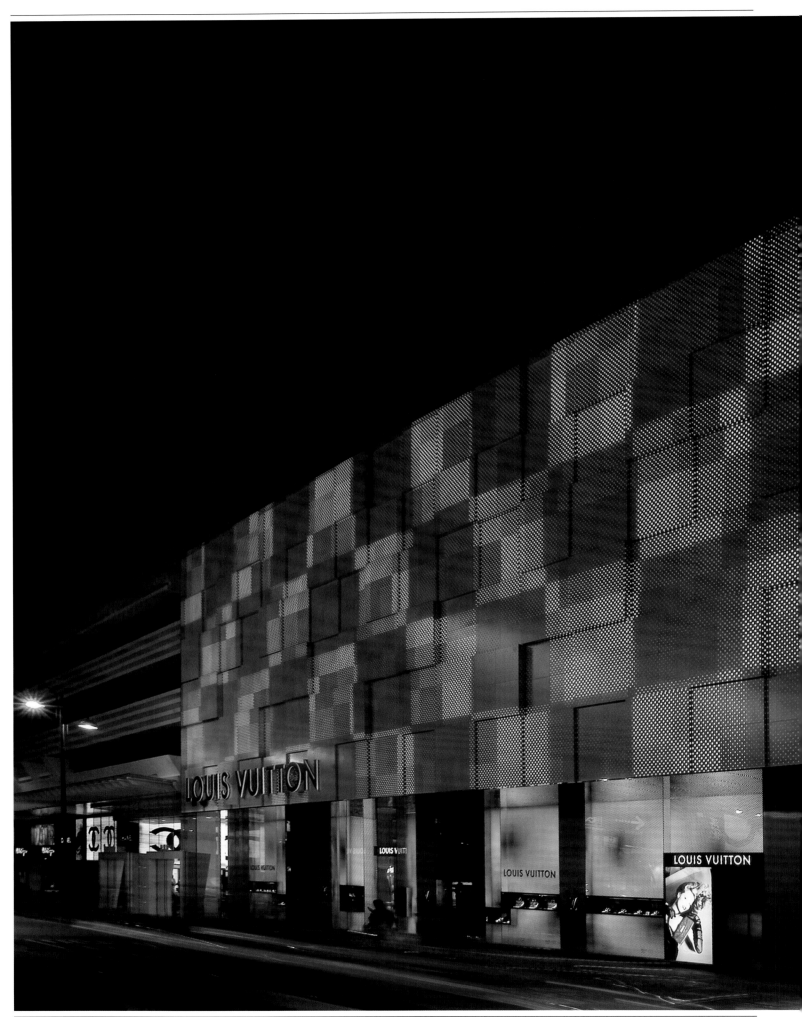

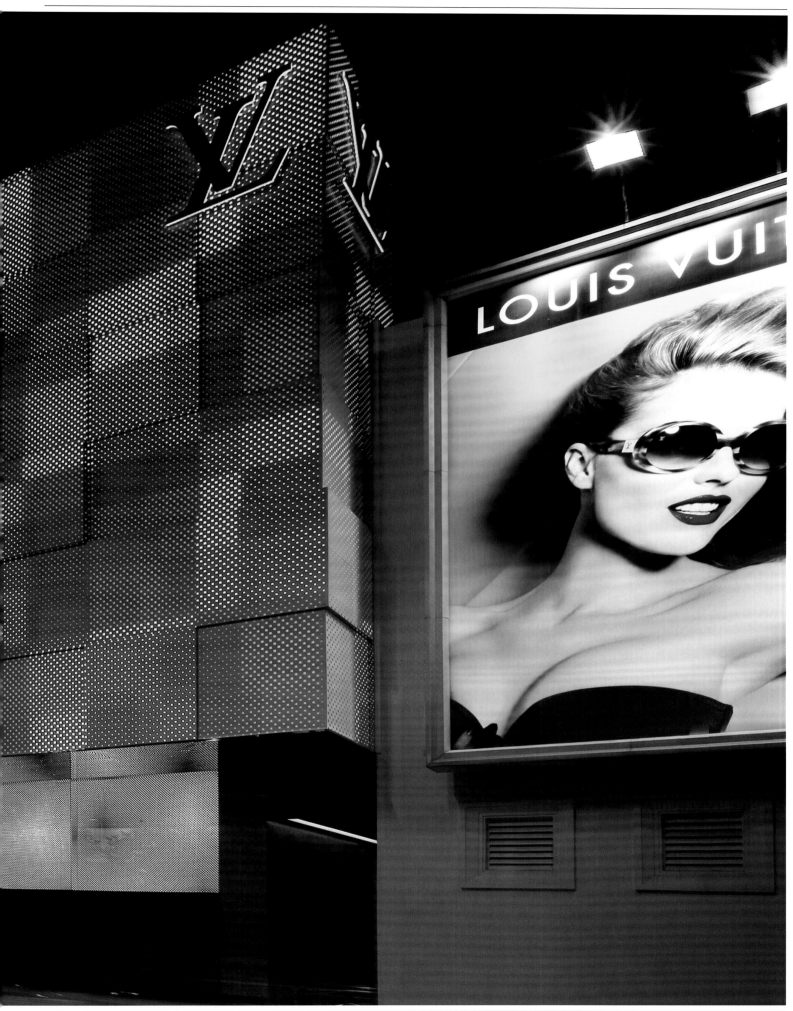

Isozaki, Arata

architect
text by Ian Luna

One of the key figures of postwar Japanese architecture, Arata Isozaki first acheived considerable acclaim in the 1960s with a number of landmark interventions.

Right around the founding of his own independent studio in Tokyo, the young Isozaki took on the design of the prefectural library for Oita, a coastal city on the southernmost island of Kyushu. A native of the region, the architect devised a solution high on formal expression. A hefty assemblage of intersecting vertical, horizontal and sloped members, the library was notable for its stunning use of concrete. Often described as as "mannered brutalism" the building—which its author proudly recalls "as his first original architecture"—became the calling card for a series of important civic commissions all over Japan.

Re-christened in 1999 as a museum commemorating Isozaki's life's work, the construction of the original Oita library job happily coincided with the building and engineering boom that engulfed Japan in the run-up to the 1964 Tokyo Olympiad. Announcing to the world the rebirth of an industrialized, democratic Japan up from the ashes of the Pacific War, the Olympics and the mostly public-sector work that followed in its wake proved a golden opportunity for a vigorous, homegrown modernism. Along with Isozaki, a clutch of architects grew around the mentoring presence of Kenzo Tange, and with

their confident forms swirling ever upwards, this elite group would determine the course of Japanese urbanism in the following decades.

That the posts and spanning elements of the Oita Prefectural Library resemble massive structural steel beams is no accident. They are rightly seen as an homage, as the city of Oita hosts key facilities for Nippon Steel, Japan's premier foundry. A few gestures on the library grounds also reference *torii*, the wooden post-and-beam gates that announce Shinto temples, and this particular ability to contextualize a structure—both materially and psychically—proved crucial to how Isozaki's work resonated with an influential clientele. With much of the 1970s devoted to a mannerist subversion of the modernist playbook, work for the office came hard and fast. These included the festival plaza at the 1970 Osaka Expo, the Gunma Museum of Fine Art (1974), the City Art Museum in Kita-Kyushu (1974) and the Kamioka Town Hall (1977).

By the early 1980s, fame in a resurgent, wealthy Japan had translated into work for Isozaki across the ocean. Ever the chameleon, he'd gently eased out of his mannerist phase and had by then morphed into a key proponent

of Postmodernism. His design for Los Angeles Museum of Contemporary Art (1986), was followed by iconic work for Disney—where his sense of play took him all the way east to Florida to build a headquarters building that clearly references Mickey's unmistakable ears (1991).

The Louis Vuitton job came on the heels of Isozaki having been awarded the Royal Institute of British Architect's Gold Medal in 1986—the first non-Briton in nearly a decade to have been so honored. The two scarves that he designed in 1987—*Repères dans la ville I & II*—are a clear nod to an extensive catalog of town center plans. With the main graphic elements inhabiting the diagonal axes of coal-black squares, Isozaki unabashedly employs images that appear to have been lifted straight out of design documents. Rendered in one square is the perspective of a horizontal building highlit in deep cobalt; etched in gold on the other scarf is a site plan for an assembly of buildings surrounded by a dense topography. Amplifying what would appear on drafting paper as monochromatic lines, the discrete use of color against a formless void creates a sophisticated drama between dark and light forms.

p.213 Top: *Landmark in the City II* silk square (1988) by Arata Isozaki. 90 x 90 cm (35.4 x 35.4 inches). Louis Vuitton Collection. p.213 Bottom: *Landmark in the City I* silk square (1988) by Arata Isozaki. 90 x 90 cm (35.4 x 35.4 inches). Louis Vuitton Collection.

Jacobs, Marc

artistic director since 1997
text by Valerie Steele

Lionized by fashion editors and adored by his fans, some argue that Marc Jacobs is changing what it means to be a fashion designer—just as once upon a time Andy Warhol changed what it meant to be an artist.

It is not simply that his collaborations with Stephen Sprouse, Takashi Murakami and Richard Prince have blurred the boundaries between art and fashion. Rather, as Glenn O'Brien says, "It would be hard to find someone who has done more to apply an artist's thinking to running a creative big business than Marc Jacobs."

Jacobs began making waves with his first runway show in New York in 1985, and was soon heralded by American *Vogue* as the "dauphin of grungy, understated cool." Both in the clothes he designed and in his personal style, Jacobs seemed to epitomize a mix of effortless New-York-cool that camaflouged the now well documented fact that he had spent most of his life feeling like a nerd. Moved by what he called "the beaten-down glamour" of the grunge music scene, Jacobs created his notorious grunge collection for Perry Ellis in 1993. Although it brilliantly captured the *zeitgeist*, it was not well received by the executives at the company and resulted in his firing. But not before Jacobs had made an indelible mark on fashion.

In 1997 he was named creative director of Louis Vuitton, where he took the same iconoclastic approach to reinterpreting the Louis Vuitton monogram by having Stephen Sprouse create a graffiti logo that was then printed over top of the classic Monogram—now more than 150 years old. Although he met resistance from the corporate side of the organization, he says, "We just did it. I thought, 'If they fire me, it won't be the first time.' And $300 million in sales later,

they thought it was a good idea." Several years later he collaborated with Takashi Murakami, replacing Louis Vuitton's traditional brown and gold palette with 33 different colors, adding cherry blossoms and pop art characters that again contrasted with the company's classic heritage. "The only time anything ever changes is when you're respectful and disrespectful at the same time," Jacobs says.

Jacobs has always enjoyed working closely with collaborators, friends and his creative teams at both Louis Vuitton and Marc Jacobs. He dismisses the "delusion" that a designer "is this great powerful Oz." It is the "creative exchange" that excites him. "Everybody who says they do everything themselves is exaggerating," he says. "Doing things by yourself is—well, it's masturbation. It's not nearly as exciting as doing it with somebody else."

The vicissitudes of Jacobs's personal life have added to his fame. His struggles with drugs and alcohol caused headlines, as has his recent dramatic physical transformation. Indeed, his move away from the nightlife has given way to a new enthusiasm for exercise and healthy living. His interest in contemporary art and popular culture have resulted in a host of fascinating collaborations, beyond clothes and accessories to include innovative advertising campaigns shot by Juergen Teller featuring celebrities such as Winona Ryder, Sofia Coppola and Victoria Beckham, and controversial retail operations, such as the Louis Vuitton boutique embedded

inside a Murakami art museum exhibition. Like Warhol, Jacobs has his detractors, who argue that he too freely appropriates styles developed by other designers, such as Yves Saint Laurent or Rei Kawakubo of Comme des Garçons. Certainly he is a magpie who references a host of past styles in true postmodernist fashion. But his combinations of references, his inspired mixture of high and low, and his impeccable timing make him one of the most influential designers of his time.

With his American irreverence, Marc Jacobs has taken the ultimate French luxury brand and given it new life. Accessories still count for a lot at Louis Vuitton, but the brand image is now more than just stunning handbags. The *malletier's* foray into ready-to-wear in 1998 has enabled Jacobs to make a powerful statement at the Paris collections. This is not simply the result of bravura showmanship, although his shows are spectacular. It is also proof of his ability to create a wardrobe of highly desirable individual garments.

Marc Jacobs appropriates existing ideas from the history of fashion. Then he morphs and samples them, and makes them look just right for now. But Jacobs is no mere stylist. He has an incredibly fertile mind. It would be more accurate to compare him with an appropriation artist, such as Richard Prince, or a postmodern DJ--sampling tracks. He draws boldly on existing work, giving it his own inimitable quirky modernity and underlying elegance.

p.215 Collection Louis Vuitton Prêt-à-Porter F/W 1998-99: the first look from the first Louis Vuitton fashion show by Marc Jacobs.

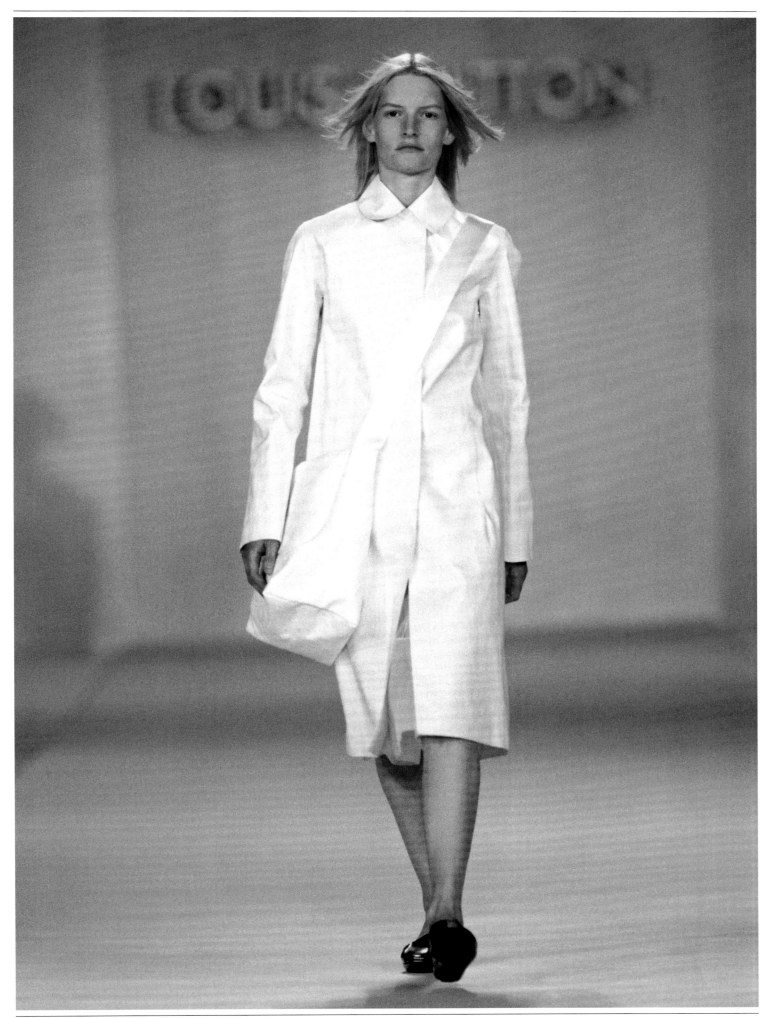

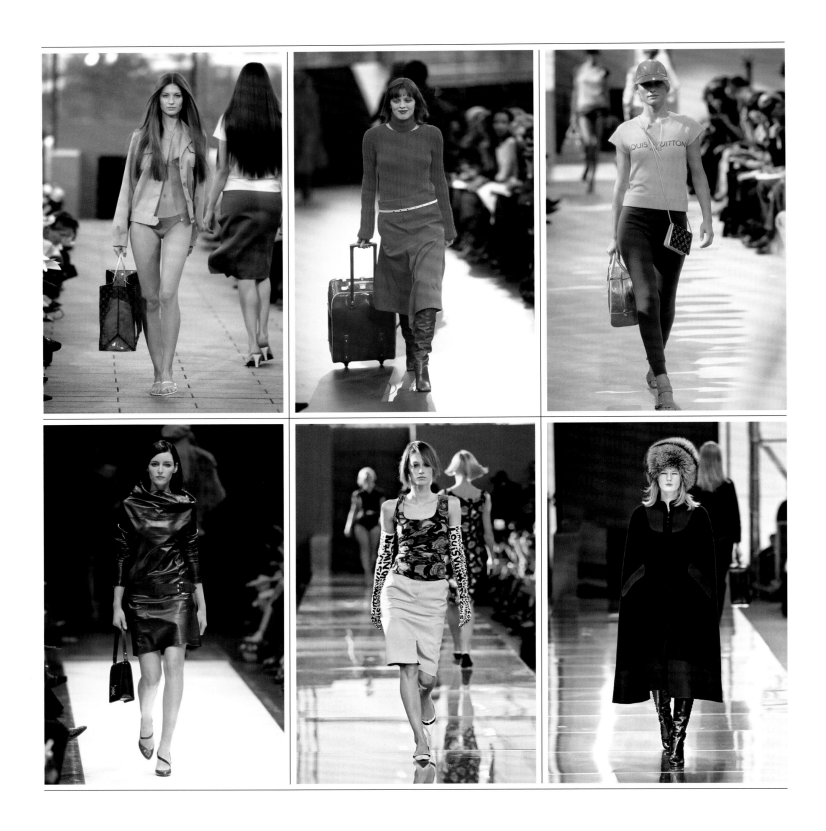

p.216 Clockwise from top left: Collection Louis Vuitton Prêt-à-Porter S/S 1999. Gisele Bündchen carries a tote in Monogram fabric and transparent vinyl. Collection Louis Vuitton Prêt-à-Porter F/W 1999-00. In travel mode, Karen Elson sports a Pégase suitcase in red leather Monogram Vernis. Collection Louis Vuitton Prêt-à-Porter S/S 2000. On Amber Valletta, a yellow t-shirt, a bronze bag, and brown leggings reference the colors of the Monogram canvas. Collection Louis Vuitton Prêt-à-Porter F/W 2000-01. The collection was inspired by the 80s. The model, wearing a black leather dress, carries a Cabaret evening bag in black patent leather embossed with the Damier pattern. Model: Danielle Zinaich. Collection Louis Vuitton Prêt-à-Porter S/S 2001. Camouflage silk jersey top, cotton skirt, ballerinas and leather gloves in black Grafitti by Stephen Sprouse. Model: Anastassia Khozzisova. Collection Louis Vuitton Prêt-à-Porter F/W 2001-02. In a Russian-inspired look, the model wears a fox hat, a cashmere cape and laced boots. Model: Lisa Ratliffe. p.217 Advertising campaign by Inez Van Lamsweerde & Vinoodh Matadin, featuring Kate Moss in F/W 2000-01 Prêt-à-Porter, with a Pochette Accessoires in Monogram canvas. p.218-219 Suspense advertising campaign by Mert Alas & Marcus Piggott, under the artistic direction of Marc Jacobs, featuring Eva Herzigová in F/W 2002-03 Louis Vuitton Prêt-à-Porter. This collection was inspired by Alfred Hitchcock 's Hollywood-era films.

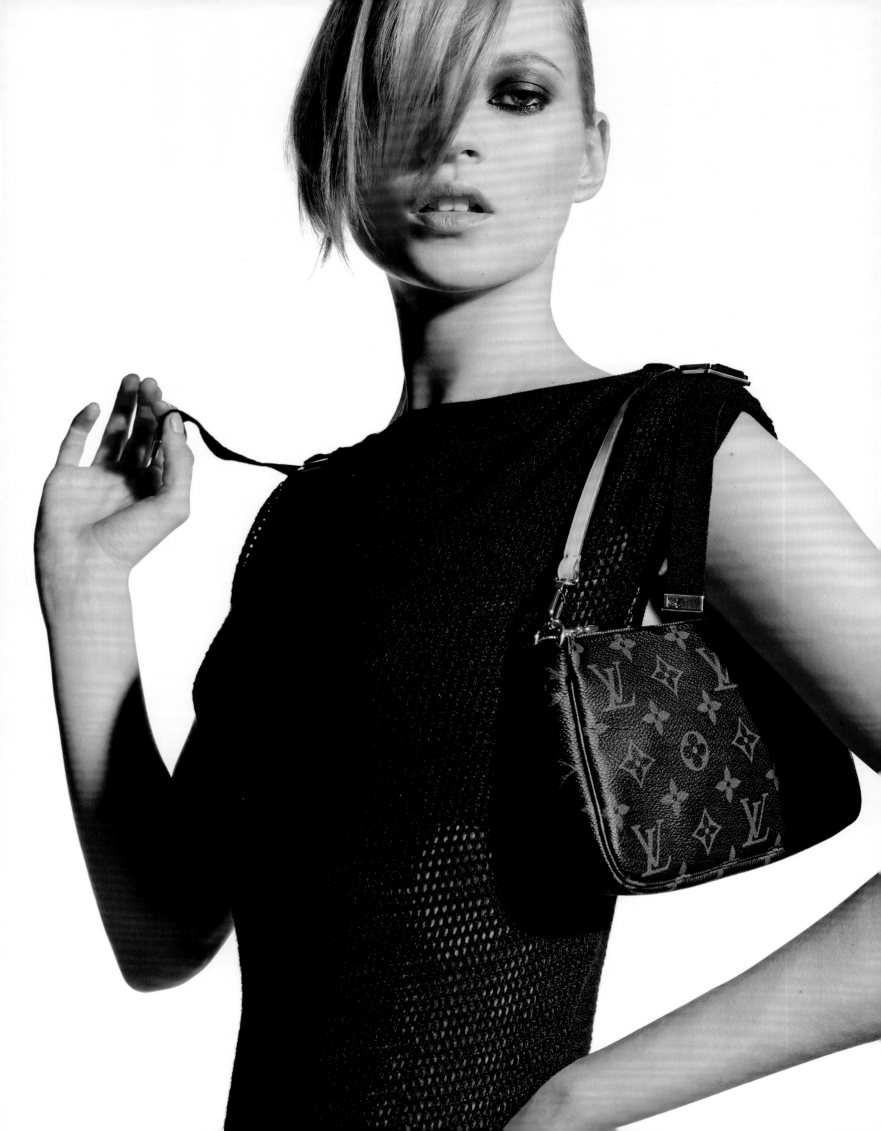

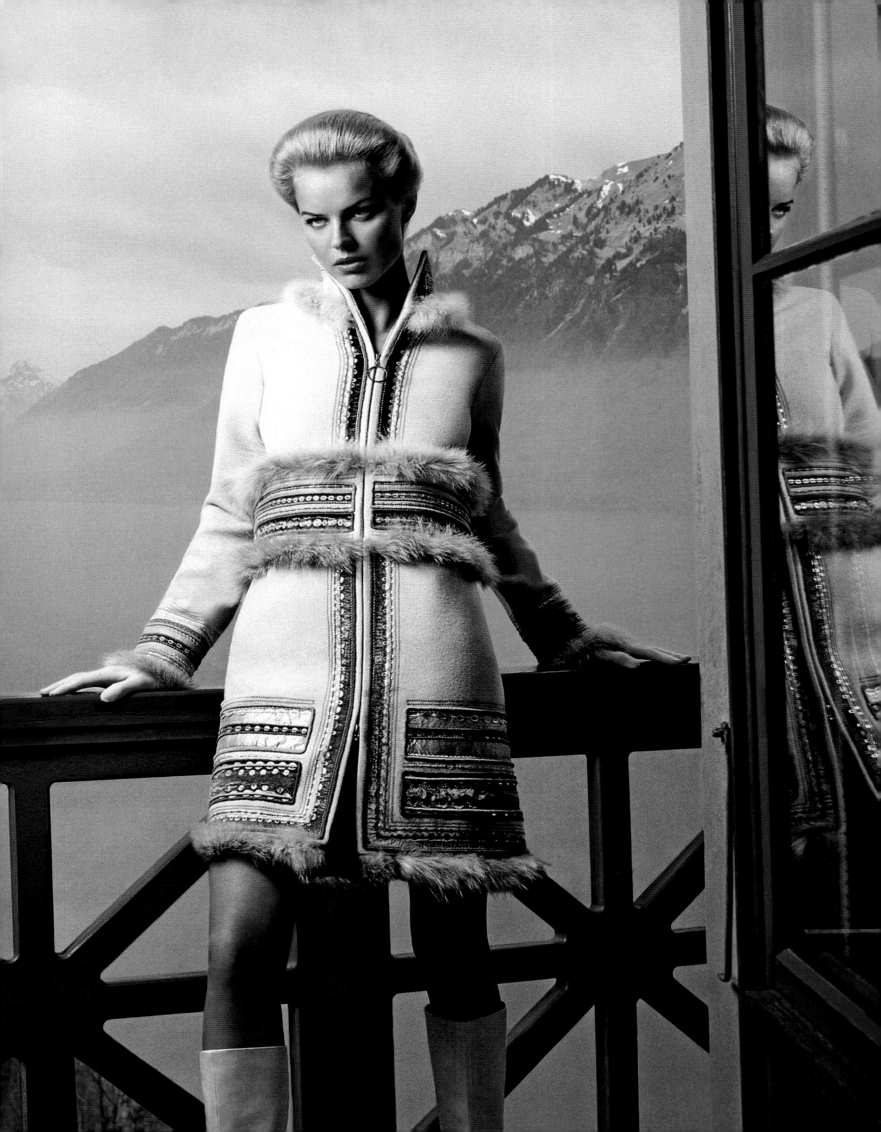

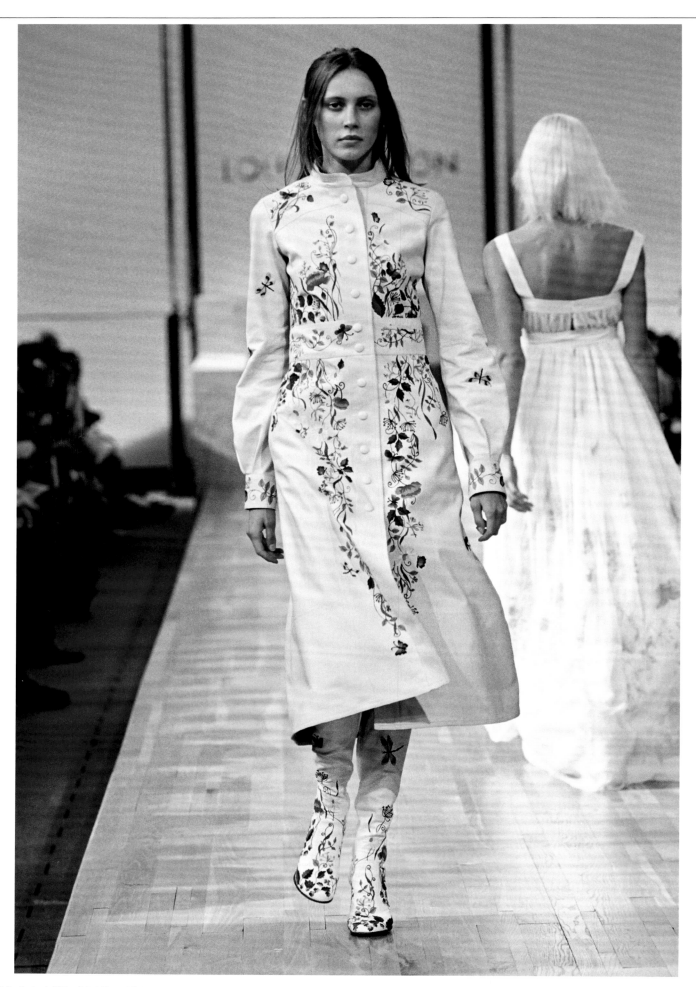

p.220 Collection Louis Vuitton Prêt-à-Porter S/S 2002. The model wears a lambskin coat embroidered with forms evoking a child's garden. For this collection, Marc Jacobs sought inspiration from traditional fairy tales, and collaborated with artist Julie Verhoeven. Model: Colette Pechekhonova. **p.221** Collection Louis Vuitton Prêt-à-Porter S/S 2003. A succession of models led by Sascha opens the show, wearing silk taffeta dresses in various colors, referencing the Multicolor Monogram that grew out of the initial collaboration between Takashi Murakami and Marc Jacobs.

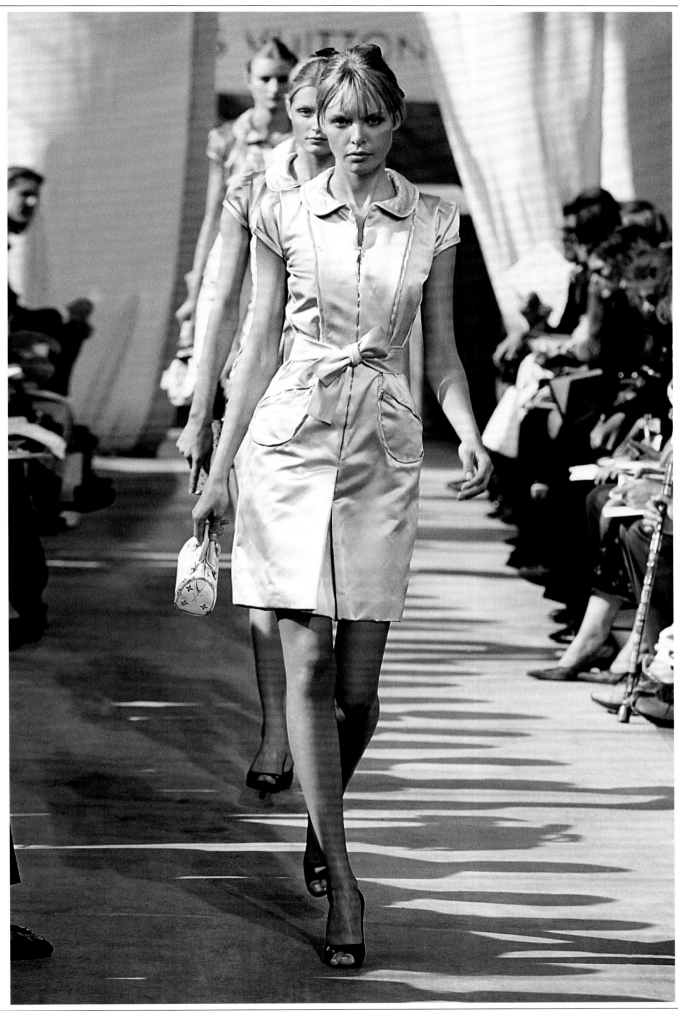

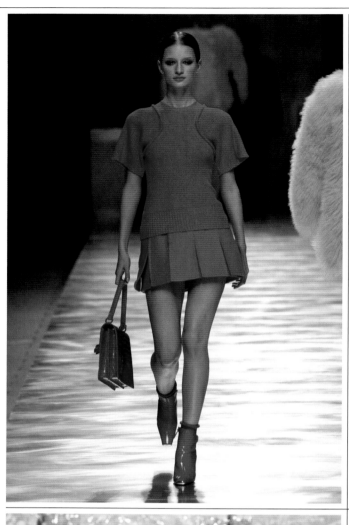

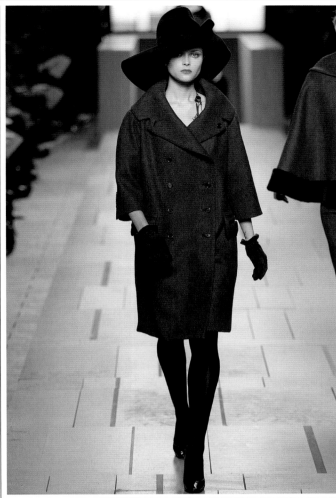

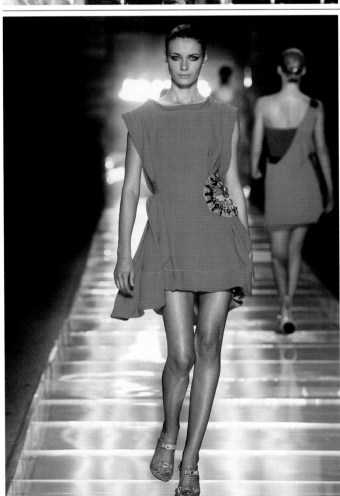

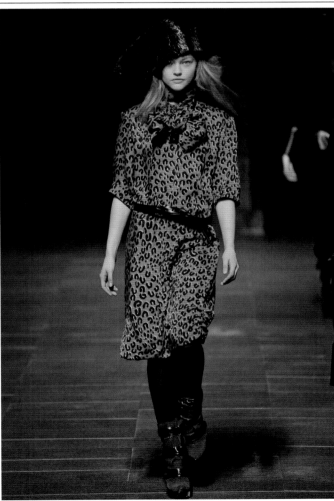

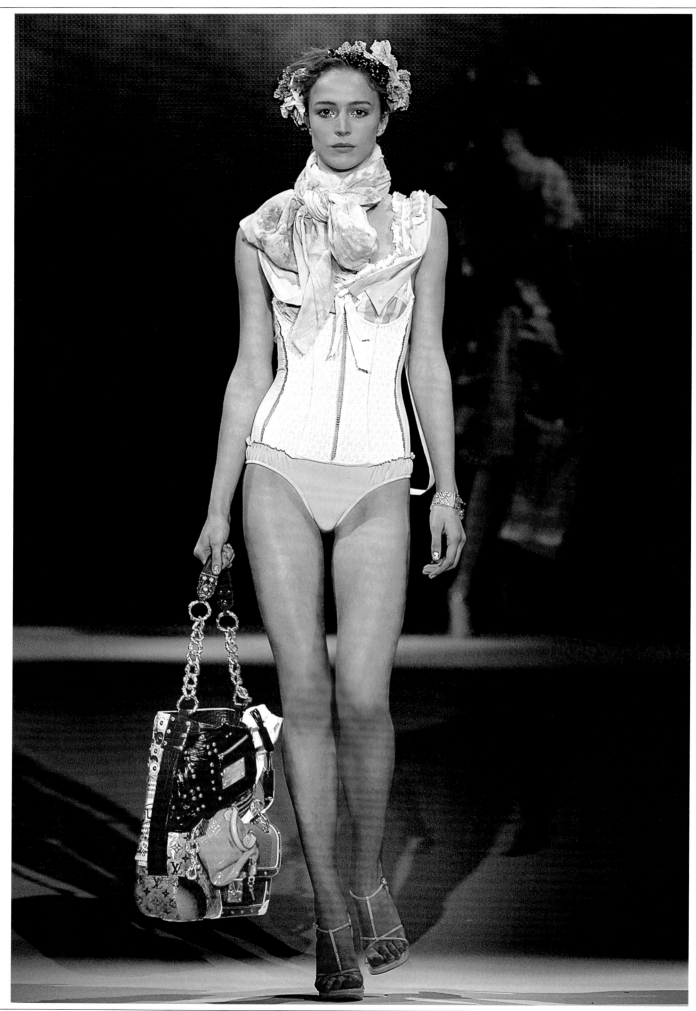

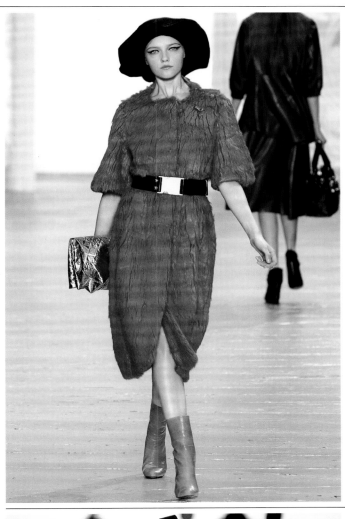
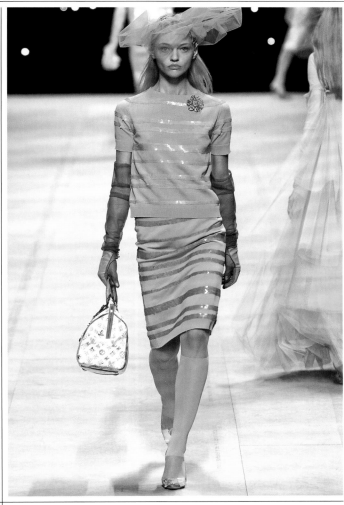
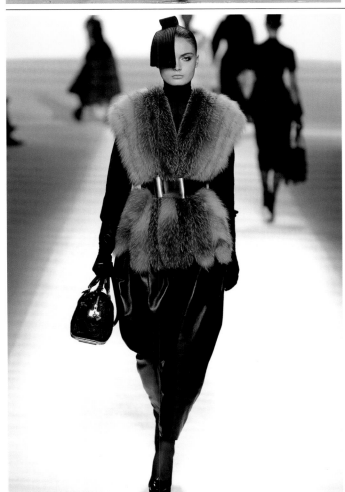
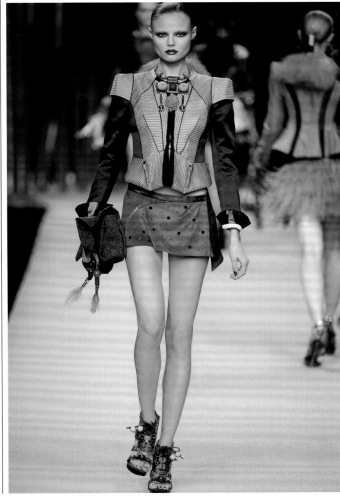

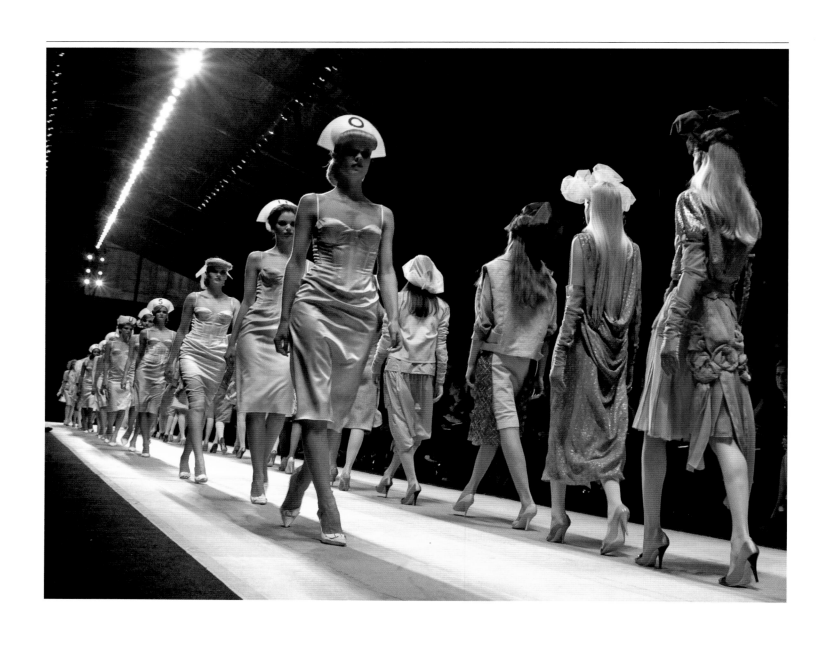

p.222 Clockwise from left: Collection Louis Vuitton Prêt-à-Porter F/W 2003-04. Monochromic looks and geometrical cuts: Marc Jacobs takes the Sixties as a starting point, and the Op Art movement, which lent its name to the bags of the season. Model: Linda Vojtova. Collection Louis Vuitton Prêt-à-Porter S/S 2004. Jessica Stam in a gold ostrich trenchcoat and a belt in gilded python. The collection took its theme from the ostentation of Cleopatra's court—through the lens of 1950s Hollywood epics. Collection Louis Vuitton Prêt-à-Porter F/W 2004-05. For this collection, Marc Jacobs drew inspiration from James Tissot's paintings and Scottish romanticism. Models: Tiiu Kuik and Michelle Buswell. p.223 Clockwise from left: Collection Louis Vuitton Prêt-à-Porter S/S 2005. A festive collection evoking a night at the circus. Takashi Murakami designed the Cherries Monogram canvas, which debuted at the show. Model: Isabeli Fontana. Collection Louis Vuitton Prêt-à-Porter F/W 2005-06. Marc Jacobs sought inspiration from the Vienna Secession and the paintings of Gustav Klimt and Egon Schiele. Model: Tasha Tilberg. Collection Louis Vuitton Prêt-à-Porter F/W 2006-07. Marc Jacobs paid homage to the late Stephen Sprouse, reinventing a dress in the leopard print designed by the artist. Model: Sasha Pivovarova. Collection Louis Vuitton Prêt-à-Porter S/S 2006. Elena Baguci wears an embroidered dress with appliquéd details. Providing the soundtrack to the show, this season saw one of the first collaborations between Pharrell Williams and Marc Jacobs. Williams designed the Millionaire series of sunglasses in 2006, and the Blason jewelry line in 2008. p.224 Collection Louis Vuitton Prêt-à-Porter S/S 2007. The Patchwork Tribute Bag is made from 15 different models of Louis Vuitton handbags and were limited to 24 individually numbered examples. They were sold for $45,000 each. Model: Raquel Zimmerman.

p.225 Clockwise from left: Collection Louis Vuitton Prêt-à-Porter F/W 2007-08. On Vlada Roslyakova is a mandarin orange rabbit fur coat, from a collection that drew inspiration from Vermeer and the golden age of Dutch painting. After the novel *The Girl with a Pearl Earring* (and the movie of the same name), Scarlett Johansson wore the same coat in the advertising campaign shot by Mert Alas & Marcus Piggott. Collection Louis Vuitton Prêt-à-Porter S/S 2008. Wearing a skirt and shirt appliquéd with contrasting sequins and mesh gloves, Sasha Pivovarova carries a Watercolor Monogram bag, based on an original work by Richard Prince. For this season, Prince mutated the 1896 monogram into a number of pop art iterations. Collection Louis Vuitton Prêt-à-Porter S/S 2009. In a collection inspired by the East, ethnic influences are notably exercised through accessories with bracelets in lacquered wood and jewelry with cabochons in rich colors. This look features a sueded ostrich skirt with python details, and a geometric jacket in silk and cotton. Model: Magdalena Frackowiak. Collection Louis Vuitton Prêt-à-Porter F/W 2008-09. This collection conferred a special place for fur, and featured in this look is a fox vest. The caps featured in the show provide an accent to the collection's lines, are the one shown here is composed of satin and oversewn leather ribbons. Model: Anna Mariya Urazhevskaya. **p.226-227** Runway views from Louis Vuitton Prêt-à-Porter S/S 2008, with the nurse look inspired by paintings by the artist Richard Prince. For the show's finale, Marc Jacobs carried the Video Trunk, with TFT-LCD screens on all sides broadcasting Sponge Bob Squarepants, whose image Richard Prince first appropriated when he sketched the character's on the back of bank checks.

Art, Fashion and Architecture *227*

Kallima, Alexey

artist
text by Marie Maertens

The Russian artist Alexey Kallima could be the ultimate dance floor painter.

His figures move, jump, leap and only show their faces in nocturnal sunlight. These interacting bodies feed the dynamism of the composition and pull the viewer into their world.

Kallima created an unusual experience for *Moscopolis*, the exhibition at the Espace Louis Vuitton in which several of his fellow countrymen were given *carte blanche* to produce a new work. These artists produced their projects in situ, working around the clock in their makeshift studios on the Champs-Elysées. His contribution was a fresco made with phosphorescent paint entitled *Les Jeux avec le feu* (Playing with Fire). Kallima is familiar with large formats. An expatriate from Chechnya, where the war made a huge impression on him, he investigated many mediums in his early work, including installation and performance. Trained in social realism early on, he is also an outstanding draftsman. In 2005, he took on the walls and ceiling of Marat Guelman, the Moscow gallery, and soon after, presented the fresco entitled *Metamorphosis* at the first *Moscow Biennial*. Kallima draws his aesthetic from a vast repertoire of art history that dates all the way back to the Italian Renaissance. He combines what he has learned from Mantegna, Uccelo and Veronese with very contemporary references like the logos of Adidas and Marlboro. He has Chechen fighters combating Russian soldiers in choreographies reminiscent of Tarantino's *Kill Bill*. The artist, inspired by the concept of heroism, offers his version in a painting presenting the war with a certain degree of passion. A deeper analysis reveals that Kallima is questioning his generation and divulging his opinion on the transfer of power in what once was the Soviet Union. Although the symbols of Communism have lost their power, what new ideologies have replaced them?

p.229 *Playing with Fire* (2007) by Alexey Kallima; Phosphorescent paint on gypsum wall, dimensions variable. Installed at the Espace Louis Vuitton for the exhibition *Moscopolis* (Fall 2007). Louis Vuitton Collection.

Kawakubo, Rei

designer
text by Olivier Saillard

The collections of Rei Kawakubo, the Japanese designer behind the label Comme des Garçons, are massive, not only in number, but also in their impact and diversity. Since 1975, the year of her first collection in Tokyo, and then in 1981, the first year her collections were shown in Paris, the designer launched a series of stylistic revolutions that today span the vocabulary of contemporary fashion. Kawakubo was quickly recognized for a pauperism in which the unfinished, holed, worn, or fragmentary became sublime. Rejecting the idea of a strict creative methodology, one that might force a designer to be repetitive, Kawakubo's collections are fresh, distinct from each other and often contradictory. A runway show in which black prevails might be followed next season by a collection that is bright in color. As ever, each article is approached with a playful sense of deconstruction.

For more than thirty years Comme des Garçons has been the symbol of avant-gardist fashion. The designer's determination and her propensity to reinvent—beyond mere form—the system of received knowledge that has long guided the profession have made her one of the most influential couturiers of the twentieth and twenty-first centuries. In addition to controlling every stage of design, production and distribution, Kawakubo has also invented a new visual language. The images, the boutiques, the events and even the perfumes are true models of expression and autonomy.

In 2008, on the occasion of the thirtieth anniversary of Louis Vuitton Japan, Comme des Garçons was invited to play with the codes of the *malletier*. Kawakubo designed six bags that were sold exclusively in only one location in the world—from a temporary boutique in Tokyo. One of the handbags was equipped with several handles, another with charms and amulets covering the famous monogrammed canvas. Each dutifully pays reverence to the storied heritage of Louis Vuitton and that of a Japanese label that is always a step ahead of its time.

p.231 Party Bag (2008), designed by Rei Kawakubo of Comme des Garçons. Louis Vuitton Collection.

230 **Louis Vuitton**

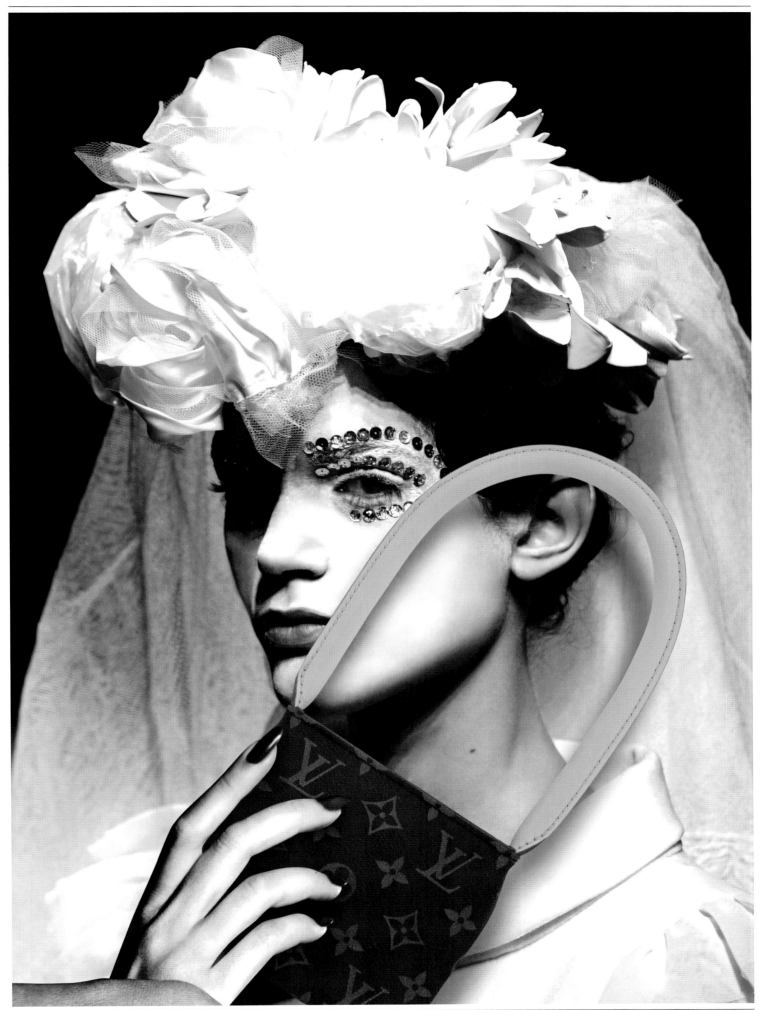

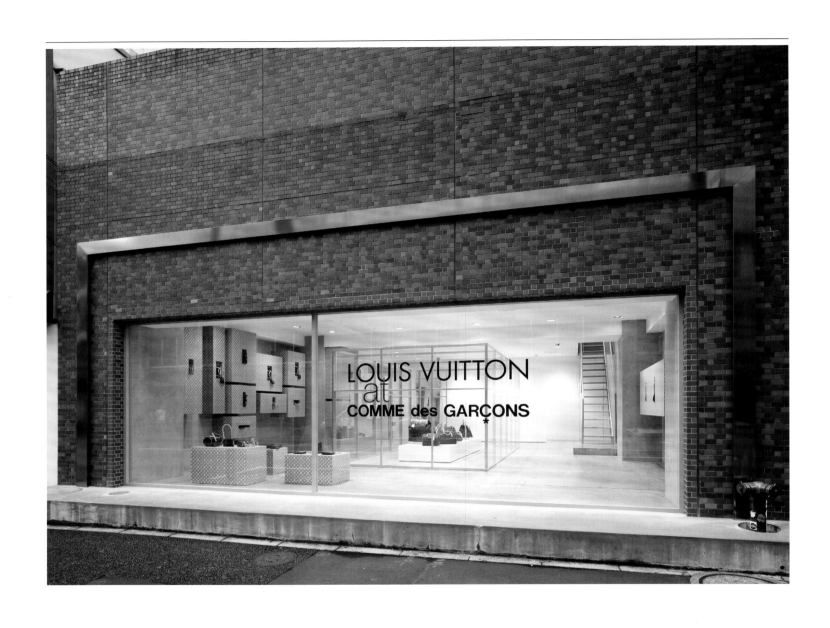

p.232-233 The limited-edition bags were sold exclusively at a temporary "Louis Vuitton at Comme des Garçons" shop in Minami-Aoyama, Tokyo in September 2008.

232 **Louis Vuitton**

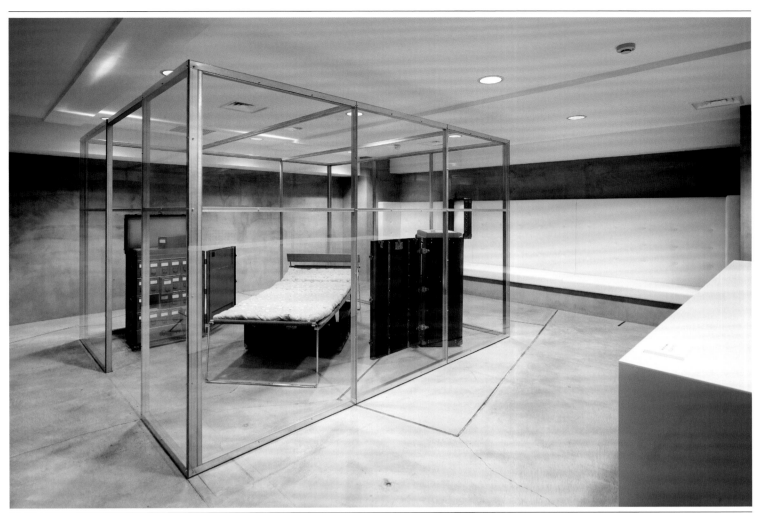

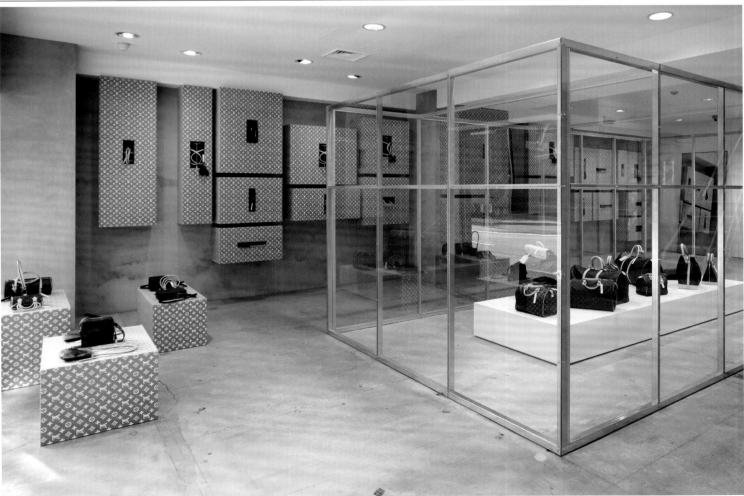

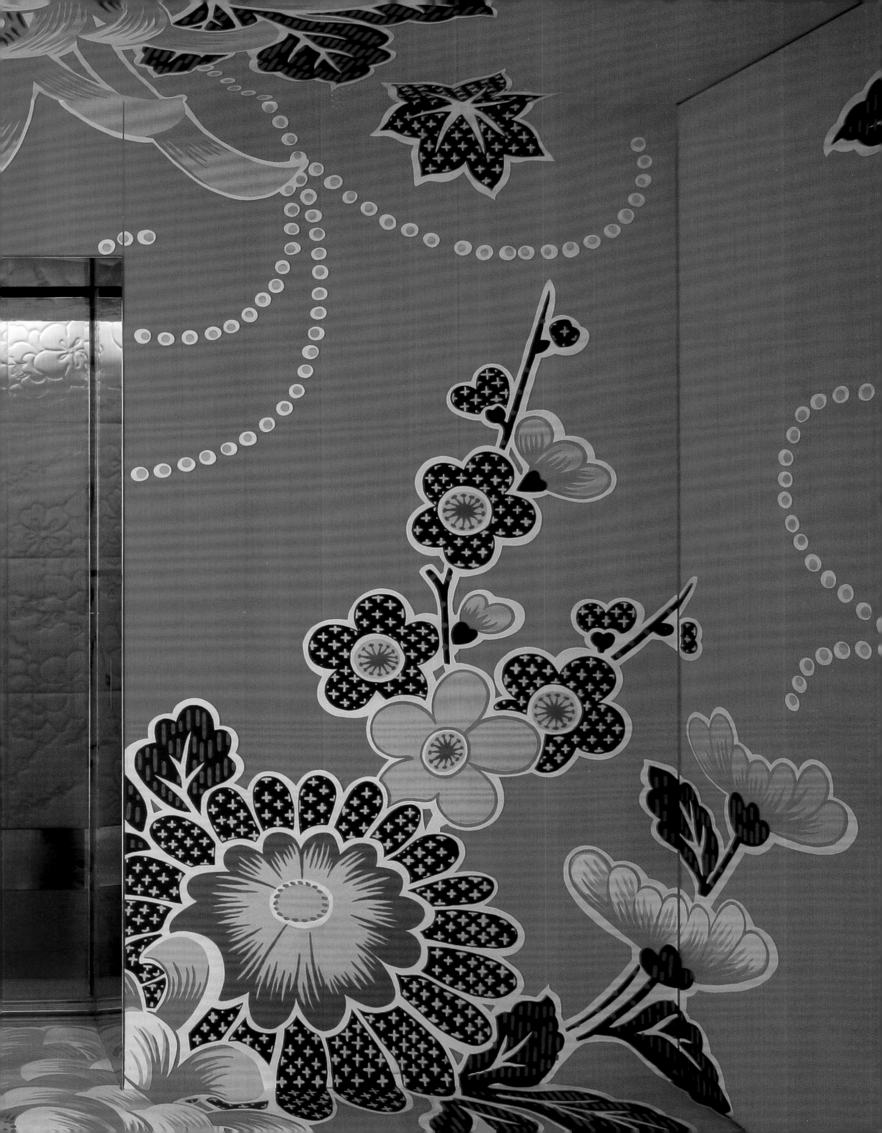

LaChapelle, David

photographer
text by Emmanuel Hermange

Born in Connecticut in 1963, David LaChapelle recalls how his mother showed him a **Playboy** *photograph of Ursula Andress nude under a waterfall, and crowed, "Now that's what a woman's body should look like!"*

His passion for photography began early with snapshots his mother helped stage. But he'd probably never imagined that years later, he'd be shooting—for the same magazine—a nude Naomi Campbell lying on a kitchen floor, creating her own personal waterfall by emptying cartons of milk over her body. A far cry from the soft-focused reverie typical of erotic images in the 1970s, this over-the-top sexuality has become emblematic of LaChapelle's world.

But make no mistake: his universe embraces more than just sex. Instead, he focuses on the visual codes and metaphors that modern culture has constructed around the human body, adopting these conventions only to disparage them with his brand derisive, neo-pop irony. His approach features a pronounced discord between the literal treatment of these metaphors and the critical distance he introduces through the deployment of saturated colors and shameless kitsch.

LaChapelle's work is immersed in American pop culture, and draws from a deep well of charged fantasies and stereotypes. The body is both an object and subject of desire, exhibited in every imaginable way: as a highly idealized exterior surface, posed amid food arranged to suggest décor rather than nutrition, smeared with household waste, reified rather than dead. *LaChapelle Land* (1996)—the title of his first monograph—featured models that were often close friends, including Amanda LePore, whose body he often shows as if completely reconfigured by silicone,

and celebrities from rock/pop circles (David Bowie, Courtney Love, Madonna, Elton John, Björk), in politics (Hillary Clinton), fashion (Alek Wek, Alexander McQueen), television (Jerry Springer, Pamela Anderson) sports (Muhammad Ali, David Beckham), as well as architecture (Philip Johnson), art (Jeff Koons) and film (Elizabeth Taylor, Faye Dunaway, Leonardo DiCaprio).

Following his first job at *Interview*, most of LaChapelle's photographs ran in fashion and punk rock culture magazines before being more widely and permanently displayed in sumptuous monographs and museum and gallery shows around the world. After making advertising films for brands like H&M and Passionata, and music videos (for Jennifer Lopez, Britney Spears, Rihanna etc.), David LaChapelle created his first full-length film, *Rize* (2005). It was a documentary on "krumping," a hyper-energetic street dance form that originated in South Central Los Angeles.

Intrigued by popular culture personalities, LaChapelle took a particular interest in Lil' Kim and Kanye West. Born in 1975, Lil' Kim was brought up in an African-American neighborhood in Brooklyn, moved out of her family home at the age of fifteen and got involved in drugs to make a living before meeting her lover and mentor Biggie Smalls in 1995. Lil' Kim's first solo album *Hard Core* was a major hit in 1997, the same year that Biggie Smalls was murdered. One of LaChapelle's best-known photographs is of a nude Lil' Kim, embellished with the Louis Vuitton monogram from head to toe. He originally wanted her to pose in an airport hangar surrounded by Louis Vuitton trunks, with her body tattooed with the names of her friends. Ultimately, however, he decided on this simpler image that better served his purpose of photographing Lil' Kim "as a high-priced luxury item." It took several hours for the street artist Ernie Vales to airbrush the monograms onto the singer's body. Kanye West, a producer on Lil' Kim's second album (*Notorious K.I.M.*, 2000), recently emulated the singer in the luxury referential game by adopting the pseudonym "Louis Vuitton Don" after using the expression in the song "Stronger" in his album *Graduation* (2007). This move inspired Louis Vuitton to invite him to design a line of men's shoes.

Photographing Kanye West for *Rolling Stone*, LaChapelle tested the limits of provocation. He decided to show the rapper as a Christ-like figure in a series of theatrically staged panels depicting the Flood, the Pieta and other themes drawn from Christian iconography. With their apocalyptic backgrounds, these pictures make it clear that David LaChapelle's body of work intends to achieve just one goal: projecting our world into the next—the world after the deluge.

p.234-235 Permanent installation (2006) by Michael Lin for the interior of the Louis Vuitton Store, Taipei, Taiwan. Store design by Kumiko Inui. **p.237** *Lil' Kim: A Luxury Item* (1999) by David LaChapelle; color print; 61 x 51 cm (24 x 20 cm). Louis Vuitton Collection.

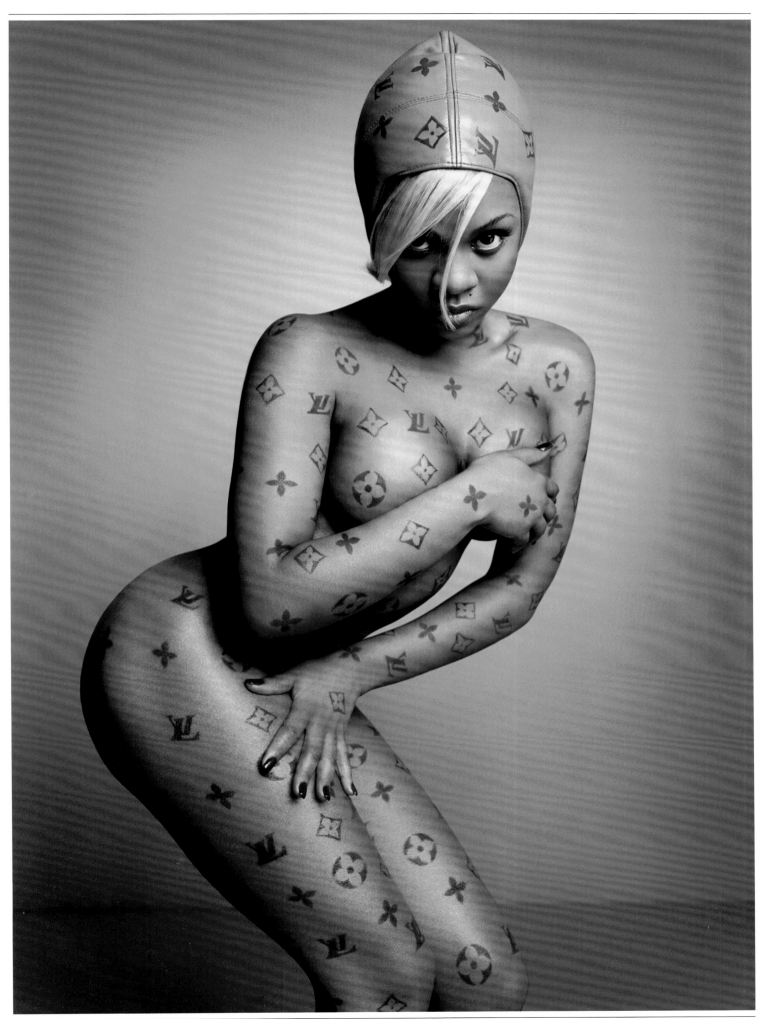

Lambours, Xavier

photographer
text by Emmanuel Hermange

Born in 1955, Xavier Lambours discovered photography when he acquired the equipment of an uncle that he had never met, but of whom, according to his family, was his spitting image. His career began at very young age. At twenty, he was a member of the burgeoning Viva agency, founded in 1972 by Martine Franck, Claude Dityvon and Richard Kalver that aimed at creating a new approach to photojournalism. He wasn't there long before he joined the magazine *Hara-Kiri*, and where, after seven years, he'd developed a unique style that combined incongruity, aloofness and humor. "It looks like you photograph animals," Jean-Louis Trintignant remarked to him while observing the portraits that Lambours showed him before their photo shoot in Cannes, where he covered the film festival for the newpaper *Libération* in 1983. His first book, *Ciné-monde*, was released the same year by Editions de l'Etoile. It included these portraits as well as others shot at the Festival de Deauville and the Mostra di Venezia. Amid the proliferation of conventional PR images during the festival, the particularity of his shots lies in his process, which often utilizes an element of surprise. He generally imagines a situation, a place and a rough scenario, into which tries to immerse his model. He also includes two singular technical elements: first, he uses a 6x6 format, quite uncommon for portraits in a reportage context, but which he adopted early on, drawing inspiration from Diane Arbus's work; second, the open-flash technique, which Lambours helped introduce to the field of photojournalism. In this method, the flash is fired several times while the shutter is opened, at times producing a fantastic aura in the image; for instance, in the shot of Orson Welles that Lambours managed to take through a car window; or the portrait of François Truffaut, whose face seemed both restless and carved in stone. Lambours once asked Eartha Kitt to hold the flash and fire it when he signaled, showing how this technique could transform the actual act of photography by sharing it with the sitter. In this fashion, he sometimes also includes himself in the image through the use of a mirror, as seen in the portrait of Nanni Moretti. This way of staging and adding a little fiction in his portraits gave rise to a number of collaborations with writers such as Didier Daenincks, with whom he created a *photo-roman* film (*La Cicatrice*, 1989).

For his portrait work in the film industry, he received the Moins Trente award (Centre National de la Photographie) in 1985, and obtained an important commission that resulted in the publication of *Figures du Limousin* (Herscher, 1987), which he produced with sociologist Pierre

Maclouf. In 1989, in collaboration with nine other photographers, including Marie-Paule Nègre, Luc Choquer and Michel Séméniako, he founded the Métis agency. Based on shared principles and a break with the sensationalism dominating the news industry, the agency concentrated on theme projects like *Paris la nuit* (Paris-Musées, 1994), a modern adaptation of the perspective Brassaï brought to the capital in the early 1930s. For this project, Xavier Lambours decided to track firemen during their night-time rounds. This glimpse of a once-familiar world after dark led him to shoot Les Halles de Rungis with a panoramic camera (*Le Rungis de Lambours*, Editions du Bottin Gourmand, 1998). He used this format once again for a behind-the-scenes series at the Cannes Film Festival, this time by putting 35mm film in a medium format camera (*Perforations*, 2003).

In 1998, Louis Vuitton asked him to become a sort of ambassador of the leather soccer ball with the Louis Vuitton monogram, which the fashion house released as a limited-edition for the World Cup. Xavier Lambours traveled to many countries in search of notable celebrities (from film, music, business, politics, etc.) and included their portraits in a book, *Rebounds* (Louis Vuitton, 1999), the proceeds of which went to UNICEF. After joining the photography house Signatures in 2007, he recently presented a work called *XL27*. Convinced of the utility of art in describing abstract political ideas, he photographed twenty-seven female artists in residence at the Cité Internationale des Arts, representing the twenty-seven countries of the European Union.

In 1994, Lambours was awarded the Niépce award for his work documenting the circles of power in contemporary Japan during a residency at the Villa Kujoyama in Kyoto, where he was the first photographer to ever be admitted (*Gaijin Story*, Editions Marval, 1995).

p.238 *Michael Douglas, USA, Actor, Central Park, New York*, from *Rebonds* series (1998) by Xavier Lambours; Diasec print; 110 x 110 cm (43.3 x 43.3 inches). Louis Vuitton Collection.

238 **Louis Vuitton**

p.239 *Peter O'Toole, England, Actor, in a Taxi, London* from *Rebonds* series (1998) by Xavier Lambours; Diasec print; 110 x 110 cm; (43.3 x 43.3 inches). Louis Vuitton Collection.

p.240 *Mickey Rourke, Paris* (1987) by Xavier Lambours; burned color positive film; 108 x 108 cm (45.2 x 45.2 inches). Louis Vuitton Collection. p.241 *Isabelle Adjani, Tan Tan, Morocco* (2004) by Xavier Lambours; black-and-white print; 92 x 175.5 cm (32 x 69 inches). Louis Vuitton Collection.

Lang, Helmut

designer
text by Olivier Saillard

p.242 Chrissie Hynde of the Pretenders with the DJ Vinyl Box, December 1995. **p.243** On the centennial of Louis Vuitton Monogram in 1996, Helmut Lang created the DJ Vinyl Box in Monogram canvas, wood, leather and synthetic materials, Photograph by Guzman. Louis Vuitton Collection.

The influence Helmut Lang has had on fashion in the last three decades is undeniable.

The Viennese designer broke away from the runway show-as-spectacle, which promoted clothing that was unwearable, but was nevertheless celebrated by the fashion press. Ever since his first collection in 1986 in Paris, he insistently promoted the allure of a simple, elegant and urban clothing that he had always been fond of. It has been incorrectly said of Lang that he spearheaded all the minimalist trends that defined the 1990s.

His work is really more about essentialism. Although his early palette was spare—blacks and grays austerely applied to a spare and fitted wardrobe—his last runway shows (Helmut Lang interrupted his career in 2005) expressed a creativity and whimsy that remained at the cutting edge. It was even apparent in evening dresses that one can slip into as easily as a leather jacket. The efficient lines at the heart of his fashion and the somber aesthetic that filled his world (from Louise Bourgeois to Mapplethorpe, whose work he collects and showed in his former boutiques) are worlds unto themselves. Lang has reconciled a commercial fashion audience with a highly personal and discreet approach, but one that does not fall into the trap of excessive intellectualizing, that sometimes transforms women into an abstraction. He also helped launch a practical uniform for the city whose pants—like a long-legged second skin—have surely contributed to the elastic silhouette that has become part of the 2000s.

Dedicated to an urban sound, for the centennial of the Louis Vuitton Monogram in 1996, Lang designed a square trunk reminiscent of a vanity case, that instead holds records and albums for the DJ on-the-go.

Larivière, Jean

photographer
text by Emmanuel Hermange

The collaboration between Louis Vuitton and Jean Larivière that began in the 1960s is one of the most remarkable relationships between a brand and a photographer in history, and transformed both advertising and fashion. Like the ties that bound Charles Jourdan and Guy Bourdin, and Cacharel and Sarah Moon, the union of Louis Vuitton and Larivière (born 1940) is notable not only for its longevity but also for its distinctive themes. In addition to his landmark advertising campaigns, the most famous of which, *The Spirit of Travel*, dates back from the early 1980's, Larivière created a series of more personal works that drew inspiration from the world of Louis Vuitton. Epic in scope, these gorgeous vistas updated the image of the firm, which was established in 1854, revitalizing it with a contemporary vision. Let us hope that these photographs, his complete œuvre thus far, will be compiled for publication some day. Much of it is currently held in collections, including those of Louis Vuitton and the Musée National d'Art Moderne in the Centre Georges Pompidou.

Jean Larivière's passion for legends in all their varied forms helps explain his method of storytelling. In his Parisian home, which also houses his photography studio, visitors bear witness to a parade of eclectic objects, ranging from marionettes, exotic furniture and gongs to a toy collection that includes games and puzzles dating back to the eighteenth century. These articles evoke tales of long ago, and they sometimes weave space and time together in curious ways. Mesmerized by a spectacular scale model of a Burmese temple, fashioned in wood with astonishing detail, the onlooker is made aware that Larivière visited and actually photographed this structure for one of *The Spirit of Travel* campaigns. This maquette was not a travel souvenir however, and was actually from an auction house in Chartes, lovingly copied from the Louis Vuitton ad by a French admirer of Larivière—who had never set foot in the actual building. Pondering the serendipitous origins of this art object, the visitor is quickly immersed in the photographer's universe. The images seen in fashion and photography magazines, and in retrospectives in Paris (Musée des Arts Décoratifs, 2006) and Moscow (Petit Manège, 2007) are merely the tip of the iceberg. The guest that delightedly follows his host through this elaborate labyrinth opens a window into the mind of a restless explorer of worlds. The scene shifts from a short science fiction feature that he has just completed (*Œuvre X*) to story boards for a four-minute animated film entitled aux *17e Rictus parallèle* created in 1968 for *Loin du Vietnam*, a group project organized by Chris Marker whom he also assisted in the film *Si j'avais quatre dromadaires* (1966). *Œuvre X* is set in the reaches of outer space, where fantastic spaceships in the forms of that legendary Louis Vuitton monogram float among the stars; a space opera that reimagines the mystique surrounding the 1896 design, then conceived primarily to protect the brand from counterfeiting. *17e Rictus parallèle*, part of which inspired Jean-Luc Godard's contribution to *Loin du Vietnam*, tells an allegorical history of a country with pink-garbed guards and an army of ten thousand penguins. There is a detour through allegorical portraits of personalities ranging from Philippe Starck, Natalia Vodianova, Pierre-Alexis Dumas and Pascale Mussart to Jacques Monory. Larivière is still working on these, deploying a combination of drawing, photography and video.

We next encounter *Jamais-Toujours*; although described as an incomplete work, the film seems like an actual locale in itself, a fertile field that nourishes and inspires all that set foot in it. Larivière began this animated film in 1962, just after completing his studies at the Ecole des Beaux-Arts in Angers, training that he had found disappointing. Lacking financial support in 1972, he had to suspend his work on this project, but the journal *Zoom* wrote an enthusiastic article about him at the time. "This photographer-graphic artist-filmmaker has introduced a new form of self-expression: he doesn't use brushwork – instead, grasping his Linhof camera, he "tapes" his subject, which, more often than not, is a machine opened up to expose wheels and bolts and cathode tubes that evoke flesh and guts, but also suggest feelings, dreams and fantasies. Then the photo is worked over and superimposed on another image, again and again. Sometimes, with clever tracing and wavelike curves […] a design emerges that takes an elliptical form, while another line shoots into the sky and a third shape follows the whimsical path traced by the artist's imagination." Larivière and the surrealist painter Roberto Matta met in 1969 through a mutual friend who was later named Miss Europe (can this be true?). Matta was fascinated by *Jamais-Toujours*, which seemed to reflect his own pictorial research into infinite dimensions. He realized, "Larivière is no ordinary artist. Instead of just showing all his work in thirty exposures, he traffics in spatial-temporal surfaces that create a film when the images are strung together." This cryptic description suggests the abstract, complex nature of the project. The words become a bit more comprehensible when you learn that Larivière developed his drawing style at a very young age. His boyhood reading concentrated on Sir Walter Scott and James Fenimore Cooper, and he was obsessed with Jules Verne, who takes us straight to the "open belly of the machine." All the images of *Jamais-Toujours* are based on photographs of six components extracted from inside a TV. They create a kind of landscape on which he superimposed objects and people to create the film's narrative texture, thus anticipating *Tron* (1982) with a less linear screenplay and a more experimental aesthetic. Matta was right when he observed in the same issue of *Zoom*:

"The art of animation has been hijacked by an unfortunate development. It's a question of our own—and Walt Disney's—stupidity…I believe in the quality of this technique [animation] because the camera can film where the body cannot go. It's very important to see the inner world with the inner eye, to represent life rather

p.245 (top) *La Rencontre* from the *Spirit of Travel* ad campaign by Jean Larivière (1997) in Burma, featuring the Excursion bag in Monogram canvas. **p.245** (bottom) *La Libéllule* from the *Spirit of Travel* ad campaign by Jean Larivière (1997) in Burma, featuring the Gobelins bag in yellow Tassili Epi leather.

244 **Louis Vuitton**

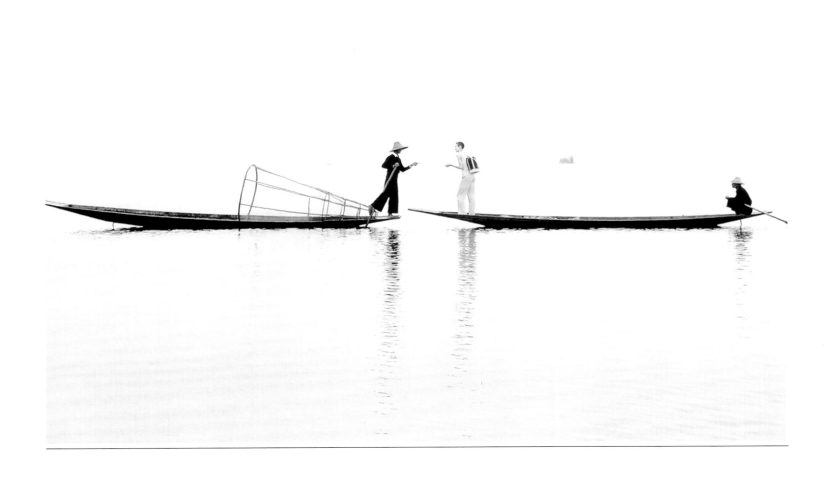

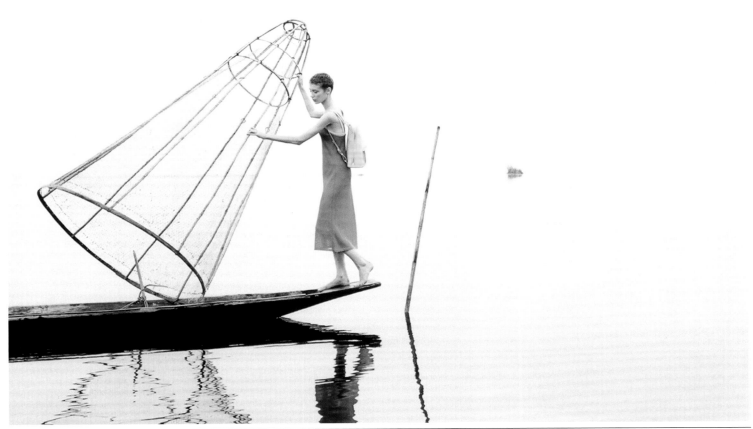

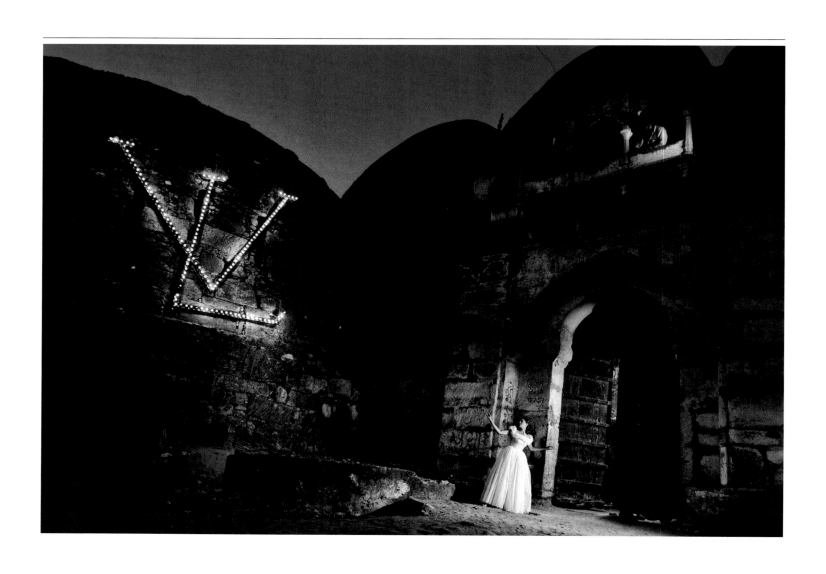

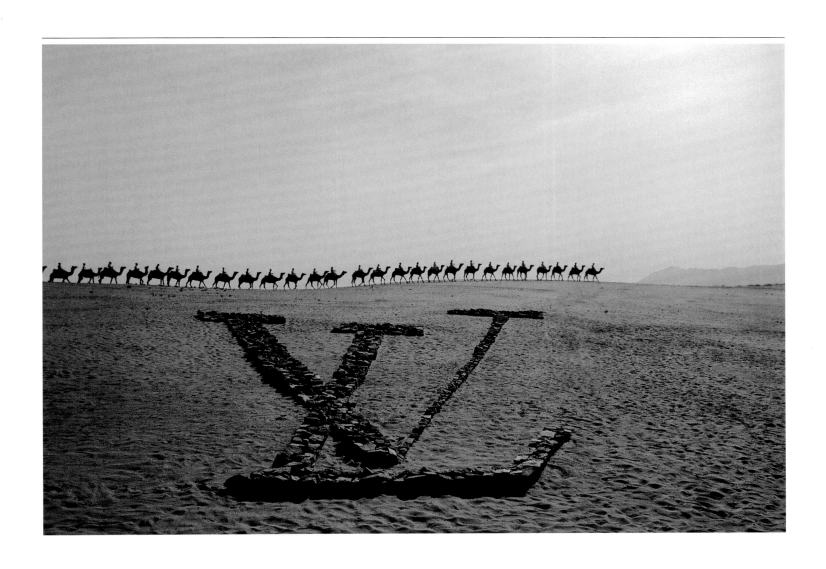

p.247 *Le LV en pierres, Œuvre Louis Vuitton, Pushkar, Rajasthan* by Jean Larivière (1988); 66 x 78 cm. (26 x 30.7 inches). Louis Vuitton Collection.

Art, Fashion and Architecture *247*

p.248 *La comète est une petite fille, Œuvre Louis Vuitton, Paris*, by Jean Larivière (1986); 66 x 78 cm. (26 x 30.7 inches). Louis Vuitton Collection.

p.249 *Le Livre, Œuvre Louis Vuitton, Paris,* by Jean Larivière (1988); 66 x 78 cm. (26 x 30.7 inches). Louis Vuitton Collection.

Art, Fashion and Architecture *249*

p.250-251 Stills from the animated film *Œuvre X* by Jean Larivière (2007), reimagining the constituent parts of the 1896 Monogram as spaceships hovering over unknown worlds. Louis Vuitton Collection.

than just the literal truth... To give life to the inner being of 'each and every thing,' you'd have to find something like Queen Isabella's jewels to pay for Larivière to solve every problem and set sail like Columbus into the open sea."

Max Ernst was also intrigued by this project, as was Salvador Dalí, who proclaimed himself ready to provide support if the author agreed to make "the great artist" the hero of the story. Larivière now claims that he would like to complete this animated film, but how can he forget that he chose its title "because this story has a beginning, but not an end, because the creator wants it to go on "forever;" it's a film that will never be finished." Perhaps Larivière will never complete this film because he's been making it forever. Thus the underlying nature of a work invades the work itself: surpassing its own limitations, it arrives at completion through the ensemble of the artist's creative activities.

Jean Larivière made his advertising debut in 1972 with still life photographs, and his first venture in fashion photography occurred with Charles Jourdan's 1984 and 1985 campaigns. He then essentially became Louis Vuitton's visionary-at-large, and found himself sought after by major fashion magazines (*Vogue, Citizen K*, etc.) and global brands such as Cartier and Virgin. Larivière spoke with Paul-Gérard Pasols about his first encounter with Vuitton's management in 1977, at the conclusion of which he was given a *carte blanche* to create. He recalled: "I'd brought along still life photos with jewelry and a book on India [...]. I remember saying that, in my opinion anyway, luxury is timeless. I wanted to do photographs that were just as much images of the past as of the present or future. They would be both contemporary and timeless, evocations of beauty, luxury, serenity, tranquility and fantasy."[1] As the brand sought

to boost its international market share with modern management and communications techniques, this *carte blanche* soon took the form of *The Spirit of Travel*. Between 1980 and 1993, the campaign transformed Louis Vuitton into the ultimate purveyor of dreams and romantic adventure, set in remote, exotic destinations. "There are gifted travelers. They treat travel as an art form," proclaimed the captions below the pictures. Larivière's photographs, taken in Yemen, Greenland, Thailand, Patagonia, Rajasthan, Burma and Nepal, have a panoramic luminosity, showing one of his favorite subjects, dawn light shimmering over expanses of water. The campaign's success was directly attributable to the affinity that Larivière created between the objects in the foreground and the landscapes behind them, tableaux peopled with local inhabitants. The trunks, bags and other evidence of travel seem to have been left there by the photographer, who has himself become the traveler, allowing viewers to project themselves into these dreamlike landscapes. In the more affected campaigns that succeeded *The Spirit of Travel,* books, musical instruments and toys add drama (1994-1996), and the artist's skillful, imaginative manipulation of relationships of scale creates a magical quality. It's worth mentioning that the people and objects represented were actually posed in the landscapes where the pictures were shot. The only retouching was done to hide the strings that held the miniature blimps and planes suspended in the photograph's sky.

This delight in playing with relationships of scale is just another variant on the convergences of space and time that pervade Jean Larivière's world. The narrative juxtapositions he conceived far outstripped the minimum requirements of a particular commission. This mindset is evident even in the photographer's website

design, where the visitor can ignore the context of the images, moving fluidly among them with keywords. In this virtual realm, there is a complex dreamlike feeling; Halley's Comet serves as a guiding thread through the maze, weaving a network of relationships between moments in Leonardo da Vinci's life and the image of a longhaired girl in a photo taken during a late evening session in the historic Louis Vuitton atelier on Rue de la Comète in Asnières. This method of website navigation also allows the artist to reflect on the past and the traces it left on his own childhood; the site is a work in progress, and its fluid nature allows him to suggest a relationship between the veins of a leaf and the contours of a landscape laid out beneath the eyes of a World War II fighter pilot.

While inspired by anomalies in space-time, Larivière always finds middle ground. He clearly respects the classical tradition, with an eye for detail and absolute mastery of the technical aspects of lighting, skillfully deployed to emphasize the elegant. His portraits of Isabelle Canovas, Andrée Putman and Loulou de la Falaise for Yves Saint-Laurent (1987) evince this sensibility. This classicism recalls the style of Jacques-Henri Lartigue, one of Jean's inspirations. The story goes that the two met in Montreal on a day when Larivière was wondering if he should agree to do a documentary on the celebrated photographer at a time when his collaboration with Louis Vuitton was in its early days. By sheer chance, he found himself standing at the corner of Avenue Lartigue and Rue Larivière. Perhaps this too is another urban fable, but it's clear that the magic of Jean Larivière's work relies much on these serendipitous alignments of space and time.

1 Pasols, Paul-Gerard. *Louis Vuitton.*
 Paris: Editions de la Martinière, 2005, n.p.

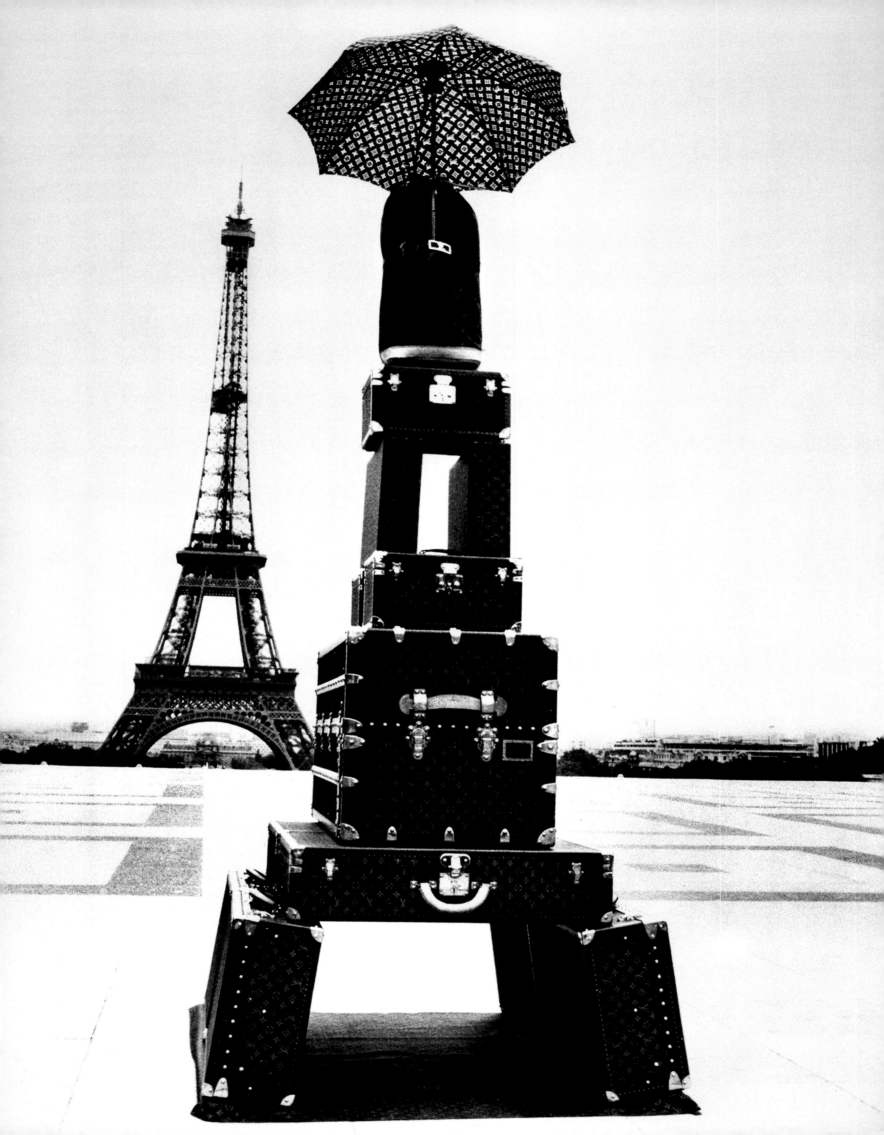

Lartigue, Jacques-Henri

photographer
text by Emmanuel Hermange

"Photography is a magical thing—something with mysterious smells, a little strange and frightening, that you quickly begin to love. Under the black veil, my dad lifted me up so that I could see the image he was about to take: a marvelous little scene, with all the colors, dazzling and vivid but upside down—a tiny image much prettier than the piece of reality it aimed at." It was in this way, with the words of his childhood, that Jacques-Henri Lartigue remembered his discovery of photography, made in the company of his father, a businessman who practiced it as a savvy amateur. If, in 1888, photography had become more accessible thanks to the first Kodak camera, it nevertheless remained a pursuit reserved for the well-heeled, who combined their leisure time with a desire to shine a spotlight on life. Technically, photography allowed one, from then on, to seize each moment, and the nascent photographic film industry undoubtedly strengthened this desire.

Lartigue was born in 1894 in Courbevoie, into a family considered at the time to be one of the wealthiest in France. His world was that of the upper middle class, which, at the end of the nineteenth century, devised new leisurely pursuits: the beaches in summer and the mountains in winter. These two worlds and the activities associated with them profoundly affected the life and work of Lartigue. At the age of six, he began using his own camera and in two years, developed his first proofs all by himself. His father made sure to regularly buy him ever more advanced equipment. The young man recieved his first stereoscopic camera in 1904, and a panoramic camera and a movie camera in 1912. Initially, his family, the household staff and some friends served as his models, but very quickly his mastery of the games offered by photographic instantaneity allowed him to shift from having people pose to recording bodies in motion. His famous snapshot of his cousin Bichonnade "flying" above a staircase is noteworthy in this way. He inserted one person or another—himself included—into the scenes, sometimes playing with superimposition to make ghostly presences appear in his images.

The relationship that Lartigue maintained with photography over his lifetime appears today to be one of great modernity, undoubtedly because his way of using this medium changed very little from the time of his childhood. In effect, among the tens of thousands of snapshots he produced, most were taken where his leisure time led him. For example, the first photographs he sold, in 1911, to the newspaper *La Vie au Grand Air* were linked to the passion he shared with his brother for the beginnings of aviation. His membership card for the Ligue Aérienne, the aviators' club, allowed him to witness and capture the feats of Roland Garros, Hubert Latham, Henri Farman, Louis Blériot, Alberto Santos-Dumont, Max Linder and many others. In 1913 he sold to the newsreels the first films he made with his new Pathé movie camera of the sporting world he frequented and loved. When Lartigue accepted commissions from fashion and design magazines, he never considered the assignments to be work but, rather, occasions to devote himself further to his passion. The series on English gardens he made for the magazine *House and Garden* toward the end of his life exemplify this approach.

The genius of Lartigue's photographic output was recognized late by historians and museums. After a 1955 presentation of some of his snapshots at the Galerie d'Orsay—alongside those of Brassaï, Doisneau, and Man Ray—it was a 1963 selection of his first images, mounted by the Museum of Modern Art in New York that sparked a vast wave of interest and recognition. The excitement was marked in France by a 1974 request from Valéry Giscard d'Estaing, the French president, that Lartigue take his official portrait, followed by the first retrospective, *Lartigue, Photographer*, at the Musée des Arts Décoratifs in Paris.

It is that very image—of Lartigue the photographer—created over the course of the numerous exhibitions and publications since 1955 that obscured another creative preoccupation, painting, which only appeared randomly in certain snapshots. In a journal he wrote: "painting is my greatest passion." Enrolled at the Académie Julian in 1915, Lartigue demonstrated a lifelong desire to become a painter and to be recognized as such. Despite his participation from 1921 to 1944 in more than eighty painting exhibitions (mostly salons), the appreciation for his celebrity portraits in the 1930s—with Jean Gabin, Tino Rossi, and Sacha Guitry among his collectors—and his relationship with Kees van Dongen and Pablo Picasso, there is no denying that today there is no mention of Lartigue the painter. A large portion of the journal he began writing as a child has been published. To see his painting today, one must go to Isle-Adam, the town where he spent part of his life and donated nearly all of his canvases, now displayed and kept at the Centre d'Art Jacques-Henri Lartigue (created in 1998).

Today the fascination with his photographic work undoubtedly stems from Lartigue's unique take on his career; photography was a companion more than a profession. It can even be said that this situation applied to his life itself, implied when he wrote: "I am not a photographer, a writer or a painter. I am a taxidermist of the things that life offers me in passing." This prescient modernity issues from what his life and work tend to conceal: in the end, it is in photographs where he himself often appears as a character that this theory for practice is best expressed.

Born two years before the creation of the Louis Vuitton Monogram, Lartigue—who was at home in his travels, and who possessed a deep affinity for the worlds of fashion and art—embodied many of the dearest values of Louis Vuitton. To celebrate the 125th anniversary of the brand in 1978, the company, in addition to publishing a retrospective collection of his photographs, asked the artist to think up a staging with the markers of the brand as its theme. True to humorous form, the venerable shutterbug had a small-scale replica of the Eiffel Tower built out of trunks, valises and bags all under a Louis Vuitton umbrella. Then he photographed the makeshift kiosk from below with the real tower in the background. Done on October 5, an "overcast day with sunny intervals," the shoot attracted several onlookers. And as Lartigue noted in his journal, one of them asked if he was selling the trunks! With Lartigue briefly transformed into a "peddler" of Louis Vuitton's wares on the esplanade of the Chaillot Palace, the question was hardly impertinent to the impish artist. Onlookers who could recall the Louis Vuitton ads of the 1930s that showed luggage piled according to size in the form of a pyramid were certainly getting the joke. The photograph is now firmly part of the legend of Louis Vuitton, and was briefly issued in a limited edition of 101 platinum-on-Arches-paper prints on the occasion of the hundredth birthday of the Maison Louis Vuitton—located at 101 avenue des Champs-Elysées in Paris.

p.252 *La Tour Eiffel Louis Vuitton* (1978) by Jacques-Henri Lartigue. Print in an edition of 101 to celebrate the 125th anniversary of the brand in 1978; 58.7 x 41 cm (23 x 16 inches).

Leccia, Ange

artist
text by Marie Maertens

Ange Leccia's video La Mer (*The Sea*), *from 1991, was shown twice by the house of Louis Vuitton— in exhibitions at the Espace Louis Vuitton, and later as the backdrop for a runway show.*

This Corsican artist made his first films in 1971 at the age of nineteen. Although he has traveled a great deal, his videos are travelogues On the contrary, they present an aesthetic of fluid energy that can be seen in his *Fumées* (Smoke, 1995) and *Orage* (Storm, 2005). In all these pieces, the motif is reduced to its essential quality. *La Mer* is a looped film. There is nothing to watch but a heavy blue swell, a breaking mass of water. The waves are projected vertically and fill the screen. At their crests, a milky foam spews and overwhelms this blue opacity. According to the artist, this white space—forever exploding—represents an interstice, the in-between. The piece was made when Ange Leccia was living in Japan between 1988 and 1993. There he discovered Shinto culture, in which nature is considered to be a quasi-meditative element, one without beginning or end. And this film plays with time. The loop perfectly illustrates the infiniteness of a time before time. Leccia's work can also be related to vanity, in that it investigates the fleeting quality of time, life and death. The artist once said: "my pieces are like hourglasses, moments that pass and that are renewed endlessly." For the Louis Vuitton Cup, which for 25 years provided the challenger in the America's Cup, this connection with the sea is particularly resonant.

p.255 *La Mer*, video (1991) by Ange Leccia, from the exhibitiom *Wind and Sails*, held at Espace Louis Vuitton, 2007

254 **Louis Vuitton**

Leibovitz, Annie

photographer
text by Emmanuel Hermange

Coming from a family where photography and filmmaking were common recreational activities, Annie Leibovitz (born 1949 in Connecticut) began taking pictures seriously in the late 1960s while studying art at the San Francisco Art Institute. Although she is drawn to Margaret Bourke-White's reportage and Henri Cartier-Bresson's sense of composition, one of her favorite photographs is the one by Robert Frank of his wife and children in a car at dawn along a road in Texas (*US 90, en route to Del Rio,* 1956), which he took while putting together a portrait of the United States. In it, she sees her personal history of migration, which she and her family experienced every time her father—a colonel in the air force—changed posts.

Autobiographical photography is hardly uncommon phenomena. But this theory for practice is crucial for Leibovitz, for it is essentially how she engaged photography for more than thirty years. "When young photographers ask me what they should do," she says, "I always tell them to stay close to home." For example, she might invite aspiring photographers to sometimes see the people they approach as if they were members of their own family. For "photographing ... people we feel close to," she adds, "is a privilege, it brings your responsibility into play." Leibovitz suggests that by turning her lens back to family, an artist can discover what situations have the most personal resonance. She had this experience in 1968 when she visited her parents at what was then the U.S. Air Force's sprawling Clark Air Base in the Philippines and took one of her first influential photographs (*American Soldiers and the Queen of the Negritos*). It is this photograph and others—like those taken during a peace

demonstration or while living on a kibbutz in Israel—that convinced Robert Kingsbury, the art director of *Rolling Stone* magazine, to hire Leibovitz. After receiving the magazine through a friend while in Israel, she went unannounced to their offices with her work when she returned to San Francisco in 1970. Quickly becoming *the* magazine's photographer, Leibovitz contributed to its success, and extended its influence in American portraiture and photojournalism. In shooting the Rolling Stones on their 1975 American tour, for example, she revived a conception of rock culture by playing on its myths. The emergence of her style can be seen when one compares the photographs she took of John Lennon in 1970 with those she took ten years later, a few hours before he was assassinated. The first is a rather classical portrait in which she was able to capture the calm intensity of her sitter. In the second, in which a naked Lennon lies on the floor intertwined with a clothed Yoko Ono, the models have allowed the photographer significant latitude to play with their image, a result of the trust that Leibovitz established with them. The quality of this relationship, reminiscent of a family photograph, can be found in her most striking photographs: John Irving as a wrestler in New York (1982); Whoopi Goldberg in a milk bath (1984); Sting, naked, covered in dried mud and balancing on one foot in the Lucerne Valley (1985); or Keith Haring naked on a New York street with the symbols of his work painted on his body (1986). In each case, it is the collaboration between the photographer and her model that is revealed as an aesthetic in itself.

It was during this period that Leibovitz's work gained wider recognition. In 1983, when *Vanity*

Fair made her a staff photographer, she had her first exhibition at the Sidney Janis Gallery in New York and published a first book for Pantheon, *Annie Leibovitz Photographs*. Then, as her reputation grew, Leibovitz continued to expand and diversify the range and form of these collaborations. Her interest in dance—which she owes partly to her mother, a former dancer—led her to photograph Mikhail Baryshnikov and Mark Morris during the development of the *White Oak Dance Project* in 1990. Interested in the intimate choreography of her portraiture, organizations and companies have often asked her to shoot advertising campaigns. The first assignment was the official posters for the 1986 Soccer World Cup. The portraits of celebrities she then took in 1987 for American Express—which received many awards, including *Ad Age's* best campaign of the decade —enticed the Gap to call on her talent the following year.

After working with Disney's theme parks, for which she reimagined many fairy tale characters, Louis Vuitton recently tapped her for one of its more popular campaigns. Steffi Graf and Andre Agassi intertwined in a hotel room in New York; Catherine Deneuve on a train station platform while on set in Paris; Mikhail Gorbachev in a taxi along an existing stretch of the old Berlin wall; Keith Richards in a hotel room; Francis Ford Coppola and his daughter Sofia conversing in a field at their ranch near Buenos Aires; and Sean Connery on a tropical beach. These six photographs present enduring values of the brand, including an enduring love of travel, and the transmission of knowledge from one generation to the next.

p.257 *Mikhail Gorbachev* (2007) by Annie Leibovitz, Louis Vuitton *Core Values* advertising campaign.

256 **Louis Vuitton**

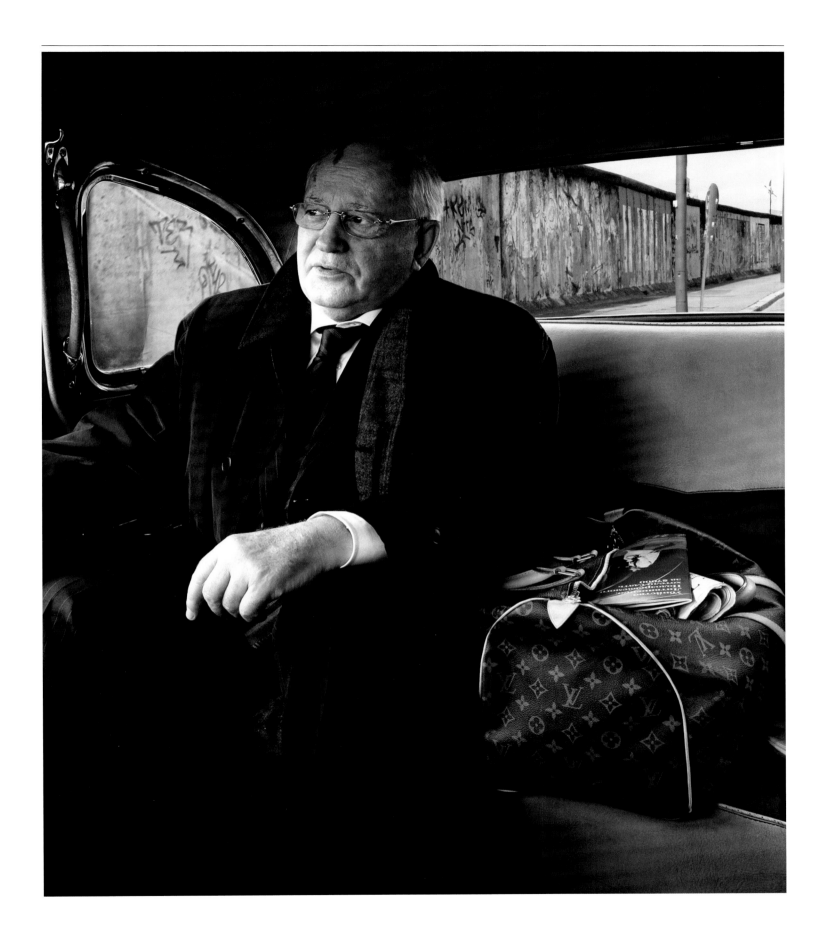

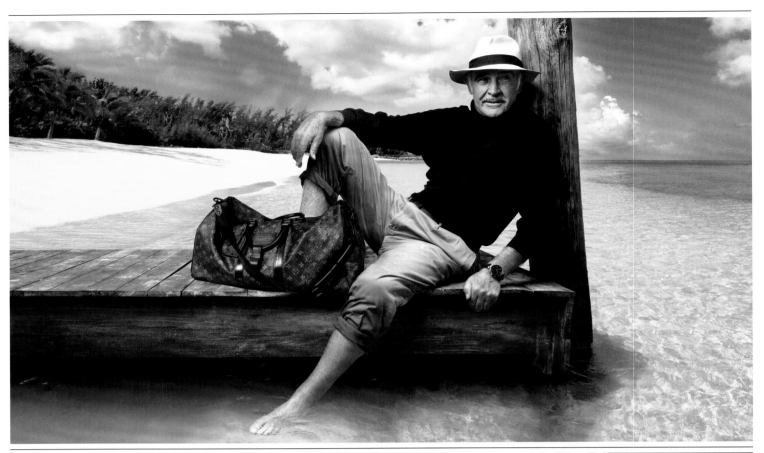

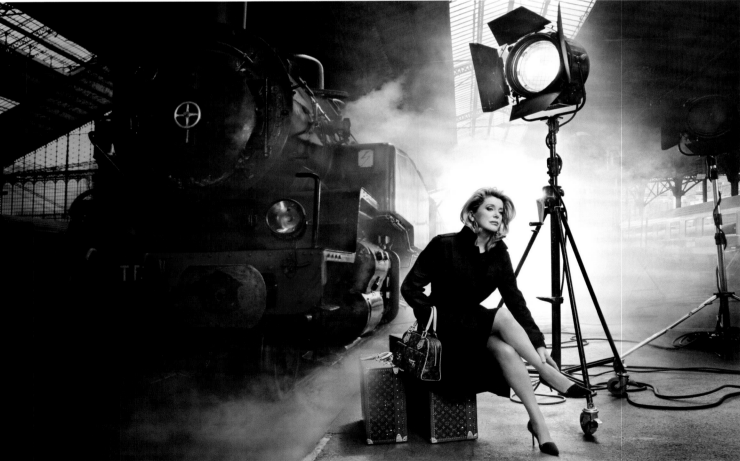

p.258 (top) *Sean Connery* (2008) by Annie Leibovitz, Louis Vuitton *Core Values* advertising campaign, (bottom) *Catherine Deneuve* (2007) by Annie Leibovitz, Louis Vuitton *Core Values* advertising campaign.

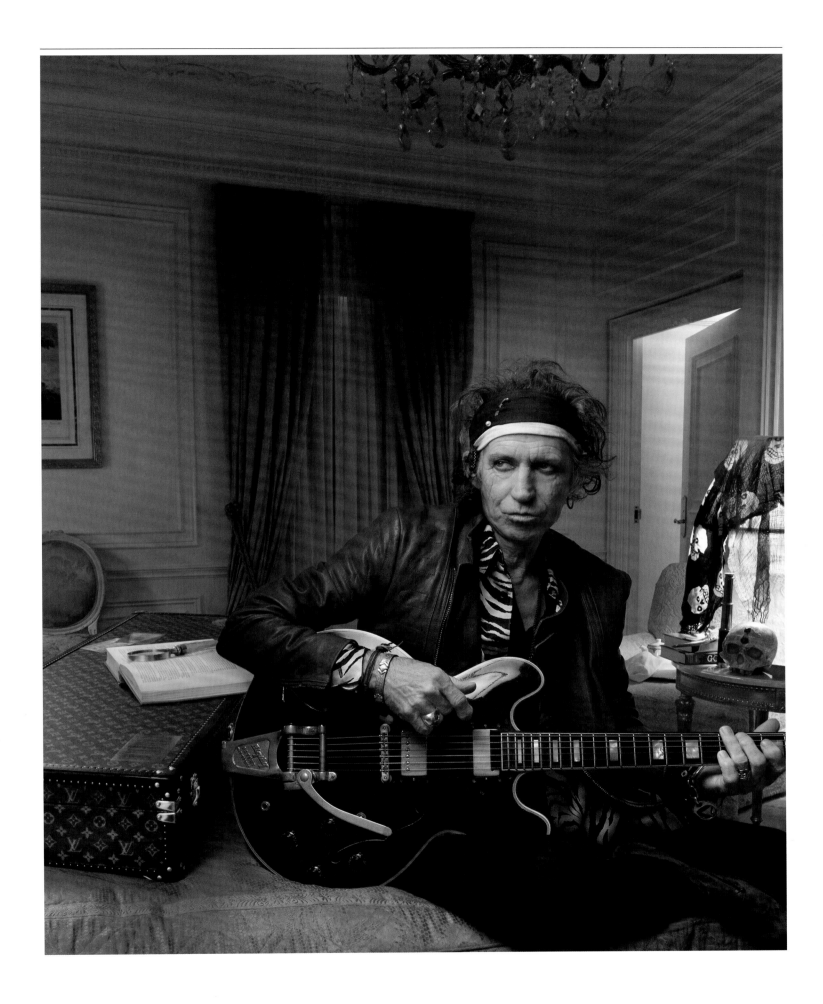

p.259 *Keith Richards* (2008) by Annie Leibovitz, Louis Vuitton *Core Values* advertising campaign.

LeWitt, Sol

artist
text by Simon Castets

When Sol LeWitt passed away in 2007, the art world lost one of its greatest heroes.

A discreet, timid soul who established conceptualism and minimalism, his influence on the history of art spans the entire second half of the twentieth century and continues to inspire contemporary artists.

The son of Russian immigrants, he was born in 1928 in Hartford, Connecticut. LeWitt studied art at the University of Syracuse before being drafted for the Korean War in 1951. After being discharged from the army—for which he had already created posters—he moved to New York where he concentrated on graphic design at the Cartoonists and Illustrators School. He then worked for *Seventeen Magazine* and I.M. Pei, whose architecture career was just beginning. To make ends meet and because fate is a great provider, in the early 1960s he worked as a receptionist at the Museum of Modern Art in New York, where he met Robert Mangold, Dan Flavin and Robert Ryman who, like him, would go on to define the art of their generation. A far cry from the prevalent Abstract Expressionism and budding Pop Art, in 1963 LeWitt began developing elementary works, strictly speaking; for instance, three-dimensional works using a cube as a starting point. According to LeWitt's rational and concise reasoning, depending on a sometimes uncertain—but always mathematic—development, the works evolve as if on sheet music. This point of view was at the opposite spectrum of the demiurge-painter of the 1950s.

Following his first one-man exhibition in 1965 at the John Daniels Gallery in New York, he began teaching and participated in the exhibition *Primary Structures* at the Jewish Museum in New York. The exhibition would later be considered one of the decisive moments of minimalism. In 1967, *Artforum* published his essay "Paragraphs on Conceptual Art," in which he set out the founding principles of his work. Furthermore, the essay affirmed the predominance of concept over form and the idea over execution. "What the art looks like isn't too important," he stated. Adopting a humble yet radical stance, he dismissed the idea of conceptual art that is inaccessible—"Successful ideas generally have the appearance of simplicity because they seem inevitable" or tedious, "It is only the expectation of an emotional kick, to which one conditioned to expressionist art is accustomed, that would deter the viewer from perceiving this art." The need to eliminate the arbitrary and the subjective, as well as the repetition of form in a given area, reflects his interest in the photographic works of Muybridge and their scientific sequences, which inspired LeWitt's first wall drawings in 1968 (Paula Cooper Gallery, New York). Determined to explore all possible variations of a given form, LeWitt created a body of works commensurate to this goal by tackling both the architectural dimension as well as, on a smaller scale, his numerous publications. His interest in books as a medium led him to co-found, along with Lucy Lippard, Carl Andre and others, the publishing house and distribution platform Printed Matter, which remains the benchmark in its field to this day. In 1978, MoMA exhibited a retrospective of its former receptionist who had become one of the leading figures of minimalism. This was followed by significant one-man exhibitions at the Stedelijk Museum (Amsterdam, 1984), the Musée d'Art Moderne de la Ville de Paris (1987) and the SFMoMA (San Francisco, 2000).

LeWitt's transition to color and his unwavering interest in the repetition of geometric structures are reflected in the silk square scarves he designed for Louis Vuitton in 1988. Entitled *Rainbow, Undertow* and *The Earth is Round*, they were created with primary colors framed by a thick black border that showcased the artist's fascination with elementary forms. A confluence of minimal avant-garde and timeless fashion, the project was as much artistic as it was unexpected, and produced what could be called a portable work of art. In keeping with LeWitt's principles, the square scarves were the realization of a concept that also dovetailed his more traditional works. According to the artist, "Since no form is intrinsically superior to another, the artist may use any form, from an expression of words (written or spoken) to physical reality, equally."[1] That same year, Louis Vuitton also commissioned Arman and James Rosenquist to contribute to this series of square scarves by artists. This initiative thus captured the inspiration of major artists at the very heart of the creations of the luxury brand.

[1] LeWitt, Sol. *Sentences on Conceptual Art,* first published in 0-9 (New York), 1969, and Art-Language (England), May 1969, n.p.

p.261 (top) *Undertow* silk square (1988) by Sol LeWitt, 88 x 87.5 cm (34.6 x 34.4 inches), (bottom) *The Earth is Round* silk square (1988) by Sol LeWitt, 88 x 87.5 cm (34.6 x 34.4 inches). Louis Vuitton Collection.

260 **Louis Vuitton**

Liaigre, Christian

designer
text by Cédric Morisset

Since it was founded, Louis Vuitton has always celebrated travel, and helped establish it as a modern art de vivre.

The brand's commitment to luxury produced classic pieces of luggage that have become essential companions to the most discriminating travelers. Those seeking solutions adapted to their journeys could count on Louis Vuitton's dedication to unique craftsmanship and the assurance that the house could create perfectly tailored instruments for their adventures. In 1905 Louis Vuitton designed a trunk-bed for Pierre Savorgnan de Brazza's expedition to Congo; in 1926, a tea-case for the Maharajah de Baroda; and in 1939, a portable secretary for King Farouk of Egypt.

In keeping with this venerable tradition, Louis Vuitton commissioned Christian Liaigre to create a contemporary line of travel accessories and furnishings in 1992. An interior designer and a creator of furniture made of fine wood and leather, Liaigre has consistently maintained a unique style since the late 1970s. Combining neutral colors, sophisticated minimalism, and natural materials, his elegant and simple forms were a return to luxury. His collaborations with noted talents and established brands have achieved considerable recognition in the worlds of fashion, tourism and architecture, and these disciplines intersect in Liaigre's award winning hotel designs.

For Louis Vuitton he conceived a travel briefcase and a portable folding table and stool that are light and easy to handle. Manufactured in a numbered series, these limited-edition traveling desks are constructed out of natural leather and sycamore wood. With satin aluminum fittings, the design is reminiscent of painting easels.

p.262-263 Luggage and traveling furniture by Christian Liaigre (1992), each item an individually numbered and limited series of 100. Made of leather, sycamore wood and aluminum fittings. Louis Vuitton Collection.

Lin, Michael

artist

text by Simon Castets

Michael Lin's work reflects the perpetual movement of his own life. After spending the first years of his life in Taiwan, he emigrated to the United States before returning to Taipei twenty years later. He later lived in Paris and today has taken up residence in Shanghai.

Known for his large installations that transform the architecture of the buildings in which he works, Lin has had solo exhibitions in such venues as the Palais de Tokyo in Paris, PS1 in New York, the Contemporary Art Museum of Saint Louis, and the Vienna Kunsthalle. He has participated in numerous biennials and triennials, including those in Lyon, Guangzhou, and Moscow.

His work almost systematically derives from a simple process: the very large-scale reproduction of floral motifs from traditional Taiwanese textiles. Once the images have been captured, they are applied to media that are as extensive as they are diverse: a tennis court (*Untitled*, 2005, The Contemporary Museum, Honolulu); the cafeteria floor in an art center (*Untitled*, 2001, Palais de Tokyo, Paris); or a resting platform (*Kiasma Day Bed*, 2001, Museum of Contemporary Art Kiasma, Helsinki). Apart from their monumental dimensions, the point his site-specific works have in common is their "functional" characteristic that encourages the public to become participants. The exhibition area fuses with the work, and the oversized reproductions of vintage fabrics become the area for related social activities that are an integral part of a visit to a cultural institution; like having a

coffee, reading a catalog or, unusually, as was the case at the exhibition in Hawaii—playing a game of tennis. The borders between the communal and exhibition spaces were remarkably erased in the installation he created for PS1 (*Grind*, 2004); the pattern reproduced by Lin slid continuously from the top of the wall down to the floor, covering it completely. That the installation space was in fact the restaurant of the museum only reinforces the connection of Lin's work to the theory of relational aesthetics put forward by Nicolas Bourriaud. Co-director of the Palais de Tokyo when Lin's flowers took over the ground floor, Bourriaud analyzes art from the 1990s as an attempt to no longer "broaden the horizons of art, but to examine art's resistance within a global social arena."[1] Although the major figures in this redefined concept of art (Rirkrit Tiravanija, Philippe Parreno, Angela Bulloch) experiment with often active strategies for the creation of social relationships, (Bourriaud sites the example of a piece by Angus Fairhurst in which two galleries wound up communicating by telephone with neither having called the other), Lin carries out his work by using fabric as the backdrop for potential exchanges. His work is thus a product of a minimal variant of "operational realism,"[2] in which the concept of "dimension" is nonexistent or secondary.

Lin's works spill out from traditional boundaries — literally and figuratively — blurring the borders between "contemplation" and "use," plastic arts and applied arts. His recent installations originate from an experiment conducted at the close of his exhibition *Interior* (IT Park, Taipei, 1996), in which his furniture was taken to the art center and left there for public use. Since Lin believed that the pillows best represented the relocated home experience, he decided to paint canvases based on the textile patterns. The sourcing of traditional imagery—some of his installations reproduced bedding customarily used as a woman's dowry—magnificently transformed through a monumental display, results in multiple viewer interpretations. This recontextualization of patterns not only reveals the personal history of the artist, a repeat expatriate, but also draws on a series of cultural references, most often Taiwanese, but sometimes from other cultures. The textile reflects an intersection of influences, a convergence between outdated imagery and the quest for exoticism. Its full use of exhibition spaces invites experiences that vary in intensity according to the cultural backgrounds of the viewers, or properly, *participants*. The iconography either calls to mind visual symbols on the verge of disappearing— the memory of which is accentuated by the

p.264 Detail of screen sculpted in Corian, part of permanent installation (2006) by Michael Lin for the VIP lounge of Maison Louis Vuitton, Taipei, Taiwan.

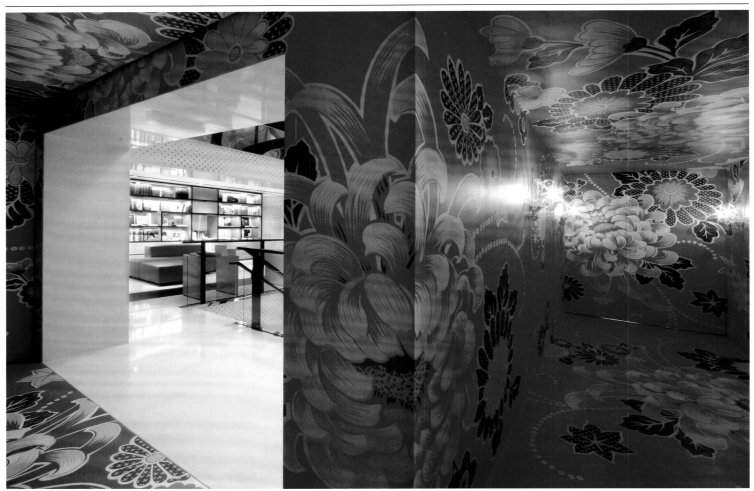

prospective dialogue triggered by the installation space—or an oversized kitsch, at once welcoming and intrusive. Lin perfectly embraces the practical dimension of his art. He explains, "When you look at a painting you stand erect and concentrate. The relationship between you and my work is perhaps closer to you and your couch than you and the painting hanging on the wall."[3] Putting aside his Warhol-inspired ideas, Lin's message automatically favors the exchange between viewers of an installation, which he describes as banal.

In April 2006, Louis Vuitton called on Michael Lin's talents for the interior of its *maison* in Taipei. For this project, the artist demonstrated the exuberance of his formal expression. The inside of the elevator is covered with leather slabs that display a floral ornamentation in bright pink relief, evocative of the inside of a trunk. The corridor leads the most demanding clients to the holy of holies (a room reserved for VIP aficionados of the brand), resulting in one of the artist's most accomplished creations.

Plunging the visitor into the heart of his favorite iconography, in unprecedented fashion Lin applied the resized reproduction of a single-tone textile, combining stylized flowers, pearls, and foliage, on all the surfaces of the corridor (floor, walls, and ceiling). Inside the room the pattern is carried onto an immaculate screen with a clever series of transparencies.

Although the luxury boutique, exclusive by definition, has few footholds for a relational aesthetic approach, this certainly cannot be said about Lin's work for the opening ceremony of the flagship store. Designed especially for this extraordinary event, a temporary installation by Lin covered the famous Chiang Kai-shek Memorial—recently renamed the National Chiang Kai-shek Memorial Hall—a 70-meter (230-foot) monument erected in memory of the former President of the Republic of China. While Lin's projections enveloped the building with colors from the "strawberry generation"— an expression that refers to Taiwanese children from the 1980s—the square turned into a

fascinating collision between artistic creation and political aspirations, past and future, personal memories, and general remembrance. It was a unique opportunity for Michael Lin to express himself on an extraordinary scale, not only on an architectural level but also for public appraisal. Resized to unprecedented dimensions, Lin's fitting traditional ornamentation took hold of a building that is eminently important in Taiwanese history. However short-lived and superficial it might have been, Lin's transformation of the Memorial exposed a vast and extremely impressed public to the issues that influence the art of this expatriate artist. From the part history plays in a shifting society to art's role in building a multiple identity, Lin's art broke free from his feigned "banality," if only for one night.

[1] Bourriaud, Nicolas. *Relational Aesthetics*. Dijon: Les presses du réel, 2001, n. p.
[2] Ibid.
[3] Michael Lin, as quoted by Freundl, Diana in "Local Boy Makes Good Abroad", *Taipei Times*, 12 September, 2004. n. p.

p.266-267 General view of a painted corridor by Michael Lin and detail of the interior of an elevator in embroided pink leather at Maison Louis Vuitton, Taipei, Taiwan. *p.268-269* Views of a temporary installation at the Chiang Kai-shek Memorial Hall to celebrate the opening of Maison Louis Vuitton, Taipei, Taiwan, April 2006.

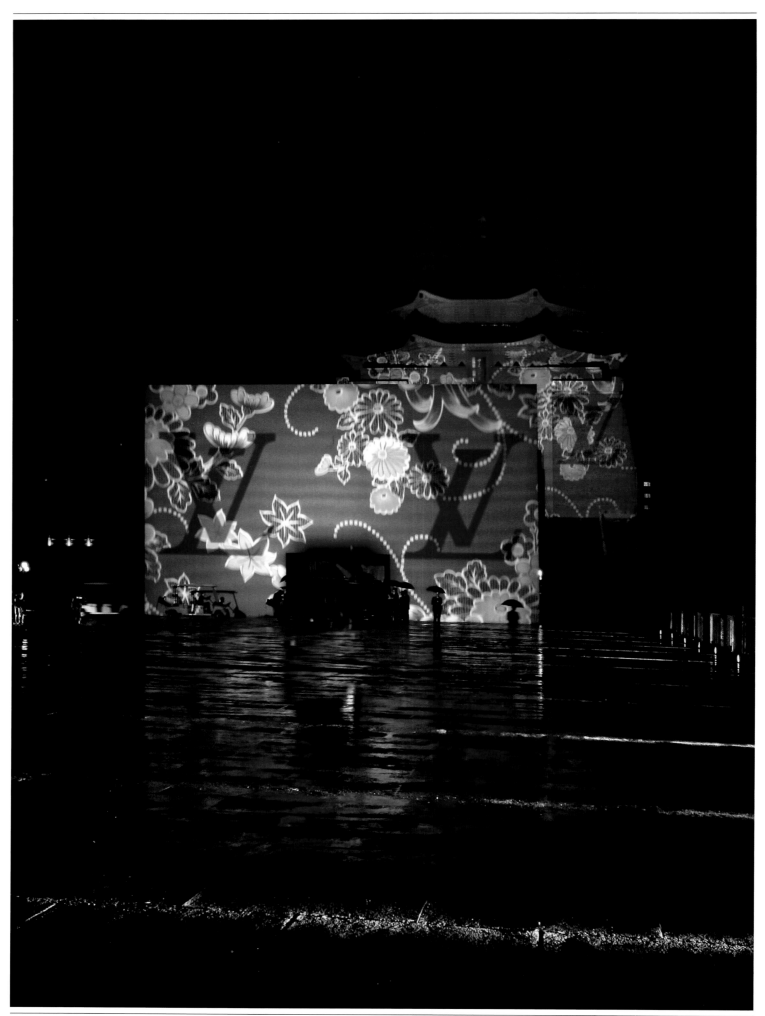

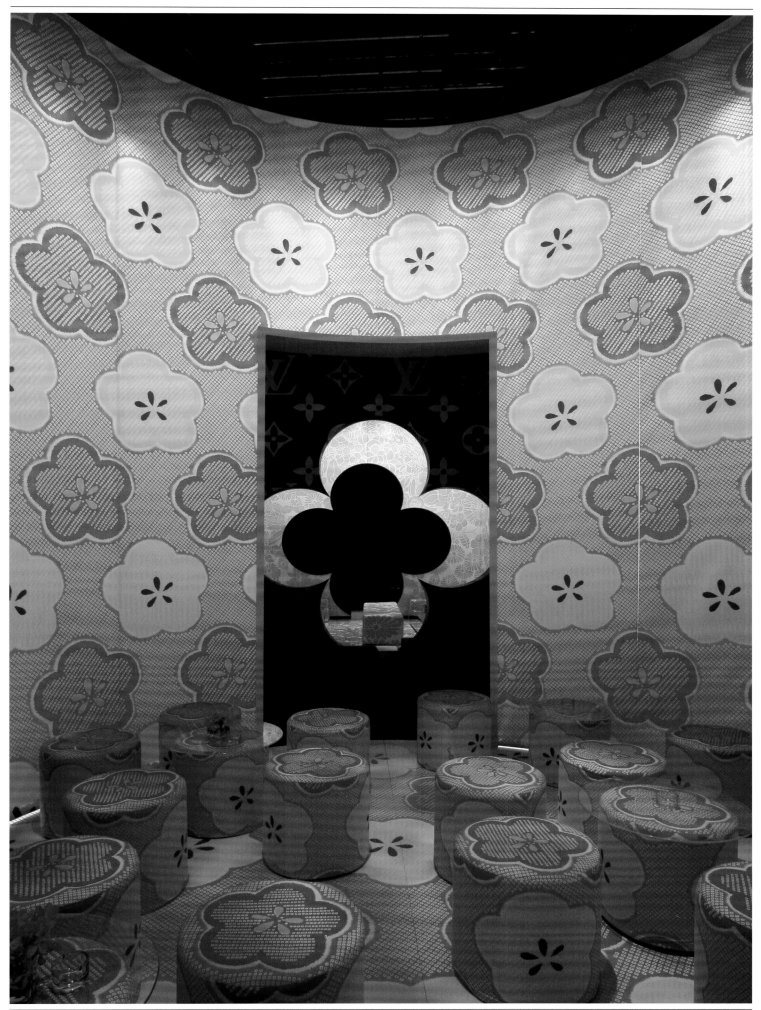

M-O

Manolessou, Katherina

designer
text by Marie Maertens

Born in Greece in 1972, Katherina Manolessou is a young graphic designer who now resides in London.

First appearing in the hippest magazines, Manolessou's work has now graced everything from *Time Out* and *Wallpaper*, to the *The Guardian*, *The World of Interiors*, *The Saturday Telegraph Magazine*, *Reader's Digest* and *Athens Voice*. A wide variety of publications appreciate her cheerful style with its playfully naïve air and its tendency to humanize our animal friends. It is not unusual to smile or even fully empathize with one of her illustrations. A little guy with a crab head sits on top of an astrology column. A pink monkey looks down his underwear, a sniveling dog conveys what happens to pets when there's a divorce, while planets and stars are shaped like small dancing microbes. Overall, the work gets to the essence of emotion and understanding. Colors are applied as flat surfaces so as not to divert attention, but they are, as ever, in full support of the message.

The two works purchased by Louis Vuitton depict a map of India in monochromatic red sprinkled with the Louis Vuitton trademark and silhouetted animals. The assignment was given to the artist by *Wallpaper* magazine in 2003 to accompany an article on the opening of the first Louis Vuitton store in India. Manolessou's idea was to elegantly link Louis Vuitton design with icons that evoke the country. Several drawings in colored pencil were made before one was selected and turned into a small series of prints.

p.270-271 Still from the short animated film *SUPERFLAT Monogram*, 5'6" (2003), by Takashi Murakami, for Louis Vuitton. **p.274** *LV—India Brown* by Katherina Manolessou, 2003. Serigraph, commissioned for the September 2003 issue of *Wallpaper**, commemorating the opening of the Louis Vuitton New Delhi store, 29 x 30 cm (11.4 x 15.7 inches). Louis Vuitton Collection.

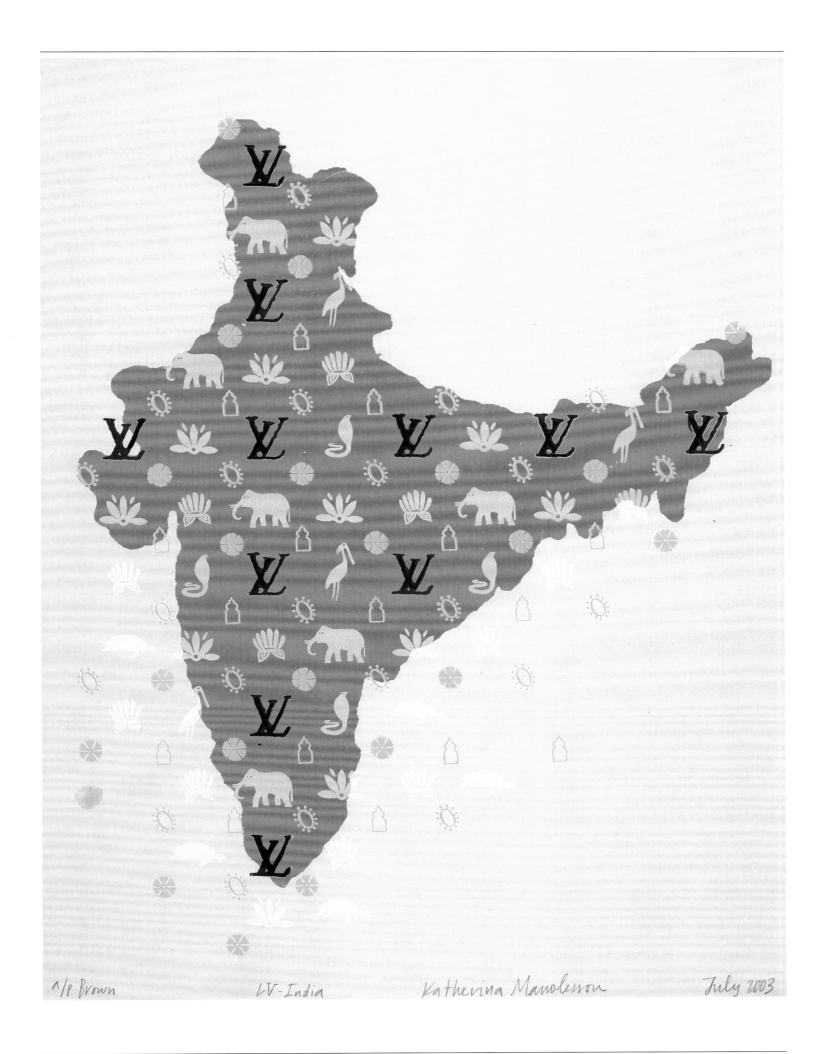

A/P Brown LV-India Katherina Manolesson July 2003

Marino, Peter

architect
text by Philippe Trétiack

When it comes to drawing up the short list of star architects—"starchitects"—Peter Marino's name does not appear. Without a doubt, that omission is his greatest success. It is his discretion that has made Peter Marino a force that can't be ignored. It is what drives his talent—the cornerstone of his flamboyant style. From Tokyo to New York via Paris, he has left his name to an impressive number of flagship stores. The big cosmetics houses and fashion designers have sought his help, even at the risk of mimicking each other. That is a lesser evil, since Peter Marino seems to have discovered the magic formula, that which permits him to dissect the DNA of these brands and transform it into dynamic spatial layouts and unorthodox applications of materials. At first sight, his style is one of pure classicism or, at best, a contemporary baroque. Dominant beige, gold, off-white, ivory and black tones reinforce each other in the stores bearing his touch. Candidly—and like the creator himself—every instance of Marino's involvement is marked by a bit of craziness, a hint of eccentricity, a quirkiness, an attempt to throw others off balance. Vigor and a calculated audacity—as in the design of a lobby floor in the form of a Renaissance checkerboard of zebra-striped marble—shake off any impression of slavish propriety. With him, a sense of displacement is guaranteed. And from that, he has created his signature style.

Peter Marino is above all a character. 58 years old at the time of this writing, he has maintained a youthful air: a barrel chest, a mover's arms, moving to heavy-metal music at night, and dance music in the morning, vitamins at set times, ultra-light organic meals on planes. And he has established himself as the eternal free-lancer—professionally, the perennial bachelor. Often dressed in slinky leather and a skintight T-shirt, he flaunts a virile look—that of the bad boy born into luxury. He presents himself as a troublemaker whose wild exploits are papered over by his blinding grin. Marino possesses the charm of a Hollywood star: He captures the spotlight, has a cinematic presence, and looks good from many angles. It should be noted here that he had good training for it. In his life, he has crossed paths with characters that show off and insist on being the center of attention, and demand that you move out of their sun. By chance, this crowd of posers included some real heavyweights. As an adult, but just barely, he met Andy Warhol and Roy Lichtenstein. The impact was radical. Marino had wanted to be a painter, but, after these encounters, he put away the palette and brushes, and enrolled in architecture school. His flair and talent led him to Skidmore, Owings & Merrill (SOM), and then to George Nelson's firm, and later still, to I.M. Pei's. Marino already had a flair for collecting. His address book quickly swelled, and his aspirations were aimed squarely at the high end.

Marino launched his own firm in 1978, and in 1984 he redeveloped the Barneys stores on Seventh Avenue, in New York. After that, things took off. Today, the waltz of stores and boutiques for which he has been responsible tends to make one forget that, with Marino, a genuine-article architect is hiding behind the decorator. He built a splendid house in Woodstock—part Amish cabin, part Finnish church—and a distinctive house in Saint-Jean-Cap-Ferrat, in the south of France. There, all the symbols of the modernist movement appear, revamped in sixties style. The Mediterranean-blue pool rests against walls in a typically Le Corbusier shade of white; the bay window is a wink at Philip Johnson, and it undulates thanks to Morris Lapidus, whose extravagantly curvy facades made Miami Beach dance. On a larger scale, Marino played a part in the restoration of New York's St. Patrick's Cathedral in 1996, built a corporate headquarters where glass bends on an arc for more than a hundred meters (Datascope, in New Jersey, 2001), art galleries, and apartments to die for. Giorgio Armani called on him for his refuge in Milan. The Wertheimer family, owners of Chanel, did the same, and for them, Marino designed stores and private apartments. He also signed on to redesign the Aga Khan's yacht club. Peter Marino has serious clients.

Chanel, Louis Vuitton, Dior, Donna Karan, Calvin Klein, Fendi and Valentino, among many others, have enlisted his services, and, to thank them, he introduced the brand to several big-time contemporary artists. For the Louis Vuitton flagship store, on Paris's Champs-Elysées, he convinced James Turrell to slip an original work into the store's second floor, and, to celebrate the store's opening, he offered the most beautiful spaces to the caustic Vanessa Beecroft, whose nude models, squeezed between steamer trunks, blew the critics away. For Chanel's flagship store in Hong Kong, he invited Jean-Michel Othoniel, Michal Rovner and François-Xavier Lalanne. Marino has an exceptional sense for the value of collaboration; he is open to the contributions of others because he has confidence in himself. Eight associates and a staff of more than 130 assist him at his New York firm. Beyond his day-job, Marino devotes himself to many cultural institutions. He serves on the boards of organizations dedicated to the promotion of young concert musicians or to the defense of Venice's cultural heritage; he is an adviser to the Museum of Decorative Arts, in Paris.

His website is all black and white—a cold minimalism that is aware of its fearsome potential energy, like a Ferrari engine at rest. He says he admires Herzog & de Meuron and Christian de Portzamparc for their ability to intrigue—to spark amazement—but clearly visible in him is an unbridled love for a couple of prominent artisans of the twentieth century: Jean-Michel Frank and Pierre Chareau. It is undoubtedly to them that he refers when he daubs a wall with diamond dust salvaged from a gem polisher or when he dresses walls with bands of travertine normally reserved for floors—or when he orders, from Madagascar, hand-embroidered braids for the back of a chair. The eternal adolescent, a formidable businessman, Marino is a potent cocktail that never ceases to amaze.

p.275 Louis Vuitton Hong Kong Landmark Store (2006), Hong Kong SAR. The Fine Jewelry and Watch departments is connected to an upper private salon by a suspended stainless steel staircase comprised of 120, 8mm polished stainless rods.

274 **Louis Vuitton**

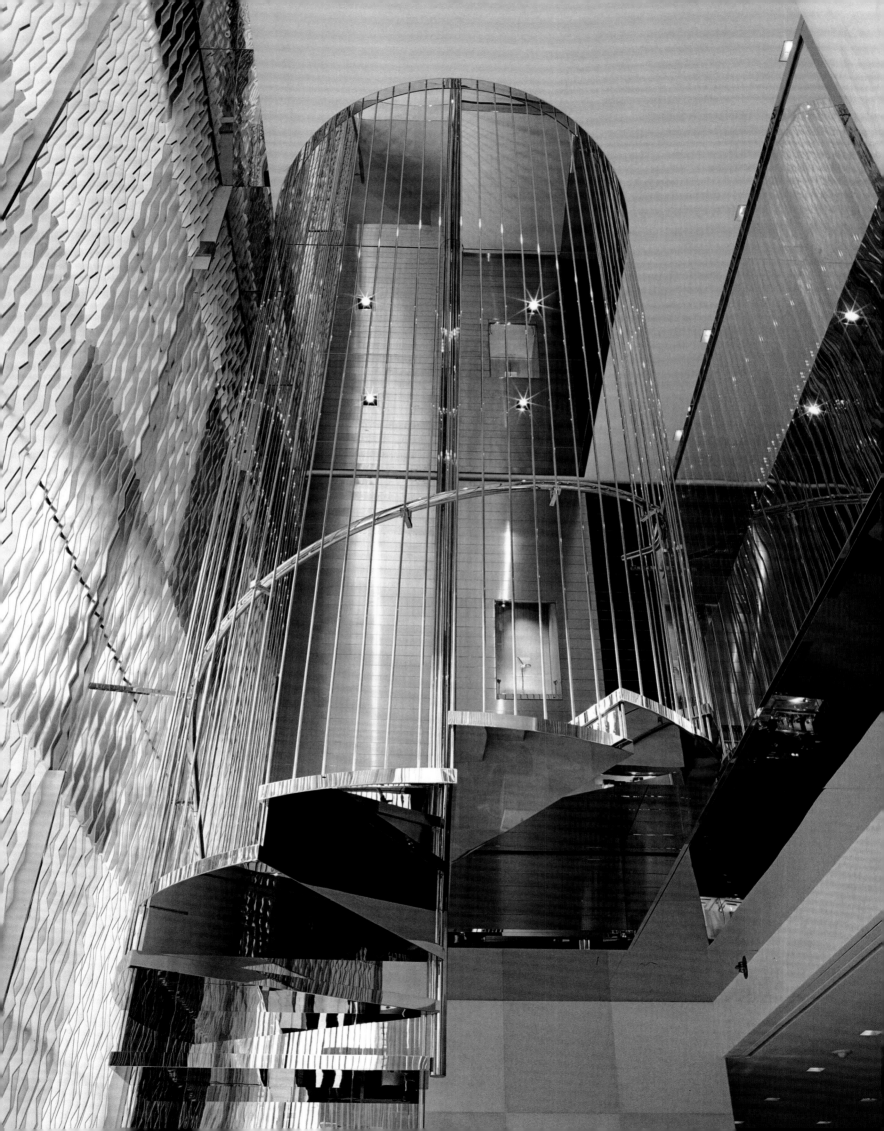

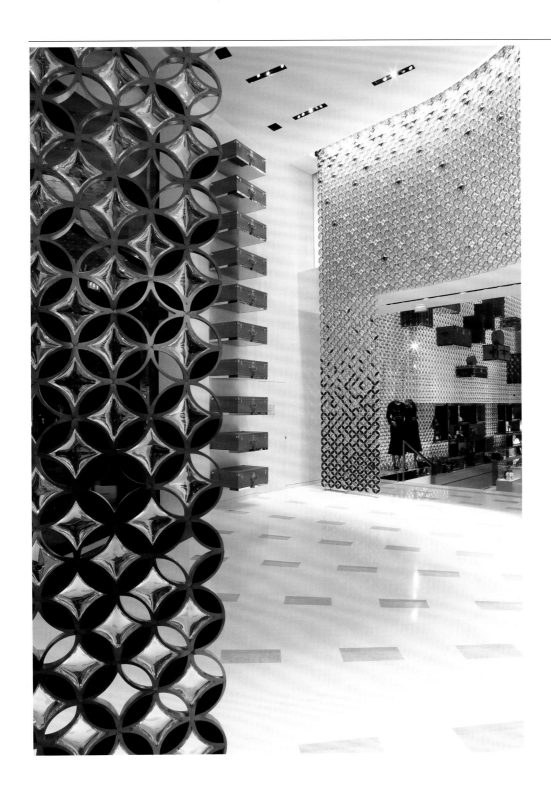

p.276 Maison Louis Vuitton, Champs-Elysées (2005): detail of the Monogram screen flanking the main escalator. p.277 Maison Louis Vuitton, Champs-Elysées (2005): view of main retail floor. Visible are stacked installations of Alzer suitcases in red Epi leather, after the artist Donald Judd. p.278-279 Maison Louis Vuitton, New York: (2004). Detail views of the "feature wall," conceived as an homage to the Damier pattern. Peter Marino and the Louis Vuitton architecture department designed the interiors of the 1,200 square-meter (13,000 square-foot), 4-story boutique.

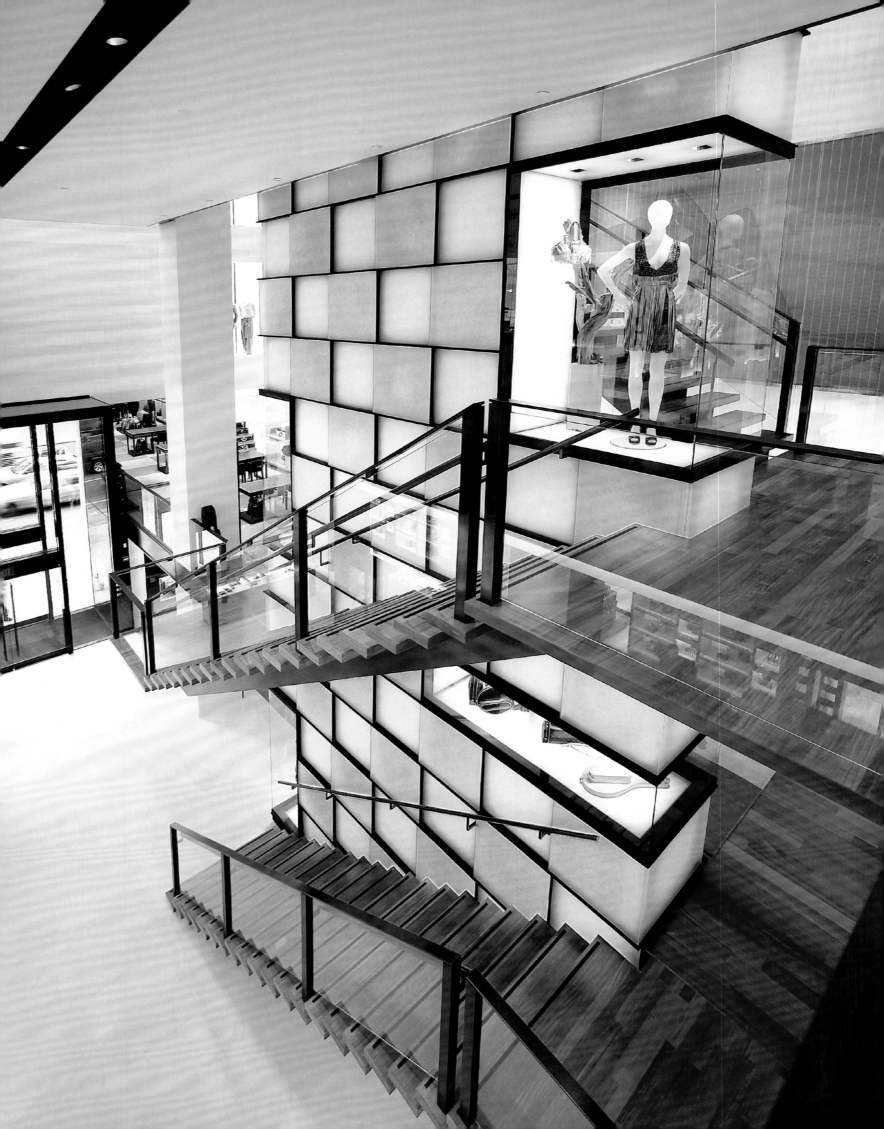

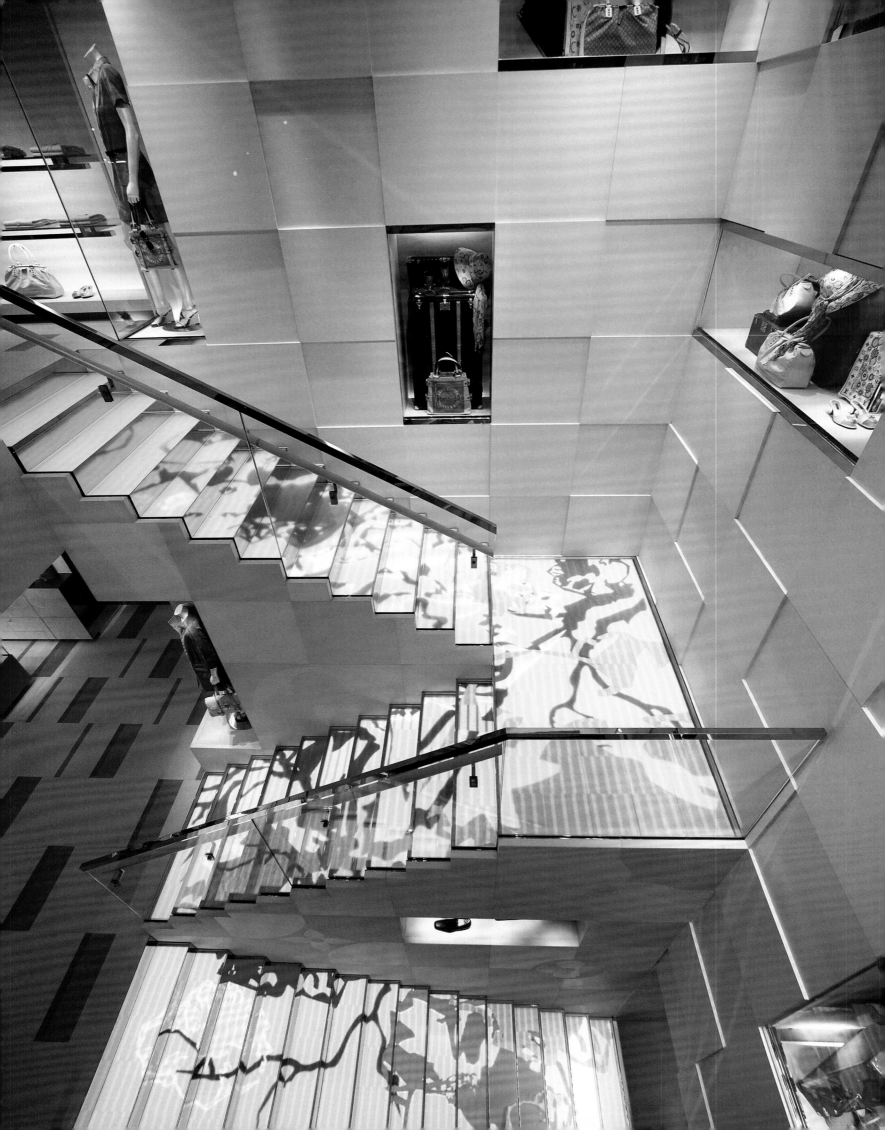

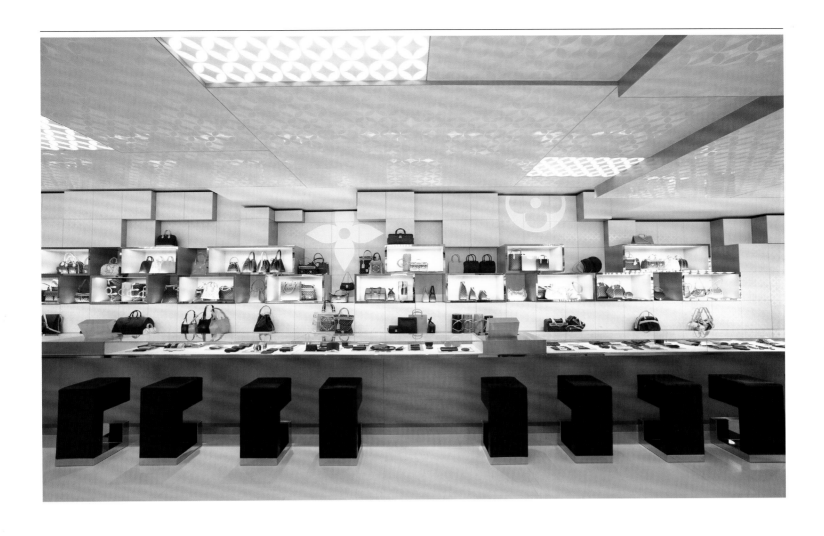

p.280-281 Louis Vuitton Hong Kong Landmark Store, Hong Kong SAR (2005): views of the stairwell and the "bag bar."

Art, Fashion and Architecture *281*

Meier, Raymond

photographer
text by Emmanuel Hermange

*As a child,
Raymond
Meier
wanted
to be an
astronaut.*

Born in Switzerland in 1957, he studied at the Zurich Art School and eventually decided to become a photographer. Following his studies, he opened his first studio in Zurich in 1977. Although he initially focused on corporate and industrial photography, he later evolved to include portraiture, advertising and fashion. Following his move to New York in 1986, he specialized in still life and fashion photography, and has since become one of the most prominent photographers in his field. He regularly contributes to a number of the leading American magazines in the field, such as *The New York Times T Magazine*, *Flair*, and *Harper's Bazaar*, as well as campaign images for designer and beauty brands like Calvin Klein, Giorgio Armani, Burberry, Prescriptives, and Clinique.

Since his work has recently developed to explore architecture, he has contributed to the equally prestigious *Condé Nast Traveller*. His interest in architecture grew when he met architect Armando Ruinelli in 2000, who he hired to create a house and a studio in the canton of Grisons, in Soglio, a patrimonial village perched in the Swiss Alps. The project was completed in 2003 and received the Häuser Award in 2005. The structure's sober, clean finish, its form and function so closely entwined, as well as the careful attention that was given to the environment and the quality of the materials puts it in touch with some of the essential principles of modernist design. Meier's first monograph,

released in 2004 (Editions Dino Simonett), is thus reminiscent of this initial architectural project that he commissioned. The book focuses entirely on the Sher-e-Banglanagar complex, in Dhaka, which the Bangladesh government commissioned Louis Kahn to design in 1962. In architecture, Kahn is considered the person whose work "marked the end of modernism." "He was a genius who stimulated my creativity," Meier affirms, and is convinced that architecture and photography share a common basis: light. His photographs in the book clearly show how, particularly in Kahn's work, light and space are mutually produced through subtle variations in materials. Generally, when Meier shoots contemporary architecture, he often uses light to interpret a building, to the point where he completely breaks with the descriptive transparency that one traditionally expects from architectural photography. This was the case, for instance, with the Guggenheim Museum in Bilbao. Meier took a wide-angle shot at a slightly low angle under a cloudy sky, which he accentuated for dramatic effect thanks to the contrasts of light. Such processing emphasizes the zoomorphic aspect of the Frank O. Gehry building, turning it into a disturbing creature hidden in the shadow of chthonian forces. Displaying a different approach, he translated the nostalgic futurism of the Niterói Contemporary Art Museum in Rio de Janeiro—built in 1996 by Oscar Niemeyer, who drew inspiration from the shape of a flying saucer—by tinting the sky green and the ground orange and yellow.

Raymond Meier's work in recent years, ranging from fashion to architecture, has clearly drawn inspiration from the Modernist movement. This is evident, for instance, in the first project he created for Louis Vuitton in 1999. For the *Epi Z* line of bags, he shot a model dressed in a black leotard that exactly matched the black color of the bag, with the saturated blue sky of the Mojave Desert as a backdrop. Everything in this series of images seems to originate from a uniform line: the pure line of the horizon. However, the unique quality of Meier's approach is the subtle manner in which he consistently clashes with and shifts the boundaries of Modernism. By making use of acid colors and baroque forms—the design of the broken line *par excellence* —that he often includes in his work, he deliberately maintains a connection with modernism instead of considering it as a period long-past. A more recent campaign for Louis Vuitton (*Cruise Line*, 2005) demonstrates how he is able, for example, to capture a few traits from Post-modernism by creating a universe of images quite similar to that of Richard Prince. The work of Raymond Meier is best defined by a comment he made to Armando Ruinelli that explains the secret of architecture, "Imperfection is the key. Breaking through perfection at the surface is what stimulates curiosity."

p.283 Advertising campaign by Raymond Meier for the *Epi* leather line (1999), with the Noctambule bag in black Kouril Epi.

282 **Louis Vuitton**

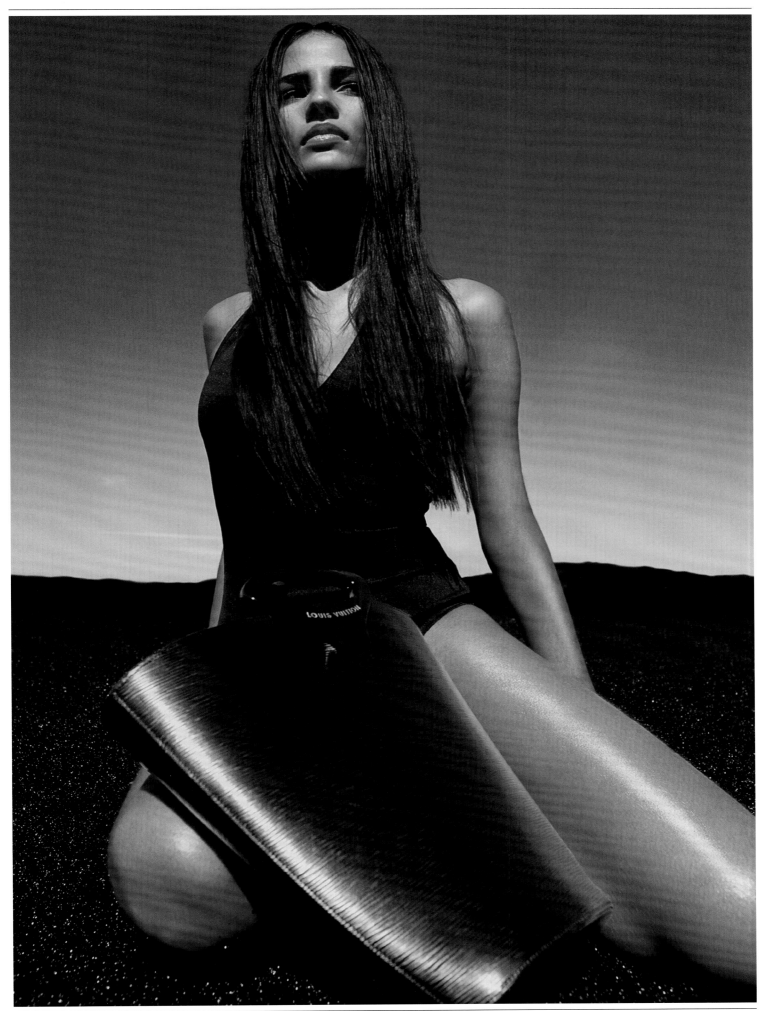

Miss.Tic

artist
text by Marie Maertens

Much like a contemporary incarnation of the actress Arletty, with her poetic cheekiness and banter, Miss.Tic has been a part of Paris's landscape since 1986.

She first worked as an actress and mixed with an arty crowd, before grabbing her first spray cans and hunting down walls in France's capital. Popular neighborhoods are her preference, but ultimately, a variety of streets are adorned with her figures and aphorisms. While at first the Miss sketched her own portrait, she later focused on the more general representations of women, adding short phrases to "give her a body." A daughter of the streets, but also a creature of fashion, Miss.Tic depicts her life, her loves and sometimes even betrays her political sentiments. A student of aphorisms and word-

play, her compositions are unforgettable and tinged with the bittersweet: "Le mal de taire" (silent sickness), "Belle et bien là" (ready and beautiful), "Trop peureuse pour être heureuse" (Too fearful to be cheerful), "L'art me ment" (Art lies to me) or even "Le Temps est un serial qui leurre" (Time is a cheating serial killer).

Gallerists, filmmakers—she made the poster for Claude Chabrol's 2007 *A Girl Cut in Two*—and fashionistas have kept an eye on her over these past years. For example, for his Fall-Winter 2001-2002 show, Marc Jacobs offered his guests

the Miss.Tic effect. The collection was called *Monogram Graffiti* and for the first time called upon a French contemporary artist, specializing in graffiti in the manner of Stephen Sprouse. The two artists were in dialogue. Inside an elegant black vinyl clutch, in a series of postcards, Miss.Tic presented a very personalized perspective of Louis Vuitton. Based on a drawing in the Vuitton museum in Asnières, they offer several takes on the visage of the house's founder. Rendered in different sizes, Louis's portrait is set against colorful backgrounds, creating an effect that is at once high pop and very contemporary.

p.284-285 *Hommage à Louis Vuitton* by Miss.Tic (2001). Stencil on a series of numbered and unnumbered postcards given out during the Women's F/W 2001-02 show, March 12, 2001; 42 x 30 cm (16.5 x 12 inches). Louis Vuitton Collection.

Mizrahi, Isaac

designer
text by Olivier Saillard

In 1996, Isaac Mizrahi was one of seven fashion designers asked to contribute a personal vision for a bag honoring the centennial of the Monogram canvas.

Passionate about simplicity and respectful of American ready-to-wear's rich traditions, Mizrahi created a bag that was entirely different from those his peers presented. Shaped like a shopping bag and completely transparent, it combined plastic and natural leather details. Bringing to the fore the playful humor so characteristic of his work, the New York designer also included an elegant pocket made in the Monogram canvas into which its future owner could discretely slip cosmetics and other beauty products. This turned the bag into the genuine face of the woman on the go. Mizrahi's designs stand at the crossroads of Perry Ellis and Calvin Klein—for whom he worked after studying at the Parsons School of Design—and Claire McCardell, who led the way to modernity and founded the vision of a comfortable ready-to-wear fashion that was both elegant and timeless. A leading figure in New York for much of the 1990s, Mizrahi gently subverted the classic lines of American fashion with his own sense of playful proportions and selection of subtle fabrics, and created the confident fantasy that has become his signature.

p.287 On the centennial of the Louis Vuitton Monogram in 1996, Isaac Mizrahi created the Weekend tote in vinyl and leather details. Photograph by Guzman. Louis Vuitton Collection.

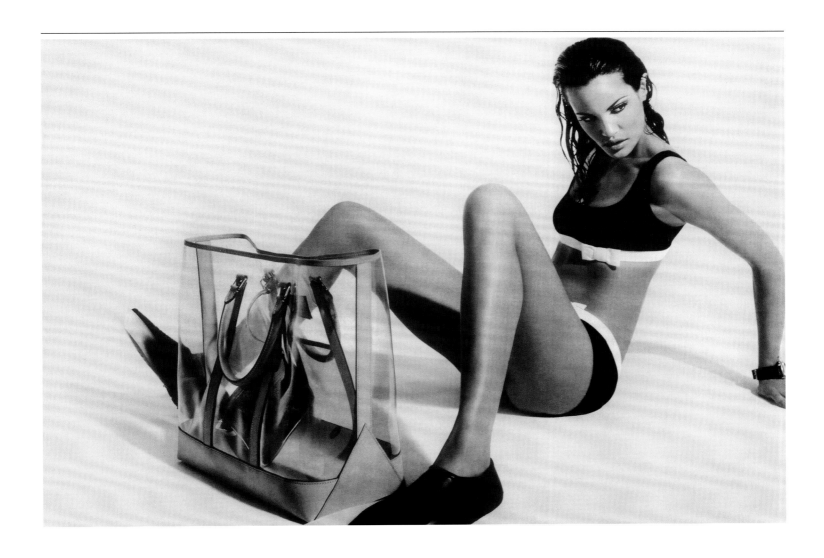

Moulin, Nicolas

artist
text by Marie Maertens

A total electronic music buff at age nineteen, Nicolas Moulin set out for Berlin and found Russian Constructivism, German expressionist cinema and science fiction literature.

To take in the city, he hit the streets for hours at a time and began photographing it. The city was as much observed for what it is physically as for what it is theoretically. What does a building represent? What are its functions, its design or its ambiance? What is the avant-garde? The rear-guard? Moulin analyzes it all: from the best to the worst, from the ugliest to the wildest. He turned to architecture because of its formal aspect, the overlap between numerous places and his vision of utopia. This French artist, born in 1970, recounts his childhood spent in a leftist family that thrived on idealism: "To be Communist in the 1970s, with people who weren't Stalinists but rather Sixty-Eighters, was actually romantic." He says he came of age in a period stretching from the fall of the Berlin Wall to that fall of the World Trade Center. He then forged work, grounded on a fiction with poetic and critical impact. The resulting pieces have an interstitial or borderline aspect, a fascination with worlds that tip towards something disquieting. Nevertheless, he rejects narrative and presents "fictions without narration."

The sculpture Moulin executed for the exhibition *The Temptation of Space*, at the Espace Louis Vuitton, proved to be a pivotal piece, especially with regard to his previous work, which centered more on the image. He began to stray from figuration, while remaining within the boundaries of realism, which he called "para-realism."

"The term 'para' shows that we are on an orbital road, at the frontier of different things. Contemporary art, as far as I'm concerned, is still a discipline situated on the fringe of others. When Louis Vuitton asked that I do this exhibition on space, I didn't want to create a Pop piece because, to me, space is truly a romantic notion, a project of civilization. Space in the larger sense of the word, if you take away the kitsch aspect, is the will to always go further, to discover the world. My response to the exhibition was to return to my sources, which were the mythologies of Suprematism and Constructivism, where these spatial utopias already existed. The piece was constructed with a very simple pendulum system, which yielded a random movement. The shiny black design could also suggest, without representing it, orbital panels. It's the story of a weightless movement that still includes that romantic idea—maybe idealist!—about cold, night, silence and immense beauty. The name of this piece resonates like music. Sternstelr suggests a slightly techno-heroic and strange side. For I began cultivating this universe listening to techno music, the imaginative world of which—especially Detroit—is very much linked to space…"

p.289 *Sternstelr* (2007) by Nicolas Moulin, part of the exhibition *The Temptation of Space* held at Espace Louis Vuitton in May 2007; 264 x 228 x 120 cm (104 x 90 x 47 inches). Louis Vuitton Collection. This kinetic installation in steel and aluminum was inspired by images of Saturn transmitted by the Cassini-Huygens probe. The hypnotic movement of the rotary arm produces the effect of a drifting mechanical body in space, deprived of notions of horizontality and verticality.

Art, Fashion and Architecture *289*

Murakami, Takashi

artist
text by Rebecca Mead

When Andy Warhol's studio came to be known as the Factory, it was an appellation layered with irony.

When Andy Warhol's studio came to be known as the Factory, it was an appellation layered with irony. While there was, indeed, a production-line quality to the way in which Warhol's assistants turned out a diversified line of products—silkscreens, lithographs, movies—the factory metaphor went only so far. (General Electric, for example, has never served as a hangout space for porn stars and drag queens, nor has it hosted amphetamine-fueled parties.) By contrast, Kaikai Kiki New York, the occidental studio of Takashi Murakami in Long Island City, really is an art factory, one in which the conventions of corporate culture are more rigorously observed. First established in Brooklyn in 1998 as an outpost of Murakami's studio in Japan, the place is both devoted to the mass production and the elite refinement of Murakami's Superflat aesthetic. Upstairs, there is an office with banks of computers manned by headset-wearing minions, handling the production and promotion of Murakami's artwork, the management and support of select artists, the semiannual GEISAI art fair in Miami and Tokyo, and the company's international merchandizing division, its products ranging from luxury handbags to inexpensive key-chains. Downstairs, about twenty skilled workers produce the fine art—cartoon-like images, outrageously edged in platinum leaf—in accordance with detailed instructions sent by Murakami's senior designers.

If the place doesn't quite have the whirring widgets of an assembly line, there are still deadlines to meet and orders from Murakami to fill, including those concerning partnerships with Kanye West, with whom Murakami started working in 2007 designing covers, and Louis Vuitton, whose monogram pattern he was commissioned to revamp in 2003 by Marc Jacobs, the company's creative director. "When I first saw Takashi's work I smiled and I wondered: Where did this explosion come from?" says Jacobs. "I thought I would love it if the mind that imagined this dizzy-making world of jellyfish eyes, singing moss, magic mushrooms and morphing creatures would be willing to give a go at the iconic Louis Vuitton monogram." After a back-and-forth with Jacobs, Murakami first re-envisioned the Monogram with letters in acid colors on a black or white background, and has continued to produce variations on the theme, a collaboration which Jacobs calls "a monumental marriage of art and commerce." (For the retrospective of Murakami's art that began at MOCA, Los Angeles, a boutique selling such products was presented as just another gallery, albeit one stocked with Murakamis that did not require millions to purchase.) Then there is, of course, the production of the paintings. When I visited the studio one Friday afternoon, two Kaikai Kiki employees had clambered up a scaffold that had been set before of a huge canvas bearing an abstracted skull with flowers in its eye-sockets—an oft-utilized image in the Murakami machine—set in a pattern of abstracted camouflage. The painting had been under production for two months, and was to ship in three days time to London for exhibition. The two workers were now varnishing it with the concerted industriousness that was reminiscent of the scene in *Alice in Wonderland* in which three servants of the Queen of Hearts are seen frantically painting white roses red.

The only thing missing from the art factory was the artist himself: Murakami spends only a fraction of the year in New York City, and is based in the central Kaikai Kiki headquarters in Tokyo. (Murakami's US outpost was established to diminish the logistics, and the costs, of selling to an international audience.) His physical presence is required for only two tasks: approving and then signing the works that have been produced under his name. "The paintings are never done until he says they're done," says Jeff Vreeland, a studio manager. "It's only a painting when he says it's a painting."

Murakami's work can only be produced because it's not Murakami who's physically producing it: it would be much too labor-intensive, and impossibly costly, for it to be handcrafted by the artist's. But at the same time that his physical presence is unnecessary to the production of his works, Murakami is bodily dedicated to his art to a degree that would trump the most compulsively hands-on artist. "I wake up and sleep in the studio, restrict my diet to live longer, exercise, read piles of books, talk to my employees all day, do some drawings, and go to bed," he says. "That's about all there is to my life. The only thing I have to look forward to is the moment a project gets completed, which lasts for about three seconds." Murakami doesn't own an apartment, in Japan or in New York; instead he lives in his studio. His private quarters in Long Island City consist of a smallish bedroom, separated from a common hallway by a translucent sliding door, and containing little beyond a queen-sized bed and a desk with a few books on it. Here's what transpires in that bedroom in the few hours when Murakami isn't actively at work: a recurring dream in which, he says, "I am being scowled at and chased by a giant robot, and I keep running at breakneck speed around old street corners."

Another kind of dream, and another kind of factory, is where Murakami's interests and ambitions really lie. While Warhol is his obvious progenitor—and his studio was originally named the Hiropon Factory in homage—a closer model is the Hollywood studio, in which a small city's-worth of talented people work to execute the inspiration of the director, who is hardly expected to operate the camera himself. "It would be wonderful if I could build a structure similar to Disney's," he says. "Disney can survive economic dangers, changing executive positions, the outbreak of internal corporate conflicts." So can there be art after life? "I want my work to continue to live even after my body dies," he says. In art, the quest for immortality is an ancient one; the establishment of a corporation to take over when the corporeal fails is something else entirely. If anyone can do it, Murakami can.

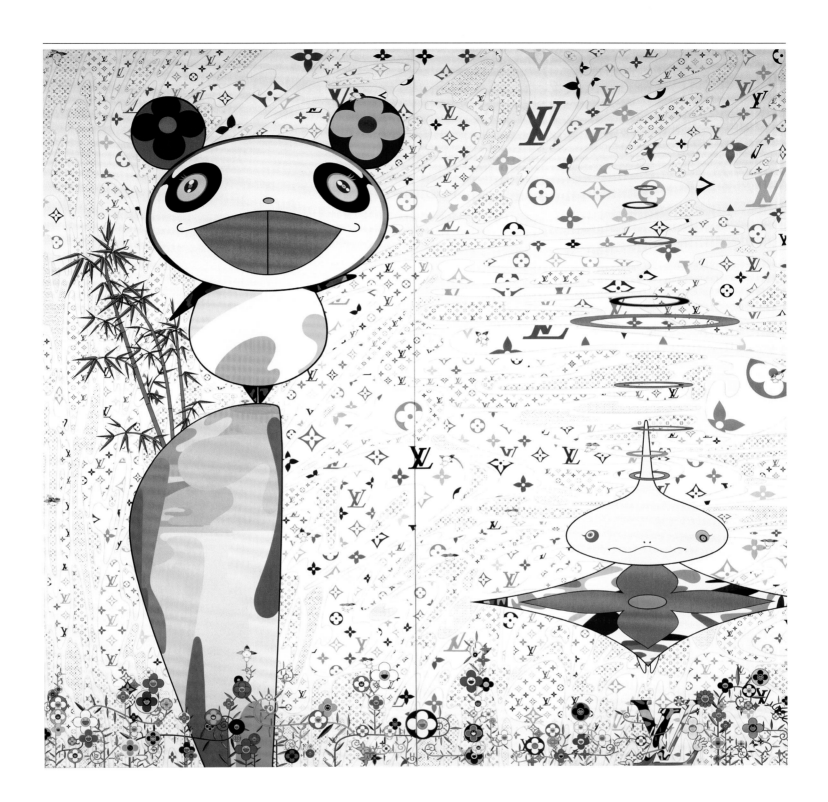

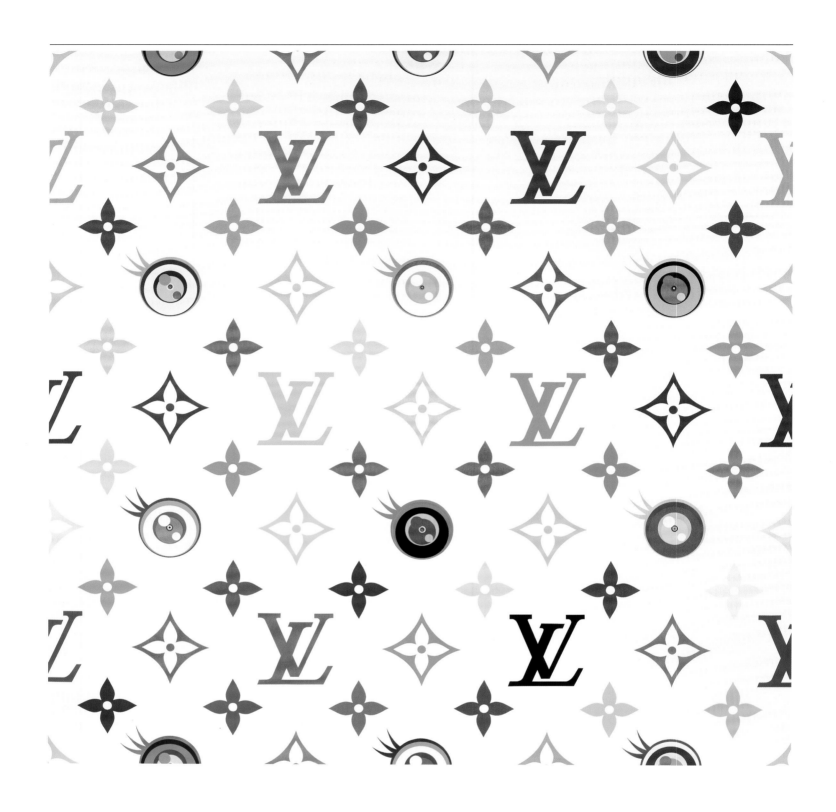

p.292 *Eye Love SUPERFLAT White* (2003) by Takashi Murakami. Acrylic on canvas mounted on board, 120 x 120 x 5 cm (47.4 x 47.4 x 2.3 inches). Gift of Takashi Murakami to the Louis Vuitton Collection. © 2003 Takashi Murakami/Kaikai Kiki Co., Ltd. All Rights Reserved. The most important collaboration by Louis Vuitton with any artist is that with Takashi Murakami, which produced, among other designs, the *Multicolor Monogram* and the *Eye Love Monogram*. Murakami first reinvisioned the trademark monogram with letters in acid colors on either a black or white background, and has continued to produce variations on the theme, a collaboration which Marc Jacobs calls a "monumental marriage of art and commerce."

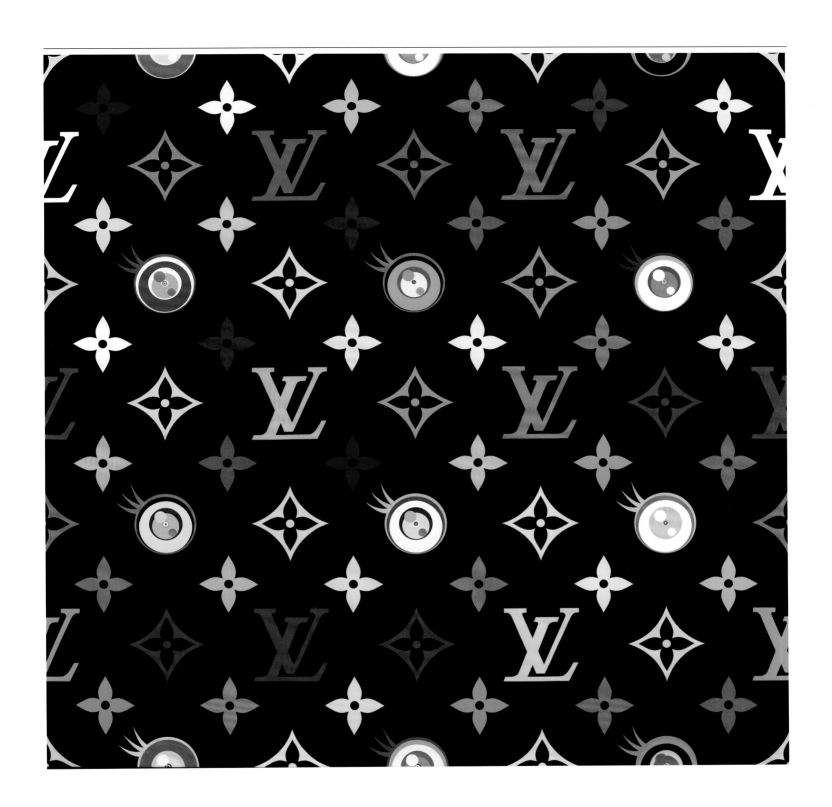

p.293 *Eye Love SUPERFLAT Black* (2003) by Takashi Murakami. Acrylic on canvas mounted on board, 120 x 120 x 5 cm (47 x 47 x 2.3 inches). Gift of Takashi Murakami to the Louis Vuitton Collection. © 2003 Takashi Murakami/Kaikai Kiki Co., Ltd. All Rights Reserved.

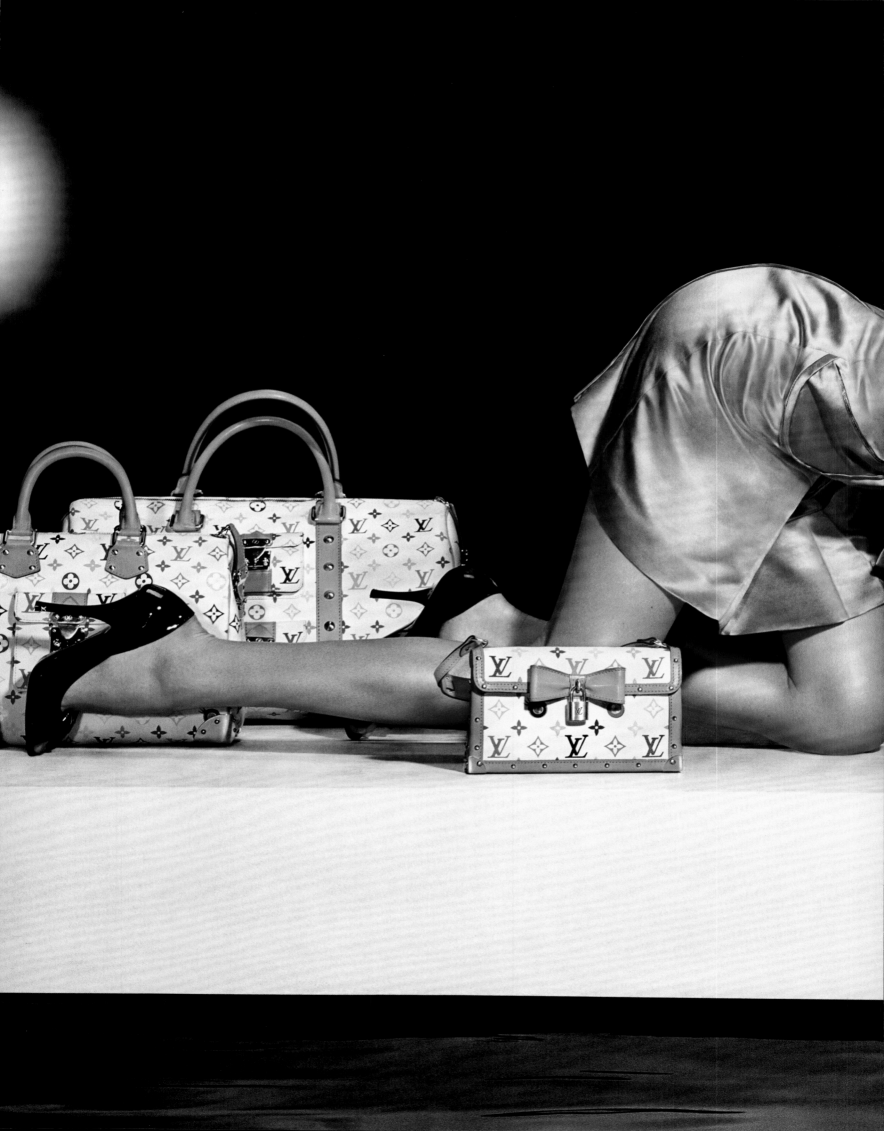

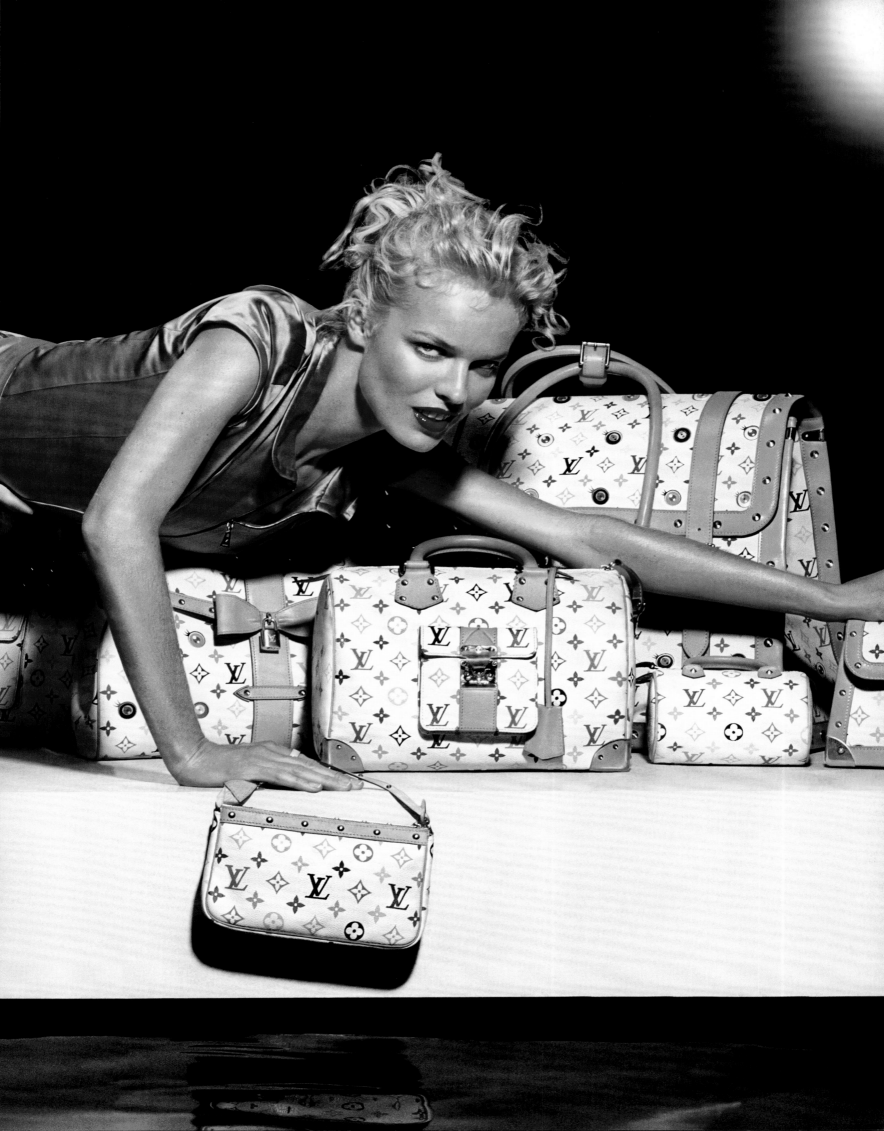

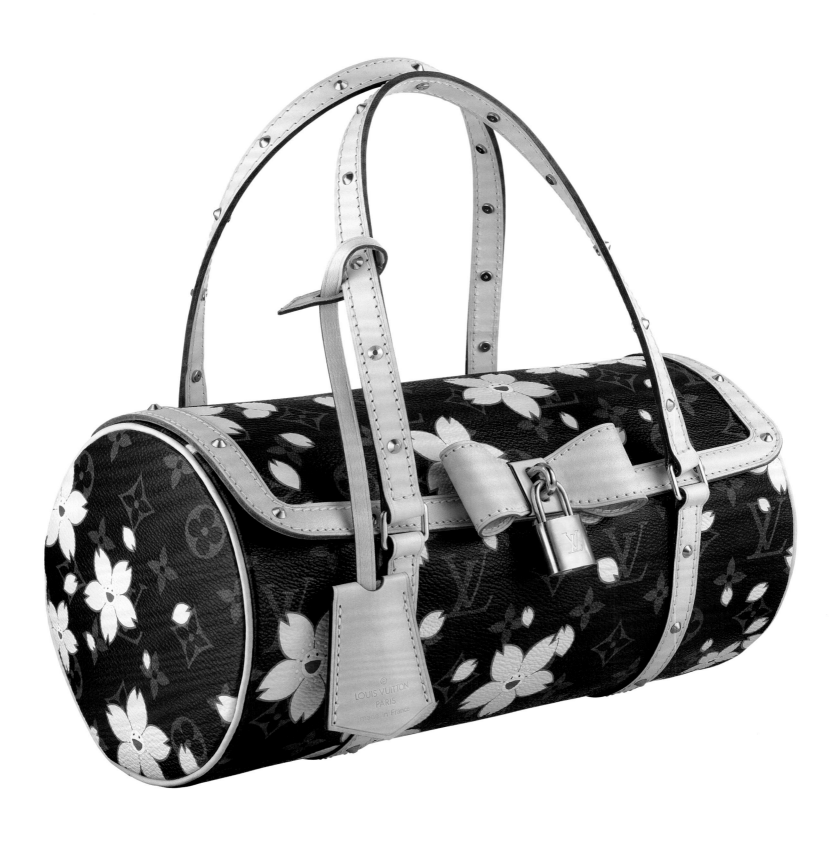

p.294-295 Advertising campaign by Mert Alas & Marcus Piggott, featuring Eva Herzigová in S/S 2003 Prêt-à-Porter, in a yellow satin dress and black patent pumps, surrounded by luggage in the white *Multicolor Monogram* and the *Eye Love Monogram* by Takashi Murakami. © 2002 Takashi Murakami/Kaikai Kiki Co., Ltd. All Rights Reserved. p.296 Papillon bag in the *Cherry Blossom Monogram* by Takashi Murakami, from S/S 2003. p.297 Windows of Maison Louis Vuitton Champs-Elysées for the launch of the *Cherry Blossom Monogram* line, 1 March 2003. © Takashi Murakami/Kaikai Kiki Co., Ltd. All Rights Reserved.

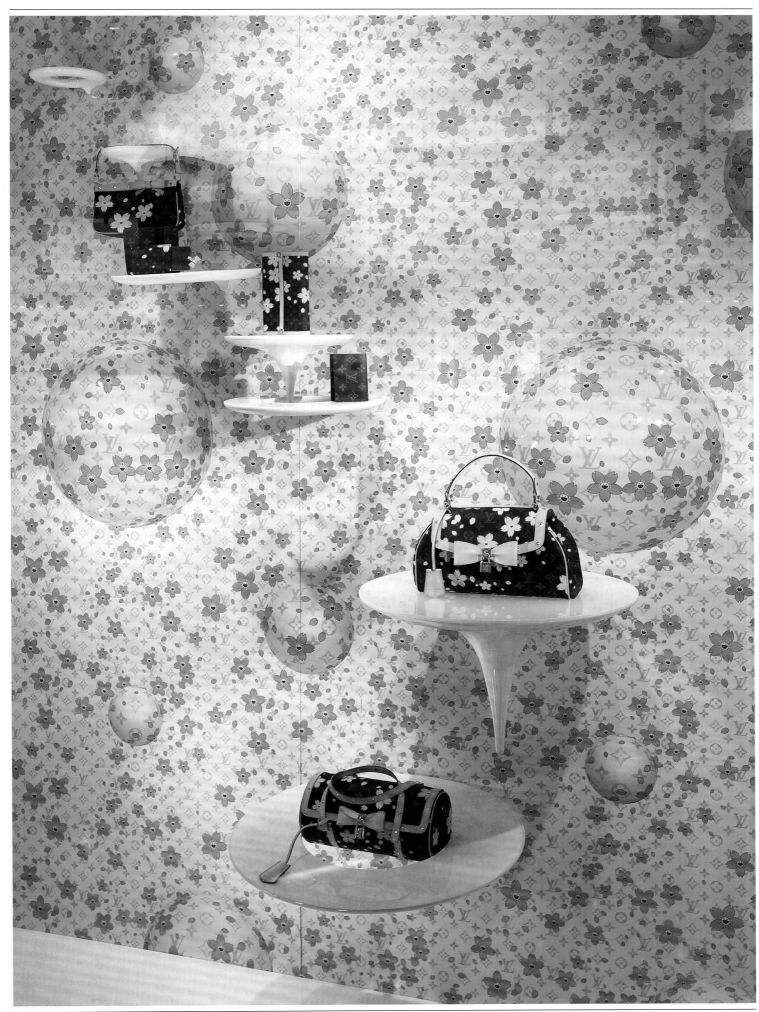

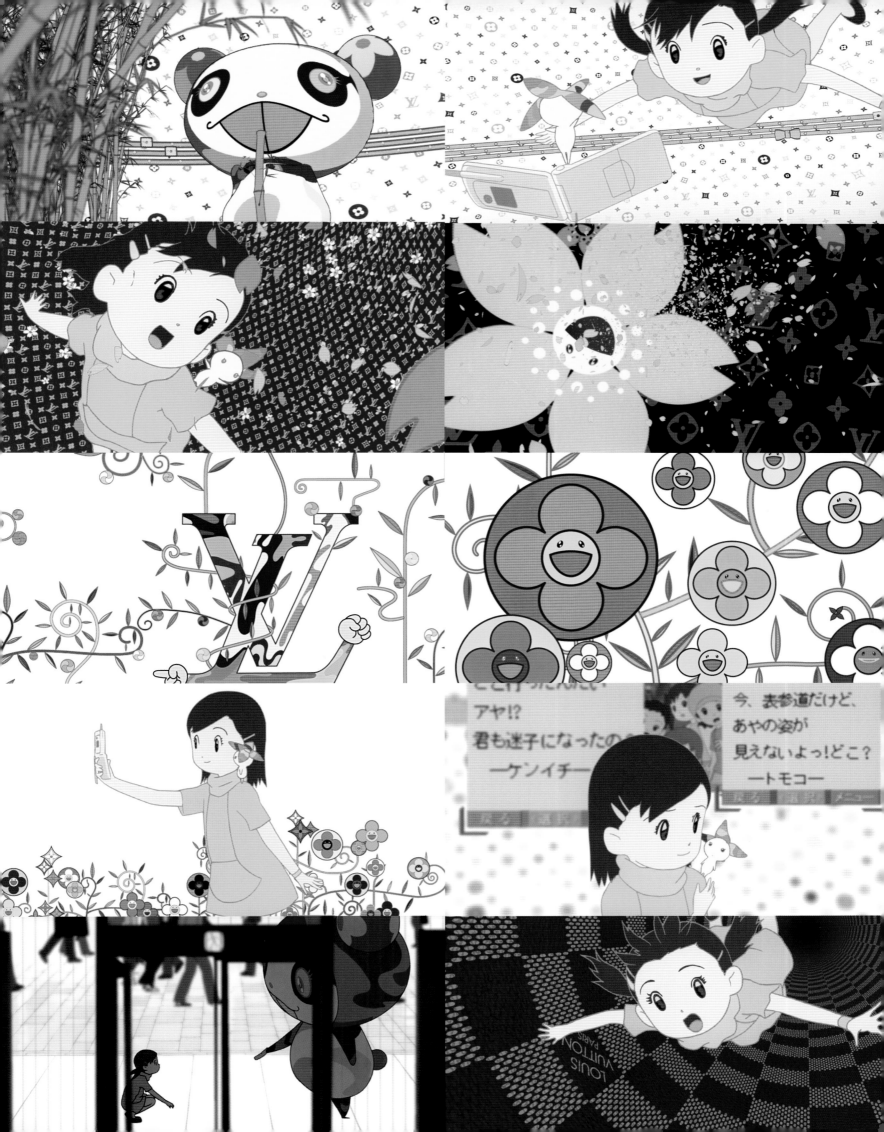

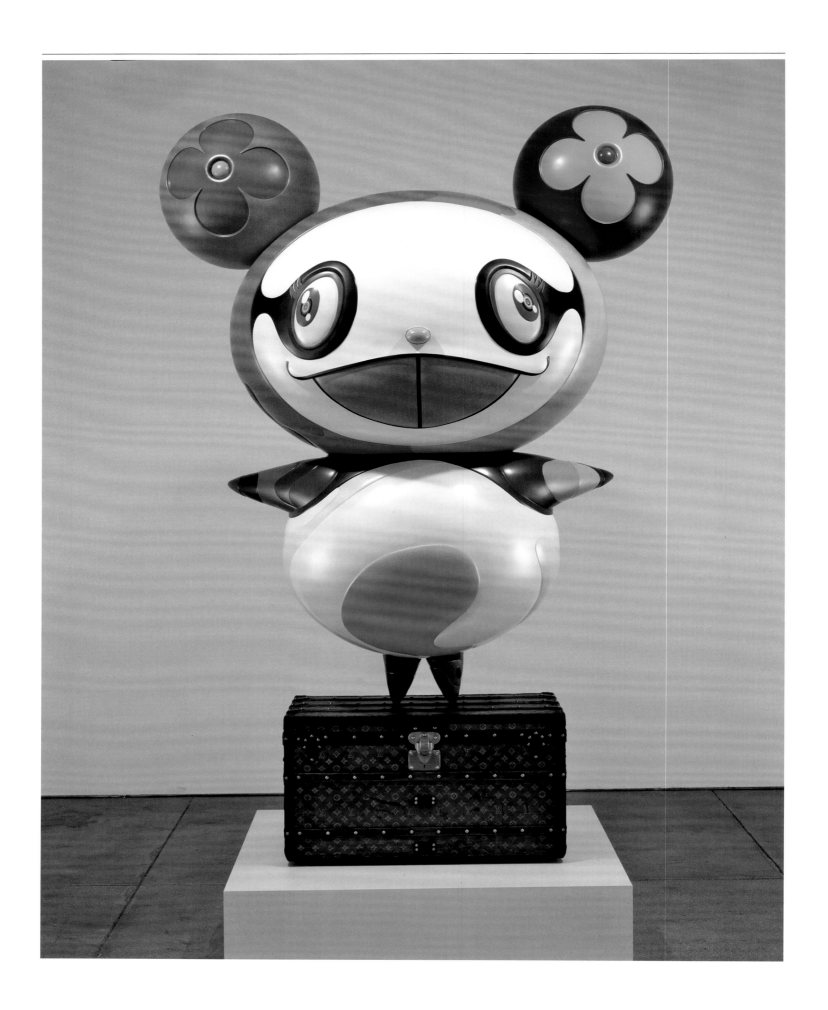

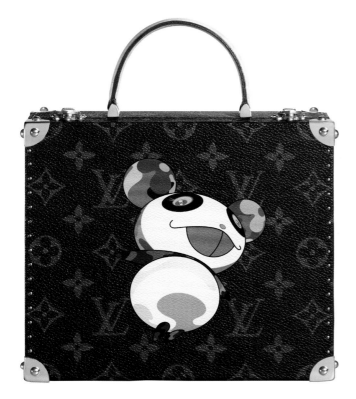
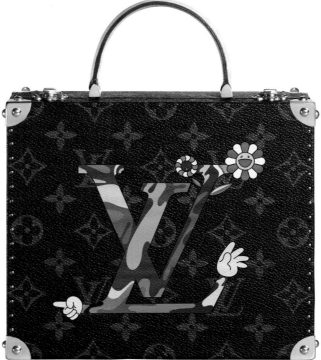

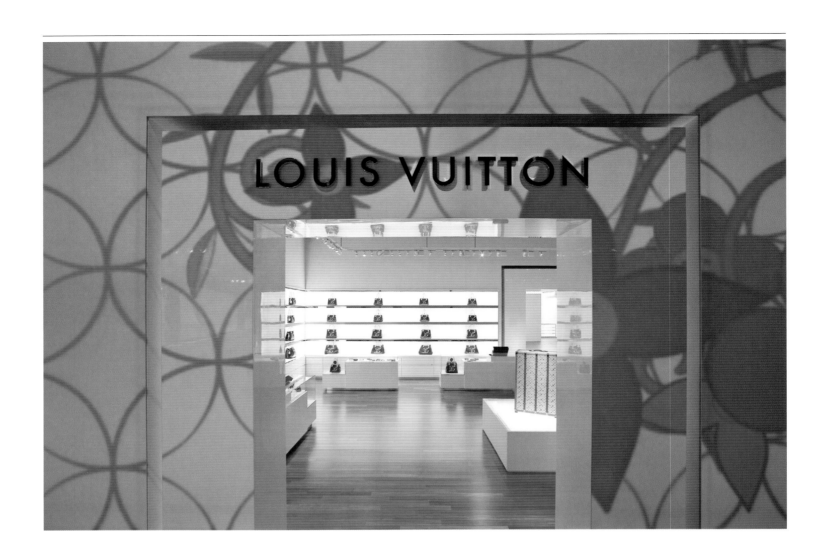

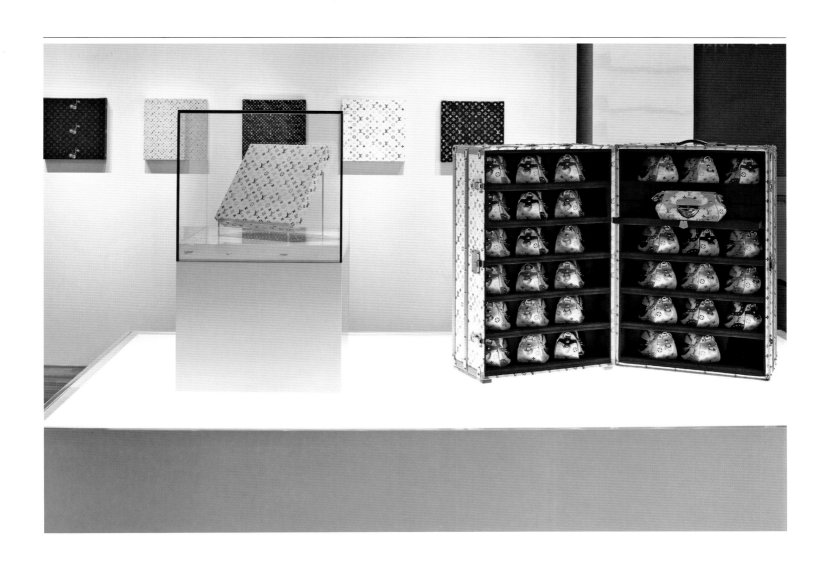

Nayiny, Malekeh

artist
text by Emmanuel Hermange

Born in Teheran in 1955, Malekeh Nayiny left Iran in the early 1970s.

After studying in London, she went to the United States where she studied the arts at Syracuse University in New York state. She went on to Parsons School of Design to study film, and later the International Center of Photography in New York. She then settled in Paris, where she has lived for some fifteen years.

Nayiny's interest in photography drew inspiration from the styles of certain avant-garde artists like Christian Schad, László Moholy-Nagy, Man Ray and even Brassaï; like them, she explored the possibilities the medium offered. Like them, she also believed that primitive techniques like the photogram and *cliché verre*, invented by pioneers of photography in the 19th century, could be used to produce contemporary works. A photogram is a negative shadow image produced by the way light is exposed to objects placed on photo-sensitive paper. *Cliché verre* is a piece of glass—or an opaque, uniform, ground-coated transparent surface—on which an image is etched to produce a print using the usual copying process. Both of these techniques require manual skills to produce the image, and results in a uniformly smooth image free of irregularities. Their magical effect on the eye stems from this apparent contradiction. Nayiny combined these techniques and added the art of collage, to produce figurative imagery evocative of the universe of fairy tales and fables. One of her exhibitions, *Tales of Light* (Galerie Foto, New York, 1982) included four stories written by an artist friend based on her works. And recently, the series *Traveling Demons* (2007), that she presented in early 2008 at l'Espace Louis Vuitton for the group exhibition *Orients sans frontiers*, included a collection of tales based on dreams recorded during hypnosis sessions (*SOS Gandhi*, 2007). This recent work, in which photo editing replaced primitive techniques, describe the role devils and demons play in the imagination of children and what form this fear takes when the child becomes an adult. By "devils" one must understand *div*, a Persian term derived from *daeva* which, in the ancient Avestan language, means evil gods—those that spread turmoil and chaos. The representations of the human body that appear like patterns in certain images were "a way of saying that the demon originates in our genes, our cultures, our customs," explained Michket Krifa, a curator who has exhibited Nayiny's works a number of times. The very vivid colors of this series, as well as other elements like the demon's mask, recall the illuminated manuscripts of the Persian poet Ferdowsi's *Book of Kings*, where Rostam, the hero, fights with horned hybrid beings. Certain illustrations from this book appear as backdrops to Nayiny's friendly-looking demons, and suggest two things: first, the need to confront the demons in order to subdue them; and secondly, the need for a more deeply rooted mythology at a time when advertising creates fleeting images. Through photomontage, the artist's demons have replaced monumental advertisements on the billboards of the world's great metropolises.

In *Vasile: Hansel et Gretel* (2007), Nayiny demonstrated how a fable so deeply rooted in popular culture can assimilate into a modern situation. In a series bringing together photography and drawing, a young Romanian boy, whom the artist found while selling the newspaper *L'Itinérant*, becomes both siblings in the famous Grimm fairy tale. She expanded the work with portraits of homeless Romanians (*Street Saints*, 2005), a metaphor for her painful experience in Iran, and her failed attempt at return. Nayiny's exile and abandonment are more explicit in *Updating a Family Album* (1997-2000), a series in which she digitally edited photographs from her family archives, most of which were taken in studios in Teheran. This updating of files buried in her memory describes the fragile balance that every expatriate knows intimately; a balance between bridging and dividing, leaving and returning, the past and present. Following the death of her parents in Teheran, she attempted a similar project by associating some of their possessions to the official portraits found on their identity paper. (*Observations*, 2000).

p.307 *Breakfast in the City* from the *Traveling Demons* series (2007) by Malekeh Nayiny; digital photomontage, 120 x 76 cm, (47.2 x 30 inches). Louis Vuitton Collection.

308 **Louis Vuitton**

Ory, Jean-Jacques

architect
text by Philippe Tretiack

Jean-Jacques Ory understood it before anyone else did: to a great extent the future of architecture lies in the restoration of old buildings.

As a pioneer, he became involved in this issue in such a persuasive manner that he became an expert. But if one is going to work with a country's heritage, if one is going to alter it, modify it, subvert it, the greatest tact is required, for any and every intervention is minutely scrutinized by a commission, ministries, appointed magistrates and local governments. There, where imagination comes up against regulation, diplomacy is in order. The son of a military doctor, Ory has learned to be at the head of a situation. Organization is in his blood. It's a strategy. Little by little, he has worked his way up. It wasn't long before his logo appeared on building facades. Now almost thirty years on, one can stroll through Paris, flitting from one of his "building makeovers" to the next. Both Louis Vuitton and the LVMH Group have often called upon his talents. Under the auspices of these demanding clients, the architect renovated the emblematic Belle Jardinière building. Ideally located along the Seine, this building, and later the central structure of La Samaritaine, bear the signature of such famous architects as Henri Sauvage and Franz Jourdain, to only name the most iconic. Ory renovated them one by one.

The house of the couturier Kenzo, also a member of the LVMH Group, acquired one of these buildings, one that was once used for the "bazaar." An awning has been erected along the streets; atriums with overhead natural lighting allow for offices and service areas to be built; a soft pink glow floods the floors; and finally a restaurant arose from the upper floor. Resembling something from another planet, a capsule in the sky, Kong is one of the hippest places in the city. Its interior design by Philippe Starck has become an icon.

Across the way, the Belle Jardinière is today home to Louis Vuitton's headquarters. A large wooden door more than 12 feet high opens onto the Rue du Pont Neuf. And on every floor, Ory has captured the very spirit of the brand, "the essence of modernity and elegance." There are walls covered in light leather, a range of grayish-beiges, light browns and whites, patinated wood. At the other end of the building, other shops for furniture and sporting goods have taken residence in a clean, polished, and open architectural space.

Sephora acquired another building belonging to the former La Samaritaine department store. During the cleaning and through historical analysis, the architects uncovered mosaics that had been lost beneath the painting. Ory relished the detective work and set out looking for a tradesman who would be able to find and recreate the identical décor. He found him in central France.

Avenue Montaigne is still home to the LVMH headquarters. Ory's firm redesigned the offices with Jean-Jacques Wilmotte's assistance. A diligent worker, Ory is not only an architect but also a painter and sculptor—he has just finished an oversized woman's pump that will soon be installed at the entrance of the Louis Vuitton factory between Padova and Venice—and has acknowledged some of the transgressions of ways of his early practice. Critics had reproached his renovation of the Trois Quartiers building designed by Lois-Faure Dujarric in the 1930s in a pure steamship style. "Today," he says, "we wouldn't do that anymore." Since then he has also worked for the Galeries Lafayette and completed the restoration of the Crédit Lyonnais headquarters destroyed by fire in 1992. The glass footbridges point to the achievement, both because they rewrite history and are simultaneously innovative. Ory's activities are wide ranging and include new buildings, residences, offices, private homes and commercial centers. With ecology a top concern, his architecture has gone green. Like the country's heritage, nature too, is a thing to be conserved.

p.311 Entrance façade of the former La Belle Jardinière department store, now the corporate headquarters of Louis Vuitton Malletier, 2, rue du Pont-Neuf, Paris. Original designed by Frederic Sorrieu, 1880; renovated by Jean-Jacques Ory, 1998.

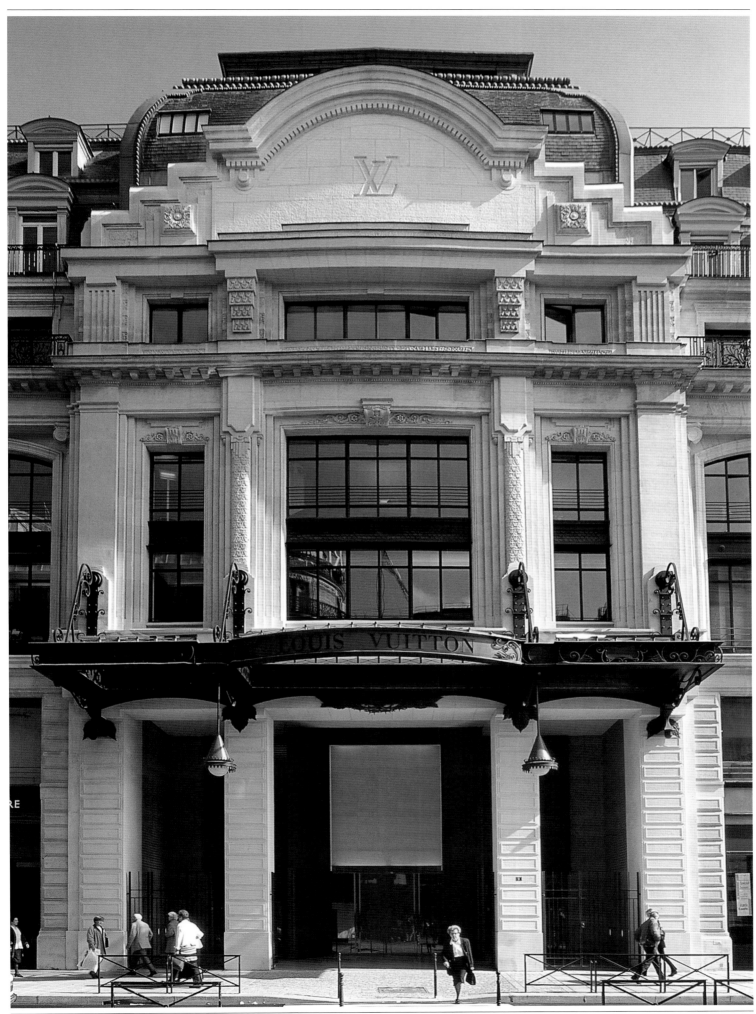

P–R

Parr, Martin

photographer
text by Emmanuel Hermange

We generally associate Martin Parr—born in 1952, in Surrey—with a group of British photographers whose emergence is closely linked with the Thatcher years and the dismantling of the welfare state in the United Kingdom.

Of the group members, which include Chris Killip, Paul Graham, John Davies, Brian Griffin and also Daniel Meadows, with whom he was very close when he first began working, Parr is the one whose photographic approach—between its conceptual influence and social realism—has enjoyed the most success. Certainly because he has offered both the most direct and the most ambiguous reflection of the principal agent that has transformed capitalist societies over the last thirty years: consumerism. His is an aesthetic of incongruous details, effectively revealed through a savvy balance of framing and proximity to his subject. Easy to read, these passages are cultural elements that can be widely appreciated because of their humor. As for the ambiguity, it is tied to the way Parr first portrayed a dying working class and then the decline of the middle classes, from which he himself hails.

Thatcherism encouraged a political interpretation of his work, where he was seen either as an earnest social critic or an overly ironic one focusing on easy targets. But he has chosen his subjects above all for their "ordinariness," which fascinates him. It is something he often associates with boredom, which the curator Val Williams documents in her monograph on Parr in 2004: "when you hear him speak about his childhood and teenage years…you hear about boredom and dullness, a childhood governed by the rhythm of church and dominated by his parents' all-consuming passion for bird watching." His inevitable involvement in the activity surely developed his sharp sense of observation and his deep interest in typology and collecting. Aside from "boring" postcards, which have become famous through two books for Phaidon (*Boring Postcards*, 1999 and 2000), he has collected all kinds of objects produced by the kitsch industry (printed plastic bags, wallpaper, commemorative plates, coasters, Spice Girls paraphernalia, etc.). At the same time, his adolescence was marked by the discovery of photography to which his grandfather, a member of the Royal Photographic Society, had introduced

him. It was with him that he completed his first photographic essay on a fish-and-chips restaurant near Leeds. The eating habits of the British have been a theme in his series ever since, presenting his fellow countrymen in what Val Williams describes as "the most fascinating, cultured barbarians."

The central elements of Parr's work emerged in the early 1970s in northern England where he had gone to study photography at Manchester Polytechnic. There he discovered another social reality: a working class region at a time of high unemployment. Inspired by Bill Brandt and Tony Ray Jones, but especially by certain American photographers he was just discovering—Robert Frank, Gary Winogrand and Diane Arbus—it was in this context that he developed his interest in the vernacular of this region. With Daniel Meadows, he began work on a documentary project in Salford, near Manchester, in the neighborhood where the oldest British television show, *Coronation Street*, was filmed. In typical rows of brick houses, he photographed workers at home, without fanfare, paying close attention to objects and arrangements. Then on the gloomy coast of Yorkshire, they were hired as photographers at a resort for the same families of workers they had photographed, selling them snapshots as souvenirs. These two experiences shaped many aspects of Parr's work. First, the almost surreal account of the social mythologies fabricated by the media has remained one of the most interesting aspects in his work. Second, the observed behaviors of people engaged in hobbies or on vacation has been the subject of some of his best series, for example *The Last Resort* (1986) or *Small World* (1995). Furthermore, his job in Yorkshire allowed him to intensively explore color photography for the first time and to discover how it can break away from reality; the holiday images that John Hinde sold to vacationers as postcards have saturated colors reminiscent of science fiction. The very particular use of color that Parr developed during the 1980s, after seeing the work of William

Eggleston for the first time, helped establish his international reputation in the early 1990s. It was at this time that he joined Magnum.

As a photographer, teacher, curator, publisher and collector producing images for both the press and the art market, presented in exhibitions, books, architectural installations and advertising campaigns, Martin Parr has successfully blurred the logic of genres and categories. His recent involvement in fashion has made him even more difficult to classify. After joining him at the Paris fashion shows in 2001, the journalist Tamsin Blanchard described him as "a man who spends no more than two hours a year buying clothes, during sales in January and July, with his wrinkled shirt and inevitable sandals." From his point of view, he considers that "the moment someone is wearing something in a photo, it's fashion photography […]. I don't know anything about fashion. I'm not into designer labels. I don't have one piece of designer clothing except for a Paul Smith jumper. I don't have any idea who the designer is when I do a shoot." These could very well be the words of an outside observer looking in on fashion, yet it was in taking assignments from magazines (*Amca, Elle, Exit, Citizen K, Jalouse, Rebel Magazine,* etc.) or from brands like Louis Vuitton, who asked him to shoot two advertising campaigns in 2007 and 2008, that Parr took his first step into fashion. Intent on showing that fashion photography can (almost) be confused with other genres of images, the photographs he took for Louis Vuitton recall certain shots from tourist sites or the buffet tables at political conferences, although they incorporate professional models in designer dress. In some respects, it is the opposite of what he developed before, in Ilford, England, when he photographed people walking by dressed in the latest collection by Paul Smith. There is as much experimentation in fashion photography as there is in fashion, something Parr recounts in *Fashion Magazine* (2005), the single issue he published with a group of other contributors from the worlds of both fashion and art.

p. 311-312 *Untitled studies* (2008) by Richard Prince. Paint, mixed media on canvas, 150x91 cm. Louis Vuitton Collection. **p.315** Men's S/S 2008 (top) & A/W 2007-2008 (bottom) ad campaigns by Martin Parr.

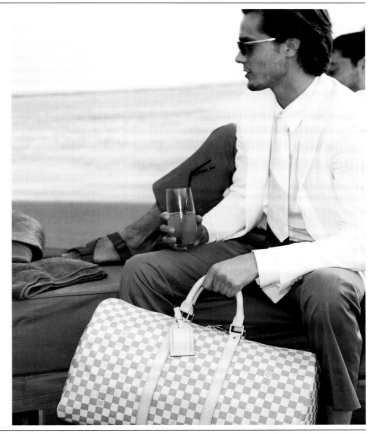

Peinado, Bruno

artist

text by Simon Castets

"Now that this has been done, it will never have to be done again" declares a series of works created by Bruno Peinado directly referencing the American artist Mike Kelley.

The irreverent quote is inscribed backwards on a multi-colored background covered with spider webs. Born in France in 1975, Peinado pays tribute to one of the leading figures of contemporary art, all the while thumbing his nose at the modernist objective of "purification" so forcefully asserted by Clement Greenberg. "I have a mind to shatter purity," affirms the artist. His work involves an extreme repackaging of contemporary symbols, from the famous Michelin Man (*Untitled, The Big One World*, 2000) to John McCracken (*Untitled, California's Custom Game Over*, 2006). Since the late 1990s, Peinado's work has been a satirical battle against the constant stream of images conveyed by the media, an attempt at "postproduction."[1] As Nicolas Bourriaud writes in *Postproduction*, in a chapter dedicated to Mike Kelley, "The art of the twentieth century is an art of *montage* (the succession of images) and *détourage* (the superimposition of images)."[2]

Peinado's art stems from the simultaneous realization of two processes, giving rise to a brilliant cataclysm of numerous and varied references, ranging from cartoons (*Untitled, Wild Disney PM01*, 2003) to art history (*Pump Up the Rhizome*, 2006). He created many drawings by appropriating symbols found while reading magazines and produced composite, often imposing installations by combining a beam of multi-colored images, lacquered surfaces, neons and strobes. Recovered by Peinado "like driftwood,"[3] the key visual elements of contemporaneity make up sculptural installations that he compares to *mille-feuilles;*[4] a clever yet playful eclecticism combining high and low cultures, in line with the principle of "creolization" championed by the artist. This is evident in his work, *Untitled, Flamingo Go Dirty* (2006), a piece of furniture inspired by Michele De Lucchi, where Peinado inlayed traces of an imaginary coffee cup on the surface. The hybridization of the object took him back to the original intentions of the Memphis group, which championed design for mass consumption rather than the creation of rare collector's items.

In another quote, Nicolas Bourriaud states that "no public image should benefit from impunity."[5] In Peinado's 2004 piece, *Untitled, Suprematist's Jogging Suit (Burberian)*, he contrasted the world of luxury and avant-garde art by applying Burberry's emblematic plaid to a composition by Mondrian. The clash of the two

images impertinently called to attention their shared character as contemporary icons. It was precisely for the *Icons* Exhibition, which opened at the Espace Louis Vuitton in Fall 2006, that Peinado pursued this exploration by creating *Untitled, Speedy Revolution* (2006). Using a Louis Vuitton bag as the central element of a piece which, "as its name implies, turns very slowly,"[6] Peinado obscured the functionality of the object to sublimate the power of suggestion. The half-open bag shot out a plume of exotic foliage, a skull and crossbones, a smiley face, a diamond and a champagne bottle, all in aluminum cut by high-pressure water jets. Described by Peinado as "baroque proliferation" or "original jungle,"[7] the piece alludes to the reverie of travel and the fascination for so-called "primitive" cultures. Shadows were projected on the surrounding walls by a strobe light that illuminated the composition, adding mystery to the proliferation of signs and symbolizing a frenzied quest for exoticism. *Untitled, Speedy*

Revolution is reminiscent of *Untitled, Nomad's Land* (2005), three house plants that the artist placed in plastic bags which were used as pots. The former thus seemed like a luxurious version of the latter, at least on a formal level. Natural elements—one in the form of a sculpture, the other, real—emerge from a bag of similar dimensions—one, the very essence of luxury, the other, a popular object. This is one of the many *tours de force* of Peinado, for whom minimalism achieves just as much as technological feats, with each work assaying the grim condition of the constrained traveler and the muffled intoxication of cosmopolitanism.

1 Bourriaud, Nicolas. *Postproduction.* Dijon: Les presses du réel, 2003, n.p.
2 Ibid.
3 Interview by Eva Prouteau with Bruno Peinado conducted on February 2, 2007 at the Frac in Pays de la Loire.
4 Ibid.
5 Bourriaud, op. cit.
6 Peinado, op. cit.
7 Ibid.

p.316 Sketch of *Untitled, Speedy Revolution* (2006) by Bruno Peinado for the *Icons* Exhibition at the Espace Louis Vuitton, Fall 2006. **p.317** *Untitled, Speedy Revolution* (2006) by Bruno Peinado; mixed media and projected images, Louis Vuitton Collection, courtesy Galerie Loevenbruck, Paris.

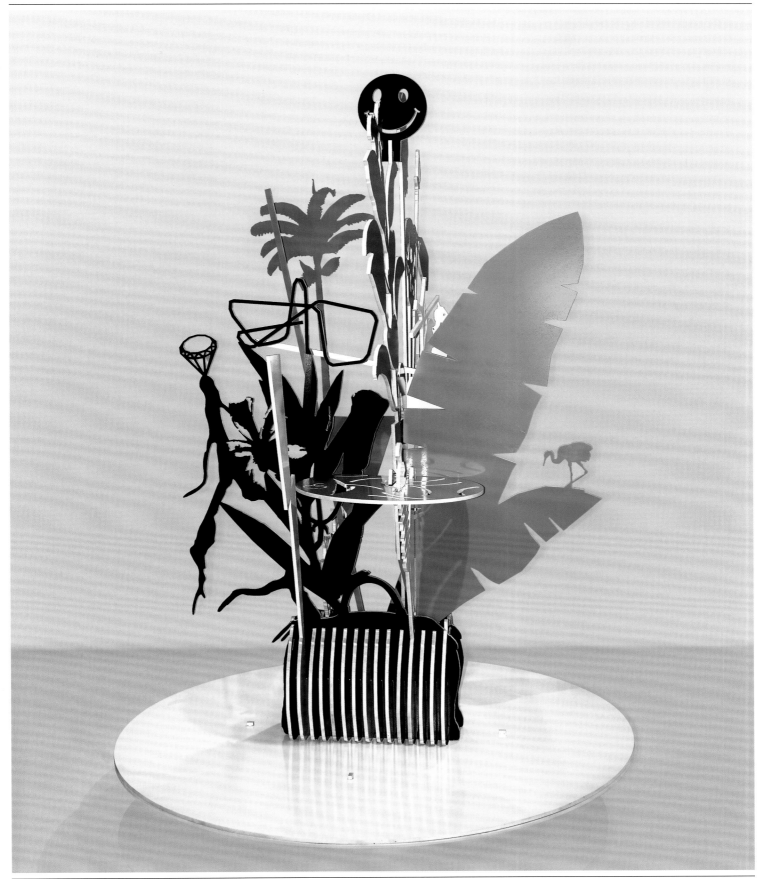

Plessi, Fabrizio

artist
text by Marie Maertens

The most recent works by artist Fabrizio Plessi attest to his Italian fervor.

Although he comes from the Venice region, upon seeing his molten lava projects one could be forgiven for thinking he might be from southern Italy. His is a personality of vehemence, passion, vivid language and gesture, and these qualities have informed the course of his work. Born in 1940 in Reggio Emilia, his career as an artist began in 1968. Although he had been concentrating on painting, he later turned to new means of expression like performance, installation, film and video. Water became the central theme of his work, an essential motif in a poetic dialogue between nature and technology, artifice and reality. He sawed through a lake, cut a trickle of water with scissors, pierced holes into the water's surface and even ironed waves. He then projected these "water forms." Plessi had established himself as one of the pioneers of European video art.

In the 1980s and 1990s, he expanded on his investigations of man and his environment by integrating images of water in earthier constructions made from stone and wood. He gradually turned to fire and lava because he loved the fluidity of its movement. He also explored the notion of luxury. How can luxury be represented? Forever fascinated by the fluidity of things, his bubbling mind imagined a video in which liquid gold was seen slowly streaming down. This idea seemed perfect for the celebration of the new Louis Vuitton opening on Canton Road in Hong Kong on March 14, 2008. Plessi presented a hypnotic installation entitled *Il Lusso e lento* (Luxury is slow) that included two giant videos in the windows framing the entrance. Luxury is earned. Luxury can also be tamed. Luxury, in the face of the complexities of modern life, can also mean withdrawing into a quiet rhythm. Opulence is linked to silence. According to the artist: "Luxury is something that seeps into our DNA very slowly, and transforms us, making us different." This is the point of descent into the underworld, but it is a golden cascade that takes us back to the most primitive, to a magical and absolute golden age.

Like an alchemist, Plessi combines archetypal art materials, for example stone, marble, carbon and wood, with elements that are entirely foreign to them, like video, LED and other newer technologies. The monolithic cube of lava rock, also in the VIP area of the Hong Kong store, serves as a prime specimen. A screen displays the cascade of liquid gold within the rock. And as part of the opening celebration, Plessi designed the first digital handbag in history. The black Epi leather bag—a Louis Vuitton mainstay—was equipped with an ultra-flat TFT-LCD screen showing images of flowing liquid gold through a cutout Monogram. This *Molten* bag was produced as a limited edition of eighty-eight, a number that brings good luck in China, and is destined to attract gold.

p.318 *Molten* bag (2008) by Fabrizio Plessi; Epi leather with an ultra-flat TFT-LCD screen. Limited to an edition of 88. Louis Vuitton Collection. **p.319** *Il Lusso è lento* (2008), video installation by Fabrizio Plessi, Louis Vuitton Canton Road, Kowloon, Hong Kong SAR (2008); architecture by Kumiko Inui. **p.320-321** Windows of the Louis Vuitton Canton Road, Kowloon, Hong Kong SAR (2008) with *Il Lusso è lento* video and *Molten* bag installation for the opening of the store in 2008.

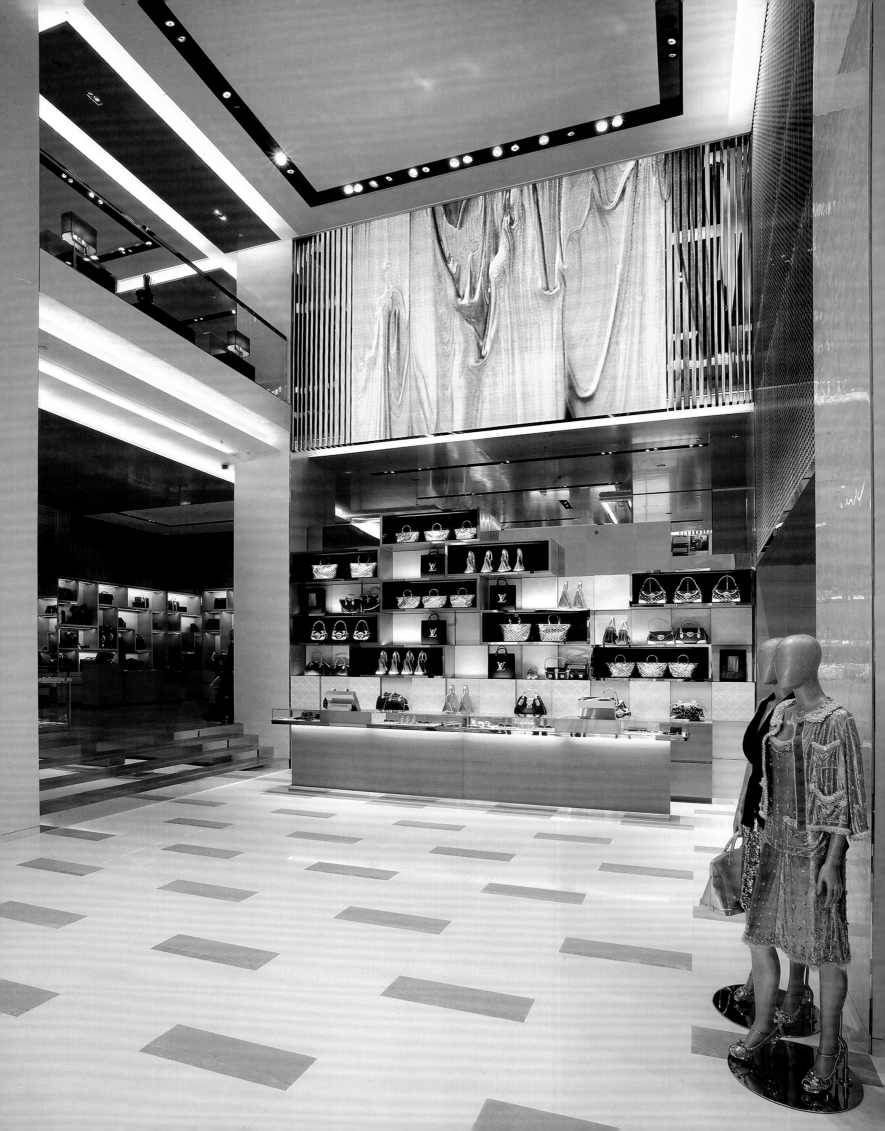

Prince, Richard

artist
text by Glenn O'Brien

"*If this works,*" *Richard said,* "*I can retire.*"

I was playing golf with Richard Prince. It was a really hot day and we were walking the course. I remember we drank a bottle of water per hole that day. It must have been around the eighth hole that Richard confided something. It was a secret and I said I wouldn't tell. He said that he had done a deal with Marc Jacobs to do a collaboration for Louis Vuitton. "If this works," Richard said "I can retire."

Richard is a joker but that was a really good one. Some people don't retire. A player doesn't retire. From golf, from his job, from any of the things he lives for, and for Richard Prince, art is a lifestyle. He makes art but he also lives with it. He is an obsessed collector of books, manuscripts, art and what you would probably call ephemera, but which also includes cultural flotsam and jetsam, the kind of treasures only an exquisite historian of culture would understand.

Because his art is so wrapped up in who he is and how he lives, Richard is a natural collaborator. He created a body of work with the legendary artist-as-art-dealer Colin DeLand that they showed under the moniker John Dogg. He has collaborated with Cindy Sherman, Terry Richardson, Christopher Wool, the poet Max Blagg, and, hey, me, too.

Richard Prince is also… well I'm not going to say a maverick, but he is an artist who goes his own way. Throughout his career he has been considered one of the most important artists of his generation, but it was in mid-career, after he took himself out of New York City and into the pure Americana of upstate New York and went into what he has called "inside world," his own world, that he emerged as a contender for the heavyweight championship of American art.

Andy Warhol, who held that position not so long ago, and whom Richard made a point of ritually dismissing, indicating his great admiration, knew that it was a whole new art world and he was among the first to announce that the old rules didn't apply. He came from the taboo world of commerce and even when he made it to the top of the fine art pyramid he could not abandon where he came from. "Pop art," he said, "is about liking things," and Andy liked money and commerce and fashion and pop music and all the things that made our post-vulgarian culture snap and crackle. Richard Prince's generation always had that knowledge and knew they could draw the line anywhere they wanted, if they had the goods.

Richard Prince broke the rules as one of the chief instigators of the re-photography movement, but everywhere he went after that on his journey he picked up tricks from the natives and extended the turf of art. He took art into the asphalt jungle and past deserted farms redolent of methamphetamine and pig shit, and he took it to the biker bar and the drag strip and the bad borscht belt nightclub. He took it to Sonic Youth album covers and Supreme skate board decks.

So when Richard announced that "if this works I can retire," he meant that he was going to do something that you couldn't get at Barbara's or Larry's or Sotheby's, he was going public. Marc Jacobs, knowing a great artist without borders when he saw one, enlisted him to collaborate in a new medium. Richard Prince would make art that had a lot of money in it. Handbags. Was it selling out? Yes, those handbags flew out of the store: sold out. Had he somehow violated the hallowed notions of art? Yes, but she enjoyed it. Had he moved the boundaries? Are you kidding? Now he's signing limited edition custom cars you can drive all the way to bank.

But the Marc Jacobs collaborations have moved the fence around art. Naturally we are prejudiced in favor of oil or acrylic on canvas, but at this late date we also accept polymer on masonite or tar and feathers on ceramic, or barbed wire and paper maché on veal shanks. The medium is up for grabs, and nobody expects it to be about canvas anymore than they expect an artist to wear a beret and smock. Today making art is often about making it in ways that are subversively assertive of the power of gesture. So excuse me if I find some perfect symmetry in the handbag as art. Damien Hirst can make a pretty good golden calf, but there is something so universal and down to earth about a handbag with a joke on it. The great Smokey Robinson wrote a song that was recorded by the Contours in 1965, and it goes something like this:

Some fellas look at the eyes
Some fellas look at the nose
Some fellas look at the size
Some fellas look at the clothes

I don't care if her eyes are red
I don't care if her nose is long
I don't care if she's underfed
I don't care if her clothes are wrong
Why? 'cause first I look at the purse!

What man hasn't entertained such thoughts. Unemployment rises. Great financial institutions crumble, and nations default. But as the most contemporary of collectors sashays down Fifth Avenue that rhythm and blues song echoes through the urban canyons of our collective consciousness.

I don't care if the teeth are big
I don't care if the legs are thin
I don't care if her hair is a wig
Why waste time lookin' at the waistline?
Why? 'cause first I look at the purse!

p.323 *Untitled Study* (2008) by Richard Prince. Acrylic on canvas. 91 x 61 cm (36 x 24 inches). Image used on the invitations for the S/S 2008. Louis Vuitton Collection.

322 **Louis Vuitton**

p.324 *Untitled Study* (2008) by Richard Prince. Acrylic on canvas. 91 x 61 cm (36 x 24 inches). Image used on the invitations for the S/S 2008. Louis Vuitton Collection. p.325 *Untitled Study* (2008) by Richard Prince. Acrylic and collage on canvas. 91 x 121.5 cm (35 x 47.6 inches). Louis Vuitton Collection. p.326-327 View of the tent designed by Richard Prince, installed in the Cour Carrée of the Louvre for the Women's S/S 2008 Louis Vuitton Prêt-à-Porter Show, October 2007. p.328 A sequence of polaroids from the running order of the S/S 2008 Louis Vuitton Prêt-à-Porter Show, October 2007. p.329 Richard Prince revisiting a painting from his 2006 *Nurse Series*. p.330-331 The "Nurses" at the S/S 2008 Prêt-à-Porter Louis Vuitton Show, October 2007, sporting twelve bags from the *Jokes Monogram* line. From left to right are: Stephanie Seymour, Eva Herzigová, Rianne Ten Haken, Anne Vyalitsyna, Carmen Kass, Natalia Vodianova, Angela Lindvall, Isabeli Fontana, Karolina Kurkova, Lara Stone, Nadja Auermann & Naomi Campbell. p.332 *(top)* Undated study by Richard Prince. Cartoon used for the Firebird bag (Women's S/S 2008 Collection) design. Louis Vuitton Collection; *(bottom)* Richard Prince's Cartoon Firebird bag, a limited-edition handbag. Louis Vuitton Collection. p.333 (top) Advertising campaign by Mert Alas & Marcus Piggott, featuring Claudia Schiffer in S/S 2008 Prêt-à-Porter, with the Pochette in the *Bonbon Rose Monogram* by Richard Prince. Marc Jacobs was inspired by Richard Prince's love of muscle cars, which can be found in his work throughout his career. One of the results of the Louis Vuitton's 2008 collaboration with Richard Prince was a play on the trademark monogram. He recreates the codes of Louis Vuitton along the lines imagined by Takashi Murakami; *(bottom) Covering Hannah* (2008) by Richard Prince, 508 x 203 cm (200 x 80 inches). This 1987 Grand National was featured in the Serpentine Gallery show, *Continuation*, the first major British public exhibition of Prince's work, London, 26 June-7 September 2008. p.334 *Untitled Study* (2008) by Richard Prince. Acrylic on canvas. 91.5 x 61 cm (36 x 24 inches). Louis Vuitton Collection. p.335 Advertising campaign, S/S 2008, by Mert Alas & Marcus Piggott, featuring Stephanie Seymour, with the Weekender handbag in the yellow *Pulp Monogram* pattern.

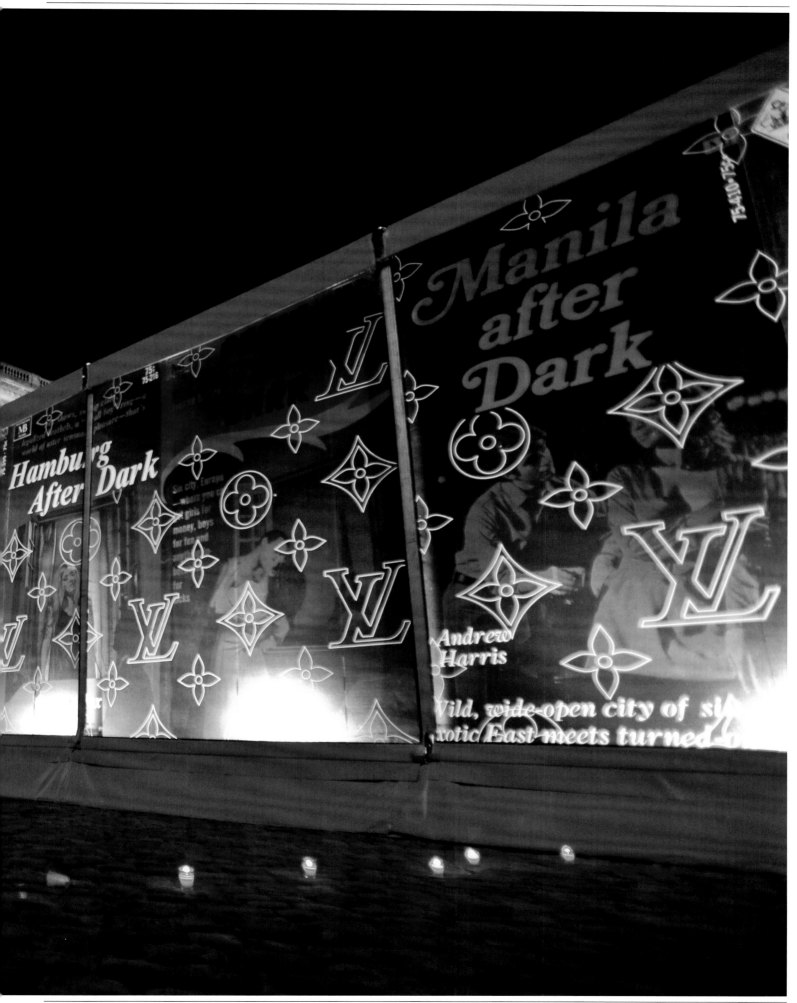

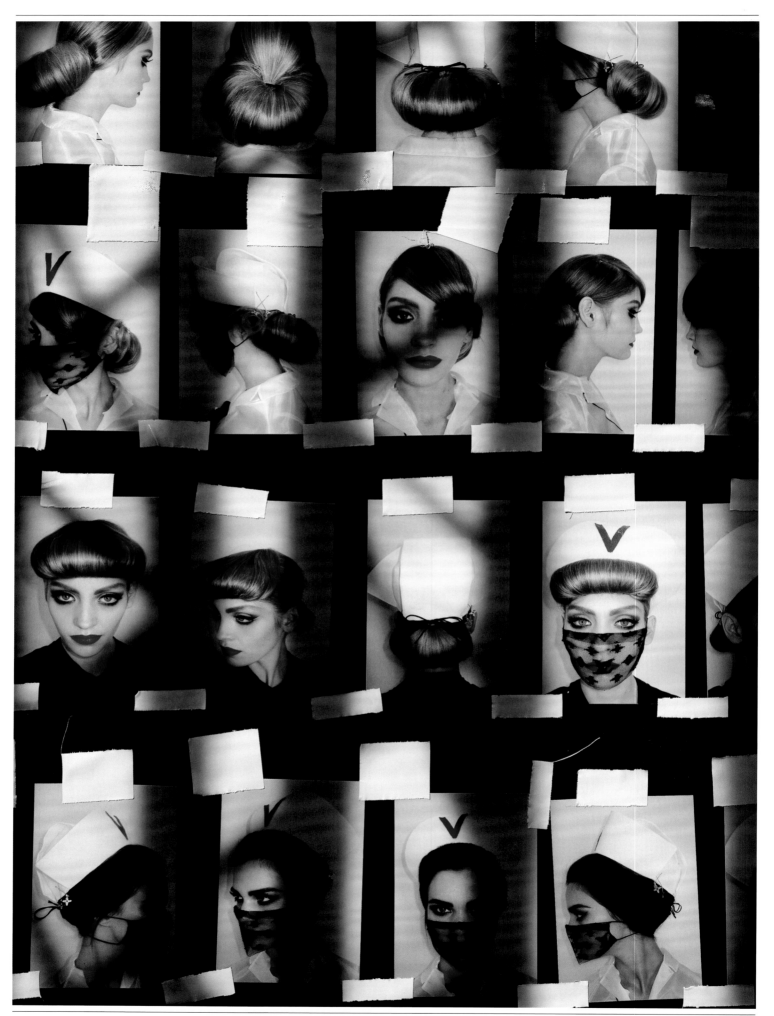

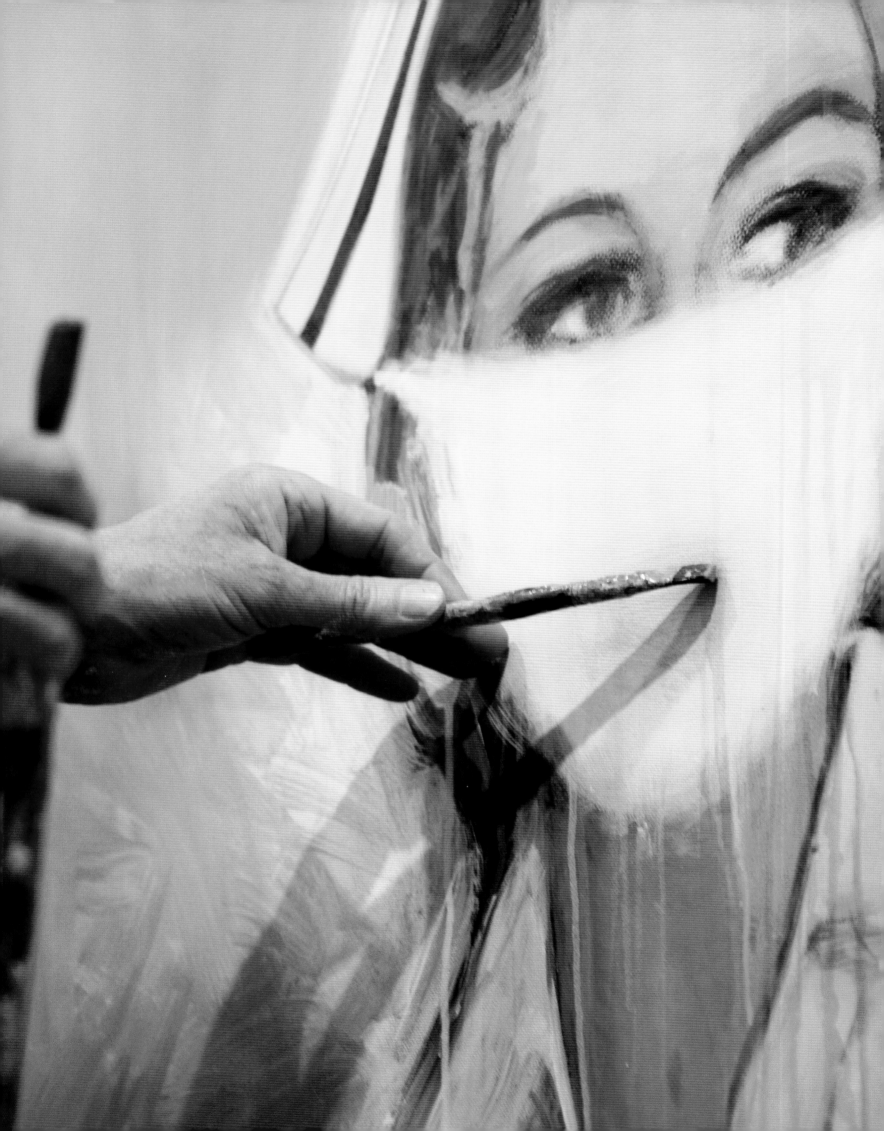

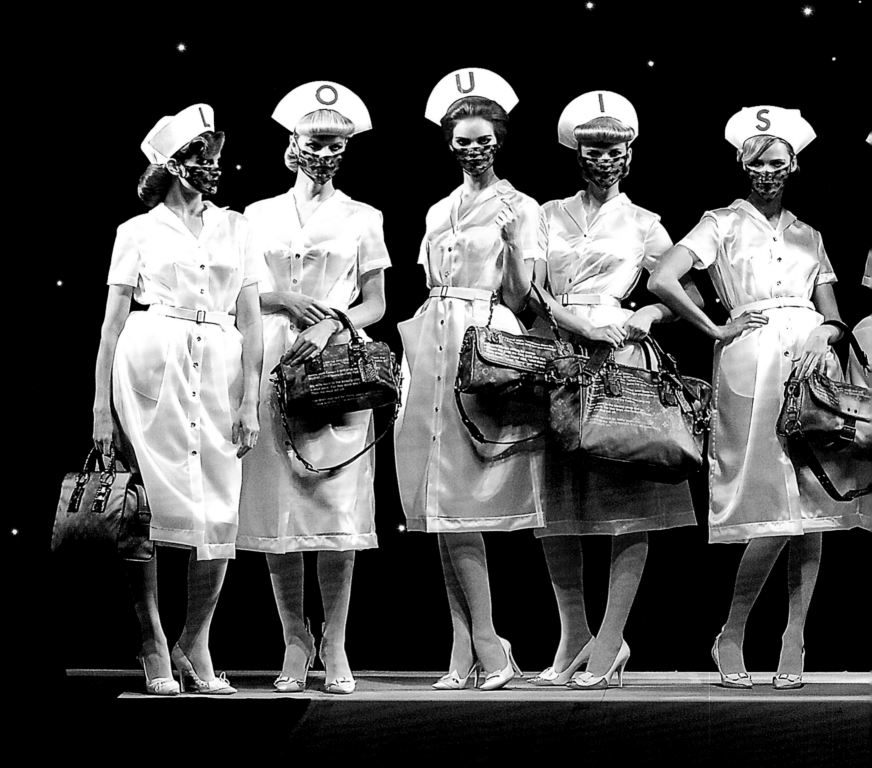

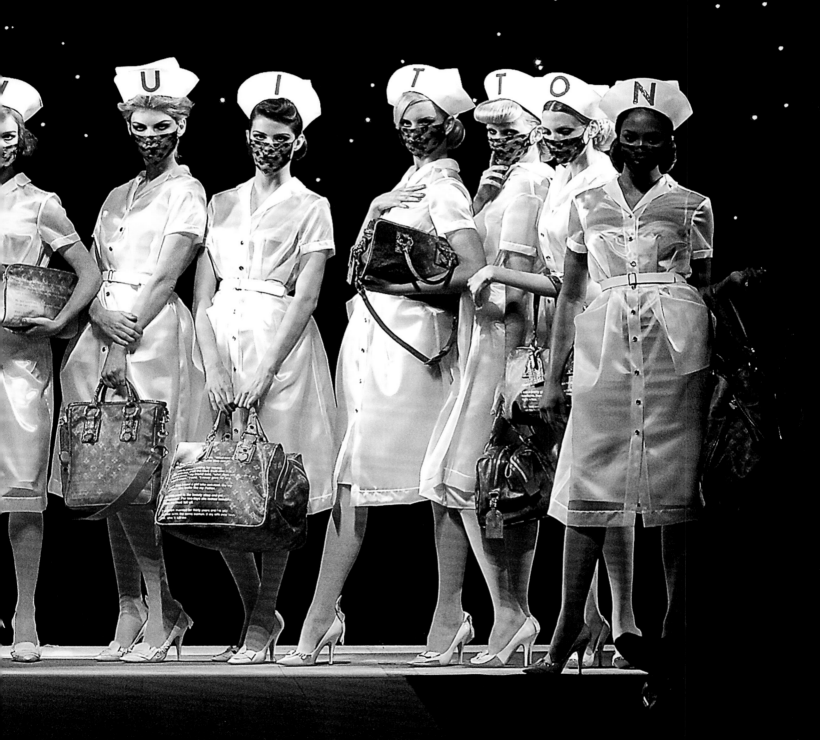

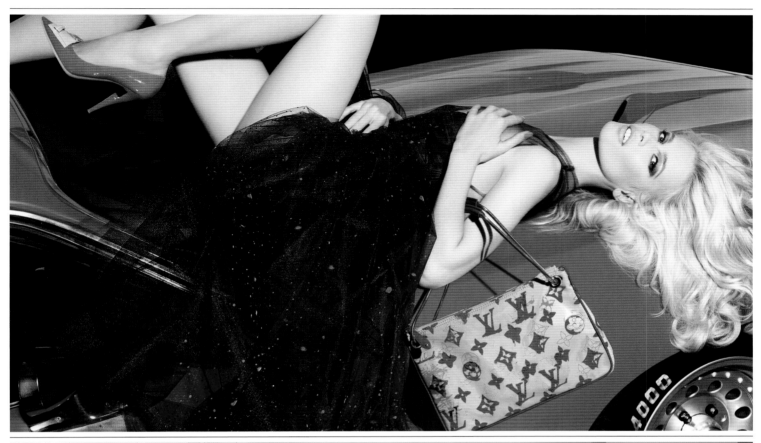

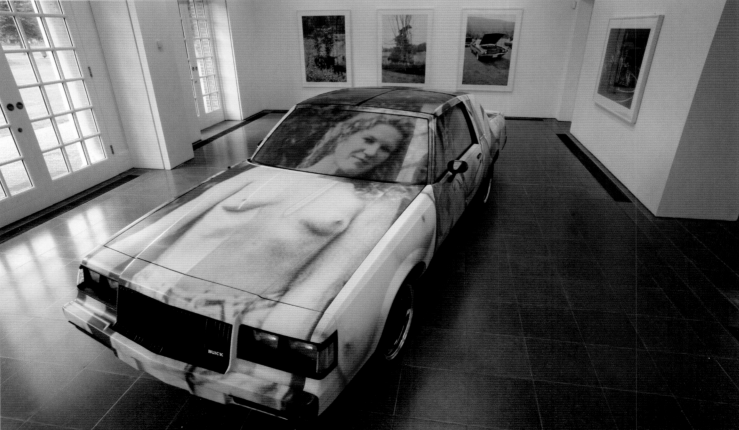

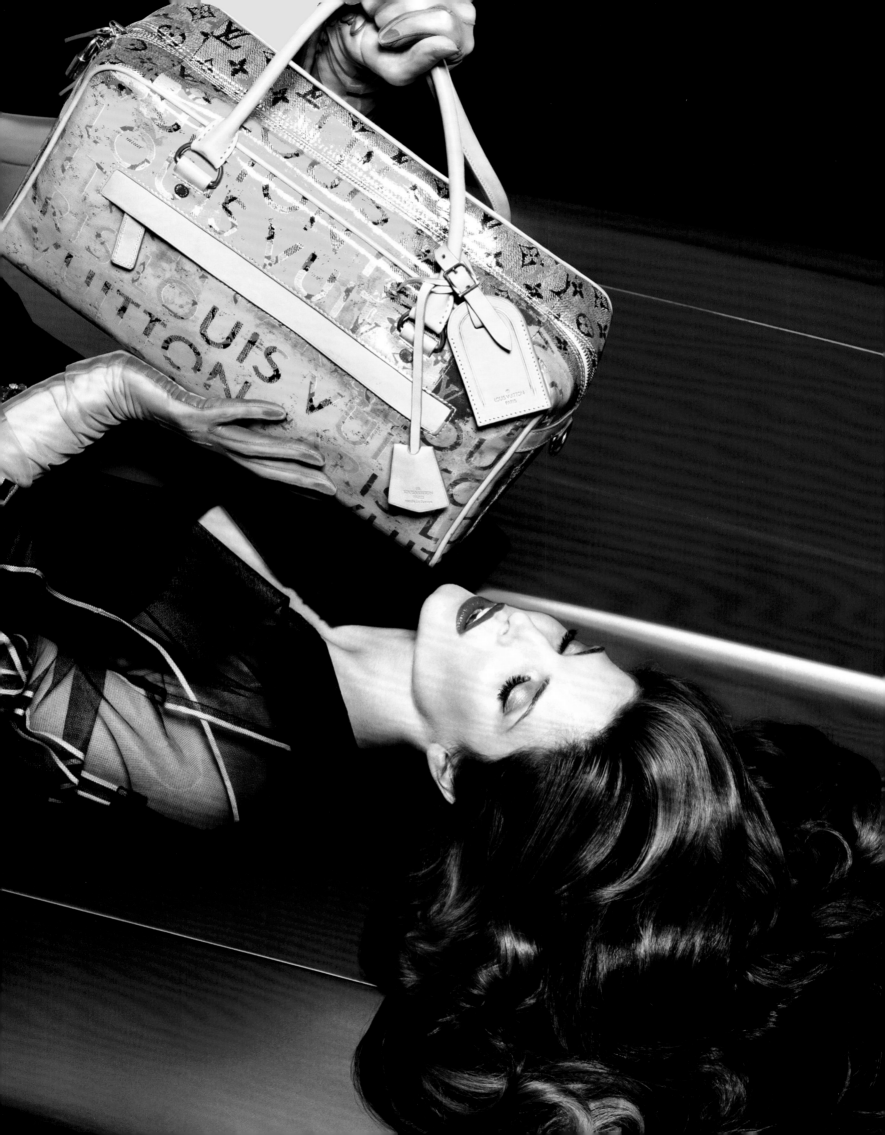

Putman, Andrée

designer
text by Cédric Morisset

Andrée Putman is a major figure in French interior architecture and design.

Born in 1925 she secured crucial apprenticeships with women's journals and art publications. She would later make a name for herself in the 1970s by establishing collectives like Créateurs & Industriels, which aimed at bringing together new talents in the fashion world and manufacturers. In 1978, she founded the company Ecart, which revived forgotten pieces from important decorators and architects of the 20th century like Robert Mallet-Stevens, Eileen Gray, and Mariano Fortuny. The 1984 launch of The Morgans in New York announced her both as the inventor of the world's first boutique-hotel as well as an international presence in interior design.

In 1990, she created the limited edition *Chemin faisant* design for Louis Vuitton, a silk crepe square scarf with hand-rolled edges. Along with eight other creatives—architects, artists, and scenographers—Andrée Putman also reinterpreted the famous Louis Vuitton Steamer Bag in 2006 for an exhibition celebrating the *malletier's* iconic bags at the Espace Louis Vuitton. A descendant of the Montgolfier Brothers—inventors of manned flight—Andrée Putman pays tribute to her ancestors by transforming the Steamer Bag into a black-and-white checkered basket, a favorite leitmotif of the interior architect. In order to manufacture the bag, Louis Vuitton reintroduced a traditional silk-screen printing process to create color gradation. Launched at an event that evoked the departure of an ocean liner, the installation invites viewers to embark on "a journey to the unknown."

LOUIS VUITTON PARIS ®

Andrée Putman

Chemin Faisant

p.336 Preparatory drawing interpreting the Steamer bag (2006). Canvas balloon and leather bag and lined fabric. Balloon: 279 cm high & 200 cm in diameter (110 inches high & 78.7 inches diameter); Bag: 45 x 51.8 x 20 cm (17.7 x 20.4 x 7.8 inches). Installed at the *Icons* Exhibition at the Espace Louis Vuitton, Fall 2006. Louis Vuitton Collection. **p.337** *Chemin Faisant* silk square (1988) by Andrée Putman, 86.5 x 87 cm (34 x 34.25 inches). Louis Vuitton Collection.

Raynaud,
Jean-Pierre

artist
text by Marie Maertens

Born in 1939, Jean-Pierre Raynaud joined the select fraternity of artists who created a silk square for Louis Vuitton one year shy of his fiftieth birthday.

The scarf he designed is entirely representative of his work but also introduces a novel touch. For it, the artist set up his composition on a bed of white tiles with black grout. It is instructive to remember that his first tile-based installation appeared in 1965. For Raynaud, this material represents, both literally and allegorically, hard and cold, both factors deeply associated with death. This artist is fascinated with the frozen and the inalterable. A lonely soul and a ruthless radical, he'd even built his homes in ghostly white ceramic.

This represented the first time Raynaud used silk as a material. He added a verdant, poetic element to the tiles, in the form of ginkgo biloba leaves (the oldest of trees, it is also considered the national tree of Japan). Being so precise, he made two versions: one with the pale green leaves of spring and one with the yellow leaves of autumn. One should also remember that he studied horticulture. Perhaps it inspired his first pieces made from cement-filled flowerpot. He also worked with road signs, which is no coincidence considering his encounter with the Nouveaux Réalistes in the 1960s. This might partly explain his interest in the quotidian, the commonplace, although he does add to it a certain vision, softened here by the presence of flowers…

p.339 *Printemps et Automne* silk square (1988) by Jean-Pierre Raynaud. 90 x 90 cm (35.4 x 35.4 inches). Louis Vuitton Collection.

338 **Louis Vuitton**

LOUIS VUITTON PARIS ®

RAYNAUD

Razzia

artist
text by Marie Maertens

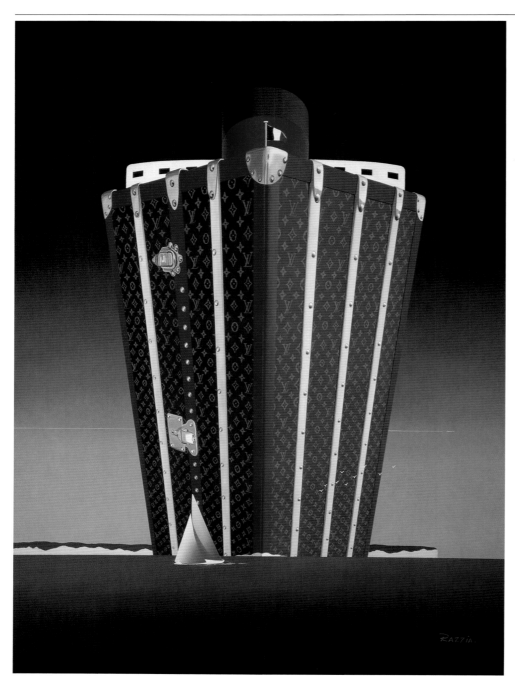

Gérard Courbouleix-Dénériaz, otherwise known as Razzia, has been a tireless proponent of classic illustration and poster art for the past twenty-five years.

He admits to being especially influenced by the period between the end of the nineteenth century and the middle of the twentieth, epitomized by artists like Gauguin, Picasso, Braque, Klee and Klimt. When he began, he also studied Cassandre, the famous graphic designer from the 1930s. Razzia started his career as a poster artist, working in dance in 1979 with the star Carolyn Carlson. Then he created album covers, before joining the crew at the Palace nightclub, and later, the fashion world.

Razzia's collaboration with Louis Vuitton, which began in 1985, has yielded over forty posters. He stresses that Louis Vuitton was his only client who gave him a creative *carte blanche*. "They fully recognize the art of the poster as the most efficient medium for leaving one's mark and surviving the chaotic world of communication." These posters advertised exhibitions of Louis Vuitton's luggage and travel accessories, but also include evocative vignettes for the Louis Vuitton Cup, the Grand Prix de Paris and Louis Vuitton Classic at the Parc de Bagatelle and New York's Rockefeller Center. His style is always lively, graphic and colorful. Figures are drawn with a confident elegance. Certain images produce an ambivalence reminiscent of Edward Hopper, but the mystery often quickly dissipates to emphasize the magic of travel, and the thrill of speed.

p.340 Painting used in a poster for the exhibition *A Journey Through Time by Louis Vuitton*, held at Harrod's, in London, 18 September to 12 October 1991, by Razzia (Gérard Courbouleix-Dénériaz); acrylic on canvas, 81 x 65 cm (31.8 x 25.5 inches). Louis Vuitton Collection. **p.341** Painting by Razzia (Gérard Courbouleix-Dénériaz) used in a poster for the Louis Vuitton Classic *Concours d'Élégance* at the Rockfeller Center on September 22-24, 2000 ; acrylic on canvas. Louis Vuitton Collection.

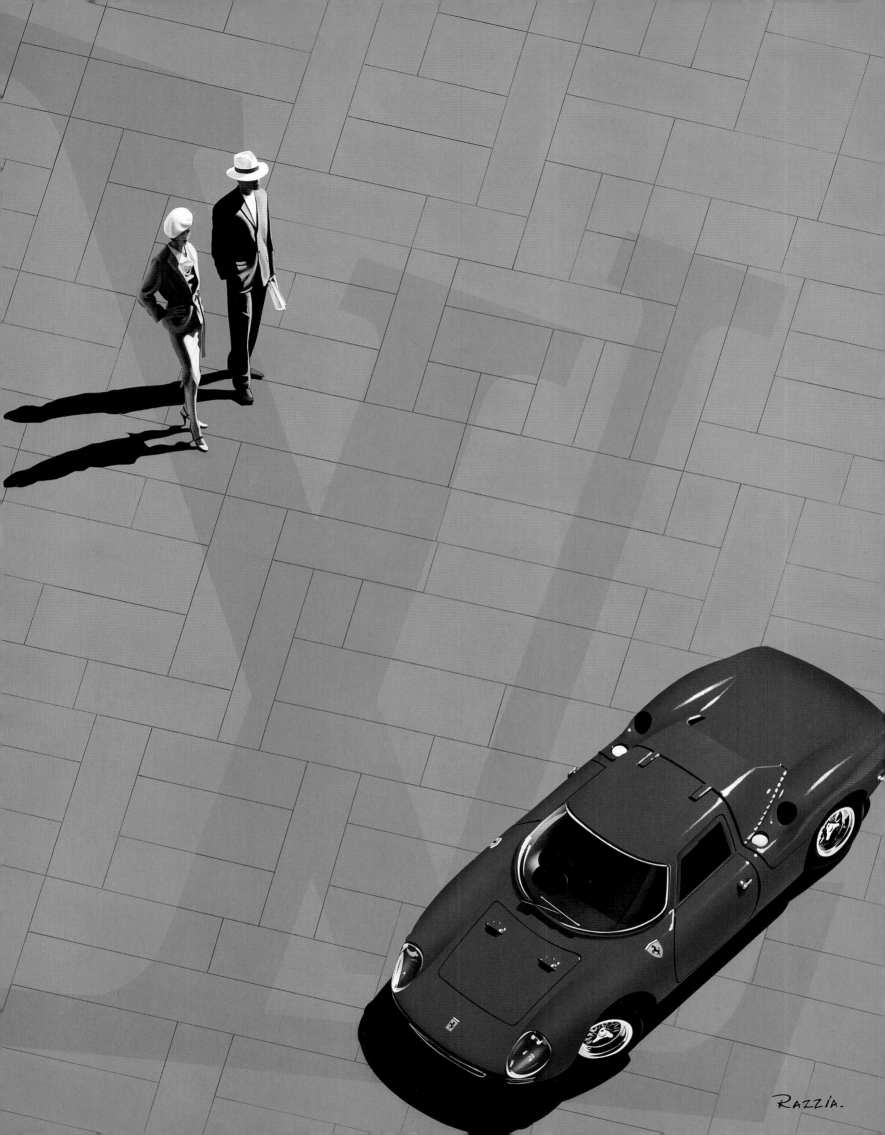

Razzia.

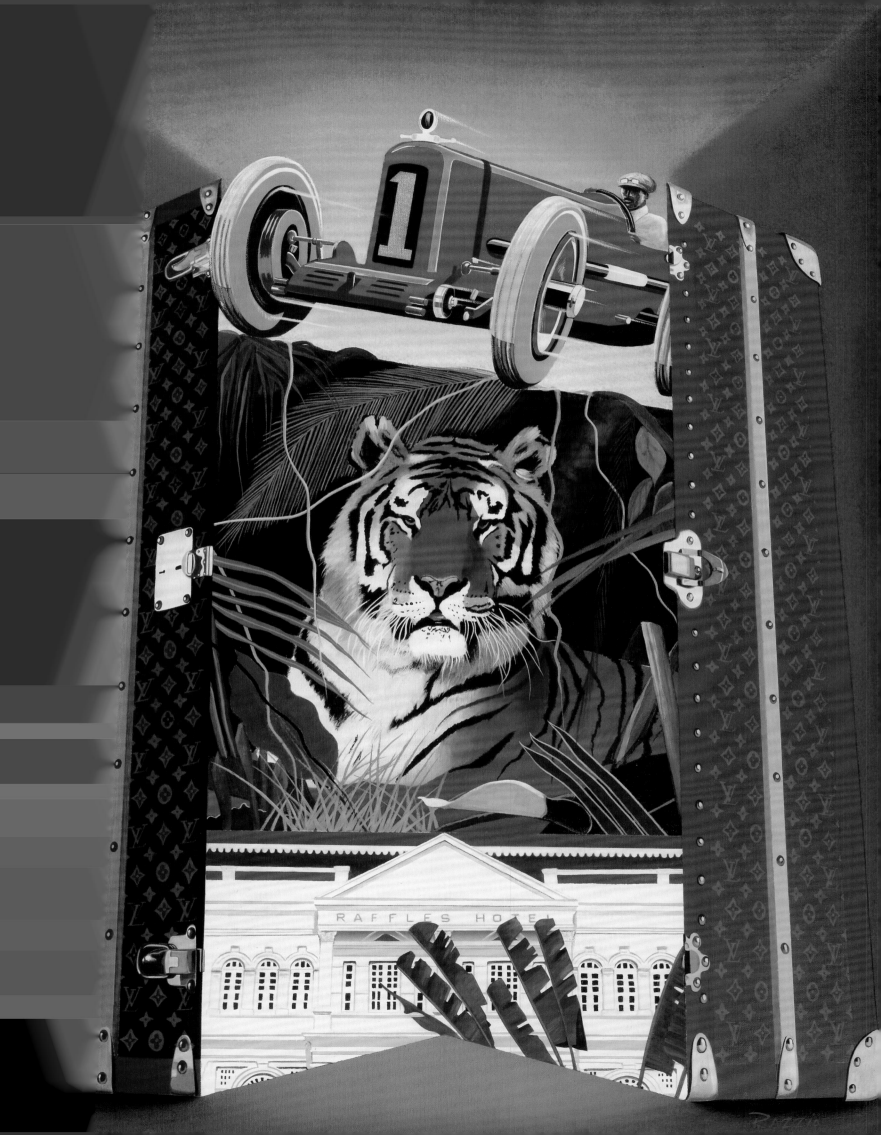

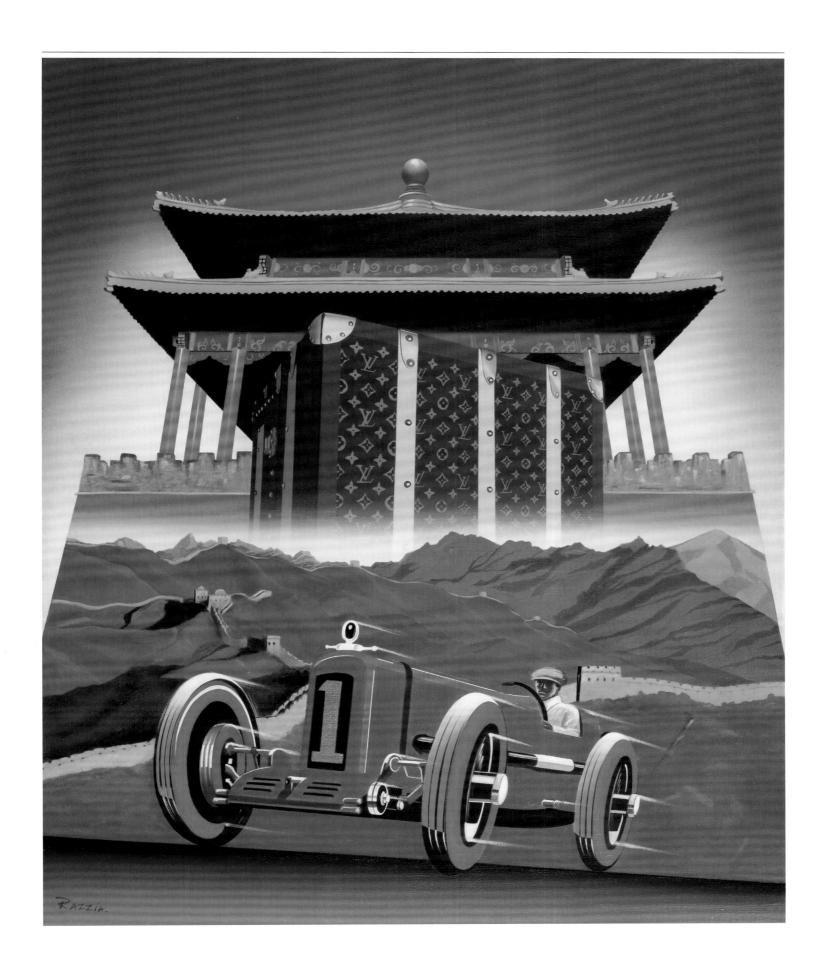

p.342 *Singapore - Kuala Lumpur* (1993) by Razzia (Gérard Courbouleix-Dénériaz). Painting used in a poster for the Louis Vuitton Vintage Equator Run from April 9 to 11, 1993; acrylic on canvas, 72.5 x 60 cm (28.5 x 23.6 inches). Louis Vuitton Collection. **p.343** *China Run* (1998) by Razzia (Gérard Courbouleix-Dénériaz). Painting used in a poster for the Louis Vuitton Classic China Run from May 25 to 30, 1998; acrylic on canvas, 72.5 x 60 cm (28.5 x 23.6 inches). Louis Vuitton Collection.

Rondinone, Ugo

artist

text by Simon Castets

Ugo Rondinone's art breaches the rules of etiquette. Unclassifiable, the artist weaves from one medium to another. Likewise, his works are successively dark or light, combining pop elements (clowns, neon signs) and fantastic images from horror movies (gnarled trees, monsters) in often monumental, desolate installations.

Born in 1964 in Brunnen, Switzerland, he divides his time between New York and Zürich. Having studied at the University of Applied Arts in Vienna, at a very young age Ugo Rondinone got his first taste of success, which has since flourished into a renowned career. Following a succession of solo exhibitions, notably at the Centre d'Art Comtemporain de Genève (1996), PS1 (New York, 2000), the Herzliya Museum of Contemporary Art (Tel Aviv, 2001) and the Musée National d'Art Moderne—Centre Georges Pompidou (Paris, 2003), he represented Switzerland at the *Venice Biennale* 2007 (with Urs Fischer). That very year, Rondinone inaugurated the *Cartes Blanches* series at the Palais de Tokyo (Paris), where an artist was invited to conceive an entire exhibition that would extend over all of the rooms. The exhibition title, *The Third Mind*, paid homage to Brion Gysin and William S. Burroughs and offered a striking curatorial perspective; a reflection of the artist's vision and a window to the complexity of his art. "The cut-up method produces connections that might have never been made if one was limited to linear thought,"[1] notes Rondinone in an interview with Marc-Olivier Wahler, as

he explained a succession of wide connections made in the form of brilliant works, from Toba Khedoori and Karen Kilimnik, to Cady Noland and Robert Gober. It is this very troubling impression of heterogeneity and pertinence that strikes viewers upon observing the composite creations of Rondinone, who claims that the concept of stratification is the common denominator of his work and inspiration. Accordingly, he cites a group exhibition by Harald Szeemann at the Kunsthaus Zürich in 1983 (different layers accumulated in his mind) and "the autarky" of the works he selected for *The Third Mind*.[2]

Consequently, his art is impossible to define and difficult to describe. In the series *I don't live here anymore* (1995), Rondinone placed his own face on those of models in fashion photos. His *Target Paintings* (late 1990s), wide, brightly colored concentric circles, are reminiscent of Kenneth Noland and Jasper Johns. The series *Moonrise* (2005-2006) included twelve monumental sculptures, one for every month of the year, all of which were grotesque and toothless ogres. The façade of the New Museum in New York joyfully displayed the *Hell, Yes!* rainbow (2007, from an original exhibited in 2001). It was created for a series of advertising signs that were in turn derived from an array of phrases that have enjoyed long reseonances in pop culture, such as "cry me a river" and "love invents us." Rondinone's multifaceted art stems from a range of elements found in magazines, art history, and both traditional and contemporary cultures. Although

diversity is the most solid constant in his art, he also explores a number of unifying themes such as alienation, isolation, and restlessness. Whereas he develops his own idiomatic expressions, he often creates his designs by appropriating recognized visual elements. He states, "I like [...] introducing archetypes like the window, the tree or the mask."[3] In fact, this very principle is what led to the collaboration between Rondinone and Louis Vuitton.

For Christmas 2004, Ugo Rondinone created a window display for Louis Vuitton stores worldwide. He designed a scene based on Schubert's *Winterriese* (Winter Journey) that showcased a melancholy, twisted tree covered with mirrors. A symbol often used by Rondinone, the tree—whether made of molded resin or schematized—was used in his exhibition *Long Nights Short Years* at the Consortium de Dijon in 2003. Previously in 1999, in the exhibition entitled *I Never Sleep. I've Never Slept at All. I've Never Had a Dream. All of That Could Be True*, he covered the exhibition space with a forest of trees that were completely blanketed with black adhesive tape. For the *Venice Biennale*, he reproduced sculptures of ancient olive trees cast in aluminum and coated with white enamel, referencing his Italian origins. For the Louis Vuitton display, the trees were not identical reproductions; rather, they were stylized, stripped bare and sculpted like constructivist scarecrows mantled in a fine layer of snow. Devoid of foliage, the winter tree was decorated with a

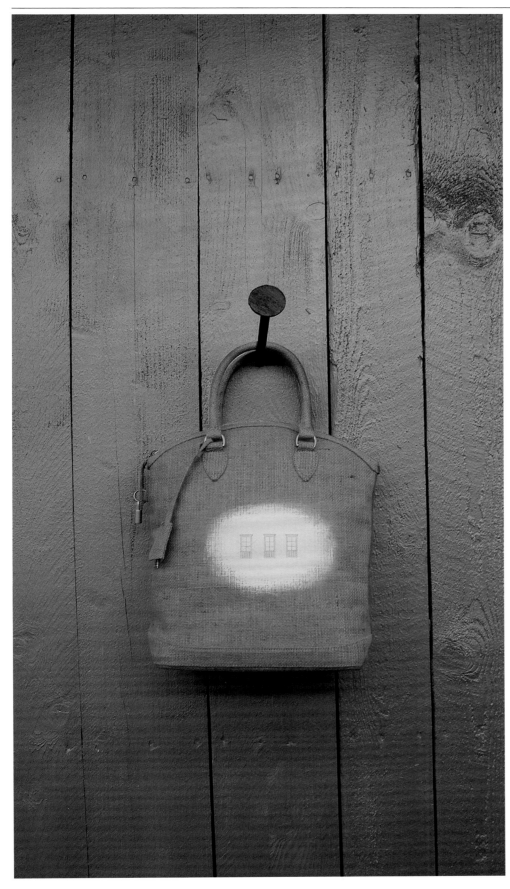

multitude of mirrors, an alternative way to ac-
centuate the role of the image and its reflection
in the boutique. Rondinone was not a newcomer
to the world of luxury; he had previously cre-
ated projects for Yves Saint Laurent (*Light of
Fallen Stars*, New York, 1999) and Mont Blanc
(*If There Were Anywhere but Desert*, New York,
2000). However, thanks to the global reach
of Louis Vuitton, he created, in his opinion,
"probably the most widely seen work I've done."
He compared it to an experiment that was
more "like public sculpture"[4] simultaneously
displayed around the world. Illuminated with a
rainbow of colors reminiscent of Rondinone's
advertising signage, the trees were a reflection
of their environment; they changed according
to the time of day and, the artist added, "...at
certain times, look[ed] like jewels."

During *The Third Mind* exhibition at the Palais
de Tokyo, Rondinone spoke of the influence he
drew from the main character Jean Des Esseintes
in the book *Against the Grain* by Joris-Karl
Huysmans. "The protagonist lives as a recluse
after purchasing a castle. He cuts himself off
from society and in each room, he creates a
personal obsession."[5] It is from a similar type
of obsession for a specific form that Rondinone
created a series of recurrent patterns for the
Icons Exhibition at the Espace Louis Vuitton
(2006). Invited to interpret the classic Lockit
bag, Rondinone drew his inspiration from two
previous works and incorporated them into
an installation. He identically reproduced the
white fence and blue-shaded window that looked
onto the street from his piece entitled, *So much
water so close to home* (1997). He removed the
speakers that were in the first piece, and placed
an oversized nail to the left of the window
where, instead of the shoes in *Clown shoes out of
leather, artificially aged, artificial nail*, (2006), he
suspended the iconic bag, which he reproduced
in burlap. On a white, seemingly sprayed-on
background, three delicately drawn windows
evoked his exhibition, *My endless numbered
days*, at the Sadie Coles Gallery (London, 2006),
where he transferred drawings sketched during
walks around Vienna. Snapshots of Paris were
captured both through the drawings and by slip-
ping a newspaper clipping in the bag that was cut
on the day the work was created, as in the *Date
Paintings* by On Kawara. Further along the fence
was a second built-in window, its blue-tinted film
affording a bird's eye view over the rooftops of
Paris. Rondinone's contribution to the *Icons*
Exhibit was thus doubly characteristic of his art,
considering that he has, a number of times, used
the exhibition space itself as an integral part of
an installation. The use of colored film on the
windows and the construction of fences were
both part of a reorganization of the surrounding
geography through a play on external and inter-
nal boundaries. The artist thus completed the
project initiated by Huysmans's protagonist—
whose domestic universe serves as fantasized re-
ality—by displaying a specific aesthetic lexicon,
of which heterogeneity is the trademark.

[1] Interview with Marc-Olivier Wahler, Le Journal des Arts, issue 266,
 October 2007
[2] Ibid.
[3] Interview with Frédéric Bonnet, Le Journal des Arts, issue 243,
 September 2006
[4] Quoted by Lisa Amstrong, "Christmas Kitsch," The Times,
 London, December, 15, 2004
[5] op. cit., Interview with Frédéric Bonnet.

p.344-345 *Interpreting the Lockit bag*, installation (2006) by Ugo Rondinone for the *Icons* Exhibition at the Espace Louis Vuitton, Fall 2006. Louis Vuitton Collection.

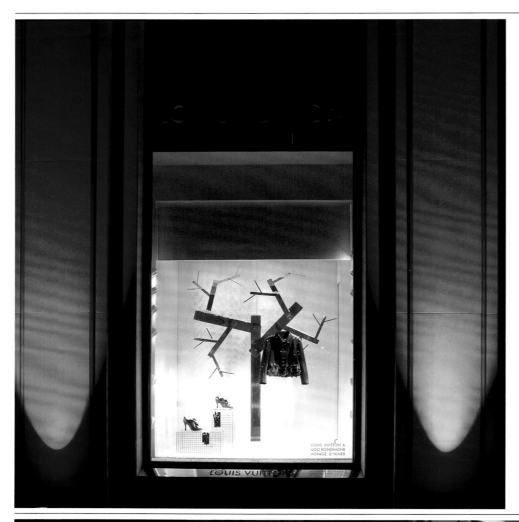

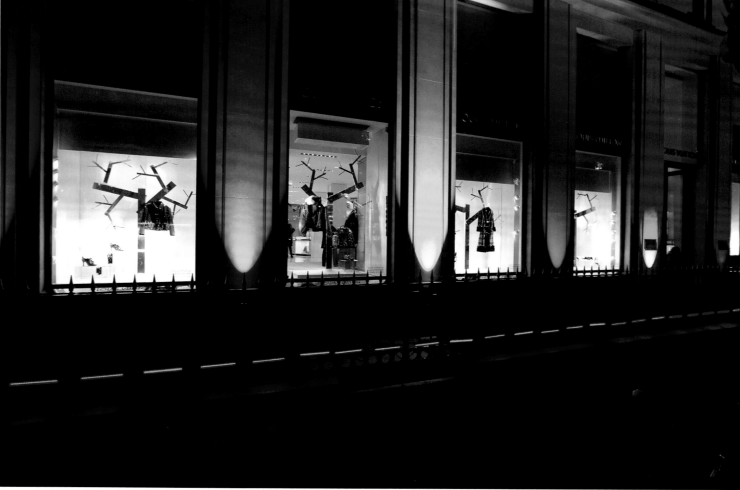

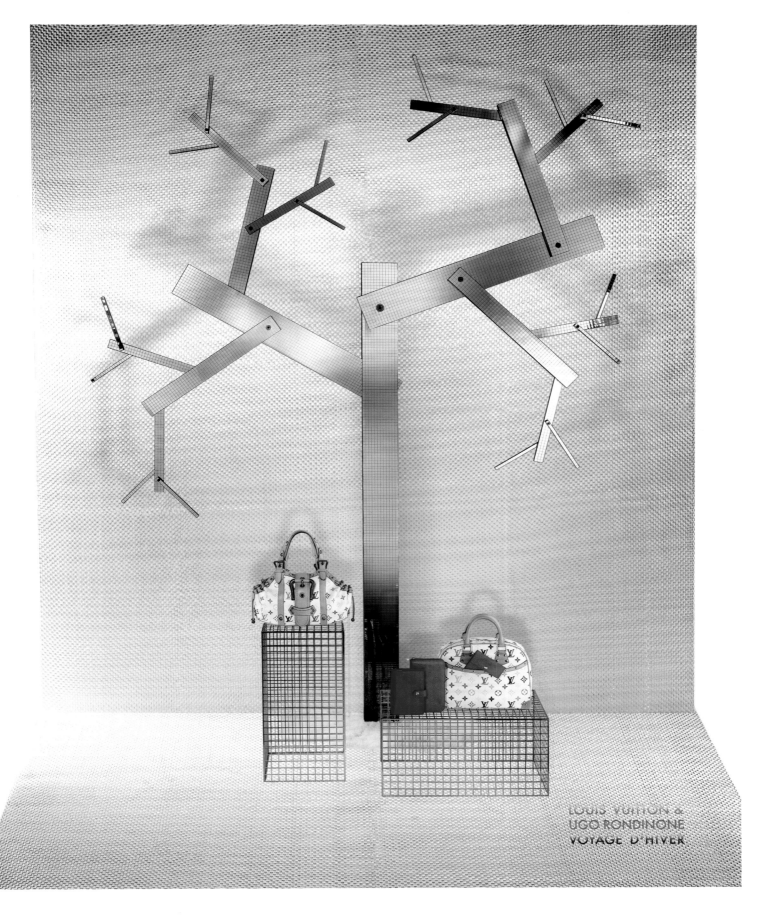

p.347 *Voyage d'hiver*, by Ugo Rondinone, windows installations at the Louis Vuitton store 22, avenue Montaigne for the 2004 holiday season. Aluminum and plastic; 250 x 150 cm (98.4 x 59 cm).

Rosenquist, James

artist
text by Marie Maertens

One rarely sees small format work by the American artist James Rosenquist since this Pop Art figure has made his mark through his very large paintings.

No wonder then that the silk square he created for Louis Vuitton acquires a monumental quality. Graphically, it contains the requisite Rosenquist motifs: bright colors highlighted with white that lend depth; multiple points of view; undulating light and objects close to the surface—as if they were crashing against it. Born in 1933 in North Dakota, Rosenquist joined the Pop Art movement in the 1960s. He drew inspiration from American realism and notably began as a billboard painter in Times Square. His strokes, complemented by lively colors, are wide and supple. In the 1980s, he also began to work with nature and vegetal motifs. His manner of combining different images is meant to ricochet a contemporary perspective, twirling from one object to the next near instantaneous associations or outright collision. Rosenquist says he does not represent anecdote, but that he rather accumulates experiences. He wants to offer the same visual chaos that one sees in the city and in advertising. Like his fellow artists, he asks that painting have the same power, the same brilliance and the same impact as advertising, and that it attract the same fascination… These associations were also broached by Surrealist painting. Might Rosenquist be the most Magrittean of the American Pop Artists?

p.349 *The Garden of Orchids* silk twill square (1988) by James Rosenquist, 90 x 90 cm (35.4 x 35.4 inches). Louis Vuitton Collection.

348 **Louis Vuitton**

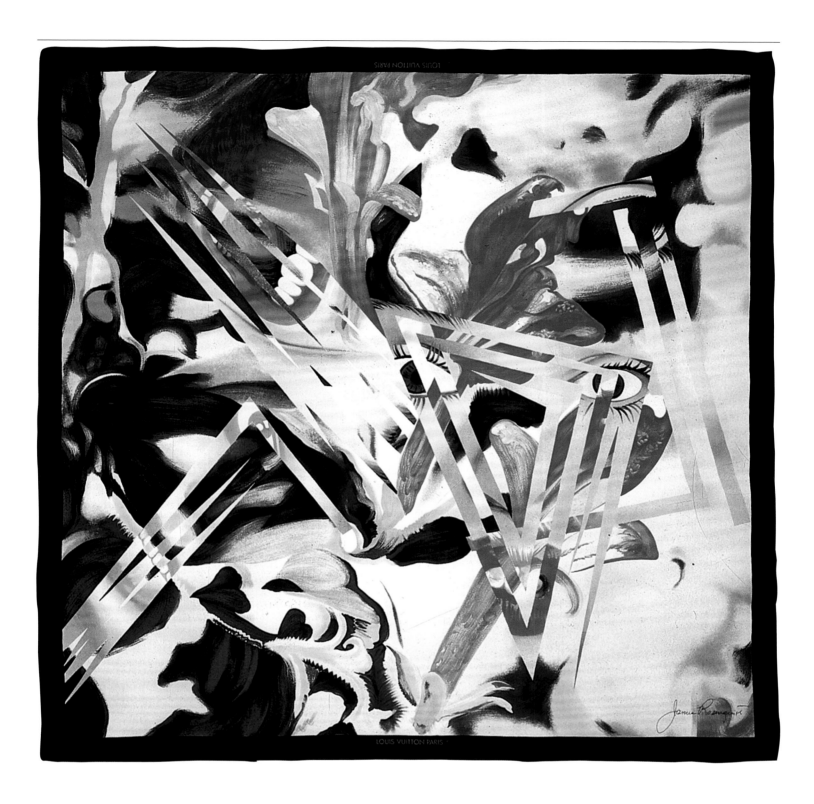

S-T

Sorbelli, Alberto
Sprouse, Stephen
Starck, Philippe
Sybilla
Teller, Juergen
Toledo, Ruben
Tran Ba Vang, Nicole
Turrell, James

Sorbelli, Alberto

artist
text by Emmanuel Hermange

Like Jacques Derrida, Alberto Sorbelli asserts that the only thing we can truly give away is time. Anything else—even a vital organ—does not really qualify as a gift. After all, time is truly irrecoverable and can never be repaid. Like Baudelaire, Sorbelli believes that the seductive interaction that occurs in a museum between artworks and visitors is indistinguishable from encounters between bar hostesses and nightclub patrons. Using these two ideas as a springboard, Alberto Sorbelli burst onto the art scene in the mid 1990s.

Born in Rome in 1964, Sorbelli was a dancer in the eternal city's opera company before studying at the Ecole Nationale Supérieure des Beaux-Arts in Paris from 1990 until 1995. The speed with which his work appeared on the art scene—while he was still at school—demonstrates that Sorbelli's dual career was based on his vital energy and drive, together with his clear sense of direction. That is not to say that everything in his life was predetermined. His career may seem to have moved at warp speed, but it was actually developed and refined through a series of experiences.

In his art-school painting class, he was immediately struck by the importance attached to the concept of work. The inherent significance attributed to labor seemed to him a relic of Judeo-Christian morality, with its insistence on earning a living with the sweat of one's brow. In contrast, the history of art—particularly art of the twentieth century—was proof to him that the quality of a work is independent of the quantity of work expended on its creation. Sorbelli transformed a situation where he was supposed to say "Look at what I've made" to one where he could say, "Look how hard I'm working." Thus he created *The Secretary of the Secretariat of Mr. Alberto Sorbelli* (1990), inspired by a prostitute who seems to passersby to have nothing more to her than her profession. At school, he took his place in an office, playing the role of the Secretary and engaging in discussions with anyone who would listen; he was promoting the work of Alberto Sorbelli—which had not appeared on the art scene since it did not yet exist. These discussions were sometimes quite lengthy and had to be adapted to each interlocutor based on age and gender. Sorbelli "was finally doing some real work, [...] quantifiable in terms of hours spent, as well as quality and content." These endeavors met with a certain degree of success and he discovered his own special aptitude for "custom-made conversation." Like Baldsarre Castiglione's courtier, whom he often quoted, Sorbelli had "the natural gift of regular features, a good height, a well proportioned body and a natural grace that made him agreeable to all."[1]

When Jan Voss, his painting teacher, said that he'd never have anything to sell if he kept up such activities, Sorbelli asked himself the question, "What did I have to sell? My time. My ability to satisfy someone else's desire to be fascinated. So I was a whore." Thus the Whore succeeded the Secretary. Among professionals paid by the hour (lawyers, psychiatrists, etc), prostitutes require the least education. This second act began with telephone calls after he published his phone number in the art press, gallery programs, and exhibition spaces, where, in Whore regalia, he handed out his business cards in an attempt to seduce visitors. In addition to appearances in the Jeu de Paume, the Musée d'Art Moderne in Paris, Documenta in Kassel and numerous gallery openings, he added two special events at the Louvre, where the Whore had herself photographed and filmed in front of the *Mona Lisa*. "The Whore," he says, "intensifies the nature of the conversation, but she also serves another purpose: the purpose of art itself, which is pleasure." His actions immediately revealed a sense of prudishness still widespread in the art world. On several occasions, Sorbelli was humiliated, beaten up and hauled off to the police station by security guards—even though he had the authorization of the Louvre's director in 1997 (*Attempt to establish a relationship with a masterpiece*, 1994 and 1997). When we also consider the curators' censoring of his contribution shortly before the opening of the exhibition *L'Hiver de l'Amour (The Winter of Love)* at the Musée d'Art Moderne in Paris in 1994, these violent reactions demonstrate that there has been no fundamental change since the days of Baudelaire: "All the fools of the bourgeoisie endlessly repeating the words 'immoral,' 'immorality,' 'morality in art' and other idiotic comments make me think of Louise Villedieu, a five-franc whore, who went with me once to the Louvre. She'd never been there before. Blushing, she covered her eyes and [...] asked me – standing in front of those immortal statues and canvases – how such indecency could be publicly displayed."[2] Sorbelli resolved not to submit to further violence, and he decided to use violence himself in a controlled manner. Thus, in 1996, the character of the Victim made its appearance. His role was to produce a burst of controlled violence in exhibition spaces. Neither disposed to nor attracted by masochism, Sorbelli had to train for these new activities both psychologically and physically, usually with friends who were equally disinclined toward sadism. The challenge was to progress from a caress to increasingly forceful movements, culminating in a final assault, but so gradually that it would not be perceived as a traumatic event. *The Victim* scenarios attempted to create a sort of collective psychodrama based on artificially created tension, like the catharsis of ancient Greek drama that continues in our day with soccer matches. At the end of this process, according to Sorbelli, "The violence can become a sort of gift, an extreme act of love." *The Victim* has appeared six times, including in exhibitions at the Ecole des Beaux-Arts in Paris, the Guggenheim Museum in New York—where Sorbelli spent a night in jail — and at the *Venice Biennale*, with the artist and his assailants all dressed and accessorized in designer labels. It was a way for Sorbelli to emphasize his concern with an issue underlying the accessibility of the body in the social and political arenas: the symbolic violence wreaked by fashion and luxury items. Among the brand-name objects appearing in the photographs and videos, Louis Vuitton handbags are readily identifiable despite the violence and speed of the action. For the last staging of *The Victim* at the *Venice Biennale* in 1999, Sorbelli put an end to the existence of this character using very Brechtian distancing techniques, theatrically replaying key moments for photographers. There are four records of the performance in Venice: a series of photographs and a video produced on the spot by Sorbelli's collaborators; another series of photographs taken spontaneously by a viewer (to which the artist attributes the same value as his own colleagues' work); and the production outside its context as photographed by Matthieu Deluc, where violence is acted out without being actually experienced by the body. One of Deluc's series of photographs is in the Louis Vuitton collection.

Sorbelli is the antithesis of an artist who allows himself to be carried away by bizarre, uncontrollable impulses for the purpose of creating a sensation. In his highly disciplined work, he operates less as an immoralist than as a cynical moralist who compels his contemporaries to recognize the fallacious values on which society is based. His recent shift of interest to drawing and the theater is evidence of this objective. Sorbelli works in darkness, concentrating on the relationship between breathing and the symmetry of the body as it is directed by the brain. His drawings occupy a place between those of William Anastasi's *Subway Drawings* (begun in 1968), who made use of the vibrations created by the New York City subway to move his hand, and the nighttime photographs that Didier Morin created from his breaths against the megalithic Carnac stones in the1980s. Fragile records of the movements between the internal and external self, they bring us back to one of the important questions raised by Sorbelli's work, which is performed in public spaces on the intimate scale of the human body.

1 Castiglione, Baldsarre, The Book of the Courtier, 1528.
2 Baudelaire, Charles, My Heart Laid Bare: An Intimate Journal (1887), entry 46.

p.350-351 Detail of the *Louis Vuitton Graffiti* (2000), by Stephen Sprouse. *p.353 L'Agressé* (2004) by Alberto Sorbelli; color Diasec print; 100 x 66.5 cm (39.3 x 26.2 cm). Louis Vuitton Collection.

352 **Louis Vuitton**

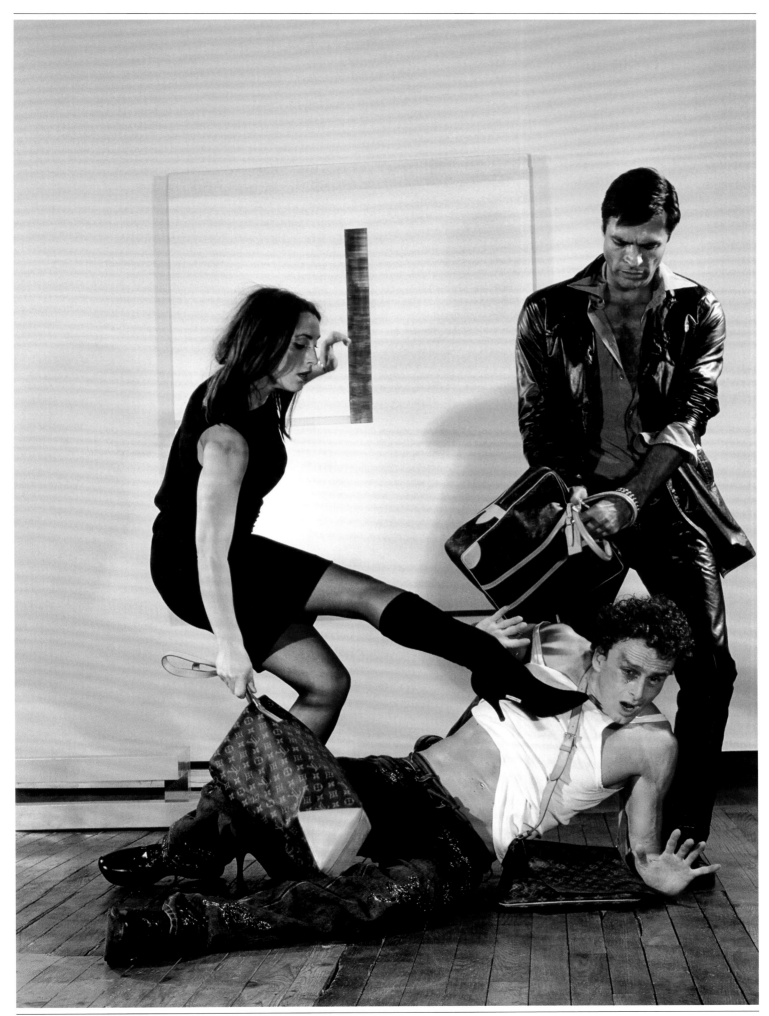

Sprouse, Stephen

artist
text by Glenn O'Brien

When I first encountered Steven Sprouse he must have been nineteen or twenty.

He was working as an assistant to Halston. Halston had come to New York from Indiana, and Stephen seemed to be following in his footsteps, literally. He was handsome and quiet, one of a bunch of young guys around Halston who worked in the studio and wore these uniform-like suits. I think he must have had an aura, because otherwise I don't know why I'd remember him, but sometimes people who speak very little seem like they have a secret. Stephen seemed like he had a secret.

When I encountered him again, the secret was out. Stephen was back in town living in a big old doorman building on 58th Street, two blocks from Bergdorf's. That building had its own rat pack—Debbie Harry and Chris Stein, photographer Kate Simon and jewelry designer Janice Savitt all lived there. Stephen had a big apartment that looked even bigger because he took down the wall between the living room and the dining room. There was no furniture in the place, just a color Xerox machine. Having a color Xerox machine was a big deal. Andy Warhol didn't even have one and Jean-Michel Basquiat didn't get his for a few years. And Sprouse was cranking out art with the Xerox, and it was all over the walls and all over clothes he was making for Debbie, who was the perfect pop icon for the next generation—a beautiful blonde with a brain, a voice and an attitude.

At that point Stephen could have gone either way—the artist route or the designer route.

And he did show as a painter, to critical success, but the designer thing was in his bones. He was a real artist-as-designer. I don't think anyone had absorbed the aesthetic of Andy Warhol the way Stephen had. He had that unnatural color spectrum in his head, the neon and the dayglo, the infra and the ultra, and he had picked up all the tricks of op and pop and the iconographics of the view from the Factory. He still didn't say much, but he didn't have to; his output said it for him. He was the quiet, cool one, and he was exploding with ideas. And when Stephen did say something, you paid attention. It was usually a gem, like when Andy died, and Stephen said, "Who will we do things for now?"

Sprouse was one of those rare individuals who is both fragile and indestructible. God knows he tried, as did most of the people around him, to test the limits of voluntary abnormal psychology, but somehow he always bounced back with pictures and clothes that amazed. He was one of those people who inspire the notion that you can be too talented. People thought Stephen was too talented to ever really make it, and he tended to supply evidence for that conclusion by designing brilliant collection after brilliant collection and then always managing to pluck defeat from the jaws of victory—and then he'd bounce back.

Sprouse was never a graffiti artist. Let's be straight about that. But he was around graffiti and around the most important of practitioners

of graffiti art, like Jean-Michel and Keith Haring, but for Stephen it was simply part of the vernacular of his generation, and despite his halting words, he was an extraordinarily eloquent stylist. Sprouse could see the handwriting on the wall, and he knew that graffiti represented the triumph of the human hand in an age of mega-corporation and mass-production. He could see and draw and paint and arrange things the way that they should look in the future, and his relentless vision transformed the landscape of fashion.

Marc Jacobs knows that, and it was a brilliant stroke for him to pick up Sprouse and his brilliant strokes. I'm sure that Jacobs saw in Sprouse a most kindred spirit. There are great similarities in their gifts but where Sprouse was limited by his reticence and slim gift for gab, Jacobs is eloquent and a force of nature. One of the similarities he saw in Sprouse was the collaborator and the fan. Stephen loved to use the work of artist friends in his fashion designs. He knew that working with another creator didn't detract from him, it enhanced him, and Marc Jacobs knows that same truth.

Both Sprouse and Jacobs understood intuitively that the act of altering the commercially sacred Louis Vuitton trademark gave a new life to the company that so jealously guards the symbol of its heritage. They understood the handwriting on the wall, that for a corporation to grow it has to be alive and have a human touch.

p.355 Screen for the *Louis Vuitton Graffiti* (2000), by Stephen Sprouse. Louis Vuitton Collection. *p.356-357* Photograph by Raymond Meier for *Vogue* (2000), of luggage in *Graffiti Monogram* designed by Stephen Sprouse.

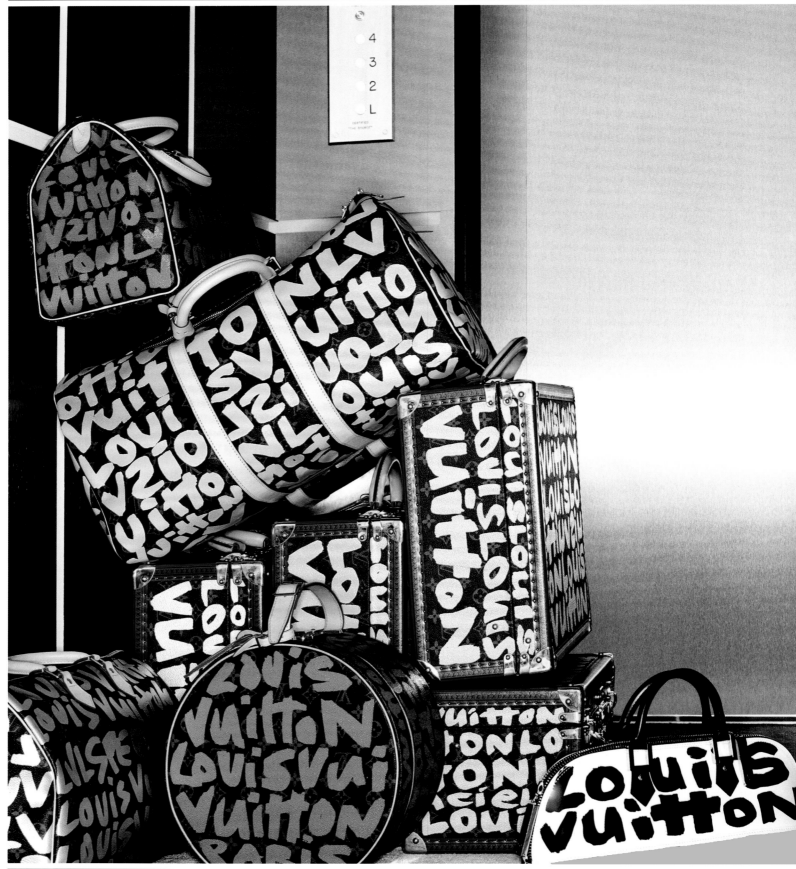

p.358 Silk taffeta skirt in *Rose* pattern by Stephen Sprouse, 2001. Louis Vuitton Collection. **p.359** Sketch for the *Rose* pattern by Stephen Sprouse, 2001. Louis Vuitton Collection.

Art, Fashion and Architecture *359*

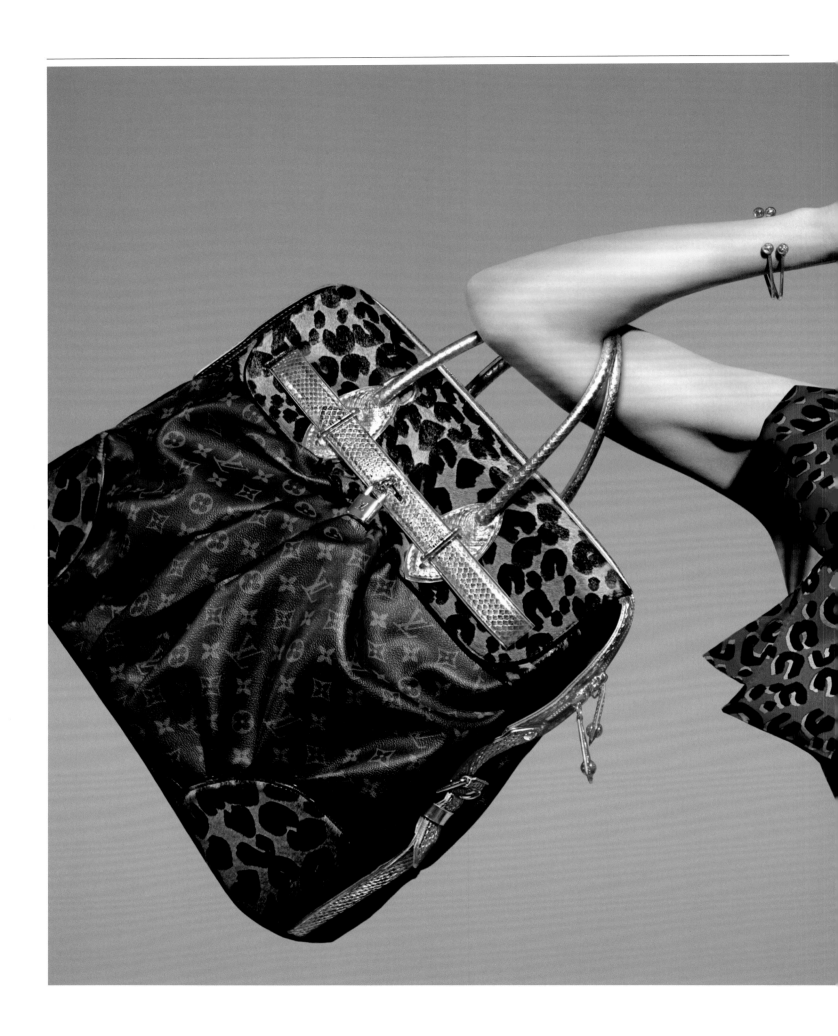

p.360-361 Advertising campaign from F/W 2006-07, by Mert Alas & Marcus Piggott, featuring Kate Moss, with the leopard pattern—by Stephen Sprouse—scarf in red, and the Adele and Pleated Steamer bags in the Leopard Monogram.

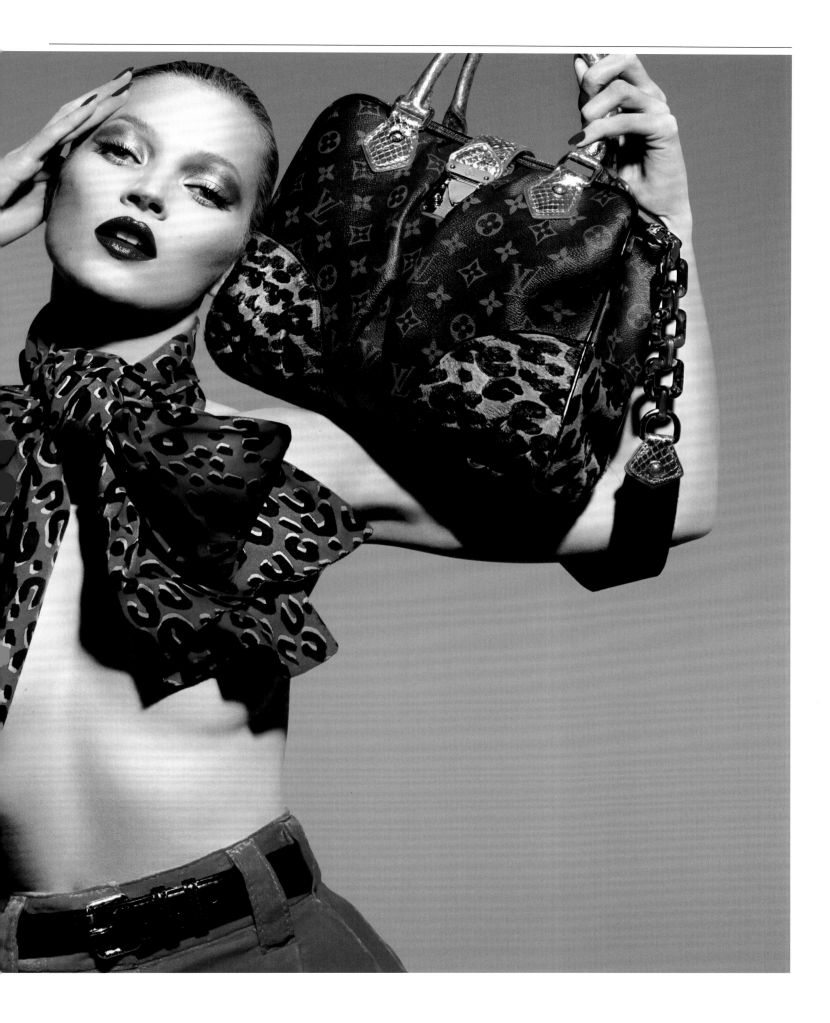

Starck, Philippe

designer
text by Cédric Morisset

In 1989, Louis Vuitton asked Philippe Starck to design an innovative attaché briefcase.

At the age of 41, the designer was at the peak of his career and was already an international star. After having established his talent as an interior architect by appointing the private residence of President François Mitterrand (1983-84) and Café Costes (1985)— then the chicest hang-out in París, he was awarded the Grand Prix National de la Création Industrielle in 1988, but 1990 proved to be his crowning year. In succession, Starck produced a number of iconic 20th-century designs (the Juicy Salif juicer, the Hot Bertaa tea kettle for Alessi, the Bubu Ier stool for the 3 Suisses catalog, the Fluocaril toothbrush) as well as revolutionary hotels that foreshadowed the boutique hospitality industry of the 21st century (the Paramount and the Royalton in New York).

It was then that he devised a very lightweight attaché briefcase for the contemporary businessman. Made of carbon fiber, and resins based on the latest technologies used in marine design, it boasts an aluminum "crowd-dynamic" shape—adapted for use in crowds, as explained by Starck—on the outside and flat on the inside, a true signature design. Differing entirely from the conventions of Louis Vuitton but in perfect sync with the "Starck style," the project was not developed beyond the prototype stage. A silk square scarf created by Starck did go into production. Rendered in dark blue, fine cross-section diagrams of a sail boat's hull mimic ships at sea. The limited series was produced in 1991 for the 1992 Louis Vuitton Cup.

p.362 Model of a fiber carbon attaché case (1990), designed by Philippe Starck, 40 x 47 x 8 cm, (15.7 x 18.5 x 3 inches). A functional prototype with a green leather twill weave interior is part the Louis Vuitton Collection.
p.363 *The Winners*, Silk twill scarf for the 1992 Louis Vuitton Cup (1991), by Philippe Starck; 88 x 86 cm (34.6 x 33.8 inches).

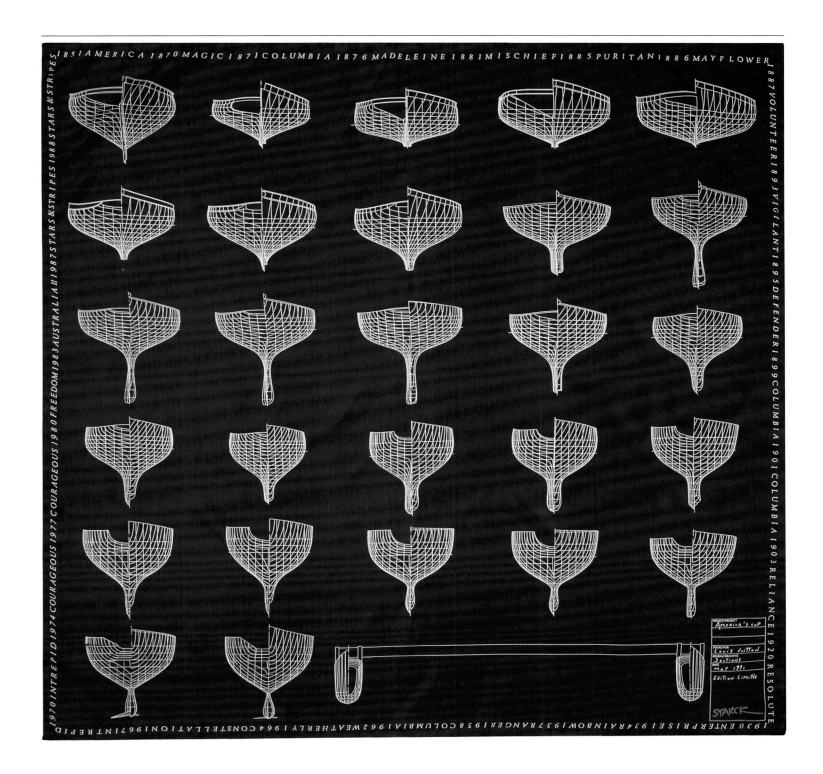

Sybilla

designer
text by Olivier Saillard

In 1996, seven fashion designers were invited to offer their own free interpretation of the Monogram whose centennial was being celebrated.

Among them was the designer from Madrid, Sybilla. Born in New York to a father who was an Argentinean diplomat and a Polish mother – she was herself a designer who worked under the name of "Countess Sybilla of Saks Fifth Avenue"—Sybilla Soronda helped launch a style that put a spin on aspects of late 1980s and the early 1990s fashion. From her time with Yves Saint-Laurent, she learned about proportion, austerity and the balance of color, which in her own work are half-tints, faded and intense, that stray as far as possible from black. Drawing on a classic repertoire of forms that she controls, Sybilla has created her own sinuous shapes that were harmonious in new ways and that broke away from the "power woman" style then in fashion. The subtle motifs and tones that constituted her palette were not without nostalgia, but they also represented a new potion that entranced Spanish fashion design in those years. In 1988, she was awarded the Balenciaga Prize whose style she surely inherited. Her clothes are skillfully cut and references to plant and floral life make them even more sensual. Her coats fall with grace and simplicity, her cardigans roll in the wind, her fragile dresses stand indecisively. The poetry that Sybilla expresses—and that Javier Valhonrat captures in his photographs— is today an example to which we ought to soon return. The discretion that is supreme elegance seems to have guided Sybilla, who started off making custom-tailored clothes, and since 2003 has aimed to continue down this path, developing her own globally-distributed line. Devoted to her lightened and feminine designs, she created a backpack for Louis Vuitton that included an umbrella. Its soft lines gave its wearer the elbow room needed to move easily through the quieted world that is hers.

p.365 On the centennial of the Louis Vuitton Monogram in 1996, Sybilla (Sybilla Sorondo) created the Umbrella bag in Monogram canvas. Louis Vuitton Collection.

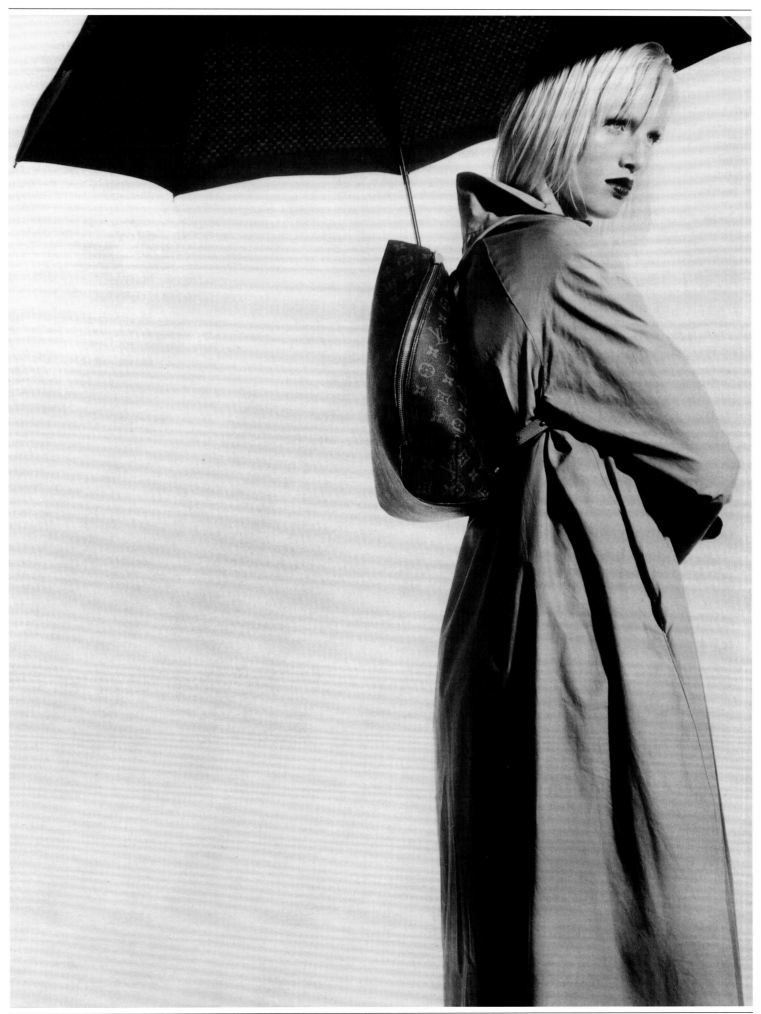

Teller, Juergen

photographer
text by Emmanuel Hermange

Born in 1964 in Erlangen, Germany, Juergen Teller was an apprentice bow-maker before studying photography in Munich.

In 1986, he moved to London where he was commissioned by two magazines that exerted a profound influence on the emerging styles of the decade: *i-D* and *The Face*— both founded in 1980 by Terry Jones and Nick Logan, respectively. In his editorials, Juergen Teller argued for a different conception of the fashion world and how it should be represented, and his photographs struck a powerful chord. Along with other artists of the same generation—he put to the test the images of idealized elegance and beauty long dominant in fashion. He reacted to a system based on a clear separation between those behind and in front of the camera. Teller reinterpreted the genre into a structure from which a single self-referential and self-fictionalized project may be developed, rather than a universe that had always been directed at meeting specific demands. In his work, the distinction between the business of fashion and the private life of his protagonists disappears—a new illusion perhaps, but one that is consciously postmodern and not a little disenchanted. His book, *Go-Sees* (Scalo, 1999), subtitled *Girls Who Come Knocking On My Door*, for instance, is a journal about the year

Teller photographed a succession of models at his London studio. This was an intriguing look at the changing face of fashion, and up-ended received ideas about what constituted a "model" in the 1990s. In place of the collective narcissism exhibited in fashion through the complex mirrors embodied by models, is a more personal narcissism. Teller often appears, as a full fledged character in his pictures, next to models, actors, designers, etc. Not incidentally, before photographing William Dafoe and Björk for the cover of *Index*, a portrait of Teller himself by Leeta Harding made the front page of the magazine in 2000.

That same year, Juergen Teller shot a fashion line especially designed by Louis Vuitton for the sailing race, the Louis Vuitton Cup 2000. This collaboration is in keeping with the longstanding relationship Marc Jacobs has developed with Teller since 1997, whom Jacobs entrusts with the campaigns of his own eponymous ready-to-wear collection. The series he shot for the designer in 2008 is representative of the dislocations that Teller perpetuates. In this campaign, he shot Victoria Beckham in

an over-sized Marc Jacobs shopping bag. The series immediately stirred up much talk, particularly the one taken in stark light, in which only the former Spice Girls's legs are shown sticking out, a rebus in a sack. Sadie Coles, a gallery owner as well as Teller's wife, accurately described the way he works with a model, "He uses a compact auto-focus, auto-flash camera to repeatedly and at speed bombard the subject, often holding and shooting with two cameras at once, no lights, no assistants [...]. This assault, quick, rapid and accompanied by a constant dialogue, means that there is no time or space for the subject to control what is being captured, no time to conceal or withhold."[1]

The exhibitions and books that Teller regularly produces in collaboration with galleries and museums since the mid 1990s contribute to his overall attempt at changing the representation of fashion. This melding of fashion firmly with art finds its most comprehensive expression in *Ohne Titel* (Steidl, 2005), the book that he, Marc Jacobs and Cindy Sherman put together.

1 Teller, Juergen. *Nürnberg*. Berlin: Steidl, 2006, n.p.

p.367 Advertising campaign for the Louis Vuitton Cup 2000 by Juergen Teller, featuring the Pakatoa bag (top), the Zealand bag (bottom left) and the Matangi bag (bottom right).

366 **Louis Vuitton**

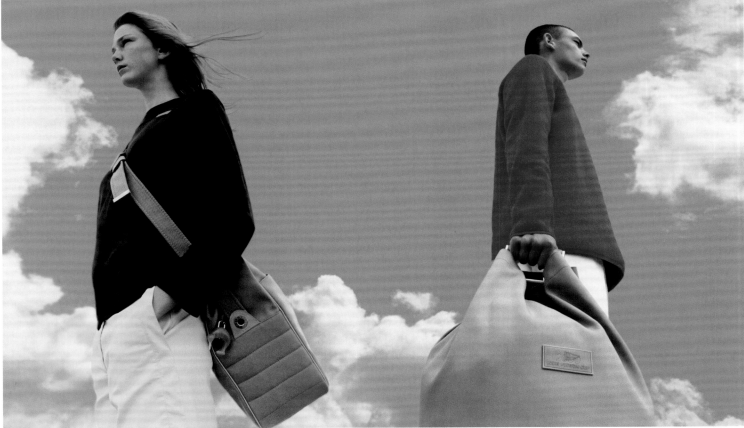

Toledo, Ruben

artist
text by Marie Maertens

A Cuban-born American, Ruben Toledo has been a fixture on the fashion scene for many years.

A public presence with his wife Isabel Toledo—a renowned designer—the pair defies easy classification. He is at once a painter, sculptor, designer, columnist, fashion critic and illustrator, and his work has been featured in *Harper's Bazaar, L'Uomo, Vogue, Details, Paper* and *Visionaire.* He has also created murals, portraits and album covers and is the author of the Style Dictionary. As a unit, the Toledos whirl through a life devoted to creating beautiful art and fashion—but not without a little irony and a critical eye.

It then comes as no surprise that Ruben was approached to illustrate the fourth Louis Vuitton travel notebook on New York, a city he knows so well. This series of notebooks invite readers to discover a city while tapping their own creativity. Blank pages are provided for personal notes and drawings, alongside sketches by the artists and watercolorists commissioned by Louis Vuitton. The New York guide takes you through the city's neighborhoods. The tour begins with a watercolor depicting the Big Apple seen from above. Then you gradually navigate its beating heart: the Statue of Liberty and Wall Street. You stroll through Battery Park, jump into taxis, push through crowds and have a quick bite in Chinatown. You eat veggies and shop, you party at the various festivals on Mott Street, get intellectual in SoHo and Chelsea, rest in Central Park and run into every kind of sartorial style. You go to the theater on Broadway, take dance classes on the Upper West Side, admire paintings at the Guggenheim… Toledo's graceful watercolors with their cheerful colors have the delicious taste of springtime in New York. The

excitement, the feeling that everything is possible, the guide really makes you want to run out of the house and explore. Toledo has been the exclusive illustrator of the Louis Vuitton City Guides since it was launched.

More recently, he has also completed a humorous sketchbook with Paul-Gérard Pasols that describes how "Louis Vuitton came into the world of fashion." The small book tells the fashion house's story and recounts that Louis Vuitton was first a *layetier* who packed the most stunning dresses for France's most stylish men and women. "He became the favorite layetier to Empress Eugénie," which incited him to found his own fashion house in 1854. Some time after, Georges, Louis's son, took the bold step of designing a fabric bearing his father's initials. It would later become the legendary Monogram canvas.

Toledo describes these episodes in loving detail. Messieurs Louis and Georges could easily be recognized attending impossibly stylish women with fine, confident features. Dressed in black with a small touch of white, accented in red—a shade matching their painted lips—they sport feathered hats and are gloved in silk. As ever, these ladies are depicted with a multitude of precious Louis Vuitton luggage.

Toledo's style is incisive and schematic. The silhouettes in the background and the décor are suggested in just a few, briskly rendered lines. Another tableau brings together fashion icons who were clients and friends of Louis Vuitton: Paul Poiret, Madeleine Vionnet, Jeanne Lanvin, Gabrielle Chanel, Christian Dior, Marcel Rochas, Jean Patou and Hubert de Givenchy. They stand with two oracles of the fashion press: Diana Vreeland and Anna Piaggi. The assembled company is impossibly elegant and each character is paired with a bag or suitcase. Again, fine and precise lines depict a vivid world as they capture its essence, and a harmony of color gives it mass. Toledo and Pasols' tale ends with the centennial celebration of the Monogram in 1996. Seven designers marked the occasion by inventing new objects with the pattern. Helmut Lang, Azzedina Alaïa, Vivienne Westwood, Romeo Gigli, Manolo Blahnik, Isaac Mizrahi and Sybilla all contributed original pieces that were presented in a year long, international celebration. With comic flair, Toledo accurately describes these outsized personalities as proudly bearing their Monogrammed offerings, while an army of photographers surround the duo formed by Marc Jacobs and Bernard Arnault. This last vignette proved uncanny, as it was at this time that the LVMH chairman decided to hire Jacobs as the artistic director of his flagship brand, transforming the venerable luggage maker founded by a *layetier* into a ready-to-wear powerhouse.

Tran Ba Vang, Nicole

designer
text by Emmanuel Hermange

The protective enclosures of skin, clothing and architecture define man's relationship with his environment.

And there is nothing more universal to all cultures than the interdependencies—real and symbolic—that exists between these three membranes. But these vary from one culture to the next, often in minute details.

Nicole Tran Ba Vang (born in 1963) has developed an oeuvre in which the linkages that the west has manufactured between these envelopes are blurred by a filter, through which she scrutinizes conceptions of fashion and identity in an era when even our most elemental conceptions of the human body are changing. Trained as a designer, she began by painting on pages culled from fashion magazines (*Icons Collection*, 1997-2006). Intervening mainly through the medium of clothing, she used paint to reveal the body—its skin—under fabric, creating a layered impression of models "dressed" in their own nakedness. "'To be or not to be seen,' my work is defined by this word play," she declares. And photography has allowed her to take her expression of the paradox further, one that she formulates in a way similar to Paul Valéry: "what is most deep in man is his skin," he once uttered. The interpretation the artist offers is clear: identity is not uncovered deep within an individual but is at play on the surface-screen of the body.

Since 1999, Tran Ba Vang has labeled her series in the way a fashion house might order their collections. In *Spring-Summer Collection* 1999, which continues to take fashion magazines as the starting point of her exercises, she randomly borrowed skin surfaces that she then transferred onto an item of clothing, so that one is not sure if a dress, for example, is partly transparent, of if the naked body of the model wearing it has become a motif printed on the fabric. The material nuance is subtle but the confusion it precipitates is profound, with the role of the garment and the image that fashion has given it determining both the conception and the perception we have of the body. The resulting images, rather large in size, surpass the materiality and scale of the magazine page through photographic enlargement. In *Spring-Summer Collection* 2000, Tran Ba Vang took leave from the glossies and adopted a production logic that she recalls for later series. Henceforth, she photographs models that she has styled and posed in such a way that ambiguity no longer only resides in the appearance of a transformed article of clothing, but also in the posture of the body, the composition and the lighting. These juxtapositions maintain a darkly humorous relationship with the codes of fashion and their representation. In this context, the clothing transformed into flesh—undergarments to be specific—is simply a more effective way to shake up the body's relationship to culture and identity. During a gallery exhibition in April 2000, the novelist Marie Darrieussecq noted that "the window had to be covered up because passersby were reacting so strongly. This is the power of Nicole Tran Ba Vang's work; she twists commercial seduction in order to better penetrate the way we see, by breaking in, by surprise, going right into our unconscious until our senses are thrown off course." Traces of her previous *modus operandi* remain however, since one of the photographs in the series manipulates an image taken from a Louis Vuitton brochure. The leather details from a pair of boots are barely distinguishable from skin, and it is the skin of a model who has posed for the artist for other photographs in the series. "In [these] fake collections," Darrieussecq continues, "there is a striking contrast between the frivolity of the context and what haunts our collective memory."

Far from limiting herself to the interchange of skin and clothing, the artist shrewdly expanded her work to address the relationship between the body and its immediate environment. Since 2003, her collections have depicted carpet or wallpaper motifs that contaminate a woman's body, or rather body ornaments that extend to the walls of an exhibition—dubbed "wall-piercings."[1] The feminine identity of ornament, spanning from seventeenth-century baroque to Klimt—before being infamously repudiated by Adolf Loos and his modernist theories—is here, freshly revived.

[1] From the exhibition "No Stress, Just Strass," Centre de Création Contemporaine, Tours, 2007

p.371 *Collection Spring Summer 2000* (2002), by Nicole Tran Va Bang; photomontage on paper, 132 x 116 cm (52 x 45.6 inches). Louis Vuitton Collection.

370 **Louis Vuitton**

Turrell, James

artist
text by Marie Le Fort

James Turrell likes to say: "I want people to physically feel the light. (...) We are light eaters." Fascinated by light, he explores all its aspects to offer us immaterial works outside the boundaries of time. The use of light, not as a medium for an image, but as a "revelation in itself" distinguishes Turrell's work from that of Mark Rothko, to whom he has often been compared. Rothko's flat pictorial work keeps the viewer at a distance, whereas Turrell's three-dimensional work immerges us into abstraction. Furthermore, the strength of his light-based works lies in the absence of any figurative element, any narration: "My work has no representation. There is nothing inside, neither image, nor design. Absolutely nothing." Only form and light emanate from each of his works as abstract colored blocks, or volumes which draw the attention of the eye and send us back to ourselves. Such works, which celebrate the power of light, also reveal materiality, and call upon metaphysics.

Turrell, the son of a French engineer in aeronautics, who immigrated to California, and of a profoundly Quaker mother, studied perceptual psychology and at the same time was interested in astronomy. He received a Master's of Fine Art from the Claremont Graduate School in California. His preoccupations soon drew him close to a circle of intellectuals that coalesced in 1960s Los Angeles. These idealist and utopist artists, among others, Michael Heizer and Walter de Maria, were opposed to the emergence of minimal art as some New York artists such as Josef Kosuth, Lawrence Weiner or Robert Barry conceived it. At the time, California was attractive, stimulating and eclectic. Cinema and newer forms of illusion were being invented there. Ephemeral works were produced there, with the specific purpose of modifying perception. Components that made the trip to the Moon possible were conceived there, and some of the most advanced scientific research

in the United States was being conducted in the valleys of California. This fertile environment enabled James Turrell to create his first works and to devote himself to the "conquest of space," culminating in his long-term project in the neighboring state of Arizona: Roden Crater.

It is impossible to talk about James Turrell without referring to his at once humble and pharaonic Roden Crater project—an extinct volcano he purchased about thirty years ago in the Painted Desert, on Navajo and Hopi Indian land. He has worked for several decades on this land art masterwork. As a tribute to the creative power of mankind, the volcano is shaped, carved out and arranged to create observation spaces. The 400,000 year-old volcanic stone, echoing the beauty of the Earth, responds to the infinite majesty of the sky where stars, constellations and Moon craters create an unexpected show. This is, undoubtedly, one of the wildest undertakings in contemporary art.

Within the framework of the 2006 Icons exhibition, James Turrell reinterpreted the Wardrobe trunk, under the condition that it would be a reflection of the volcano. A series of photographs were therefore taken especially for the exhibition. They featured the trunk—one of Louis Vuitton's trademark pieces because it opens vertically as a wardrobe—with Roden Crater and the immensities of the Arizona desert as the background. A unique trunk, transported by light, is transformed into a work of art.

Light, nothing but light. He explains: "[...] light has various sensitivities. The light I use in my work is rarely seen with open eyes. It is only when the eyes open that the sensation comes out of them, as a caress and then, you have the impression of physically feeling this light." James Turrell uses only one material: light. Whether artificial or natural, it interacts with space, creates visions in enclosed places (in situ installations) or open spaces (such as Roden Crater

which is transformed into an observatory of the firmament). Turrell celebrates the "paradoxical immateriality" of light as an intangible material. He transforms abstraction into a concrete perceptual experience. His work teaches us how to examine emptiness and find something unthinkable in it: a form of contemplative life or the magic of vision and light. James Turrell's universe can be linked to Plato's cave and the infinite space which frightened Pascal. The viewer walks into dark rooms, where geometric surfaces or shapes appear and define spaces of colored light. At the beginning, you see nothing, because there is precisely nothing to see. Then, a multi-sensorial experience follows, contouring the outlines of an abstract luminous shape. Is it a real vision or an optical illusion? *Trompe-l'œil* may be an age-old artifice but Turrell's work should not be limited to a simple game of visual effects. His *Partition Pieces* blur all boundaries and expose us to the temptation of the emptiness and the infinite. As they are

put into abyss, his works draw the viewer into a process of silent, almost spiritual contemplation where visual perceptions constantly evolve according to the intensity of light and the time spent to observe it.

With this in mind, Louis Vuitton suggested that James Turrell would create a visual installation for the renovated store on the Champs-Elysées. The artist asked to see the architect's blue prints right away, insisting that visualizing the setting is for him an essential part in the creation process. Once he had visited the site, the concept and the dimensions of the installation instantly appeared to him. The installation entitled *First Blush, Oct. 2005* he realized for the Champs-Elysées flagship is the first of the series entitled *Wide Glass*. As a modular light-based sculpture projected on a flat screen, *First Blush, Oct. 2005* creates a visual encounter and makes the viewer aware of the fluidity of his own perceptions. To a unique work belongs unique sensation.

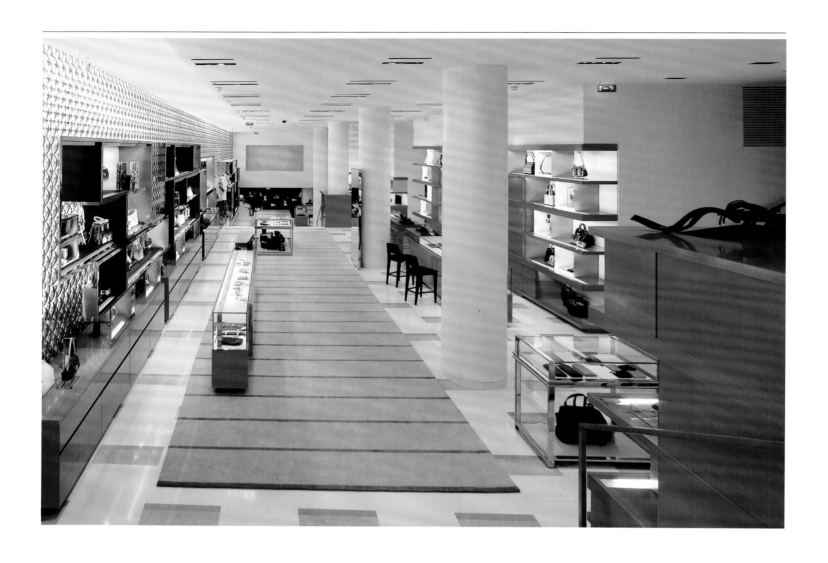

p.372-373 *Interpreting the Wardrobe trunk*, installation (2006) by James Turrell for the *Icons* Exhibition at the Espace Louis Vuitton, Fall 2006. Louis Vuitton Collection. **p.374-375** *Tall Glass* (2005) by James Turrell, a permanent "light sculpture" installed in the ground floor of the Champs-Elysées flagship.

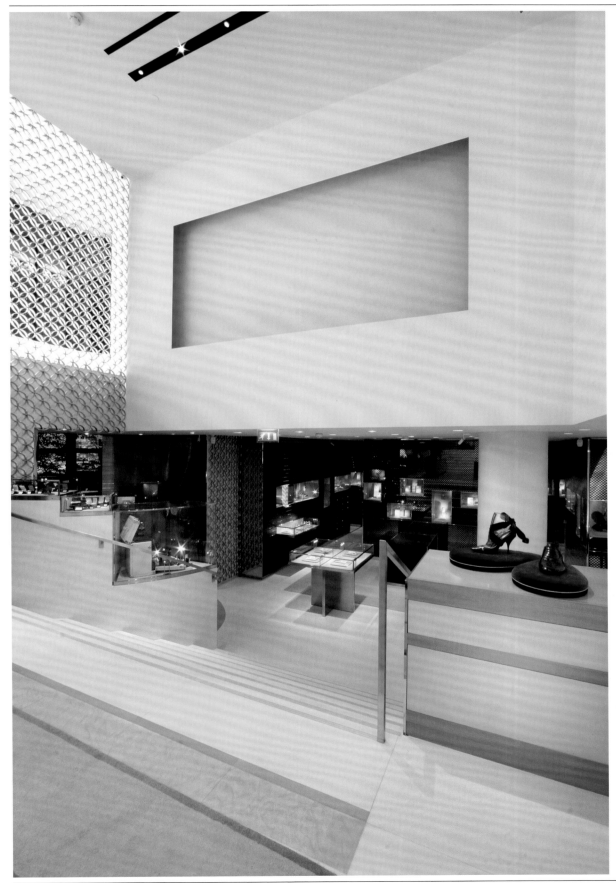

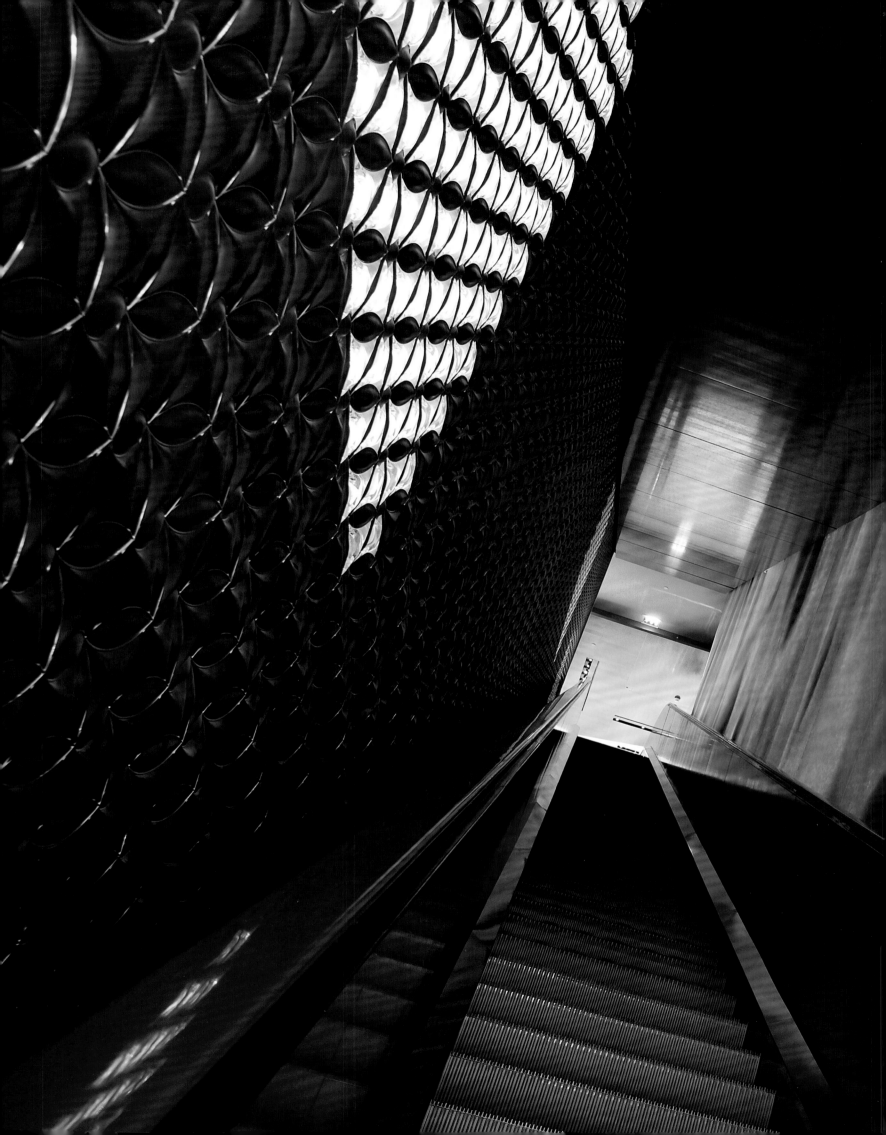

V–W

Van Lamsweerde, Inez
& Matadin, Vinoodh
Verhoeven, Julie
Wang, Zhan
Westwood, Vivienne
White-Sobieski, Tim
Wilson, Robert
Wilson, William Adjété

Van Lamsweerde, Inez & Matadin, Vinoodh

photographers
text by Emmanuel Hermange

Both natives of Amsterdam, Inez van Lamsweerde (born 1963) and Vinoodh Matadin (born 1961) are a partnership whose steady contribution to the exchange of values between the worlds of art and fashion is undeniable.

They met in 1986, when she had just entered the Rietveld Academie, and he—a graduate of Amsterdam's Fashion Academy—had already launched his own line of apparel. Matadin initially worked on styling van Lamsweerde's photo shoots and formally engaged in collaborative work in 1995.

Van Lamsweerde attracted plenty of attention with her shots of scantily clad women in artificially ecstatic poses, set against urban backdrops that exist mainly in magazine editorials (*Vital Statistics,* 1991). Other models were shown entirely nude against a white background with their genitalia brushed out and their skin buffed to look like a silicone mannequin (*Thank You Thighmaster,* 1993). These series were exhibited in a number of shows with the work of other artists, including Aziz+Cucher, Keith Cottingham and Orlan. Like these photographers, she was interested in introducing the concept of a post-human future (inspired by science fiction) into art. The post-apocalyptic universes of writers William Gibson and Bruce Sterling, and the coldly realistic atmosphere of Philip Pearlstein's paintings are cited as influences. She blends these sources of inspiration with a careful attention to detail in her representations of the body—whether for fashion, beauty products or erotic media. Her goal is "to stress that we are creating a body that is perfect but otherwise completely useless."[1] Her work obviously addresses the issue of bodily identity and transformation, but its most striking aspect is the profound ambiguity with which she imbues these bodies. In contrast to many of her contemporaries, who have offered a range of digitally manipulated body types, her images compel our attention primarily because of their posing, materials, lighting and backgrounds. Each of these elements may be individually identifiable in her work, and nothing calls undue attention to itself, but the visual vocabulary she has created for this new type of human is indeterminate, even obscure.

These bodies find themselves in inconceivable situations—and an alien disquiet pervades her photographs. This ambivalence also carries over into the critical reception of her—and Matadin's œuvre. The pair have even been charged with sexism; such was the case with the large format photos from 1993, of women mimicking pornographic poses that she suspended beneath one of Amsterdam's bridges. On other occasions, the work has been perceived as radically feminist. But in *The Forest* series, which featured masculine bodies with a number of feminine traits, the artists' stance on gender politics is not completely legible. As Francesco Bonami wrote, they are committed to both a "new gender of art and a new art of gender."

The worlds of fashion and advertising were equally seduced by Van Lamsweerde and Matadin's preoccupation with ambiguity. Beginning in 1994, commissions included images for *The Face, American Vogue* and the sumptuous *Visionaire.* The year also saw them snap a portrait of Vivienne Westwood for the cover of *Flash Art.* The interdisciplinary character of their work—yet another layer of ambiguity—posits fashion images into an artistic context and injecting artistic issues into fashion shots. In their exhibitions, they often add to the confusion by including self-referential, fictionalized self-portraits, which exploit van Lamsweerde's charismatic presence. Madonna, who proclaimed her admiration for the two artists after they photographed her for the magazine *Spin* in 1998, compared Inez van Lamsweerde to a Modigliani portrait. Björk also found that their vision resonated strongly with her own imaginative universe and commissioned them to make a video for *Hidden Place* (2001). In this film, otherworldly liquids appear and disappear on the surface of the singer's face, an effect created through a collaboration with the Parisian graphic design team of Michael Amzalag & Mathias Augustyniak, M/M. They also worked on a number of other projects with M/M, including *The Alphabet* (2001) and *The Alphamen* (2003), a set of typefaces incorporating images of male and female beauty.

The duo has executed five advertising campaigns for Louis Vuitton, but the first, which was for a line of pens in 1997, attracted the most attention. Maps were sketched onto the faces of the models, who included Stephanie Seymour and Kirsty Hume; they were shot holding a pen between their teeth, the skin around their eyes tattooed with the trademark Monogram canvas in the shape of sunglasses. In other campaigns for the *prêt-à-porter* collection (1998 and 2000) and jewelry (2001 and 2004), the models are all photographed with their lips suggestively parted. There is a strange continuity with their first campaign for Louis Vuitton, suggesting anything from a sense of absence or a detachment from life. Open to interpretation, their authorship is unmistakable.

[1] Artnews, November 2001, n.p.

p.376-377 *Moving Painting* (2005) by Tim White-Sobieski: video installation measuring 20 x 2.5 meters, flanking the main escalator at Maison Louis Vuitton, Champs-Elysées. **p.379** Advertising campaign by Inez Van Lamsweerde & Vinoodh Matadin, featuring Christy Turlington in F/W 2000-01 Prêt-à-Porter, with a blouse in Monogram fabric.

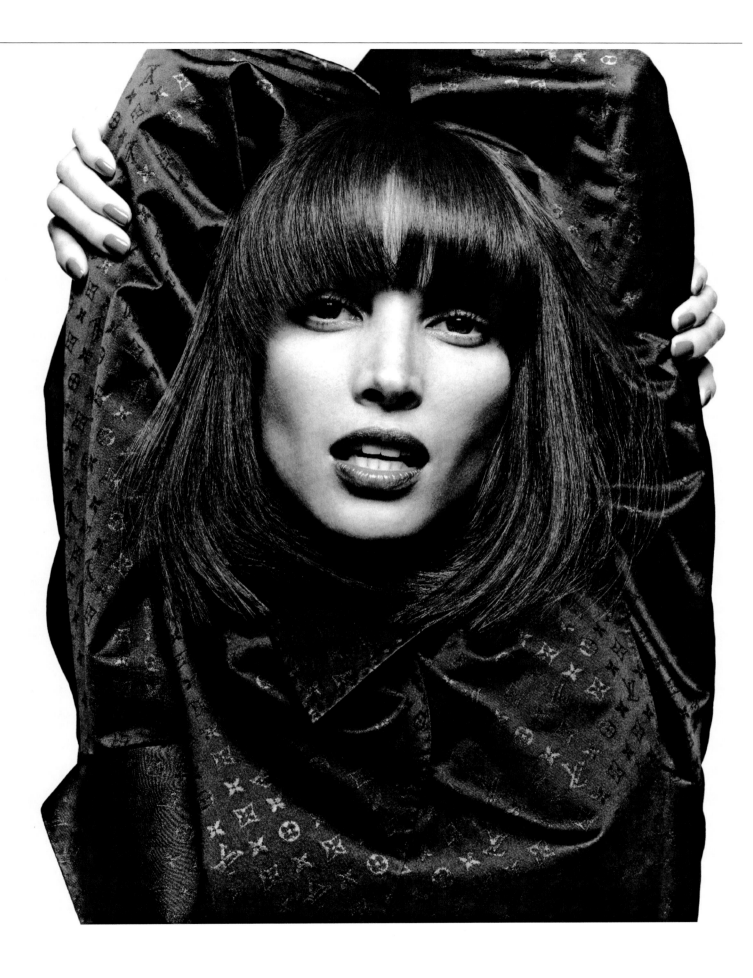

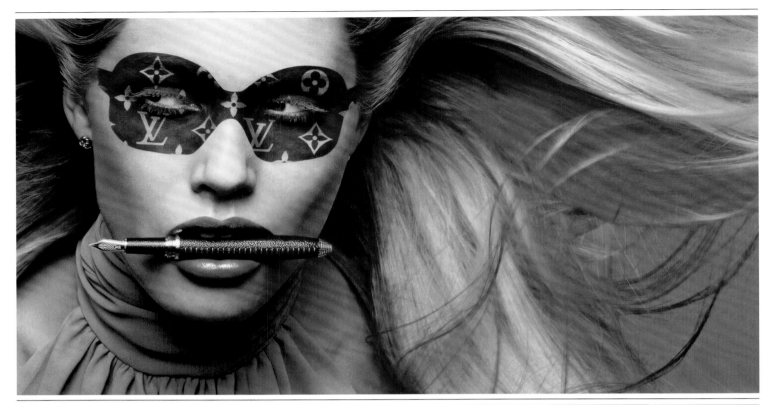

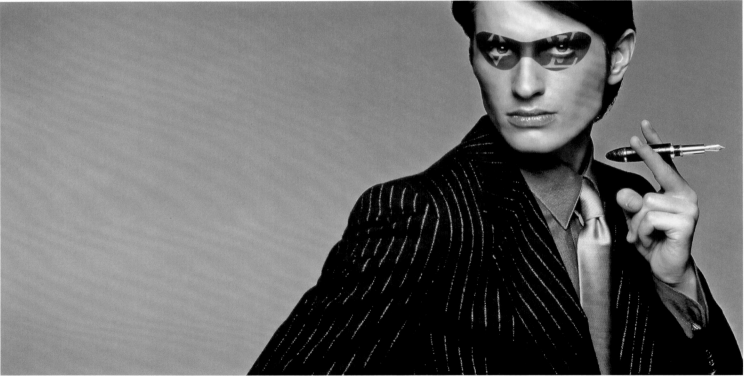

p.380 Images from the *Ecriture* campaign (1997) by Inez Van Lamsweerde and Vinoodh Matadin promoting fountain pens—Doc and Cargo—designed by Anouska Hempel. p.381 Image by Inez Van Lamsweerde and Vinoodh Matadin of model in Monogram makeup, with Faux Cul bag created by Vivienne Westwood for the centennial of the Monogram canvas in 1996.

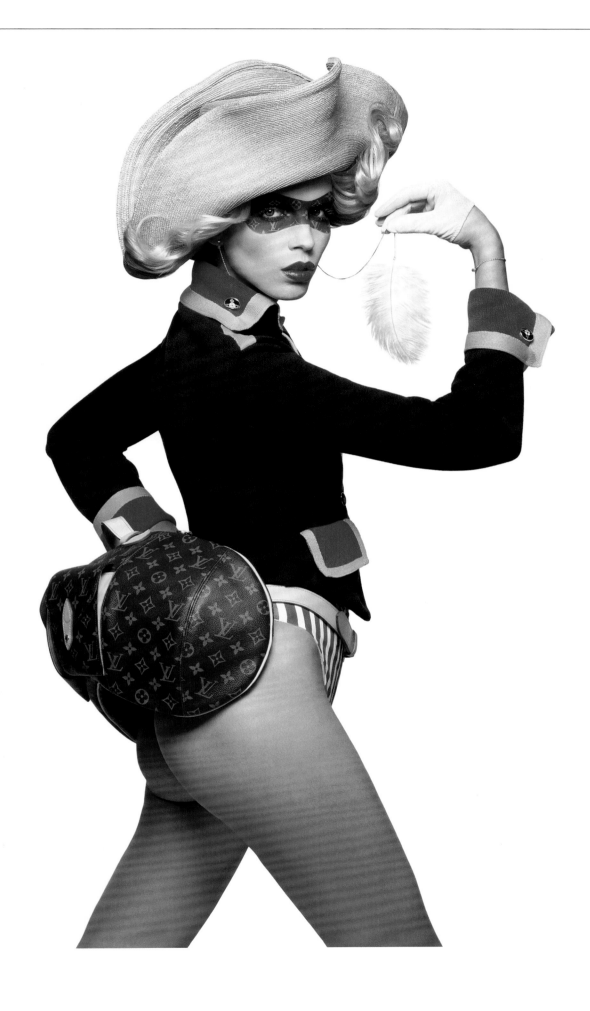

Verhoeven, Julie

designer
text by Marie Maertens

Julie is sometimes called "Alice Verhoeven" or the "Verhoeven fairy" because she is so taken by wonder.

An English illustrator and designer, she studied with John Galliano and then Martine Sitbon. Being a woman of many talents, she has also designed album covers and appears regularly in the hippest magazines like *I-D, The Face, Dazed and Confused* and *Numéro*. She often draws music and once illustrated forty of her favorite pop tunes. Utterly mischievous, shy yet eccentric, Verhoeven represents the elements that comprise her imaginary world in her own way and in every possible form. When Marc Jacobs invited her in 2002 to design a collection of bags for the spring line, she magically brought together snails, butterflies, deer, rabbits, shells and rainbows made from precious materials. The different Louis Vuitton leathers (Damier canvas, Damier Sauvage, Monogram Vernis, Epi leather and exotic leathers) were topstitched and embroidered carefully over Monogramed materials. The young designer indicated that she was trying to stir up both funny and intriguing feelings. Her strength lies in how she combines multiple sources of inspiration, from 1940s glamour to the 1980s television shows she watched as a teenager. Strict and structured lines are paired with exaggerated lamé dresses and cocktail hats. Miss Julie likes to scramble the constituent parts of what is clearly a singular style and does so in explosions of color.

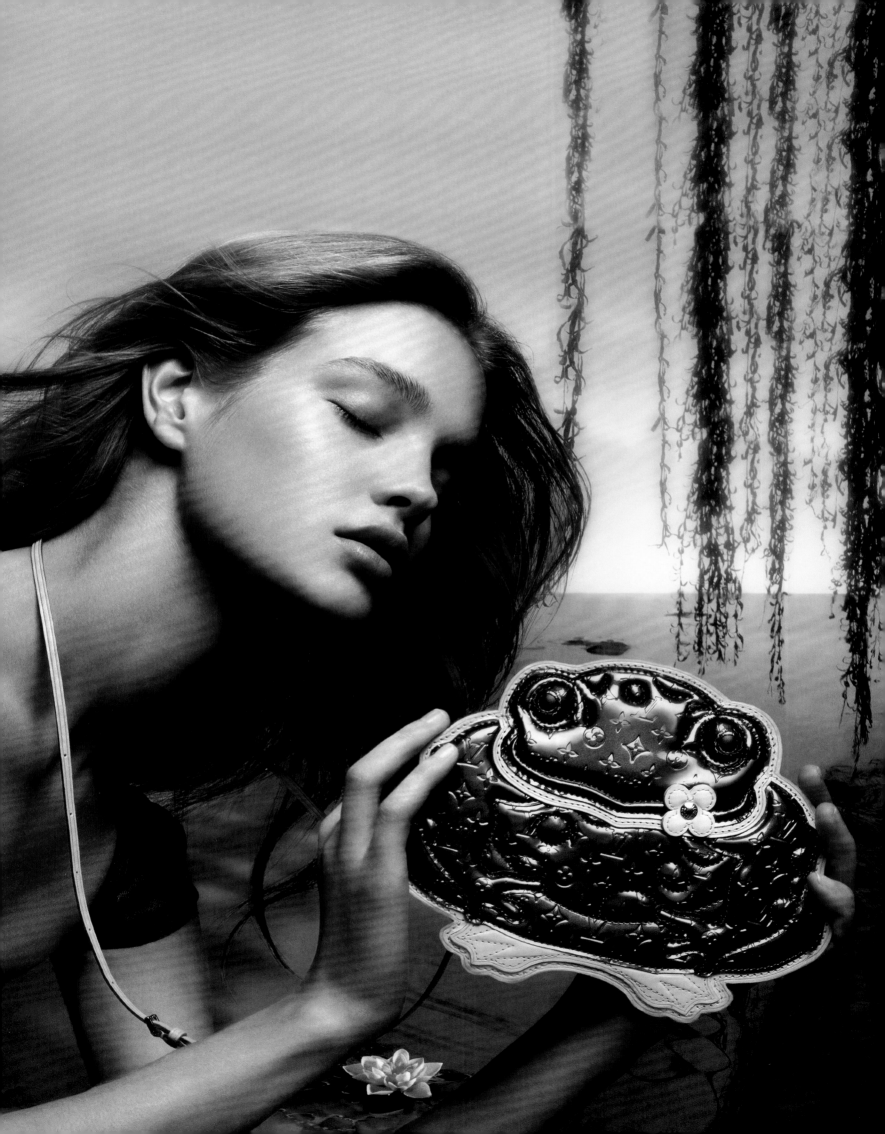

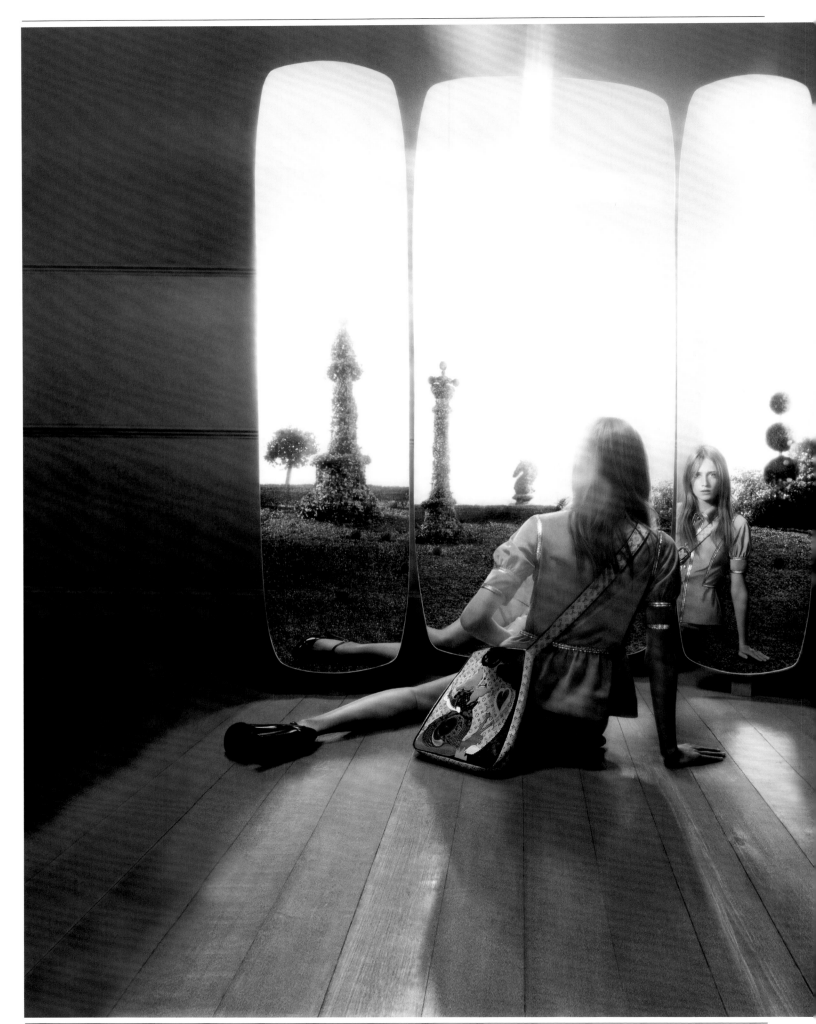

p.383 Advertising campaign by Mert Alas & Marcus Piggott: The Frog Prince, featuring the Toad Mini Monogram purse from Julie Verhoeven's *Fairy Tales* series, S/S 2002. p.384 Advertising campaign by Mert Alas & Marcus Piggott, featuring Ann Catherine Lacroix as Alice in Wonderland, in S/S 2002 Prêt-à-Porter, with the Garden shoulder bag from Julie Verhoeven's *Fairy Tales* series.

Wang, Zhan

artist
text by Marie Maertens

Celebrated in China, Zhan Wang's work has received considerable acclaim internationally.

Since 1995, he has been noted for his work made with ancient Chinese rocks. These stones, sculpted by nature into complex forms are used to decorate traditional Chinese gardens and encourage contemplation and spirituality. But what's original about this artist, who was born in 1962 in Beijing, is that he offers a contemporary vision in stainless steel. The piece, *An Artificial Rock*, acquired by Louis Vuitton for the Landmark boutique in Hong Kong serves as an example. Its presence in the boutique, which is devoted to luxury, is all the more pertinent when one understands the artist's approach. "Placed in a traditional garden, these rocks satisfy people's desire for a return to nature by offering them a fragment. But a new era has made this traditional idea entirely retrograde," He transforms these natural rocks into manufactured products, gathering them them, grinding them, polishing them, folding and shaping them to obtain various topologies. He then surrounds each in stainless steel, thus applying an envelope, a modern skin to this ancient geological body. The fact that he chose steel is interesting because of its reflective quality, one that mirrors anyone who looks at it or anyone who has come to buy. It in fact reflects modern life. Buffed to a mirror finish, these rocks are more water than stone, and the material makes the object appear lighter. It also allows the artist to speak to Chinese history, to the clash between tradition and modernity, between migrating and putting up roots. The function of this rock, therefore, has not changed. Its goal is still to encourage contemplation and spirituality, even if the reflections are now unfamiliar.

p.387 *Artificial Rock Jiashanshi 101* (2006) by Zhan Wang; Polished steel, 100 x 190 x 136 cm (39.3 x74.8 x 53.5 inches). Installed at the Louis Vuitton Hong Kong Landmark Store, Hong Kong SAR. Louis Vuitton Collection.

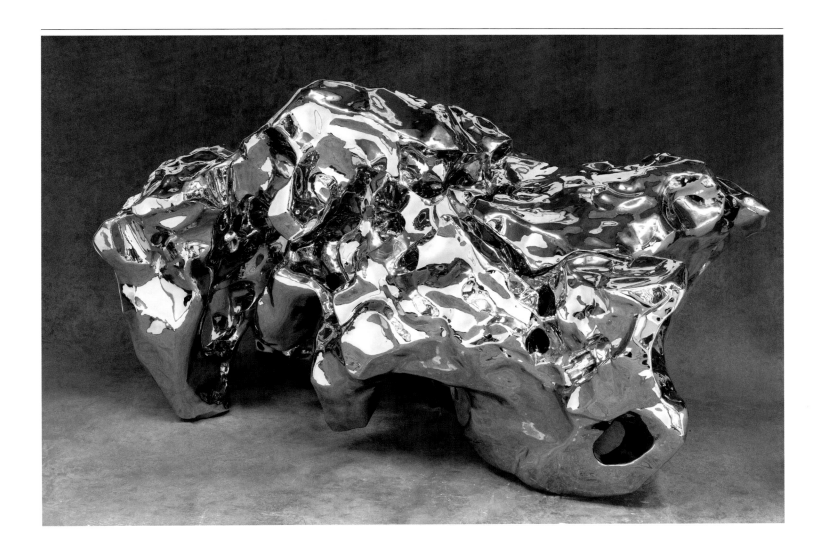

Westwood, Vivienne

designer
text by Olivier Saillard

Vivienne Westwood plays with paradox cleverly.

When she began in 1971, alongside Malcom McLaren, she became known for a scandalous fashion influenced by the aesthetics of punk a message she carried with pride. The holes and the slashed clothing, with straps that created the "bondage look;" that was the key to their success. Much later, after the English designer had founded her own fashion house in 1982, Westwood took a similar cheeky interest in the splendor of eighteenth-century dress. She reveled in corsets, crinolines and the *faux cul* bustles that became a trademark, a snub to convention. She then mastered cuts and invented new processes that resulted in truly original clothing combining historical classicism and contemporary irreverence. Her talent gradually took on the archetypes of *haute couture*, a language of codes she was quite familiar with and knew she could transcend. Westwood was very much a party to the seismic developments that irrevocably changed fashion at the end of the twentieth century. She, along with an elite group of Japanese designers shrewdly and defiantly set the trends. For the centennial celebrations of the Louis Vuitton Monogram in 1996, Westwood created a false-fanny bag that exaggerated one's hips, but could also be carried like a handbag.

p.389 On the centennial of Louis Vuitton Monogram in 1996, Vivienne Westwood created the Faux Cul bag and platform boots in Monogram canvas. Louis Vuitton Collection.

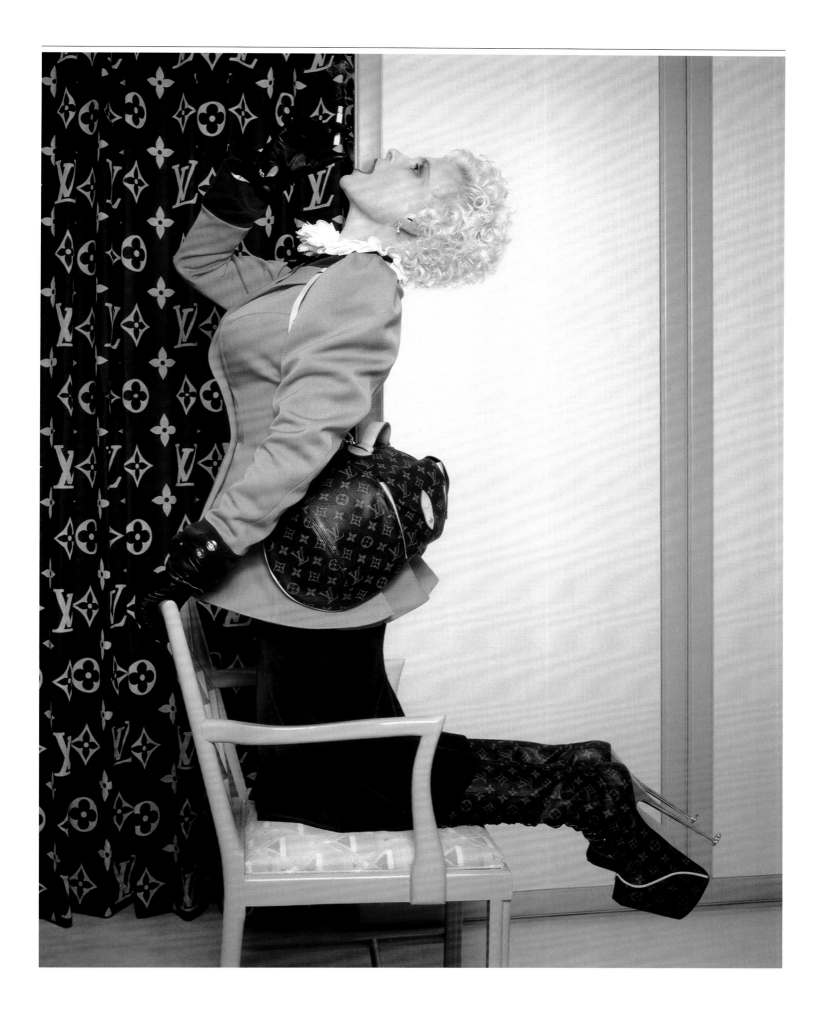

White-Sobieski, Tim

artist
text by Marie Maertens

American video artist Tim White-Sobieski has collaborated with Louis Vuitton on several occasions. He was the first artist to realize a video flanking the large escalator leading to the upper levels of the Champs-Elysées boutique. The piece *Moving Painting* ascends over 18 meters (60 feet) and its title holds no double meaning. It was truly conceived as an animated painting. This projection was for a time accompanied by a still image that filled the window overlooking one of the most storied avenues in the world. Born in Poland in 1967, but now living in the United States, White-Sobieski was first recognized for his use of new media. His films are vector videos, meaning that the quality of the image remains the same no matter the scale to which it is enlarged. For Louis Vuitton, he also completed a project based on the Alma bag, for which he imagined what relationships such an accessory might have with its owner. This was a multi-channel video installation mounted for the *Icons* exhibition at L'Espace Louis Vuitton in 2006. Crossing a dark room, the viewer was invited, on the sly, almost like a voyeur, to discover the contents of the bag floating around him, partaking in the private life of a stranger.

While utilizing advanced media technologies, White-Sobieski likes to analyze and retranscribe the deepest of emotions. One of his pieces, entitled *Awakening*, contends with a teenager's existential questions. The photographic process he employs, based on an old video, despicts the state of growing and maturing, revealing the traces of the past, as it intimates the adult on the way. The video artist trains his gaze into a world situated between dreams and reality, employing symbols to bear his message. He has also shown a tendency to interrupt rhythms, employing static to modulate photographic perfection, and combines it to explore new techniques. His installation *Deconstructed Cities/Deconstructed Reality* also presents still images with moving projections, using snapshots from metropolises like London, Paris, Berlin, Tokyo, New York, Los Angeles, San Francisco and Rio de Janeiro. This project revealed a wish to examine contemporary environments by deconstructing images of them, before reconstructing them in a new virtual reality, and thus uncovering psychological portraits of each city. White-Sobieski's art is forensic, drawing to light the uncertain forms hidden behind appearances. He focuses on the surrounding chaos, the world and its contradictions, uncovering layers of meaning—or their absence—and does not propose easy answers.

p.390-391 *Moving Painting* (2005) by Tim White-Sobieski: the video installation flanked the main escalator at Maison Louis Vuitton, Champs-Elysées, while a vertical installation stood behind a shop window.

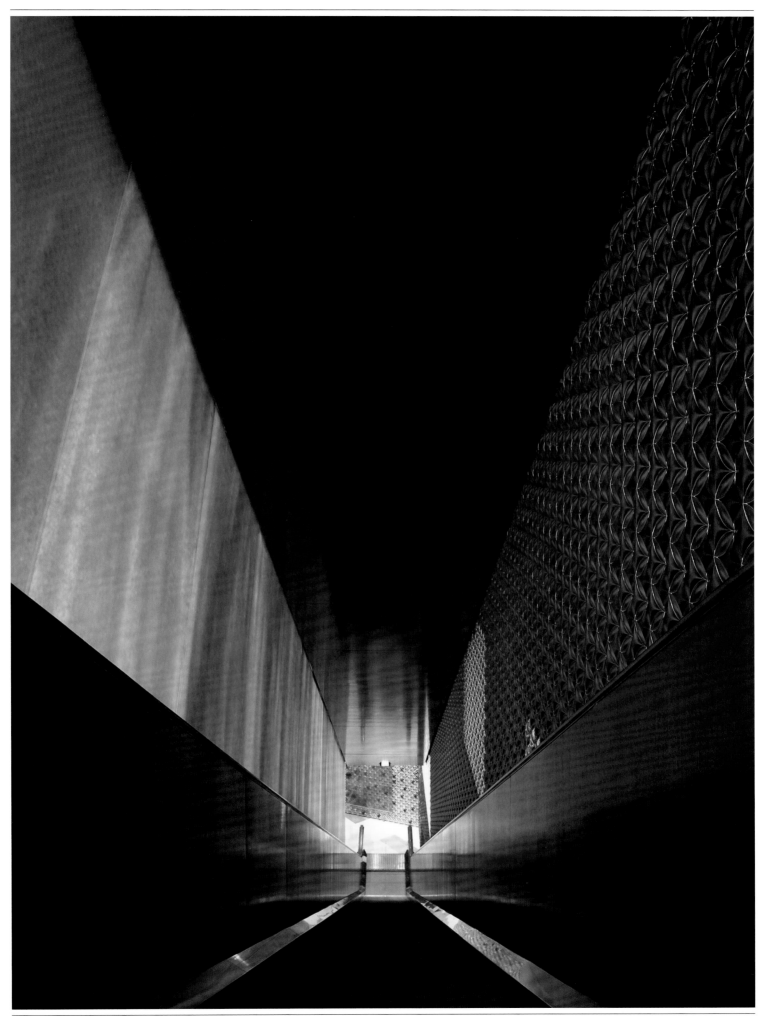

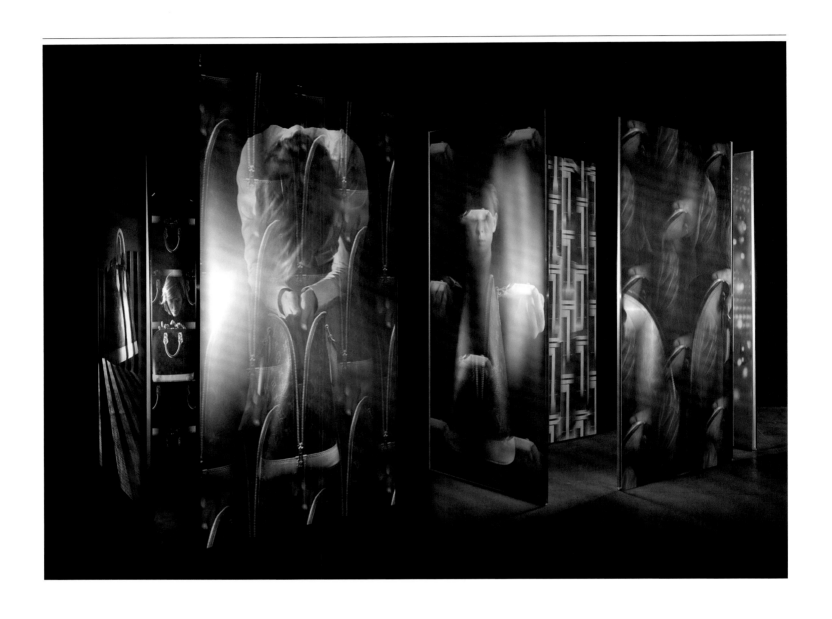

p.392-393 Interpreting the Alma bag (2006) by Tim White-Sobieski for the *Icons* Exhibition at the Espace Louis Vuitton, Fall 2006. Louis Vuitton Collection.

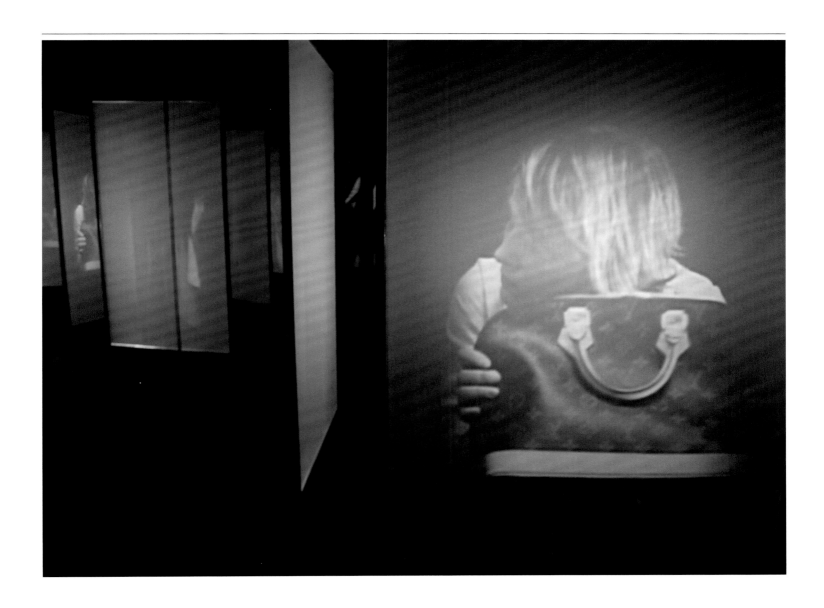

Wilson, Robert

artist
text by Marie Maertens

With a leap of faith, the renowned artist and director Robert Wilson, known to his intimates as Bob, enthusiastically took the first step and contacted Louis Vuitton.

From *Deafman Glance*, a silent opera created in 1970 for the Festival d'Automne in Paris, to Büchner's *Woyzech*, in collaboration with Tom Waits, Wilson has always been a master of many artistic disciplines. He has focused as much on experimental theater as he has on opera, dance, painting, architecture, design, sculpture and music. Its worth remembering that he studied architecture and fine art before establishing his reputation in the late 1960s as one of the pioneers of New York avant-garde theater. Ever since, Wilson's work has been seen in every major opera and theater house around the world, including *Le Songe de Strindberg*, *Wings on Rock*—a show based on Saint Exupéry's *The Little Prince*, *Orlando* with Isabelle Huppert, *Poetry* with Lou Reed at the Théâtre National de l'Odéon, Schubert's *Winterriese* with Jessye Norman at the Théâtre du Châtelet, Strauss's *The Woman Without a Shadow* at the Opéra de Paris, *The Fables of La Fontaine* at the Comédie-Française and more recently Heiner Müller's *Quartet*. He has also exhibited his fine art in places like the Centre Georges Pompidou and the Boston Museum of Fine Arts, as well as in art institutions in New York, Bilbao, Rome. A sign of his openness to multiple disciplines, every summer since 2002, Wilson has developed his artistic projects at the Watermill Center, in New York's Long Island, where artists from across the globe come together, joined by anthropologists, mathematicians, writers and bankers, as part of an amazing laboratory of creative exploration.

A lover of Louis Vuitton luggage, he one day proposed that he design a Wardrobe trunk himself, which he personalized with an image of a penguin, one of the animals that has always filled his imagination. An evening sponsored

all Black space

all white space

2 IS 1

"ICON BAG"

p.394-395 Concept sketch for an untitled installation interpreting the Noé bag (2006) by Robert Wilson for the *Icons* Exhibition at the Espace Louis Vuitton, Fall 2006. Louis Vuitton Collection.

394 **Louis Vuitton**

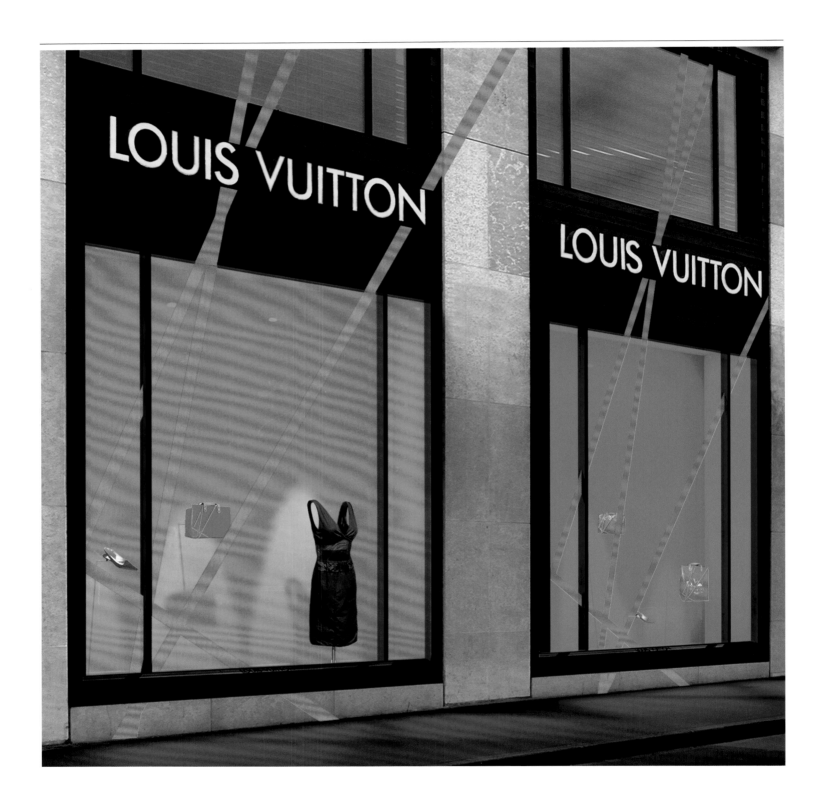

p.396 Window displays by Robert Wilson showcasing the fluorescent bags he designed for Louis Vuitton—Houston, Reade and Lexington—in 2002. p.397 *Bandana Fluo* silk square (2002) designed by Robert Wilson for the Christmas 2002 collection; 90 x 90 cm (35.4 x 35.4 inches). Louis Vuitton Collection.

by Louis Vuitton for the launch of this leather luggage was organized in July 2001 to support the Watermill Foundation. Another charitable event for a trunk equipped with a lithograph followed. The first collaboration led to a Christmas window project in 2002-2003. Wilson created a scene that in places drew on specially redesigned Monogram initials. During winter, when colors oscillate between gray, ochre, purple and midnight blue, Wilson boldly introduced the contrast of fluorescent colors. He directed the window space like a show, knowing that it could contain a multiplicity of desires. His palette, cheerful and dynamic, revolved around orange, pink and green tones. These were pure, uncomplicated and fresh colors, over which he

introduced energetic variations. Bright oranges and explosive pinks formed geometric LVs while creating depth—a foreground and a background—as in a theater set. Wilson also daringly created huge Monograms that streaked the outside of the windows and the store façades. At certain flagship stores, the tip of the V crossed over the bottom of the window, going across the wall down to the ground, and the corner of the L reared up obliquely. The lines of the two letters, originating from the storefront, stretched out to the sky and spilled onto the street. Not incidentally, the strong lines and day-glo colors were excellent shadowboxes for Louis Vuitton merchandise. The house also invited Wilson to create a collection of bags. Made in the same

dynamic colors as the window displays, but expressed in patent leather, they were named after New York city streets (Houston, Reade and Lexington), and took the form of clutches, totes and handbags. There were even matching accessories, such as bandanas and wish bracelets.

Finally for the *Icons* exhibition, for which nine designers reinterpreted nine emblematic Vuitton objects, Wilson used the Noé bag as inspiration. It could be found amid a play of black and white lights. The tunnel at L'Espace Louis Vuitton symbolized a quest, a means of conveying product while telling its own story. Wilson casts the spectator in the role of a child who simply looks at what is before him with wonder.

Wilson, William Adjété

artist
text by Marie Maertens

After commissioning silk scarves to the artists Arman, César, Jean-Pierre Raynaud and James Rosenquist, Louis Vuitton wanted the young French painter William Adjété Wilson to have a go at it. This request was unique in that it fully incorporated the theme of travel, which has been so dear to the fashion house. This artist, who has a rich background—his father was from Togo and his mother from Orléans—created a series of watercolors based on a three-month voyage through the heart of an ageless America in 1994, his gaze poignantly directed at the culture and disappearance of Native American peoples of the southwest. The nine watercolors he produced, five of which were transformed into silk square scarves, have a cosmologic structure. Built around circles symbolizing the womb, the earth and an eternal return, they also include half-human, half-animal figures. The circle is the image of cyclical time, the "Sipapu" of ancient creation myths, the original hole from which the Navajo people emerged from the ground. Starting with his first drawing in 1973, Wilson has always expressed the weight of history, and the spirit of his ancestors, in a colorful and lively world. His drawings are naïve, echoing a child's innocence. He set out on this journey with Isabelle Jarry, whose writings describe their surroundings as being "filled with Saguaro cacti, dust, sand and boulders... Rocks were sometimes orange or light salmon and would stand out sharply in the dry and pure light... Sandstone spotted the landscape... The wind would drive one mad... and then there were the Navajos galloping on their horses or growing maize..." What is this time? What is this space? What is this custom? "I do not know," Jarry confesses.[1] Wilson's paintings offer mute yet eloquent testimony, and take us up on this journey.

[1] Isabelle Jarry, novelist, has written an account of Wilson's voyage in French, *Vingt-trois lettres d'Amérique (Twenty-three letters from America)*. Paris: Editions Fayard, 1995, n. p.

p.399 (top) *Arizona Tour* silk square (1995) by William Adjété Wilson, 87.5 x 87.5 cm (34.4 x 34.4 inches), (bottom left) *Horses* silk square (1995) by William Adjété Wilson, 87.5 x 87.5 cm (34.4 x 34.4 inches), (bottom right) *On the Road* silk square (1995) by William Adjété Wilson, 90 x 90 cm (35.4 x 35.4 inches). Louis Vuitton Collection.

Index

Credits